THE FORGE AND
THE FUNERAL

THE FORGE AND THE FUNERAL

The Smith in Kapsiki/Higi Culture

Walter E. A. van Beek

Michigan State University Press
East Lansing

Copyright © 2015 by Walter E. A. van Beek

⊗ The paper used in this publication meets the minimum requirements of ANSI/NISO Z39.48-1992 (R 1997) (Permanence of Paper).

Michigan State University Press
East Lansing, Michigan 48823-5245

Printed and bound in the United States of America.

21 20 19 18 17 16 15 1 2 3 4 5 6 7 8 9 10

Library of Congress Control Number: 2015930097
ISBN: 978-1-61186-166-2 (pbk.)
ISBN: 978-1-60917-453-8 (ebook: PDF)

Book design by Scribe Inc. (www.scribenet.com)
Cover design by Shaun Allshouse (www.shaunallshouse.com)
Front cover image of smiths in the wedding ritual and back cover image of Gwarda are used courtesy of the author.

g green
 press
 INITIATIVE
Michigan State University Press is a member of the Green Press Initiative and is committed to developing and encouraging ecologically responsible publishing practices. For more information about the Green Press Initiative and the use of recycled paper in book publishing, please visit www.greenpressinitiative.org.

Visit Michigan State University Press at www.msupress.org

For Kwarumba Wuzhatizhè, kwajuni

Contents

Preface

ANTHROPOLOGY, IN MORE THAN ONE SENSE, IS TIME TRAVEL. NIGEL Barley noted the inverted time travel of fieldwork: after the intense fieldwork experience the anthropologist returns home changed. He then expects his home culture to have changed as well, but it has not, and he gets his "secondary culture shock" in adapting back to his roots.[1] But there are two more time travels. In its classic inception, the anthropological discipline journeys around the world in order to find varieties of culture, lovingly embracing cultural differences while trying to explain both variations and similarities in cultures. Coming from a postmodern Western world, those differences inevitably reminisce of the past, sometimes our own past, often mankind's past; though we have left the notion of "contemporary ancestors" behind us, the impression when entering a traditional African smithy is one of sliding into mankind's past: this is in archaeological terms "Iron I," a culture that has been, in a different form, ours.

The third travel is into my own past. I grew up in a family dominated by my father's profession, manager of a major factory of cutlery and stainless kitchenware. Our table talk was steel, stainless steel, and its many varieties and applications. When in the usual gentle revolt of a teenager I veered off into cultural anthropology instead of following in my father's footsteps, I never dreamed that I would end up in iron, eventually. But that is what I did. From my first encounter with the Kapsiki/Higi of northern Cameroon and northeastern Nigeria, I was fascinated by the blacksmiths. One reason was indeed iron, and my fascination with this crucial metal has stayed with me. And it soon turned out that the Kapsiki smiths were much more than just blacksmiths, as they furnished most of the specialist services essential for the Kapsiki. So, through anthropology, I ended up in iron after all, not stainless steel, but in its deep roots, and also the roots of African culture.

This book, which follows on a monograph on Kapsiki/Higi religion that can be viewed as its companion volume,[2] results from a lifetime of intermittent, deep immersion in Kapsiki society over four decades; after a first visit in 1971, and a major field stay of one-and-a-half years (1972–73), I have been

returning to the field each five years for two decades, and every other year since the mid-1990s. Some of the material of this book has been published in various journals and edited volumes, but the bulk is new, and anyway all earlier publications have been reworked. The book is not written from the viewpoint of the pupil, as I explain in the text. I remained *melu*, non-smith, in my immersion in Kapsiki society, but from the viewpoint of one close to the *rerhε*, the smith, someone fascinated by a group of people who are absolutely essential and still assigned a lower status. That is one major riddle this book tries to solve, one that many other scholars have tackled in their own ways. To arrive at some understanding, I place the phenomenon of the African smith, of which the Kapsiki smith is a striking example, inside two scholarly discourses: one is the theory on the anthropology of belonging, the ways in which we construe our own belonging in opposition to the "other," and the second is on embodiment, as an approach to craft in general. The first debate then is informed by ecological anthropology, in particular Ingold's notion of "dwelling"; the second gets its ethnographic angle by the anthropology of the senses. Those are the conceptual strands that tie together the rather wide array of smith occupations in Kapsiki/Higi society, strands that are reflected in the chapter titles that relate to "otherness" and to the various senses crucial in each of the smiths' crafts. Though change in the smiths' work and position is part of each chapter, the last chapter tries to situate the whole smith phenomenon in the deep history of this part of Africa, which is why the book, strangely enough, ends with a historical overview.

Acknowledgments are a pleasure to do, always. My institutional support has been constant and unwavering, first from the Department of Anthropology at Utrecht University, later from the African Studies Centre, Leiden (with thanks to Ruadhan Hayes for his excellent editing), and from the Faculty of Humanities at Tilburg University. Additional financial support came, in all these years, from various sides, first of all from WOTRO (Scientific Research in the Tropics) funding W 52-91 plus two travel grants, but also travel grants of the Royal Academy of Sciences (KNAW) and the Hollandse Maatschappij voor de Wetenschappen (Dutch Science Society). All photos are mine, and the objects photographed are part of my own collection. For the drawings I am grateful for the kind permission granted by Paul Wartena. For the partial reuse of previously published material I thank Oxford University Press (New York), LIT Verlag (Berlin), Africa World Press (Trenton, New Jersey), Indiana University Press (Bloomington), Langaa & the African Study Centre (Leiden), and Brill (Leiden).[3] All of this material has been reworked, but their kind permission is gratefully acknowledged.

My debt to the Kapsiki of Mogode is the first and major one; despite the small services I could provide for the village, the reciprocity is never balanced, and I owe them a deep and lasting gratitude. Many of my first informants are no longer with us, and such a long field involvement generates its own sad nostalgia. My great friends, the blacksmith Cewuve and the chief smith Gwarda, long since have gone to their "other existence," and I count myself lucky to be able to work with their children and even grandchildren. But the nostalgia is definitely there, as I severely miss many of my good friends. My assistant's wife, Marie, once said: *"Kahale Zra we"*: "Zra [my Kapsiki name is Zra Kangacè] does not grow old." I wish it were so, but life does run on a different gear in Africa, and the longing for the past sometimes surges when I come back, again, to the Kapsiki area: so much changed, so many people died, time runs differently here.

I am very fortunate to have my assistant still working with me, Sunu Luc, who came into the ethnographic project as an experienced assistant from an earlier linguistic research, and quickly took the place of Jean Zra Fama, my first aide who had to attend secondary school in Mokolo in 1972. Fortune has decided that Jean Zra is back in the project now, after a career in agricultural extension, so my first assistant is a retired functionary, serving now as my urban field station. With Sunu Luc I have kept working, even if he had his stints of work outside the Kapsiki area. Together we studied the smiths, though sometimes he was apprehensive as the power of the smiths should never be underestimated. But also as a nonsmith he learned to appreciate more the stature of these smiths, their knowledge, their skills, and their craftsmanship. It is also he—plus his wife, Marie, and his grandchildren—who urged me never to come back without my wife, Tini, whom he lovingly calls "Wuzhatizhè." So the book is dedicated to Tini with the name Luc uses, and together we intend to honor the smiths of Mogode, Gwarda, and Cewuve, and all their families, people we will encounter in the pages that follow.

Language and Orthography

THE KAPSIKI/HIGI LANGUAGE CLUSTER IS KNOWN AS PSIKYE IN CAMeroon and Kamwe in Nigeria, and the two are considered similar. The cluster has in total eleven dialects, four in Cameroon (Psikye, Zlenge, Hya, and Wula Karantchi) and seven in Nigeria (Nkafa, Dakwa, Sina, Futu, Tili Pte, Modi, and Humsi). The dialects of Fali Kiriya and Fali Mijilu are closely related, but viewing the considerable cultural differences I do not count them inside this Psikye/Kamwe cluster; on the other hand, Gwavar (Kortchi) is considered a different language (of just one village only) but is that closely related culturally that I consider it as part of the Kapsiki/Higi conglomerate. The linguistic lineage of Psikye/Kamwe language cluster is Afro-Asiatic/Chadic/Biu-Mandara.[1] Psikye refers to the process of beer brewing, in particular the sprouting of the seeds (*pseke*). The strong dialectization of the Psikye/Kamwe language mirrors the proliferation of languages in the area. The greater Mandara Mountain area counts some sixty-five languages—twenty-two in Nigeria and forty-three in Cameroon. The Kapsiki language has no standardized orthography yet. For Psikye, the dialect I do my work in, I use an adaptation of the orthography of the New Testament by the Alliance Biblique du Cameroun, Yaounde, 1988.

Specific signs:

ɛ	mid-central, unrounded	c*a*p
h	voiceless velar fricative	
rh	voiced velar fricative	
c	voiceless alveo-palatal affricate	kit*ch*en
j	voiced alveo-palatal affricate	*G*eorge
g	voiced velar explosive	*g*ood
y	voiced alveo-palatal halfvocal	*y*es
ŋ	voiced velar halfvocal	*long*

ɗ voiced alveolar implosive

ɓ voiced bilabial implosive

' glottal stop

tl voiceless alveolar lateral fricative

dl voiced alveolar lateral fricative

The **e** represents the sound phonetically indicated by a schwa, as in "th**e**," and adapts to its environment: after the **w**, as in *kwe*, it becomes rounded—in English "l**o**ck"—after **w** and followed by another consonant—for example, in *gwela*, it is lengthened, in English "b**oa**t." For the proper names I use a simplified orthography; thus, I speak of Mogode, and not *ŋgweɗu*. All terms in Psikye are italicized throughout the book, because quite a few Kapsiki words occur in English as well (with a completely different meaning of course). Other non-English words are put between quotation marks.

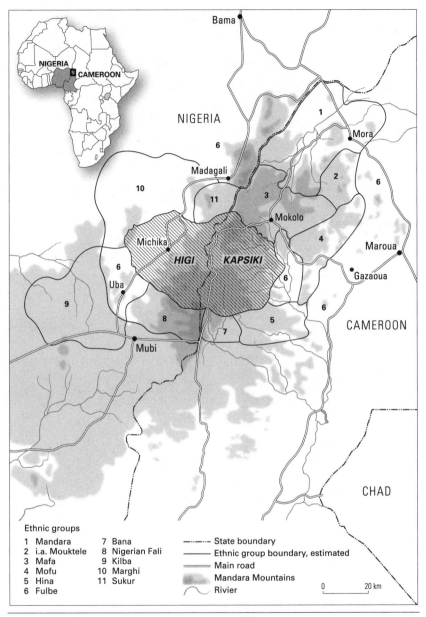

Map 1. Kapsiki in North Cameroon/northeastern Nigeria (The maps were made by Nel de Vink, London. The relevant information is taken from the 1:25,000 maps of both the Nigerian and the Cameroonian side of the border, and Seignobos & Mandjek 2000.)

Ethnic groups

1 Mandara	7 Bana
2 i.a. Mouktele	8 Nigerian Fali
3 Mafa	9 Kilba
4 Mofu	10 Marghi
5 Hina	11 Sukur
6 Fulbe	

- - - - - State boundary
——— Ethnic group boundary, estimated
═══ Main road
▓▓ Mandara Mountains
〰 Rivier

0 20 km

Smith, Skill, and the Senses

THE SACRIFICE OF A SMITH?

THEY SAY IN KAPSIKI COUNTRY THAT THE CHIEF OF GUDUR SACRIficed one or more smiths when a locust plague hit the mountains. Two young people are said to be put inside a hole as an offering for the plague, and if possible these people should be smiths; then the locusts would feast on the corpses and the plague abate. This gruesome tale of a human sacrifice highlights three aspects of Mandara Mountain culture: the power of that very chief of Gudur, the desperate measures needed against the catastrophe of a locust swarm, and for the purpose of this book the curious position of the smith. Indeed, when such a plague hit the Mandara Mountains area, representatives of the Kapsiki and Higi villages went abroad, first to the iron production center of Sukur, their northern neighbor, and then all the way to the great ritual center of the Mandara Mountains, Gudur. For many groups all over the Mandara Mountains, Gudur is the village from whence they trace their origin; at present it is still the center of rituals, but more than anything else his prowess against locusts gives the chief of Gudur his ritual eminence in the Mandara Mountains. This "big chief" is the one all appeal to in times of great stress, not only the Kapsiki and Higi but also the Mafa, Mofu, and Hina, who also trace their descent from Gudur.[1]

Sacrificing a couple of smiths. Really? What exactly the chief of Gudur did when a swarm hit the area is discussed by many but known only by a few, and the description that follows stems from the Kapsiki village representatives and from some people from Gudur, including the chief himself. The preparations are well known. First, the representatives of the villages in question go together to Sukur, on the Nigerian side just north of Kapsiki/Higi,

with money, goats, and clothes. Wula village, a close kin to Gudur, sends its rainmaker. At the request of the delegation, the smiths in Sukur forge five irregular-shaped sheets of iron, which the delegation, together with other gifts, hands over to the chief of Gudur, the one who "commands" the locusts. Somewhere, deep into the mountains that belong to the village, is a hole in the ground, too deep to see the bottom. The word goes that at the bottom lies the *melɛ* (sacrificial jar) of the locusts under an upturned beer jar. The Gudur chief sends an elder of the particular clan that is in charge of this *melɛ* to perform the sacrifice. Over the hole the elder butchers two cattle, bull and cow; shuts the opening, reputed to be about 1 meter in diameter, with the iron sheets; and then covers the sheets with earth. At least in recent times it was cattle, but formerly the Kapsiki stress, mainly smiths were sacrificed. Informants describe the setting in terms of a tomb, fitting for a human sacrifice. This hole in the ground is the home of the locusts, which, according to Kapsiki, have no wings, but once in a few decades perform their initiation and then the males develop wings. The others are like termites. During initiation they swarm and eat everything, so they have to be calmed with the sacrificial meat. Iron, of course, is used to stop them as it takes locusts "decades to eat through a sheet of solid iron."

This ritual generates a lot of contradictory information, especially from those informants who had no part in it, an indication of the emotional value and almost mythical dimension of Gudur. Formerly, people told me, it was indeed a human sacrifice, and villages in the Mandara Mountains were asked to send victims. People assured me that it was better to sacrifice a few than that all would die, and the ones they sent were sacrificial victims. Even allowing for the usual and well-founded skepticism of these kinds of stories in anthropology, this case might have some historical foundation. When I came to Gudur for the first time, in 1973, there had been a "false alarm" some years earlier, and people from Hina had sent a nicely fat woman to ward off the threat. However, the plague never materialized, and as this particular woman was not a smith, the chief had married her. She showed no sign of ever wanting to go back to Hina.[2]

The area has suffered great losses in human life in the past, and people used to sell their own kinsmen into slavery during famine; so sacrificing the odd smith is a definite possibility. In any case, Gudur is a dangerous place for smiths: at the funeral of the Gudur chief, a smith was buried with him, the story goes, though nowadays it is a dog. Not only blacksmiths might have been sacrificed; children can be considered as a commodity as well. During a beer party, some elders were discussing death. One of them said: "If Death comes, do not ask him why he comes, but immediately give him

a child, and then he will not take you." As for the smith, he is often called the "child of the village," so the equation holds.

Outside Gudur all people think the chief of Gudur himself performs the sacrifice and that the chief of Sukur himself is part of the delegation. One story from Wula—a neighboring village of Sukur—underscores the danger of the ancestral place:

> Last time the chief of Sukur did not want to go to Sukur for the sacrifice, when it had to be held. His own people then cuffed him and brought him to Wula, the first leg of the journey. From there he went on his own. When he returned, people chose another chief, and the old one died within two years.

In Sukur, these tall stories were denied vehemently: damned lies. Anyway, it was never the chief of Sukur who participated in the delegation; he sent delegates. Locust plagues are a longtime threat and are still the major catastrophe for any crop, according to the Kapsiki. These swarming species are not any locusts; these are what the Kapsiki call *dzale*, carnivorous insects. In contrast their own *jamaya*, the resident locusts (the generic name is *hegi*), are considered healthy food. The *dzale* used to come once in a generation; but they have become rarer, and the last plague dates from the early 1930s.

For our purposes here, this case of the locust sacrifice illustrates the strange place of smiths in this area; after all, the iron sheets, blacksmith products, were crucial in combating this major threat—but then smiths themselves were sacrificed? Whether this was actually the case is not decisive, as a mythical tale about a smith sacrifice illustrates the ambivalence of the smith just as well, so the story highlights a crucial aspect of "smithhood." The focus in this book will be on the smiths of one particular group—the Kapsiki/Higi—but the phenomenon can only be understood at a wider regional level, as the smith links the various groups and villages in a regional power configuration, and at the smith level the distinctions between the various ethnic groups are not overly relevant anyway.

So this is a story about smiths. The Kapsiki distinguish between two kinds of people inside their society: the *rerhɛ* and the *melu*. The latter are the "normal" people—the nonsmiths or "farmers"—and comprise 95 percent of the population, while the former—the *rerhɛ*—form a 5 percent minority and are called "smiths" in this book. The smiths perform many functions: music, funeral, and divination; but when they perform ironwork, I will call them "blacksmith." Brass casters are also "smiths." Often the vernacular terms will be used—*rerhɛ* and *melu*—both in their singular form so as not to confound the issue (the plurals are *karerhɛ* and *kamelimu*). The separation between

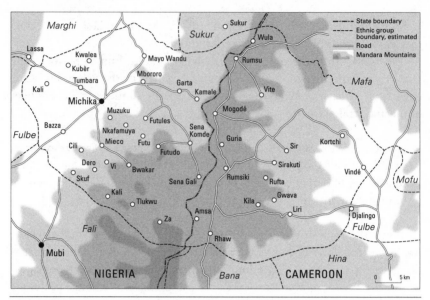

Map 2. Kapsiki villages

rerhɛ and *melu* is extremely clear in Kapsiki; within the general society of *melu* farmers, the *rerhɛ* form an endogamous segment with specific tasks, their own food taboos, ritual duties, and prerogatives, combined with notions of pollution. This is not uncommon in this part of Africa, but the Mandara Mountains show this complex in its full force, and in fact this is the thread running through the whole book.

KAPSIKI VILLAGES AND THEIR SMITHS

A "shatter zone" is what Eric Wolf called the mountain areas that dot the huge savanna belt of Africa.[3] These are the regions where people took refuge from the vicissitudes of history, and the Mandara Mountains indeed form such zone with highly fragmented ethnic groups and a plethora of languages and dialects. The Mountains host over forty smaller and larger ethnic groups, of which the Kapsiki/Higi conglomerate is one of the larger ones, with its 70,000 Kapsiki living in Cameroon and 140,000 Higi in Nigeria. Though some literature assumes that the two comprise two different but related ethnic groups, in fact it is not their cultural distinction but the border that has cut one conglomerate of villages in two; so I consider them as

one ethnic group that straddles the international border. In these mountains, the whole notion of an ethnic group is a colonial construct anyway, as in precolonial times no authority or identity existed beyond the village level, with loose clusters of three to four villages joined by a tradition of common descent, as shown in the way warfare was conducted between them.[4] The German, British, and French colonial administrations gradually created the larger units; in the complicated interplay between these forces, the shifting international border[5] in these mountains dictated the ethnic division, which thus has followed the ebb and flow of colonial fortunes. But culturally, the Kapsiki and Higi are best considered as one group. As is often the case, language is a crucial argument: the language cluster Psikye and Kamwe[6] with their eleven dialects are mutually understandable—if only with some effort—but distinct from Mafa, Mofu, Marghi, and also, though less clearly, from Bana, Fali, and Hina. But also cultural links run between the villages; for instance, initiation (*gwela*) and a ritual against epidemics link the various villages. And, as we shall see, their definition of what is a smith is an important common factor.

A language or ethnic cluster is defined by intermarriage as well. In Kapsiki society brides tend to remain within the village for their first marriage, but wives leaving their husbands routinely go to another village and then choose a Kapsiki/Higi one. Together, all these secondary marriages—which

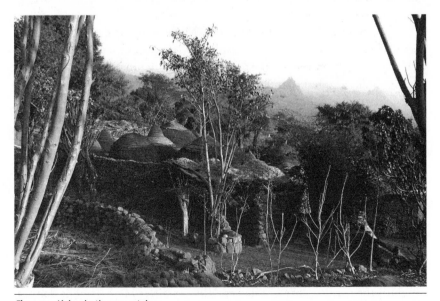

Figure 1. Living in the mountains

are very numerous—form a dense network of relations, resulting in a cluster of intermarrying villages with rather clear boundaries, defining the Kapsiki and Higi as one more-or-less endogamous unit—and so one ethnic group. The term "Kapsiki"—infinitive of *pseke*, to sprout the sorghum grains in order to make beer—is traditionally used for three villages only (Mogode, Guria, Kamale) but since colonial times is used for all Cameroonian villages. "Higi" means "locusts" (*hegi*), a term probably used by their western neighbors the Marghi, because the Higi were numerous. The present Marghi call the Kapsiki/Higi, *karhweme*, mountain people.

To the north and northeast, the limit of the Kapsiki/Higi territory is quite clear, as the chiefdom of Sukur is in fact one major village,[7] and Mafa culture is quite different anyway. In the east, a valley inhabited by Fulbe separates the Kapsiki from the Mofu-Diamaré, while in the west, the Marghi have a distinct language and culture[8] with a more centralized political organization. The southern limit is the most vague, as the Hina and Bana are culturally more similar to the Kapsiki, while the Fali of Nigeria[9] are quite distinct again. I count the village of Wula as Kapsiki, as villagers there speak Psikye, even if they share a tradition of common descent with Sukur, Mabass, and Sirak. On the east side, Kortchi/Vinde is a quite isolated village, which could be considered a microethnic group, as its language is a separate dialect—if not a proper language—but it is culturally Kapsiki and part of the marriage network, so I count it as part of the Kapsiki/Higi conglomerate.

It is a beautiful area. The Mandara Mountains form a rugged landscape, where the hand of man is visible in the terraces that the inhabitants of old have built on the steep, stony slopes (see figure 1). At the center of the mountain area, an undulating plateau is dotted with huge, spectacular rocky pillars, the core of old volcanoes whose rocky mantles have long since eroded away, and a plateau renowned as Le Pays Kapsiki. This landscape has become famous and is now a major tourist attraction, with its spectacular views from the plateau rim.

About thirty-five villages form the Kapsiki/Higi territory, varying in size from 1,500 to 7,000 inhabitants (relatively large villages are common in this part of the Mandara Mountains). The villages of the Kapsiki/ Higi, called *meleme*, are clearly recognizable units and are defined by a demarcated territory, a name, a set of specific patriclans with their migratory histories, and specific religio-political organization. Recent decades have shown a marked population boom, with many settlements expanding until they are the size of villages. Villages differ in settlement density, from a highly nucleated settlement such as Rumsiki, to the dispersed ways

of living in Sir or Ldiri. In all cases the boundaries of the wards, and especially the villages, are clearly marked by boulders, special rock formations, and dry riverbeds. All villages share a similar social and political structure, as well as an important feeling of togetherness as members of the same village, and the village is the most important source of identity. Internally it is divided into wards, clans, and lineages, the descent groups usually being scattered over various wards. Smiths' compounds are widely dispersed over the village, as people of all wards have to have access to their services; their compounds are similar to those of the *melu* but for an eventual smithy next to the house. These groups were especially important during the bouts of fighting within the village in the past, when village halves fought each other with limited weaponry;[10] since pacification their hold over the lives of the members has lessened.

Limited as they are to just one village, the patriclans have a finite range of action and do not command much property, but they do serve as crucial points of reference. People often refer to their clan in daily discourse, as a constant redefinition of identity, an internal structuring of the village. Especially during the times of ritual, clans are cultural ways to make a small difference. The smallest social unit is the compound, inhabited by a monogamous or polygynous family with the man's parents sometimes living in, and is crucial in daily life, bolstered by a pervading sense of privacy and individual autonomy, even if situated inside larger kin groups. Smiths' compounds share the same characteristics, with a slight twist: their lives are less private and more public, as they are in fact service providers for the community.

Each village has its specific historic tales, as well as its own founding myths, and forms not only a social but also a religious unit. These founding tales usually indicate a common descent from an ancestor who came into the area, settled, and undertook heroic exploits. Usually in these myths, the area was not completely empty but inhabited, and the ancestor's exploits were aimed at carving out his own niche in the territory.[11] Each of the *meleme* has its own territory with marked boundaries, even with spots marked where wars against the neighbors were fought. So every village has its own history, sacred place, and chiefly lineage, its own smiths and smith chief. The *rerhε* are part of the *melu* lineages by means of social adoption, in ways that maximize the number of their relations with their *melu* clients.

Characteristically, the clan and lineage system does not transcend the village border: each village in the Kapsiki/Higi group has its own set of village-specific clans and lineages. The only commonality between the villages is that all have a clan called the *maze*, the chief clan, from which all village

chiefs are chosen, often each next chief from a different lineage of that clan. So, in the kinship system the relative isolation of the villages shows, as in principle different villages share few descent ties. Some have a tradition of common descent and define themselves as brothers, using the terminology of the polygynous family—such as brothers of the same father but different mothers—that is, half-brothers. This link provides a modest degree of peace between them, as during the wars of the pre- and early colonial period they did not fight with bows and arrows (that is, with poison), nor did they capture the other villagers as slaves. The wars between those villages—which did indeed occur—were defined as wars between wards within the same village. They did fight, though, but just with clubs. The Kapsiki knew a kind of segmentary war, in which the use of weapons escalated with the social distance between the parties: close opponents fought with clubs, opponents from village halves with knives, and enemies from different villages with poisoned arrows.[12] But war, in the past, was something for the *melu*, not *rerhɛ* business, for several reasons. Their mobility precluded them from developing the deep roots inside one village that is the norm for *melu*, so a *rerhɛ* could count on finding kinsmen in that other village.

In Kapsiki society most sons choose not to live close to their father's compound, or too close to their brother either and definitely not next to their half-brother, a classic kinship tension within Kapsiki society. Only the youngest of the sons is expected to remain in his father's compound and to inherit ("eat" the Kapsiki call it) the compound. Therefore, the patriclans are dispersed throughout the village, each ward housing members of most of the village's clans. The days of internal wars and slave raids forced the Kapsiki to live huddled together in a safe place and not to build their homesteads in or near the fields they cultivated. Pacification gave them the opportunity to join their fields and live out in the bush, so bush wards sprang up; however, population growth meant that land had to be cleared farther into the bush, so not only is there little unclaimed bush left but people have their fields at quite a distance from where they live.

The territorial subdivision of the village is the ward (*rhudukwu*), led by a headman. The village of Mogode has sixteen wards, including one Christian settlement and a large Fulbeized core, almost each of which houses a smith family. Wards have a loose structure, with a ward headman (*mblama*) who assists the village chief in matters such as collecting taxes, party dues, and fines—a less than popular endeavor, which older men might shirk and some younger ones covet for a political career. Members of any clan can become *mblama*. In the last few decades, people from some of the outer wards have moved into Mogode's central ward,

resulting in one Christian and two Muslim wards, though both religions are now also to be found in other wards. As all the arable land has been claimed, the other wards tend to be close to available water, as due to its increasing scarcity, people are moving to the few bore holes that dot the plateau. Mogode is one of the larger villages and the administrative center, and it has a primary school and a lycée that attracts pupils from all over the Kapsiki area. There are also plans to build a second lycée, a Catholic one. Some bush wards have attained semi-independent status as a bush village.

So there we are, a village-based society without much ranking or hierarchy, with a subsistence agriculture in a demanding environment and deep roots in a turbulent history. For agriculture and social life, so both for physical survival and social reproduction, the products of the smith are absolutely essential. Yet, the particular configuration of their social relations seems to contradict their centrality, as throughout this book we will see how these craftsmen and craftswomen entertain very dialectic, even ambivalent, relations with their host society. So we will first zoom in on the issue of craft itself.

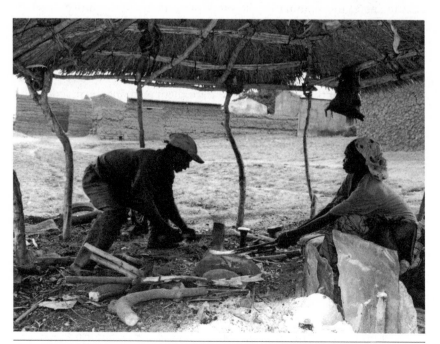

Figure 2. Husband and wife *rerhε* in an open-air village smithy, Guili

CRAFTS, EMBODIMENT, AND THE SENSES

Two questions occupy us throughout this book. First, the historical and sociological puzzle of the smith's position: why is the smith separate and unequal? Second, why do the crafts cluster? The first inquiry is one on crafts in general and will engage us later in a quick view on preindustrial craft organization in the world. Here I address the second issue and see whether—discounting for the moment historical contingencies—there is a common denominator in the smiths' specializations. The various crafts call for distinctly different skills, but all demand specific capabilities. In skilled practices, Tim Ingold[13] distinguishes five critical dimensions: intentionality-cum-functionality; skill as part of the relational structure of the artisan; qualities of care, judgment, and dexterity; transmission through "hands-on" experience; and finally the notion that skills generate the form of the artifact, more than executing a preexisting design. In short, a skilled craftsman consciously makes something usable, which has to have quality, and the shape of which depends on function first and the craftsman's way of working second, while he or she has a clear niche in society and has learned the craft by actual practice. It is the "praxis" more than the "logos" that is relevant here, the training of the body more than the cognitive development. In crafts, the "body has to know." Concepts and precepts are not important, but dexterity and bodily routines are. A common joke in the Netherlands, when someone does not handle his sailing boat well, is that he has learned sailing by taking correspondence lessons. The same holds for the many crafts of the smith: he has to learn them by doing, by practice, and throughout there is a "primacy of process over product."[14] So we are talking about embodied skills, about faculties of doing that are neither conceptual nor theoretical: the body knows, so the body has to learn.

The array of smith crafts and skills ranges from dominant somatic acts, like forging, to cognitive-visual ones, such as divination, and the notion of embodiment is relevant in the whole range, albeit in different ways. In the last decades, cognitive psychology has moved toward the notion of "embodied cognition," which views the nature of the human mind as informed for a large part, even determined, by the structure of the body; in this view, cognitions are part of a system in which sensory, motor, and reflective abilities converge, all stemming from the embodied nature of human existence. Thus, sensory and motor skills—crucial in crafts—are intrinsically connected, subsystems of the same structure of our being open to the world.

This notion is highly relevant for the smith's specializations: embodied, unconscious, deeply imprinted, and not easily altered, a skill transforms its

bearer, fine-tuning the human with his material surroundings and tools. Thus, the embodiment is an active dynamic, leading to parity between perception and action: perception always includes "affordances," options for action, while action guides, stimulates, and informs perception. For instance, seeing a ball implies kicking it—as a ball has to roll—while viewing a cube invites a haptic reaction, to feel the sides and angles—a cube does not roll. When we hear music, we tend to move with it, a reaction that has to be unlearned by classical-concert goers. On the other side, any action we engage in toward the outer world is guided by our expectations of the results of our actions: kicking a ball is intentional but also directional; the ball has to go somewhere. Raymond Gibbs, in his seminal work on embodiment and cognition, concludes that our perception of an object always links the notion of what we can do to it with our actual handling of it and with the expected outcome of our action.[15] Thus, our cognitions as such are informed by realities outside the brain: "a new vision of cognition as emerging from continuous interactions between a body, a brain, and a world."[16] Or, in an engaging phrase, the mind is a "leaky organ that mingles shamelessly with the body and the world in the conduct of its operations."[17]

We are even intersubjective in this interaction: when we see other people act, we can empathize with reactions—both our sensory and motor cortices are stimulated when we watch someone else act.[18] Our arms twitch with the returns of tennis-player Novak Djokovic, at least if we have also played tennis. In short, sensory and motoric neural systems seem to operate in tandem as a largely autonomous dynamical system: "Perception and action are not different entities, but are two aspects of behavioral control."[19] This informs the question how we can react so fast, if needed. There is no lengthy chain of visual stimulus/interpretation/reflection/decision that would send signals to a separate motoric system, but it is our embodied system that can react or act in a flash. When returning the serve on the tennis court, I definitely do not think; I just hit the ball in a split second. And hit it well, I hope. An overdose of conscious attention can cause the phenomenon of choking, drowning in a sea of thought those automated reactions that my extensive practice has wired into my body, as "the body mediates all reflection and action upon the world."[20]

This embodied aspect of perception-cum-action is a crucial vantage point for the study of skills, both in their acquisition and performance. Skill training is a lengthy process of setting up immediate connections in the sensorimotor part of the brain. The body has to know, so the body has to remember, a bodily engrained knowledge that is almost impossible to forget. Whoever has learned to cycle will never unlearn it. Training engraves

itself in our bodily memory, which coupled with conscious elements of knowledge forms the basis of a skill, the core of a craft.[21]

Thus, we can approach crafts through the integrated body, as an embodied and deeply engrained activity engaging the whole person. My angle is that the notion of embodiment is productive especially through the sub-discipline of the anthropology of the senses, as in the embodiment of skills the question of the coordination of motoric skills with perception is crucial. Craft is never just routine, and always combines various senses. So, as smith crafts are quite different from everyday acts, I choose to approach this gamma of skills by the senses, one shared embodied faculty which in itself allows for enough variety. These comprise the usual ones: smell, sight, touch, hearing, taste, but also proprioperception, the experience of one's own body in space. This sensory angle serves both as a means to "feel ourselves into the craft" and a literary device to enhance the impression of both the familiarity and "otherness" of the smith.

In this approach the environment of the skilled performer is a major variable in learning and performance, as all skill learning is contextually informed. Our sensorial apparatus is much more than just passive perception, it is an integral component of our being in and acting unto the world. The senses are our connection with that outer world, and as embodied beings we do not "use" our senses, but in many ways we are our senses. It is this sensorial connectedness between craftsmen and their outer world that is crucial for craft theory. Craftsmen occupy a specific place in their society—and the Kapsiki smith is one major example of this—and within each culture a craftsman has to learn how to see, how to hear, how to taste, how to feel, in a more elaborated way than his customers. A blacksmith has to read the color of the hot iron, the diviner has to trace the patterns the crab made in the sand, the brass caster has to feel the texture of the wax and to judge the redness of the mold to decide when to invert it, the drummer has to hear the other instruments in order to change the rhythm of the mourning dance, and the healer has to observe, closely and minutely, the eating patterns of wild animals in order to gauge the medicinal capacities of wild plants.

Craftsmen are embedded in the process of crafting by their very working with matter. How to make things is of course informed by the desired product and just as much by the qualities of the material from which it is made. Craft implies primacy of process over design, and each type of material they work with has its own dynamics, its own stubbornness, its own agency; craftsmen follow the substance, materializing the hidden qualities of the matter in question into new emerging properties of the "thing."[22] Thus, when the blacksmith forges a torque bracelet, the fluidity of iron emerges, a

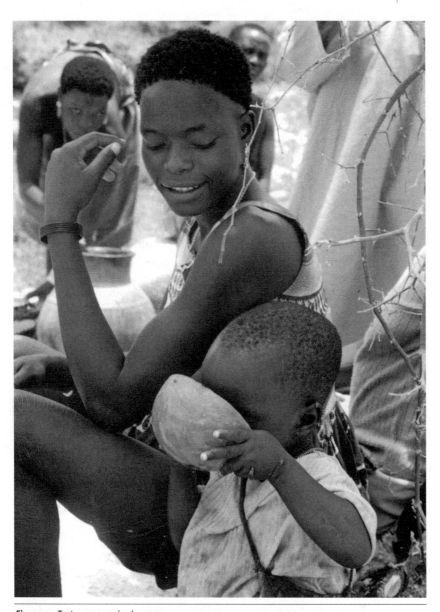

Figure 3. Taste, an acquired sense

quality that comes out only with the combination of intense heat and hard, skillful beating; when his wife fires a pot, the reverse happens, the soft clay showing its inherent hardness. This "sense of matter" is essential to workmanship and implies a heightened use of particular senses, each skill

demanding a specific combination of various senses in their motoric and perceptual faculties.

Our senses are informed by the cultural definition of the world that we have internalized in childhood.[23] We see, hear, smell, and feel what we are "wired" to experience as a body while constantly filtered and shaped by what we learned as a child, so looking at the way our various senses structure our relation with the world offers insight into the relation between self and surroundings, as well as into the cultural definitions that shape our opening unto the world. Within the anthropology of the senses, an open debate has been going on whether culture directly influences our sensory perception as such or not.[24] However, starting from embodied cognition, it is unproductive to separate sensory perception from motoric action, thus from our total embodiment. So it is not perception that is culturally colored—as one part of the longer chain—but our already embodied reactions to the world that are informed by culture. Whatever we are and whatever we do always bear the imprint of our corporeal existence and just as inevitably of our culture, and that interrelation is always dynamic. We are not a corporeal tabula rasa on which culture inscribes, but biology-cum-culture in any instant: our nature is mediated by culture, just as our culture is grounded in nature. This means that culture is always intertwined with the body, just as it is with the outer world.[25] The body is what the body does,[26] and sensing the world is our prime way of existence.

For me, smell brought me into the anthropology of the senses—that is, the realization that the Kapsiki separated the smith from the *melu* with the nose.[27] This will be a recurring theme in my discussion of the Kapsiki smith, for smell is an elusive sense that forms an excellent signal of differences between cultures, as well as within a single culture. Within one culture an idiom on odor can create a clear division between people who are otherwise very similar, the predicament of the Kapsiki smith. Between cultures the question is how much weight, i.e., empirical authority, is attributed to the various senses. This is not a question of biology or epistemology but of cognitive style, of what a culture considers a conclusive argument. Thus, the discussion on the relative importance of the eye versus the ear, aims also at highlighting a major characteristic of our Western society, the fact that we highly prioritize the eye over the ear.[28] This is partly a cultural critique of our own society, partly a way to point at hidden, background differences between cultures. So I will use the angle of the senses as a descriptive tool in order to draw attention to subtle but pervasive differences and to the internal articulation of Kapsiki society, while it also serves as a literary device.

WHERE CRAFTS DWELL

The essence of a craftsman's skill resides in transforming raw materials, adding value to value-free substance by plying his hand-cum-tool in an action that combines some cognitive knowledge with a lot of body knowledge—in short, a craftsman produces technology. For Ingold, one of the characteristics of technology is the gradual withdrawal of the craftsman from the product, and one of his strongly worded sentences runs: "There is no such thing as technology in premodern societies."[29] Without belittling in any way the technical skills in premodern culture, Ingold argues that the concept of technology is simply not applicable, as the hunter-gatherers (the cultures he analyzes) strive to minimize the distance between nature and society. Be that as it may, iron working does represent the first stage of real technology; if anything, the institutionalization of the smith position stresses and elaborates the difference between society and nature. It is through the blacksmith craft that the Kapsiki dwell in their environment. The notion of "dwelling," which stems from Heidegger, in Ingold's hands means "the immersion of the organism/person in an environment or life world as an escapable condition of existence . . ."[30] Any perception of the environment is the result of interaction between humans and ecology, in whatever way or fashion, and the dwelling perspective views human culture and the environment as mutually constituted through their interaction.

Ingold contrasts this with "building," the notion that man has to construct a world with his own hands before he can live in it; in "building," the environment is an a priori given, a fixed cadre resulting from a cultural design, within which one employs one's agency.[31] In the building paradigm technology takes a maximal distance from nature, and the artifacts do not bear the traces of their history or of the limitations of the craftsman's tools. The distinction resembles Lévi-Strauss's "bricoleur" versus "ingénieur"—but extended into a full ecological paradigm.

Crafts are crucial in the notion of "dwelling" in the Kapsiki case, and the tool becomes part of, in the words of Merleau-Ponty, "our mode of our insertion into the world."[32] People do not conceive ideas first and then impose their conceptions on the world: it is a joint process because that very world is the "homeland of their thoughts."[33] Similarly, in the microecology of the craftsman's shop, the idea of the thing, the model for the product, the technical acumen of the craftsman, and the stubbornness of the material from which the thing is made all come together in the technological process of crafting the artifact. Thus, the artifact is generated through the craftsman's skills, not just the implementation of a design. The artisan "dwells"

in his product, and together they are part of the general "thickness of the world."[34]

This dwelling is nondiscursive, which makes it difficult to analyze, as science is more attuned to verbalized processes than embodied ones, and our focus here is not on the mouth but on the hand. The artisan's hand is, in the dwelling perspective, the inner circle of the tool, or as Kant put it: "The hand is the outer brain of man."[35] Although Kant is speaking about touch in the sense of haptic feeling, it holds well for tool use. A tool is not just an object, since the craftsman's tool becomes inseparable from his hand, and conversely he and his hands also become indistinguishable from his tools: "it is in what it does, not in what is that human hand comes into its own."[36] More than any other craft, the hand of the blacksmith is a hand holding a tool, a hammer, a pair of tongs, a poker, or—held by his assistant—a pair of bellows. The tool is the extension of the hand, and vice versa, the hand is integral with the tool. Iron is impossible to treat without tools, and—a lesson an apprentice or a participating anthropologist learns very quickly—the iron is much too hot to touch with bare hands. No one learns the blacksmith's craft without the searing pain of a severe burn; the first lesson in forging is to always have a tool in your hand; the iron is hotter than you think. One has to get the feel of the tool, and through that tool the feel of the matter.

Dwelling is not only a relationship with the environment; it also means dwelling somewhere. So, crucial for our analysis here is the sense of place—in fact, the artisan's shop.[37] The craftsman separates a part of space to create a "place," a structured area for him or her to work in and sometimes to sell from. Crafts dwell at a specific work place, implying an inhabited space with a definite structure and a specific purpose, imbued with meaning and guiding action; in short, a work place is dwelt-in space. Craftsmen construct a place for their respective trades in their manifold functions and crafts. The blacksmith's smithy is a prime example, and so too to a lesser extent is the brass-casting oven; but the same holds, mutatis mutandis, for divination, healing, magic, and ritual in general, including music. In these latter cases the place becomes a zone, a space of both work and interaction between the craftsman and his customers.[38] The smith delineates a zone in which to ply his trade and apply his skills, in full view of and with continuous interaction with his audience, be they customers or other. But he always interacts with the others as a smith, a *rerhe*. Thus, in zoning he dwells in the physical environment in the very same way he dwells in the social environment; this double definition of a zone, for working and for defining himself, makes his craft possible and sets him apart at the same time.

Embodiment implies motion, and perception is about movement.[39] We exist in the world to the measure that we move toward and through it, changing perspectives as we do so, in an acting-cum-perceiving dynamic with that world. Agency is creating "lines," in Ingold's terms,[40] and the lines we make not only render the world three-dimensional, moving as it does around us, but also continuously affirm our bodily existence within it. Within their own zones, craftsmen create their proper lines, but these have a few peculiar characteristics: they are short, repetitive, and goal-oriented. Bound by their zones and object-oriented as they are, these movements are highly specific for craftsmen: confined, predictable, and economical. Craftsmen do not roam, eschew the grand gesture, and usually are sparse on discourse, moving and speaking as much as needed, not more. Unless of course, their very performance consists of movements, as in dancers or actors, where they have to cover the whole stage; we shall see the smith dancing with the corpse, but then he is performing, as a "dancing dead," not as a smith: he moves as "the other." Through the dense meshwork of small movements within the craftsman's zone, he lives not so much *in* the world, as *at* the world, and just as his zone defines him, so do his gestures; again, what makes his craft possible sets him apart.

The place and zone a smith creates, as well as the peculiarities of his movements, are not only for production, they form also a spectators' theater. Much of his work is done before an audience, either directly as in musical performances, or indirectly as when he is producing for a market, viz iron tools or brass decorative objects. His work is at least semipublic in its performance. A blacksmith's forge is often a public place, where nonsmiths watch the proceedings, usually when they have to be there and wait for the things they have ordered, but also out of simple curiosity and fascination by a craftsman-at-work. After all, it is the smith's forge where something "happens" in the village, where someone is at work for the general good, performing work that is difficult, important, and interesting to watch. And most daily life in the village lacks these qualities.

A theater implies judgment by the public, since a craftsman is always judged, both in how he works, and in his products. Here Ingold's aspects of care, judgment, and dexterity come to the fore, as both the craftsman's performance and the qualities of his products are crucial. In the village discourse, a blacksmith is immediately characterized as producing good stuff or not, always having his output compared on two scales: functionality, as it has to "work"; and the output of other smiths. Thus, functional evaluations enter in, but also aesthetics—ethno-aesthetics to be sure: people evaluate the work of a craftsman, rating craftsmen on a scale of their own. Craftsmen

are continuously judged, weighed in their performance, and compared with competitors as they form a market. More than their covillagers, they have to live up to expectations, in a constant accountability that makes them vulnerable. Their special position and their internal organization, in effect, shield them from that vulnerability, and throughout this book we will see that the work of the smith is both circumscribed and protected by his special status—and that this protected status leads to a lower social ranking, a considerable social cost that is, however, not just a liability.

Thus, the fifth criterion of Ingold—the skill as part of the relational structure of the artisan—in fact forms one of the leading themes of this whole book. The notion of "othering" is important here, as the smith is both a completely integrated artisan and the "essential other" in Kapsiki society. On the one hand, he is expected to be skillful in a difficult field and is therefore considered already different. On the other hand, his being "different" is also an asset, inducing him to specialize first of all but also giving him the social zone that he needs to perform before a judgmental public. For instance, in his religious functions—such as divination, healing, and music—the smith benefits greatly from his "marginal" position, thereby reinforcing the existing cleavages in society.

<div style="text-align:right">

CHAPTER 2

</div>

An African Enigma

AGAINST WORMS

LATE JUNE, EARLY JULY 2003, WHEN THE SORGHUM STALKS ARE ABOUT knee-high, the ritual called *gedla* (smithy) is due to protect against worms. It is the *maze wudu*, the master of the hoe, who is in charge in the village smithy. Two days earlier, he announced the ritual by shouting in the village, because the day before the *gedla* people should not go too far into the bush, and the day of the ritual itself nobody should touch a hoe. In the afternoon, the ward chiefs gather, eat some mush, and head for the smithy; among them is the *makwajɛ* clan-elder—he is the elder of the clan the smithy is affiliated with—who "commands" the smithy in question; this elder's task is to collect some plants in the bush for the ritual. The smith in question, Mbekewe, crushes with his iron hammer some grains of white and red sorghum, sorghum leaves, and eventually some *ŋgwɛdɛ* (larvae that attack the plants and against which the ritual is aimed). He finally adds some sesame, a plant that binds the sauce. He then divides the mix, also called *gedla*, and prepares some *zhazha*, a mix of beans and grains often used in ritual, and also distributes this. Each ward chief gets a potsherd with the mix to place on the dancing square of his ward, not so much for his own fields, but to be placed at a spot where many villagers pass and few strangers come.

My presence at the ritual is no problem at all—more of a welcome addition; this is my second time, and also when I just came out to the Kapsiki, I already participated in this ritual. At that time I was welcome as a member of the *ŋacɛ*, the clan that "commands" this particular smith's family and is responsible for the ritual; my name is even Zra Kangacè, and though *melu* (nonsmith) from the start I was known as a "smith friend," like many of my clan. That is, as aforementioned, the stance from which I write this book, as a nonsmith who is close

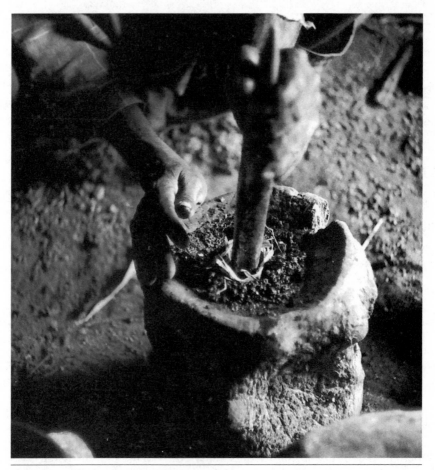

Figure 4. Crushing worms at the *gedla* ritual

to the smiths, a friend and pseudo-kinsman, but not an (adopted) smith myself. Though I have tried my hand at several of the jobs the smiths habitually perform—forging, healing, adorning the corpse, music—I remain part of the majority, a *melu*. Coming to the ritual again confirmed my belonging.

ABOUT IRON AND SO

This book is about smiths but not just about iron. We saw Mbekewe work in the forge, but never heat a fire, never strike the hot iron with his hammer

or use his tongs. He was grinding an insect, something anyone could have done anywhere, but it had to be done in the smithy and by a blacksmith, the one in the forge. The core of this book is right here, in the fact that the one who wields the hammer also does a host of other things, with little or no evident logical relation to metalwork. So this is not a technical treatise, but primarily a socio-religious one, simply because the main occupations of the smith, at least in the Kapsiki/Higi culture we are dealing with here, are not in the forge but elsewhere. A smith is undertaker, healer, sorcerer, diviner, musician, and potter as well as metalworker, so the first question raised is why we call him smith anyway, and second, why that many specializations are tied into the group that does work the metals.

The answer to the first question resides both in consensus and in the general picture of smiths in Africa. The literature on smiths in Africa in general, and in this region in particular, is growing rapidly, and this literature uses throughout the term "forgeron" or "smith" as the international translation of the vernacular terms, such as the Kapsiki *rerhe*.[1] So, for comparative reasons, speaking about "smiths" makes sense. But there is also a more generic reason. Kapsiki/Higi culture defines almost all specializations that are part of their ecological adaptation as the work of the *rerhe*, thus defining all major artisan jobs as either exclusively smith-related—such as funerals—or dominated by smiths—such as divination. Other groups in the Mandara Mountains, living in fact "just around the corner," considering the density of settlement in this region, have slightly different constellations of functions for the smiths,[2] but they always include metalwork. Elsewhere in West and Central Africa—North Cameroon, in fact, is the border region between these large subcontinental areas—configurations of the specializations differ even more, but metalwork is almost always among them. If artisan groups are organized in several separate groups, as in the Mande societies of West Africa where leatherworkers and bards are distinguished,[3] there is always also a group of smiths (sometimes even more than one) who combine their metalwork with other functions. So we call them smiths, and "blacksmith" if they forge iron.

Thus, the general picture of the African smith is of a profession that has at its core metalwork, but easily accrues other specializations like magico-religious and healing functions. Metal in Africa is never alone. Metals are "metals-plus," and indeed, the Kapsiki form a very clear case of the array of smith functions. Such an observation calls for an explanation, at several levels.[4] The first question is why does metalwork always accrue so many "sidelines," which may even become dominant? That general question has been addressed many times in the literature, and I will venture

a comprehensive and comparative answer, however tentative. The second question is a more detailed one, the question of the specific configuration of Kapsiki/Higi smiths' functions. For outsiders, this is always the first question that pops to mind when seeing "strange customs": "Why do they do it like that?" The epistemological problem here is that explaining the "other" implicitly starts from a seemingly self-evident "own": we tend to explain what seems different and unexpected, which is essentially an ethnocentric stance. But shorn of that ethnocentrism, the phenomenon of the "metals-plus" does call for an explanation; and since the Kapsiki configuration is not fully idiosyncratic—representing as it does one variation on an array of themes—this general problem should also be addressed.

The metals involved are iron and brass (an alloy of copper and zinc).[5] Both metals not only each have their own technical exigencies but also their own set of symbolic associations, which we encounter in the following chapters. To have both metals symbolically charged is not unknown in Africa, but is uncommon in this form.[6] It is also uncommon in the Mandara Mountains, which gives the case of the Kapsiki smith a special flavor in this area. In a recent publication on metallurgy in the region, David and Sterner compare the various combinations of smith work, the types of "metals plus."[7] One of their types is that of the transformer, the smith who combines a large number of specializations, all geared to a certain transformation, from earth to iron, from life to death, from sickness to health. The Kapsiki smith clearly belongs to this, together with the well-known Mafa smiths,[8] but among full "transformers" in the Mandara Mountains is the only one with a brass casting tradition.

But the discussion on smiths in Africa does center on iron black-smiths, not at all on brass or bronze, for the whole continent is "into iron." Brass and bronze have a much more restricted distribution, especially if we limit cupreous technology to the cire perdue technique; other ways of casting copper or copper alloys are more widespread but produce a much more restricted array of objects.[9] Anyway, the lost-wax casting technique is central for the Kapsiki/Higi, as for them no other copper technology exists; the word for copper or brass in Kapsiki is "*mnze*," the word for "bee," as the wax of the honey bee is not only crucial for the cire perdue casting but in the minds of most Kapsiki bears an astonishingly close association with the metal itself.

Almost all African societies depend on iron technology, and even the present-day hunter-gathers use iron implements when they can get hold of them. So the history of "iron-plus" is crucial for Africa, and the theory on metalworkers in Africa does focus on iron. It also focuses on smelting, the

production of iron.[10] The large discussions center on the furnaces and not on the forges, on the smelters and not on the smiths. But for this book in which ironwork means primarily forging, these debates are also of relevance, as the forging of iron always falls under the larger umbrella of iron production. After all, when we speak of transforming and transformers, the fundamental transformation is from "earth" to metal, and the transformation of bloom[11] to tool is a secondary one, though often more closely associated with the blacksmith craft.

When speaking about iron in Africa, one question immediately pops up: the original provenance of the smelting technology—that is, is African iron production a result of diffusion or of independent invention? Given the archaeological fact that the earliest forged iron objects have been found in Anatolia, from the period 1800–1200 BCE, some consensus holds that the first invention of iron production was in that region, even if no furnaces as yet have been excavated there. However, increasingly early dates for iron production sites have been reported from Africa, dates that are gradually encroaching into the early first millennium BCE, getting closer and closer to the earliest Anatolian ones.[12] Thus, some archaeologists posit an independent invention of iron production in Africa, not earlier per se but independent.[13] Not only do they point at the early dates, but also at the rapid proliferation of furnace types as well as at the deep ingraining of iron production in African culture. And evidently this question is not without its political and ideological consequences. African scholars, and many with them, would love to have a major invention in Africa as this would mean a welcome revaluation of African inventiveness and technological acumen, even if the creativity of African inventive behavior is underestimated by nobody.[14]

But the notion of independent invention is not without its problems and surely cannot be established solely by C14 dates, the interpretation of which is not easy due to the need for calibration and the problem of old firewood in dry Africa; just picking the oldest end of C14 calibration ranges is not serious scholarship. The main issue, however, remains the absence of an established previous copper technology in Africa, as it is difficult to envisage how an iron technology could develop without a metal smelting technique that demands much lower temperatures.[15] Also, iron smelting is not just about furnace temperatures, but demands a very careful balance between carbon and iron ore, as well as astute monitoring of gas flow.[16] And the few instances of an earlier copper technology do not seem to be linked to subsequent iron production.[17] The North Sahelian sites are reported to be the oldest, but this area is not overly suited to sustained production, as

the ecological demands, especially for wood for charcoal production, seem soon to exceed the local resources.[18]

One additional argument concerns cupreous technology itself. The discussion in African archaeology so much focuses on iron, that the intricacies of bronze and brass production are neglected. A recent overview of archaeometallurgy[19] shows how much know-how is needed for the production of cupreous objects; just the many alloys possible with copper, tin, arsenic, zinc, and lead demand so much experimentation that even a very short bronze age must have left many traces. So the technological objections against independent invention, of both cupreous alloys and iron, have yet to be really countered. As Stanley Alpern, citing the historian Jan Vansina, stressed, invention of such a complicated technology as iron production is not an incident but a process, and a long one at that.[20] Without traces of that process, no single dates will be convincing, and the race for ever older C14 dates is bound to make truth a victim. Strong claims need strong evidence, and that is not yet around.

So the jury is still out on the issue, and probably the question will be resolved only when the political implications have faded away and the emotions been assuaged, and many more excavations have been done. So the jury better take a long holiday. For me, the arguments still weigh into the direction of a very rapid diffusion of both metal technologies: a traveling idea, together with some individuals and definitely iron objects. In any case, independent invention or diffusion, African prehistory has witnessed an astounding amount of successful experimentation in techniques of iron production. If Africa has indeed learned its iron technique by diffusion from the north, it must have been a complicated and spectacular process of diffusion, fast and many-stranded, of both knowledge and techniques, possibly also of people such as individual experts, a highly creative adaptation of technology to new surroundings.

Consensus reigns, after all, on one issue: the astonishing diversity of iron furnaces in Africa. From a technical standpoint, there are just a few options for reduction in charcoal furnaces, and the African continent seems to have produced almost all possible options, as "every conceivable method of iron production seems to have been employed in Africa, some of it quite unbelievable."[21] This is not an argument for independent invention, but definitely one for the creativity of local adaptations independent of the original place of invention. African smelters and blacksmiths must have been experimenting with iron technology, inventing new ways of metal production as they adapted to varying local natural resources and social circumstances, such as the differences in qualities of iron ore, wood for charcoal, and clay type.

Indeed, African ironworkers must have been "scientific bricoleurs, with local flashes of technological brilliance."[22] This resulted in a greater range of furnace designs than anywhere else in the world, of which the Mandara furnace is a special case, the only one with a top-to-bottom forced draft, and its provenance is not clear. It does produce specific blooms and has made sustained major production in one village, Sukur, possible.

SMITH, CASTE, AND GUILD

I started out with the notion of metal-plus, and that is precisely the aspect where the forge is more important than the furnace. The questions about these additions are in principle not technical, but social and religious. Three questions arise here: first, the specific array of additional functions; second, the tendency toward endogamy; and third, ranking—that is, the relations within the society as a whole.[23] The actual array of the specializations, the "plus," varies across the area and, in fact, across the whole of West Africa. Some commonalities emerge, however, as there are four clusters of the "plus" specializations.[24]

The first, the most universal cluster, is the smith-potter combination, with the male smith working the iron and the woman smith as potter. As with all combinations, it has its exceptions,[25] but it is the dominant one. The reason perhaps resides in the notion of specialization itself. Smithing is a time-demanding job, especially during the cultivation season, which precludes the blacksmith and his wife from staple cultivation. Small crops cultivation is a woman's affair anyway, less time consuming, and combines well with the incidental work of potting. In those cases where pottery is not considered a specialization inside the village, the combination does not hold. For instance, where villages as a whole specialize in pottery—as among the Dogon in Mali—all women pot, and smith women have no monopoly.

The second cluster is burial, a role for the men only. In an astonishingly high proportion of West African cultures, the smith is funeral director, or at least has an important role in burial proceedings. The man of iron tends to also be the man of death. For a large part, this undertaker role forms the high point of a more general function in ritual.

The third cluster, with a large variation in importance between smith groups, is healing, which forms another nexus, with magic—also the black variety—as a logical part of the healing function. For smith women, similar options are child healing and midwifery, as throughout West Africa the

association of smith women with the welfare of children is rather strong. For the men, divination may be part of this healing function, although it does lead to its own proper specialization, often open to anyone interested in the craft, or—in the case of inspirational divination—open to anyone who is "called."[26]

The fourth option is music. In quite a few cases the smiths are also the musicians, as among the Kapsiki/Higi, but in other parts of West Africa this craft often has its own endogamous group, the bards-cum-musicians. The same holds for leatherworking and carving, which are tied into the production of musical instruments first and into status definition and ritual production second.

The most difficult question is the one pertaining to endogamy, often combined with notions of purity and pollution. Kapsiki smiths have different food habits from the *melu*, and the two groups do not eat together or drink from the same vessel. Such a clear case of noncommensality is relatively rare,[27] and just endogamy is more common, the simple fact being that smiths tend to marry among themselves. As the intra-Mandara comparison shows, endogamy is not an either-or variable but should be treated more as a continuum, in which also rule and practice do not always coincide.[28] The combination of a marriage strategy with notions of pollution

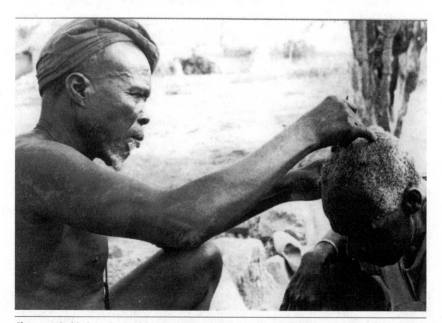

Figure 5. Smith Gwarda shaving a neighbor's head during a funeral

evokes more than anything else the notion of caste, while some of the subspecializations of the smith, such as bard-musician, call upon the specter of a guild.

The fundamental process encountered here is professional closure, and the association between group closure and professional specialization is much wider than the smith in Africa. Throughout history and all over the world, artisan groups have a tendency to self-organize or organize into groups with clear boundaries and fixed relations between them. Most relevant examples of professional closure, though, stem from complex societies with elaborated political organization and full-blown cities; the two major examples, guild and caste, are part of complex cityscapes. So let us have a quick look at these two phenomena.

It seems that craftsmen tend to organize in guildlike institutions rather easily; of course crafts are older than urbanization, but the city does two things with crafts: it organizes as well as proliferates them. In his classic *The Preindustrial City*, Sjoberg noted: "The most obvious aspect of the preindustrial city's economic organization is its guild system, one that pervades manufacturing, trade, and services, even marginal forms of economic activity like begging and thievery." And "the overwhelming number of craftsmen, merchants, and persons in service occupations are organized along guild lines."[29] Hobsbawn calls it a "type of organization which appears to be quite universal wherever and whenever there are preindustrial cities."[30] The formation of larger and more centralized polities may also have boosted the institutionalization of guilds, as exemplified by the rise of guilds after the installment of the Ottoman Empire.

All over the world guilds arose in cities, where they were either under the tutelage of the ruler or—gradually—formed a kind of countervailing force and in some cases took over the city in terms of power. Anthony Black analyzes the complicated political dynamics of guilds in medieval and early modern Europe,[31] and though the European social cityscape is quite different from the African rural one, the comparison of the African smith with the guild can help us to understand something of the smith. In principle, a guild was a voluntary association of free people who shared the same craft and organized into a fraternity of colleagues. The core of the guild system was the regulation of new craftsmen through a thorough and long training system. This transmission of knowledge resulted in high standards of performance, on the one hand, and in a focus on esoteric aspects of the knowledge, on the other—the "secrets of the craft."[32] Yet the guild system proved to be very enduring, spanned half a millennium of turbulent times, easily branched out into new professions, and sometimes made a comeback

after being eliminated.[33] Variants and descendants of this type of professional organization are still with us.

My question is not whether the smiths "are" more of a "guild" than a "caste," because that would put the horse behind the cart. Morphologically, and probably also historically, the village-based form of artisanal closure we encounter in this book may well represent older forms, and anyway is less elaborated and structured than in these urban systems. But the elaborated guild system does offer a ready point for comparison. In West Africa, smiths-as-a-guild is a popular description in cultures far to the south of the Mandara Mountains, such as among the Ibo, Ewe, and Akpafu, and less explicitly among the Krun, Dan, and Losso (Burkina Faso).[34] In coastal West Africa smiths are important as mask makers as well as mask chiefs, especially in cultures that engage in initiation into secret societies. There the smith position is invariably very high,[35] as smiths are members of a deeply respected and often feared craft. In most of these West African forest-based societies, recruitment to the nonendogamous smith profession is not exclusively on the basis of descent, but smiths also take nonkin pupils, a crucial indicator, as it is the structured in-service learning that formed the core of the guild.

For a considerable part, these are also the cultures that engage in cire perdue brass casting. Brass casting has a specific distribution with a large presence in the South and the West of the West African subcontinent. Probably because of this association, brass seems not to correlate with the formation of endogamous groups, and the brass casters and the blacksmiths tend not to be the same subgroup, even if they all fall under the category "smith." Clearly, however, brass casting smiths and gold/silver smiths tend to be highly ranked professionals in these societies. Yet the standard African situation is not urban, and the specialists are more integrated with village life, in which the regulation of production is important, kinship is the dominant idiom, and often the esoteric side of the knowledge, the "power" of the smith, prevails.[36] Within the ethnic group, an African smith may choose his specialization and then has to go into training, and any on-the-job training is more easily done with kinsmen than with nonkin. So an "incipient guild" might be more apt as a phrase for these specialist groups. In these societies a struggle for power may occur between smiths and king, or at least an expression of the kingly powers in terms of metal (gold, copper, and iron), a situation found in Central Africa.[37]

But the notion of "caste" is used just as much as a referent, as is "guild," for West Africa also shows several other trends in the position of the smiths. After the north–south gradient of savanna-forest, in the savanna region an

important west–east gradient is clear as well. The Mande area in the West shows a more complicated system of occupational groups such as in the case of the Bambara, Malinke, Soninke, Kuranko, and even the Dogon and Songhai.[38] In the East, especially in the region south of Lake Chad with as its core the Mandara Mountains, one separate group incorporates most of the relevant specializations, always with metalworking at its core. On the western and southern flanks of this long gradient, the smiths form more or less nomadic groups—for example, Bikom, Rukuba, Dyerma, Ibo, and Kpelle—or often form or stem from separate ethnic groups—for example, the Bororo, Tamachek, and Dakari smith groups. Relations between smith and power, as well as religious functions for smiths, are found throughout the region, with no particular center, and the same holds for the smith woman as potter.[39]

Therefore it is in the more eastern part of the subcontinent that the term "caste" is used, with the tendency toward endogamy among the smiths as the main argument. In the Kapsiki/Higi case, both endogamy and purity/pollution are crucial, including specific food taboos—a cluster of features that makes the comparison with Indian caste systems easy—but that does not hold for all smith groups in the area. Nevertheless, the tendency to combine craft specialization and endogamy throughout much of the West African savanna area is sufficiently marked to raise the specter of "caste" for more than just the Mandara area. However, many scholars working on smiths in West Africa are reticent about using the term "caste," and so am I. "Castelike," or the slightly ambiguous French *casté*, or more cautious still, "endogamous professional group"—these are the terms of choice, thus avoiding the implicit identification with the Indian subcontinent[40] if only by a narrow margin. For West Africa, a suitable definition runs: "A specialist endogamous group socially differentiated by prescribed behavior and genealogically inherited professional capacities,"[41] a definition that includes Indian castes.

The overview of Schmitz-Cliever shows that the older ethnographers had less compunction in using "caste" than more recent anthropologists.[42] There are good reasons to be careful with the use of "caste." In India, the notion of a caste-system is dominant, and many Indologists—such as Dumont—have stressed the idea of a system. The Indian hierarchy with four *varna*, and thousands of distinct *jati*, plus hosts of castes or "tribal groups" outside the *varna* system, all of them set in a complex political and geographical framework, is a rather far cry from the superimposition of just two layers, smith and nonsmith, inside a lineage-based society.[43] Also absent in West Africa, to a large extent, is the enormous influence of religion: even

if smiths are constantly defined and redefined as a separate group in Kapsiki religion, there is no way in which one could state that the whole system is "religiously generated," as scholars of Indian caste often state about India.[44] Demographics are also very different. The nonsmith group in Kapsiki comprises approximately 95 percent of the society, the *rerhɛ* 5 percent; so in fact there is just one dominant group plus one caste. Indian castes, on the contrary, form a complex—and continuously shifting—pyramid, even several competing pyramids, with a relatively small elite and a large body of lower echelons.[45] But, throughout, the main argument against using "caste" is similar to the argument for not using "guild": the relatively undifferentiated African situation is morphologically prior to, not dependent on, caste systems.

Yet the voluminous literature on caste does give some pointers in our treatment of the measured inequality of the African smith. The first is a reflexive one, as our own preconceptions about human equality are fundamentally challenged by castelike systems; Western thought is based on fundamental equality, not hierarchy, and we are irked by inherited social inequality. So one has to reconsider what is the "explanandum": human equality or structural human inequality? What really demands to be explained? I choose to explain human inequality, looking at general theories of social inequality and stratification, but that is just my choice. This is Dumont's basic argument: in the West we start out with *Homo equalis*, in the Indian system with *Homo hierarchicus*—leading to a severe Western underestimation of the principle of hierarchy, while both are fundamental in human organization.[46] Ideas of purity-impurity generate hierarchy, both as an undercurrent in actual complex political processes and as an ideational paradigm for the society as a whole. I take up this issue when speaking about the smith as the "internal other" later on, as this rather disconcerting concept pops up in all social relations.

Second, one should not mistake deep structural integration of castes in the sociopolitical structures for historical depth. Baily stressed: "Caste is not and never has been a fixed fact of Indian life,"[47] meaning that even if it is important, caste-as-we-know-it is a relatively new phenomenon, not older than a few centuries in its present form and pervasiveness. Colonial influences have shaped the system as well. At the end of this book I argue that though iron specialization is old, its specific form among the Kapsiki is a result of historical processes, some of which are fairly recent. The wide variety of smith positions, even in the restricted area of the Mandara Mountains, attests to both the flexibility of the dynamics of professional closure and the importance of the contingent factors of history.

A third point is the notion of systematic inequality. Dumont's insight that caste has no meaning on its own but only in a relational sense with other castes has been lauded by his numerous critics and is relevant for the smiths as well.[48] One caste as such has little explanatory value.[49] This, in fact, is one reason why in the Mande area of West Africa the term "caste" is used sometimes, as the various endogamous artisan groups—blacksmiths, bards, leatherworkers—do form a system of ranked inequality servicing a court.

But here an important proviso holds, which is highly relevant to the West African case: what does hierarchy mean? In our Western thought, Dumont stresses, hierarchy is a ladder, of more or less complete superposition. In India, a different model of (and also model for) hierarchy prevails, an inclusive, encompassing one, two-dimensional more than vertical; here society encompasses the higher-ranking minority, which is not superimposed, but enjoys centrality, a model of bowls nesting into each other. I do think it is an apt model for the smith as well, but then one with upturned bowls: the larger society covers the smaller smith section, and as such is on the average "higher" than the smiths' one, but the crucial aspect is the encompassing nature of the relationship.

SMITH, SLAVES, AND HIERARCHY: A CONTEXTUAL INTERPRETATION

Social inequality being a pervasive feature of West African life, notions of inequality will have to be integrated into the dominant African kinship discourse. Kinship and lineage organization form the dominant social grid, sometimes overriding vertical distinctions. Marital relations similarly are used to bond as well as to separate. In African society the dominance of kinship is uncontested, though often more in terms of descent than of affinity. Smiths, as mentioned, often form an endogamous group yet are still considered kinsmen in the village. Various mechanisms allow for this exclusion-through-inclusion, ranging from separate but recognized smith lineages to inclusion of the smiths in regular lineages.

Throughout, local discourse defines the smith in kinship terms as "children of the village" or as "women of the village." This characterization, however, illustrates one fundamental aspect of the generalized kinship discourse: its focus on difference. Kinship always comprises two dynamics at the same time: bonding and difference. Kin terms express a close but limited

identity, bonding over the chasms of generation, age, or gender and binding lineages together as brothers or sisters. But the differences in generation, age, and gender are stressed even in bonding expressions: father and son are close, but vertically; brothers are identical, but one is older than the other; spouses form one union, but through difference. *Homo hierarchicus* is at home in the family, a form of holism, which creates a system in which everyone has his own specific but different place.[50] On the other hand, this kinship discourse also conflates the opposition between equality and hierarchy. However different people may be, they are still kinsmen, and however close they are, there is an inalienable bond between them: the bond of difference and the equality of hierarchy.

The combination of kinship with territoriality, in Africa, brings in ethnicity—often undervalued in the smith literature—and determines smith mobility. De Barros indicates that, historically, iron smiths often had their own ethnic identity or formed migrating lineages of ethnic groups, or were at least quite mobile.[51] The deep-rooted identity of many African ethnic groups—at least in their historical discourses—is not for the smiths; in many cases they are the indwelling newcomers, the strangers-that-belong. This mobility of the smith can have various causes: for smelters, the depletion of resources; for smelters and smiths, the control of an ambitious king over their production; and throughout history for all ironworkers, the economic need to disperse evenly over towns and villages[52] as a crucial service industry for farming.[53]

As mentioned above, in the case of smiths we should also not surmise a timeless institution. Despite its legitimacy as being traditional, the smiths' position must have changed through time, and is now again changing rapidly. Specific historical conditions have led to the formation of layered social formations, conditions that are not unique but might be unique in their configuration. So we have to delve into the large-scale history of the region in order to view the rise of these institutions. Thus, the deep history of West African state formation, including its history of slavery and slave raiding (the exploitation factor), should be drawn into the interpretive and explanatory model, as well as the region's early cities.

Given these a priori, the question has to be tackled: why this ordering and ranking of the smiths as either a lower or a higher group? And, in the Kapsiki case—and in the majority of the Mandara cultures—why is a group that is as essential as the smiths ranked lowly (if "ranked" is the appropriate word)? This question admittedly stems from my own cultural proclivity to problematize human inequality. My attempt at an explanatory chain runs as follows. Craft knowledge is always a social process, and metallurgy

especially is an embodied and social activity; therefore, the craft of ironwork has its own political economy/ecology, easily leading to a distinctness of the artisan. This distinction can be articulated in several fashions, depending on the techno-ecological adaptation characterizing that particular society, including its division of labor. This adaptation in turn is informed by the political, economic, and ecological history of the larger area. Given this historical adaptation, local identity politics and internal cultural logic integrate the local definition of the smith into a system of meaning. Let us see what the main factors are for the Mandara Mountains.

The village-based horticultural societies of West Africa, with their pre-industrial iron technology, produce a small surplus only, in which a limited division of labor is feasible. Of the limited number of crafts possible, only the iron smith is absolutely essential, as only this craft is difficult enough to need a long learning period, while smiths also have to be in the immediate vicinity of everybody. African precolonial cultures knew few technologies as intricate, difficult, and spectacular as metalwork, especially smelting and casting; therefore, from a materialist perspective this is one technology that can easily stand out. Wood carving, plaiting, weaving, pottery, leatherwork, but also singing, drumming, and recitation require their own expertise, but they stand closer to everyday experience, lacking the danger of the fire, the stubborn hardness of the material, and the need for a separate infrastructure, the smithy. And of course, smiths' products are absolutely essential in food production and war, so life-as-Africa-knows-it simply would not be possible without them. Iron is crucial, and so therefore is the smith. But that does not explain the whole gamut of specializations, the iron-plus, neither does it say anything about the endogamy.

Caste and guild are products of city-based state formation. What are the possible influences of state formation on the organization of specializations? The history of state formation in West Africa shows a west–east gradient of state formations: after the empires of Ghana (in Senegal-Mauretania) and Mande (Mali, Guinea), a series of jihad-triggered Islamic reform movements, from Futa Jallon in the fourteenth century to the largest one, the Usman dan Fodio *jihad* that resulted in the Sokoto Caliphate in the nineteenth century. These large-scale empires contrast with the much more local kingdoms of the West African coast, such as Asante, Benin, or the Yoruba states. Two elements are important in state formation: the availability of weapons and slavery. For a centralizing state, for any predator state—such as all polities in the West African savanna have been—control over smith production is crucial, and either creating or officializing a hereditary position of smiths offers some guarantee for a constant supply of craftsmen (and

weapons). Of course, a court also generates other specializations, like the bards/musicians who may stem from the early phase of the Mande realm—but the crucial position of the smith in state formation is undisputed.

Besides the military necessity of the blacksmith, a system of endogamous craft groups provides a handy order for any ruler or elite—in fact, like the guilds in medieval cities. Such a system assures a diversified production under tutelage of the ruler, regulates competition, guarantees the transmission of knowledge, and links the various crafts into a network of mutual obligations. Closed craft groups bring order and stability to a realm and are also needed for war. To some extent cities appeared with these states, and cities are crucial in the formation of a multi-tiered system of inequality. The same west–east gradient is discernible, the first cities in the west of West Africa developing centuries before the earliest eastern ones.

In effect, hierarchy is built into such a system: first, through the suzerainty of the elite under which it operates and through the relations the crafts have with that elite and with each other; and finally, through the relative pricing of the products. Closeness to the court is one factor to establish a higher status of the craft—such as in the case of the Mande bards—but then those intercraft differences will continue to shift and be renegotiated. That is exactly the situation Quigley analyzes as the core of the caste system: the ruler is the center of an ever-shifting circle of occupational *jati*, including the Brahmans, all vying for status in the *varna* system. Again, West African processes are quite comparable.[54]

My final factor is slavery, one major theme that runs throughout West African history and has a clear and unbreakable link with iron—and therefore with smiths. In the Mandara area, this link was obvious. Scott MacEachern relates how the mountain people traded iron with the Wandala emirate, against salt and fish, but on the other hand were enslaved by their trading "partners"; or, as a Montagnard put it: "They bought our iron, then used it to make the shackles they held us with."[55] In fact, the very first contact Europeans had with the Mandara Mountains was in slave raids. In 1823, it was Major Dixon Denham, who as first "nasara" (white man) saw the Mandara hills: "We continued to approach a noble chain of hills, which were now in full view, of considerable height and extent with numerous trees growing on the steep and rugged sides."[56] He was traveling from Bornu to the Mandara area at that time, on his way to the Sultan of Wandala,[57] in a mixed expedition "as much a result of internal politics at the court of Bornu as it was a slaving expedition."[58] Slave raiding was part of warfare in the area, an ever-present threat to the people living in the Mandara Mountains. The search for refuge has been one of the reasons for settling the

Mountains, though by no means the only one, and began much earlier than the arrival of the jihadists. Whatever its actual incidence in history, slavery has been extremely important, both slave raiding and what has been called the "slave mode of production," the use of slaves in state building.[59] Slaves were essential as plantation labor,[60] as domestic slaves, and simply for progeny, but then women slaves more easily entered into kinship relations with the slaveholders.[61]

Craftsmen were usually not enslaved, as their products, like the iron produced in the Mandara Mountains, were crucial for trade and warfare. These empires had a continuous hunger for slaves,[62] and they organized small or large slave raids like the one described above by Denham. In fact, the open countryside of the Sudan permitted easy travel on foot or horseback for the war parties, and for the victim populations it offered only a limited number of places for refuge—just a few mountain areas and some major inundation zones. In these defensive locations, the Mandara Mountains being one of them, populations that wanted to stay "out of history" could defend themselves against the marauding Muslims. In between the plantation economy and the slave raids, important slave markets have flourished, such as Mora, just north of the Mandara, seat of the Wandala emirate, mentioned above.

Of course, the mountain populations like the Kapsiki did not readily submit to this threat and fought back wherever they could, even if they faced a better organized enemy with superior armament—that is, mounted marauders, later also armed with guns. They also had their own internal warfare and slavery, capturing enemies—in Kapsiki, this meant people from other villages—to sell to slave merchants or to have them ransomed back by their kinsmen. The toll in loss of life is difficult to establish. The tales of horror about one particular Fulbe chief, Hamman Yaji from the Nigerian side of the Kapsiki/Higi, still reverberate through the whole mountain area.[63] The intensity of his raiding surely was exceptional,[64] but whatever the loss of life, the main effect was a sense of insecurity, a Hobbesian situation of "Warre," of armed conflict against each and everybody, to be expected at any moment.

For our smiths' group, this meant several things. First, weapons involved iron, barbed spearheads, arrow points, iron clubs, throwing knives, and later also shields (the earlier versions were of buffalo hide but also a smith product). The tales people tell about war, internal as well as external, leave the smiths themselves out of the fray; the craftsmen were essentially nonfighters who made war possible. Like women. Theirs was an inside job, with the smithy inside the village, their craft a rooted one. Also, since they did not fight in the internal wars, they were not captured and sold either. The

smiths furnished both the poison for the arrows and the medicinal services after the battlefield. Agriculture was not possible without the smiths' products, but war made the dependence on smiths more immediately visible.

The third effect is more profound, I think. Slavery is hierarchy incorporated and inequality hammered in. With iron. The continuous threat of slave raiding makes one thing above all crystal-clear: people are not equal. Either by descent or by accident, people are or become fundamentally unequal. The notion of slavery is rather complex, and the strictly legalistic definition as "someone who is not a subject but an object"—that is, slavery as a property relationship—is not very helpful. Better is Patterson's definition of "an institutionalized alienation from rights of labor and kinship,"[65] as this provides more room for different kinds of bondage, such as serfdom and debt pawnship as well as the distinction between house and chattel slaves.[66] Slaves have no rights to their own products and lack the natural rights that should accrue to their kinship relations; in slavery, the relation with the master is dominant and compulsory. Slave raiding generates a worldview in which the other is the enemy, and as all others are enemies, the enemy is always stronger and more numerous than oneself. This is, essentially, a minority worldview and, as such, one of inferiority. Slave raiding creates victim populations, which tend to fragment and very seldom organize at a higher level than that of the village.[67]

Any relationship between slavery and smiths' ranking is complex and indirect. The Mandara "experience" shows that both occur together, but without any direct correlation between the incidence of slaving and the cultural crystallization of the smith position. Before the Hamman Yaji days, the Kapsiki must have been subjected to incidental slave raiding, hit-and-run raids more than large-scale ones, though the Higi part of the group might have suffered more. Other groups in the Mandara Mountains, such as the northeastern groups closer to Mora, have borne the brunt of Muslim slaving much earlier and for a longer period.[68] And, as argued, the ranking of the smith is shot through with an ambivalence that is completely lacking in the slave case. But my point here is that both types of structural inequality are part of a general notion of *Homo hierarchicus* in West Africa, and that they do reinforce the notion of inequality, generating a worldview that makes ranking of categories easy and acceptable, not only outside one's own society but also within, making for a pervasive experience of difference.[69]

THE SMITH IN THE MANDARA REGION

The "tainting" of the smith, so obvious among the Kapsiki/Higi, cannot be seen isolated from the clustering of the specializations, the remaining feature to be addressed. One major difference from the caste and the guild system is the much simpler division of labor in the West African situation, but the exact clustering of the specializations is quite variable, including within the small cultural area of the Mandara Mountains. As one of the major refuge sites in West Africa raided by a number of Muslim emirates (Baghuirmi, Wandala, and of course Sokoto), these mountains have also been a major iron production area, while ethnically extremely splintered, containing over thirty ethnic groups—in fact, a high-diversity area, a veritable hothouse of "iron cultures." So, metal-wise, the Mandara Mountains and its immediate surroundings form a veritable laboratory of smith specializations, as already highlighted by Wente-Lukas in 1972 and recently by David and Sterner.[70] Throughout the region, one "caste" has accumulated all relevant specializations, in various clusters. David and Sterner distinguish five types. The first is the full transformer type mentioned above, the smith/potter with complete endogamy, a lower rank, and a significant number of secondary specializations, the most important of which is funeral direction. Mafa, Marghi Dzirngu, and of course Kapsiki/Higi, as well as Cuvok, Bana, and Namchi show this configuration.[71] A specialized form of this pattern is the Sukur type with intensive and extensive smelting, occupying a large part of the nonsmith population, while within the smith population some internal specialization occurred (for example, of funerary smiths).[72] Interesting in their account is also the "primitive pattern," in the northwestern horn of the Mandara area. Here the smiths seem to be less the general specialists, but just noncasted craftsmen without secondary occupations. It is called "primitive" because it forms the obvious morphological point of departure for more complex configurations. One of these is the northeastern pattern, such as among the Mukhtele,[73] without endogamy and without additional crafts but lodged in specific land-owning lineages. The fifth form can be thought to stem from both the primitive and transformer types plus northeastern packages and concerns the Mofu-Diamaré definition of the smith.[74] Here the craft is nonendogamous (at least in principle, but the criterion is not so dichotomous at all), with a clear association with the ritual-political power in the villages. The smiths divine and bury, but spirit possession is here a crucial element, different from smiths in other groups, and a distinguishing feature anyway of the Mofu-Diamaré culture.[75]

What characterizes the Mandara Mountains is indeed a high diversity in definitions of "smithness": at the core, the blacksmith-potter combination

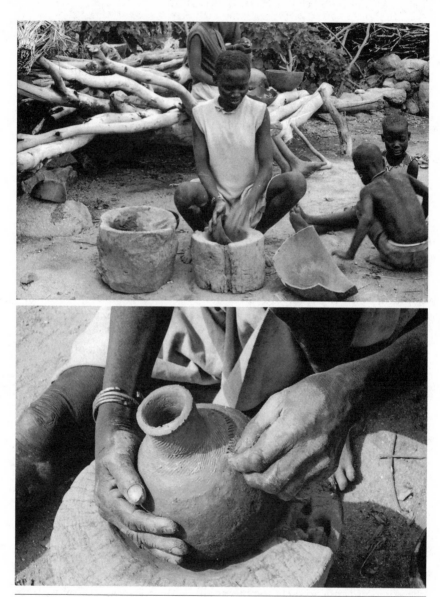

Figure 6. A rerhɛ potter, Kwayèngu, with her children

can be posited, which then accretes other craft specializations in various ways and along different parameters. The inclusion of divination and ritual functions seems an evident choice, with funeral direction as a defining feature in their relation with the nonsmith population. Another parameter is the relation to land—whether the smiths have access to cultivation options—which also relates to the way the smiths are integrated into the rest of society. Whether they form their own lineages, or are adopted into existing clans and lineages, or reside mainly in their own wards—all this impacts also on the economic position of the smiths. Demography, too, is a factor, as in some of the groups smiths are or have become rare, and a low proportion of smiths precludes a clustering of craft specializations.[76]

Throughout, endogamy has been one of the characteristic features of castelike organizations, but the division into endogamy versus nonendogamy is somewhat simplistic. In some groups, endogamy was absolute and remains strict, such as among the Kapsiki/Higi and the Mafa, the full transformer type. In Kapsiki, the first small dents in the *rerhɛ* endogamy are only today appearing, as some Fulbeized Kapsiki begin to marry some smith girls, a gentle hypergamy that is well known in Indian caste systems. In other groups, such as the Mofu-Diamaré, the rule of endogamy is denied, but marriages, in practice, are within the smith group; also, an occasional or ritual marriage of the village chief with one smith girl (as among the Marghi[77]) does not really break the rule. If, as in the primitive pattern, marriages are in principle open, the chances of marrying within the craft are still considerable, just like in the medieval guilds.[78] Finally, when smiths belong to specific ethnic groups or wander around, as happens more to the south,[79] a tendency for spousal choice within their own group will remain. So the chances that a nonsmith boy marries a nonsmith girl will always be great, and the chances that a smith boy finds a smith girl will be considerable, in any given situation.

Historically, migration must have been a crucial factor, for several reasons. First, the Mandara Mountains do have a deep population history, starting well within the Neolithic, but the configurations that led to the present phenomenon of the smith are not that old. Iron is old in Africa, but traces of settlements in the Mandara Mountains appear in the archaeological record after the fifteenth century CE only. Any complex form of *rerhɛ-melu* interaction, such as we are viewing in this book, must date from after that time. The mountains are replete with migration myths in which smith and nonsmith patterns are different. So the precise historical integration of smiths into the village societies must have been influenced by the order of arrival, by migration numbers, and by the political relations between the newcomers and their hosts. Notions of autochthony, still very present in

the Montagnard societies, easily generate differences within a local community, as well as between communities, since either the smiths or the *melu* could have been the original inhabitants of a place, or, for that matter, the newcomers. Thus, the contingencies of migration inform the particular relation the smiths have with existing power configurations. As smiths, throughout the larger region, have a definite link with local and regional power holders,[80] this is a viable historical approach into the specifics of "metals-plus" for the Mandara Mountains.

Back to the central question we started out with: why the accretions? James Wade suggests a course that is quite probable.[81] In many of the local cultures in the Mandara Mountains, oral histories indicate slightly different historical tracks of provenance; almost all migrations inside the Mountains are small-scale, originating just outside or even inside the Mountains themselves. So the craftsmen tend to come from another village, not too far away, and the various subspecializations from different places; for instance, the Kapsiki brass casting smiths have tales of southern origin, the iron smiths stem from Sukur, while the bulk of the population stories relate to Gudur, all of them places "just around the corner" but still different. So, indeed, families of craftsmen may have joined an existing population in which a distinct smith group was already established. Owing to the importance of that group, they integrated the craft and became ever more marked as a separate echelon in society. With some late-coming specializations, such as brass casting, this is a very likely scenario.

Finally, our tainted smith. The time lag is important here, as is the political marginality of the area. Whereas in the Mande area in the deep west of West Africa political centralization came early, stimulating high-ranking court specializations such as griots, the Mandara area has remained at the margin of political developments. The centers of politics were far away, either in Bornu, Sokoto, or Baghuirmi, with only the Wandala emirate close to the Mountains, but this was never much more than a local fiefdom.[82] Thus, the conditions for a configuration of multiple occupational groups, such as among the Mande groups, were absent. On the whole, the political movements that I have associated with general notions of inequality, came centuries later in this area than in the West, as did the cities. Only Bornu/Kanem has a deep history, but that never seems to have been a major influence on the Mandara Mountains other than indirectly through the Wandala emirate. So the timing of the incoming and upcoming specializations might have been more spaced in the Mandara area, the new trades being easily incorporated by a well-established transformer group. Finally, when organized slave raiding hit the area, it struck hard and lasted until well in the

twentieth century.[83] Slavery was the dominant issue in the Mountains during the nineteenth and early twentieth centuries, slavery and war in which the smith was both important and exempt. On the one hand, these pressures surely have stimulated population movements within the area—and the oral history is replete with small-scale migrations—and thus the mixing of smithing types. Also this may have hardened and solidified the actual smith position in the villages, underscoring his separateness.[84]

On the other hand, the cultural logic of several craft combinations surely also had its impact. The combination of iron smith and potting is not universal (the monopoly of smith women on potting is sometimes lacking) but yet so common that it needs a materialist explanation. Sterner and David provide one, zooming in on the rhythm of seasonal production of iron and pots, and show how the seasonal demands of cultivation and the timing of metalwork and potting make a smith-potter combination very likely for a multifaceted production by a smith family.[85] But that does not hold for burial, of course. Podlewski, in his study on the Mafa smith, suggested a close association between the handling of the corpse and a low-ranked endogamous undertaker group. In her overview of smiths in the larger area south of Lake Chad, Wente-Lukas found, in sixteen out of twenty-five well-documented cases, that this association does indeed hold.[86] It is, clearly, an association the Kapsiki/Higi would make themselves: the smiths are tainted with the smell of death, so are "dirty" and of lower rank. The association is strong, but what does this mean? All societies bury their corpses, and most do not have a class of despised undertakers at all. One essential condition for a corpse to be polluting is to bury late, and that is exactly what happens in many of the mountain cultures. The Kapsiki are a case in point, as they bury at the end of the third day. So the preliminary question is why they bury so late. In my analysis, I relate this to the internal political situation in the Mountains, the fierce history of slave raiding and internal warfare, the marriage complex that is also part of that political history, and the general social values that pertain to Kapsiki culture.

So there we are with the Kapsiki and Higi smiths, an endogamous minority practicing iron and brass metalwork, pottery, divination, ritual functions, and magic and healing, and considered dirty by the nonsmith majority. We can now summarize our chain of reasoning for the special smith position.

For the Kapsiki/Higi smith, the factors sketched above mean the following. The political-economy of small villages, based on hoe horticulture with gender and age as the principal division of labor, has a limited niche

for specialization, so crafts tend either to be part-time or to cluster. Iron-work being the most exacting craft, clustering of other special jobs around the smith is an easy option. Smelting and forging demand different types of organization. Smelting readily concentrates in major production spots—which may have to shift in time due to ecological bottlenecks—while forging as a service industry has to be close to its customers. In a predomi-nantly ethnic discourse smelters readily are assigned a varying degree of local integration-as-strangers.

On a large scale, the history of West African state formation led to a late arrival of cities and states on the front of the Mandara Mountains, precluding a multi-tiered system of craft specializations. These jihadist states are predatory polities, increasing insecurity in the area, with slavery as a dominant characteristic, which stresses fundamental inequality. War renders smiths both more important and more different—they are needed but not as fighters—while external domination may also induce migration of artisans. Enhanced importance makes ironwork a ready focus for add-ing on other, often lucrative specializations. Local identity politics in the Mandara Mountains use a kinship discourse for border definitions, which mediates the hierarchy "free–slave" into a kinship idiom, apt for express-ing both difference and belonging, within an encompassing definition of hierarchy. The ironworkers have their own reasons for maintaining this ambivalent belonging and may even cooperate in fashioning and main-taining social borders within the village. The combination with pottery is one of these. Various cultural expressions of these borders prove effec-tive, a major one being endogamy. The clustered additional specializations follow their own cultural logic, with corpse handling as the prime one. Notions of pollution, separate food customs, and a hardening of endog-amy imbue the smith/undertaker combination with an additional system of meaning. Other specializations can be fitted in according to the cultural meanings attached, and thus the Kapsiki/Higi configuration of smith spe-cializations forms one of the options realized in the cultural hothouse of the Mandara Mountains. Their form of "otherness" has developed into a system of Kapsiki semantics, and it is time now to take a closer look at the way smiths are attributed meaning within Kapsiki/Higi culture, in particular at the cultural expressions of the "othering" of the smith within this society, the internal "alterity" of the smith.

CHAPTER 3

The Internal Other

ADVICE TO A YOUNG SMITH

AFTER THE FINAL RITES OF A FUNERAL—A LARGE ONE INVOLVING AN important person in the village—chief smith Gwarda and his son Kwada drop by my house to greet and chat. Kwada is full of good cheer as his drumming has earned him a lot of money during the dance: the sons-in-law of the deceased have been generous. Gwarda is not overly happy about his son's ebullience, and gives him a long lecture on how to behave as a smith.

"You were too noisy during the dance, too much laughter, drawing too much attention to yourself. Think hard about ourselves. We are not *ndegwevi* [autochthonous people from Mogode] but we are *ndenza* [people who 'immigrated' from other village—in fact, smiths routinely come from other villages] and we have to behave accordingly. Yet the *melu* [nonsmiths] have allowed us to become chief smith. That is not because we are 'hard,' but because we are 'soft.' We are 'soft' and thus people have made us chief. If you are always calm, behave decently, clap your hands softly when others speak, the *melu* will repay you. They have to, really they have to. You will have the chieftaincy; it is for you. People have made me *mazererhɛ* [chief smith] not just because of me, but because I have a son like you. You do well. If I hear about Kwafashè Gwarda [Gwarda's other son, who moved to the city of Mokolo and tries to pass for a nonsmith] my heart hurts. He no longer belongs to us, is no part of us any longer; it is sad. Such a *rerhɛ* who wants to become one of the *melu*, will never really be *melu*, but is lost for us as a smith. It is much better to become what you are destined to be and to acquiesce in your position and make the most of what is the effective meaning of a *rerhɛ*. You, Kwada, will be chief smith. But you do

have to look for medication for your penis, which is dead. As it is, you cannot keep a woman with you, as all will leave you quickly. Even the wife you took from me [Kwada married a woman his father had destined for his brother's son] has left you. You have to be calm, behave gently; then you will be chief. If you do not change your behavior, it will not be possible."

Gwarda is surprisingly open and direct, probably using my presence to add pressure to his admonitions. Anyway, smiths are considered to have less privacy than nonsmiths, so mentioning Kwada's intimate problems in the presence of a third party does not raise eyebrows in the audience. As for his demeanor, Kwada indeed has an easy, relaxed way of approaching people, bordering—for the Kapsiki—on immature behavior, even for a smith. Kwada must have taken his father's words to heart and solved at least one of his problems, as his next wife stayed with him and bore him two sons. Eventually, Kwada did become chief smith in 2003, long after his father's death; in between the role passed to another smith's family in Mogode. However, Kwada did not enjoy the privileges of the office very long, as he himself died in 2006, to be succeeded eventually by his son Maître in 2009.

THE SMITH INSIDE KAPSIKI SOCIETY

Each village has its own smiths, and the social distinction between smith and nonsmith is clear everywhere in Kapsiki. Smiths form part of the standard system of clans and lineages, as each smith belongs to a nonsmith clan and lineage. Being endogamous, the *rerhɛ* have of course no blood relations with the *melu* of the lineage; nevertheless they are counted as adopted members of the *melu* clans and lineages. As Gwarda pointed out, smiths are classified as "newcomers" in each clan, like people who came from abroad long after the establishment of the village. But those *ndenza* (newcomers) who are *melu* can develop descent relations within their adoptive clan and affinal relations with other clans, whereas smiths, whose families all stem from elsewhere, never can. So, owing to the inclusive nature of Kapsiki clan structure, there are no specific smith clans. The patrigroups to some extent feel some obligations toward "their smith," so the clan and lineage elders will assist their smiths when problems arise, and they will also consult their own smith first in cases of illness, at least if he has some reputation as a healer. All clans thus should have their "brother" smith, and when for any reason smiths leave, the chief smith will try to find smiths from another

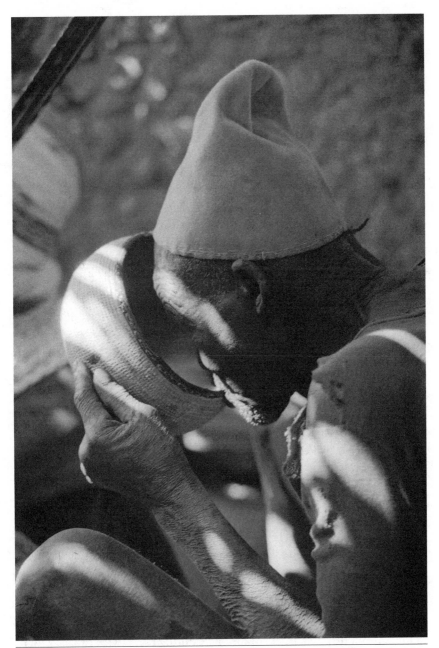

Figure 7. Chief smith Kweji from Wula drinking from his *dzakwa*

village to take their place. Recently this happened, when the chief smith of Mogode asked his colleagues from Fete at the Nigerian side to come and settle in Mogode, filling up a void in a smithless clan.

The smiths use the habitual kinship terms for their *melu* clansmen, such as *wuzeyitiyed'a* (son of my father, "brother") or *wuzhatayitiyed'a* (daughter of my father, "sister"). Each smith has a special person in his lineage who is responsible for him, his *ndemara* (the one who commands). Most smith families stem from elsewhere, mobile as they are as a group, and any incoming smith has to have a patron in the new village, just like any *ndenza*. This holds for all immigrants, including *melu*. The immigrant will be considered as the son of the patron, adopted into his lineage. But for a smith, this "social father" has to be a nonsmith, as a smith mentor could never be a viable introduction in the new village. So the mentor relation is for a smith much more important than for a *melu* newcomer; the *ndemara* relation is inherited by the family of the original host, the smith retaining a considerable dependency on this patron. In the few instances where a smith is *ndegwevi* (autochthonous), his *ndemara* is the family of the original immigration, usually part of the chief's lineage. In actual daily life, this *ndemara* relationship is important in any conflict, court case, or public gathering the smith may become involved in. In a public gathering and certainly in a court case, a smith does not speak for himself, but silently waits for the *ndemara* to plead his case.

For smith women, a similar dependency shows in the way the *yitiyaberhe* relationship, that is, the relationship between a smith woman and her ceremonial father, is defined between *melu* and *rerhε*. Each Kapsiki bride, during the rituals of her *makwa* (first marriage), is assigned a *yitiyaberhe*, usually a close kinsman of her father living near her new abode. He should watch over her, and guard her from any abuse inflicted upon her by her husband or cowives, thus serving as her social father in daily life. The relation is quite playful and relaxed, but does provide an escape for the woman in time of need. For the smith bride, however, the *yitiyaberhe* is much more important. Smith brides marry habitually into another village, which already strengthens the position of the ceremonial father, and for smiths the *yitiyaberhe* has to be a nonsmith, like the patron of the immigrant. Sometimes a smith in the village may serve as second ceremonial father, but only after a *melu* one. It is the *melu* bridal father who will help her in the many rituals pertaining to the Kapsiki first marriage. For instance, during the *makwa* rituals, a lot of food has to be prepared for the guests, most of whom are *melu*, who never eat food prepared by smiths. So the wives of a bride's *yitiyaberhe* will prepare the food for her wedding. Also, he will represent the bride in any public gathering or court case, as her husband cannot do so, being a smith.

The institution of *yitiyaberhe* is also crucial in second marriages,[1] *kwatewume*, both for the *melu* women and for the smith brides. An in-marrying woman first takes up residence with a kinsman in her new village of choice, using his compound as a springboard for her next marriage. For a smith *kwatewume*, however, this bridal father relationship is again more important than for her *melu* sister, for the reasons mentioned above; the smith *kwatewume*, upon entering the village, will of her own accord scout for a *melu* man who can serve as her *yitiyaberhe*, as she really needs one both for food exchanges and public appearances. Thus, in all crucial relationships, the smith, man as well as woman, has nonsmiths representing him or her, indicated by kinship terms. Inside his own lineage, the *ndemara* has a kind of father role, while the *yitiyaberhe* of his mother serves as a representative of his mother's family (*ksugwe*, "mother's brother/sister's son"). Through his wife's *yitiyaberhe* his in-law relations are also covered by *melu*, indicated by the term "*mekwe*" ("father-in-law/son-in-law"). Map 3 illustrates how these relationships incorporate a male smith (thick triangle) into the *melu* kinship system; the solid lines represent actual kinship bonds, while the broken lines indicate those fictive kinship relations.

Smiths and nonsmiths also have links beyond the kinship system—that is, through friendship. Friendship is important in Kapsiki daily life and also characterizes *melu-rerhε* relations. A close friendship between a smith and a nonsmith is quite common; the two can walk together through the village scouting for some beer, and these friendships are considered well within the

Map 3. The young smith (ego) inside his network of fictive kinship with the nonsmiths (in black)

Kapsiki norms. The caste difference adds some piquancy to the relationship, in fact, as the nonsmith partner has some joking privileges in his friend's compound, and he may take away some small objects such as plaited objects or pottery; after all, these are smith's products. The smith partner has to be slightly more reticent and only takes from his friend's house any animal that is taboo for his friend: if the *melu* has by any chance captured a savanna monitor,[2] his *rerhɛ* friend will take it home without asking, as "for whom else did you catch it anyway?" Eating and drinking, however, retain some tension, as the friends will not eat or drink from the same vessel, and the *melu* friend will generally not eat food prepared at his friend's compound; in the recent decennia, however, *melu* have started to drink beer brewed by their *rerhɛ* friend's wife. A clan like the *ŋacɛ*, which harbors a small number of smith families, is quite proud of being a "friend to the *rerhɛ*."

Smith women also develop friendships with *melu* women, just like the men. Whereas the friendships between *melu* women among themselves are usually restricted to neighbors, *rerhɛ* women are more mobile and find their friends in all corners of the village. Quite different are the cross-sex friendships, which are in fact frowned upon among *melu*, as they easily lead to rupture of marriage. But the friendship between a *melu* man and a *rerhɛ* woman is quite possible: endogamy rules prohibit any kind of sexual relationship, so this kind of informal bond is acceptable and occurs rather often.

But no link, be it *ndemara*, *yitiyaberhe*, or friendship, is ever strong enough to cross the endogamy boundary, and ultimately all smiths are related much more closely among themselves than with the *melu*. Endogamy forces the smiths to find their marriage partners among their own 5 percent minority. Smiths go far afield to find a suitable partner, to other villages, even quite far away to the outskirts of the Kapsiki/Higi area, and the majority of their marriage partners come from other villages, even for the first marriage. For instance, 12 percent of *melu* brides (*makwa*) marry a groom from another village, as against 42 percent of smith brides. For a second marriage, 79 percent of the Kapsiki *melu* women go to another village, while none of the smith women stay inside their village for their second marriage.[3] Also, the *rerhɛ* have slightly different exogamy rules, and marry closer kin than the *melu*. For instance, while for the *melu* a second cousin is too close, for a smith it is not, even in the case of a second parallel cousin like a FaFaBrSoSo. Smiths may also marry the child of their mother's cowife after she remarried, and practice sister exchange or repeat marriage relations of older generations. For the *melu*, these types of marriage would be, in their words, "marrying death," implying that

marrying two sisters means that one counts on the death of one, with her sororal replacement already in place.

In these examples, both first and second marriages are taken together; in all instances, including sister exchange, the marriages are independent unions, each with its own bride wealth and wedding rituals,[4] except for a few levirate marriages. Bride wealth among smiths is somewhat lower than for the *melu*, both for the first (*makwa*) and second marriages (*kwatewume*). For the second marriages, the *melu* tend to pay their bride wealth with the arrival of each child—in fact, per successful pregnancy—while the smiths pay a one-time sum at marriage, with small gifts for each child later.

Marriages in Kapsiki tend to be brittle, though the last few decades have seen the number of very short marriages decrease.[5] Yet smith marriages still tend to be more stable than their *melu* counterparts, with fewer very short marriages. For instance, one out of four *melu* marriages lasts less than one month, while with smith unions this is one out of nine.

Among the *melu*, it is rare to see a *makwa* stay with her first husband for all her life, but this is quite common among the smiths; in fact, in my marriage survey I found only one instance of a *melu* bride never leaving her husband and a dozen examples among the less numerous smiths. For a nonsmith, the critical period for the marriage is between one and five years, for a smith between nine and thirteen years. An average nonsmith man marries during his life 8.5 wives; a smith man has 5.2 unions.

So smiths have more stable marriages, a trend that has continued in spite of the general decrease of marriage frequency in Kapsiki. Several reasons account for the larger marriage stability: the economic activities of the smith partners are more interrelated, the average economic position of the smiths is better, child mortality is lower, and the wife's kinsmen have less influence on her. For a long time, one major reason for marriage instability in Kapsiki has been the high rate of infant mortality: a wife leaves the compound and the village where her child dies. Infant mortality has traditionally been lower among smiths (see table 2).

These figures represent the pretransition situation of the Kapsiki, up until

Table 1. Marriage expectancy, smith/nonsmith

	Rerhɛ mean	*Rerhɛ* median	*Melu* mean	*Melu* median
All types	5.8 years	4–5 years	4.1 years	1 year
makwa	11.8 years	9–10 years	9.4 years	5 years
kwatewume	3.7 years	2 years	3.0 years	7 months

Table 2. **Demographical dynamics, smiths/nonsmiths**

	Smiths	Nonsmiths
Gross reproduction rate	2.5	3.8
Mortality under 5 years	35%	67%
Mortality before marriage	45%	72%
Female sterility	17%	13%
Net replacement ratio	1.05	0.95

the late 1980s. From the 1990s onward, demographic transition occurred in Kapsiki country, through effective programs of epidemic control (meningitis, cholera, malaria), better medical facilities, and a general rise in the economic situation. At this moment the Kapsiki population is booming; for example, the population of Mogode mushroomed from 2,800 in 1973 to around 7,000 in 2010. Consequently, the differences between the smith and non-smith demographics have diminished, and both groups now have—as far as my more impressionistic data from 2000 indicate—approximately similar life expectancies. What has remained is one health factor: food. As we shall see below, smiths are better fed than the *melu*. One reason resides in the *melu* food taboos, which are still very much in operation: smiths eat a fair number of animals that the *melu* deem inedible—but this will occupy us in detail later. Yet, as we shall see, in the last decades the number of smiths is going down, not because of lack of fertility, but because young smiths migrate to the cities, and then are lost to the group of specialists.

While a *melu* father sometimes seems to exploit his daughter, by playing off various marriage candidates against each other, for a smith that is not an option, as his future sons-in-law are close kin, and he has a strong bond with them anyway as members of a small minority. So the smiths are not as involved in the "Kapsiki marriage complex" as their *melu* friends and are more relaxed on the marriage market; often his *melu* friends stimulate a bachelor smith to marry, as the village needs new smiths.

When a *rerhɛ* woman does leave her husband, she will leave for a faraway village, and the smith man will probably never meet his *zamale*. *Zamale* means "husband of my wife," indicating the traditional enmity between two consecutive husbands of one woman; with the *melu*, these men can and do meet—and fight—but with the smiths they remain far apart. The marriage trajectory of a smith woman easily brings her beyond the borders of the Kapsiki/Higi area. Here follows an example, contrasting one typical *rerhɛ* and one *melu* female trajectory (see map 4).

Map 4. The marriage itineraries of a smith woman and a nonsmith woman

The numbered itinerary is the marriage trajectory of a nonsmith woman; the dotted line with *a*, *b*, *c*, and *d* is the itinerary of a smith woman in her consecutive marriages. Whereas the first hops neighboring villages in each next marriage, the second is not tied to the Kapsiki area as such at all. Coming from Sukur, the central area of iron production in

the Mandara region, she just as easily moves to the Marghi as to the Kapsiki. For the smiths, the ethnic boundary is not a border at all, as they move within an area with similar smith positions, Marghi as well as Sukur.[6]

When smith women do leave their husbands, the quality of the relationship with their husband is mentioned as a reason for leaving.

> Blacksmith Cewuve quarrels with Kuve Derha, one of his wives. He shouts: "Go to Rumsu, your hut is still standing over there. You do not have to stay here. I, son of Zra Ba, am telling you, you do not have to stay here." The neighbors are listening to the quarrel and see Kuve Derha leave the compound taking the road to Rumsu, the village to the North of Mogode. She explains to the—quite interested—bystanders that Cewuve has broken the roof of her hut and that she will surely not sleep in Mogode. Also, the village chief will give his judgment tomorrow. Cewuve yells from the compound: "She is an old woman who is alone on her land. Why should I love her?" [She is old, has an adult son and cultivates her own sorghum, has her own granary, and is economically quite independent of her husband.]
>
> The next day there is no judgment, and two weeks later Kuve Derha is back at Cewuve's, continuing their marriage without further problems.

If *melu* quarrel like this—which they do—it means the end of the marriage, and the wife will never come back; in fact, in most *melu* divorces the wife leaves at the first hint of a problem. But a smith marriage can stand a quarrel; in fact, a real quarrel presupposes some stability in the relationship.

Finally, several specialists' tasks of the smith entail a close cooperation between man and wife (see figure 2). A smith couple works together more closely and keeps track of each other's dealings. For instance, most smiths know quite well what their wife is doing at a given moment, which the *melu* find hardly interesting. "*Rerhε* obey their wives," *melu* state, sometimes adding, "like the Europeans." Indeed, a smith sometimes strolls through the village with his wife, which elicits awkward comments by the *melu* men, who would not dream of doing the same.

> Among the many sick people that I took to the hospital in Mokolo, one couple stood out: the woman had broken her arm, and her husband went all the way to help her. Not only did he make a long walk through the night to get her belongings, but during the car ride he supported her arm caringly. This was a smith couple.

The *melu* men may think the attention smith men give to their spouses is shameful, and likewise, the *melu* women sometimes make fun of a *rerhɛ* "sister" who wants to stay with her husband:

> Kuve Meha, the *makwa* of smith Zhinerhu, has stayed with him now for thirteen years, and with two healthy children is not disposed to leave him. Yet four years ago she went to Kamale to marry Yèngu Kwaberhe. Why? She explains. The women of her ward, all *melu*, chiding her on her lack of mobility, asked her: "Are you still with your first husband. Never been away? What kind of woman are you?" She had enough and "went for a walk," choosing a neighboring village where her husband could easily come over and get her back. He did after four days, and she went back with him, relieved to be home again with him and her children. She never left him again, but now at least counts as a "real woman."

Smith compounds tend to be slightly larger than nonsmith dwellings. More often than the *melu*, smiths have their parents living in and have more coresident extended families. The rather rare situation of a polygamous father living in the same compound with his polygamous son is found only among the smiths. After all, the *rerhɛ* work together and have craft knowledge to impart from father to son.

Economically, smiths are slightly better off, as they combine a specialization with horticulture, having their own fields. An overview of year budgets[7] shows a higher average monetary income and less dependence on imported goods. One difference again resides in the relations within the smith compound. In *melu* households, husbands and wives tend to have their own personal budgets, the personal flow of money and goods being quite separate from each other; thus, it can happen that a *melu* man buys goods at the market, while his wife is selling the same goods at the same market. This does not happen within a smith family, as husband and wife will always furnish each other with their own products.

SPECIALIZATIONS AND PROVENANCE

Thus, the social position of the smith is defined by a complex combination of separation and belonging, of dependency and autarchy, of a lower status versus economic and health advantages. For the individual smiths, their situation in life depends also for a large part on the actual specialization

they practice. No smith performs all smith functions in Kapsiki society; all have their own combination of *rerhɛ* contributions to society. Surveying all specializations, three clusters of combinations of smith work appear, each belonging to a specific subgroup of the smiths:

Cluster 1: drum, funeral, divination, and the guitar
Cluster 2: brass casting, funeral, divination
Cluster 3: iron, guitar, flute, and divination

Playing the violin, medicinal knowledge, and magic can be combined with any of the above, as can leatherwork, an occupation not restricted to smiths but still dominated by them. In former times, before the 1970s, weaving and birth assistance were dominated by smiths also, but in these fields the nonsmiths have taken over. I never saw a smith "sage femme," but smiths are still among the weavers. For the Kapsiki, these are simply occupations one can learn, and smiths are quick learners. Weaving and birth assistance could be performed by any smith, whatever his or her provenance.

For Cluster 1, the chief smith is the prototype; his sons and the other young *rerhɛ* of this cluster play the drum at a funeral, and some of them play the guitar in bardlike praise singing. The older men in this cluster take care of the corpse. Cluster 2, the smallest group, comprises of smiths with a southern origin. They combine brass casting with participation at funerals; they use a different divination technique (pebbles), and their youngsters play only the drum and no other instruments. Cluster 3 are the masters of the forge; they participate little in funerals, play the flute and the guitar, but do not drum—the quintessential instrument of a funeral. So the three clusters group themselves around the chief smith (master of the funeral), the brass caster, and the iron master, respectively. These smiths have different traditions of origin, the second cluster stemming

Table 3. Provenance of smith clusters

	Cluster 1	Cluster 2	Cluster 3
Core activity	Funeral	Brass	Iron
Stemming from	North	South	North
Important in	Rites of passage	Cyclical rites	Agricultural rites
Playing	Ritual instruments	Few instruments	Nonritual instruments

from the south, the other two from the north—that is, Sukur. These three clusters are crucial in different rituals, such as rites of passage, cyclical rites, and agricultural ones. Table 3 shows a combination of the three clusters with the rituals.

The three clusters of smiths and their activities feature in different aspects of Kapsiki culture and supplement each other. Each of these activities will occupy us in later chapters, but this overview leads into the question of smith provenance. Viewing their mobility over longer ranges than the *melu*, what are the migration traditions of the *rerhε* compared with the tales of the *melu* origin of the villages as such? Without going into detail on the population history of the Mandara Mountains,[8] a significant difference appears between the two sets of migration histories, smith and nonsmith.

Essentially, the Kapsiki/Higi villages know two major areas of *melu* origin, two (closely related) places in the west and one particular village, Gudur (or Goudour), in the east, the latter still within the Mandara Mountains. Generally, the provenance of the smiths' families follows that of the *melu*: of the thirty-one villages, in seventeen cases the smiths came with the first migration; in three cases they came later from the same point of origin. However, in eleven villages they have a different origin, and in all of these cases the smiths traced their origin back to Sukur (or Sukuru), the iron-producing center just north of the Kapsiki/Higi area.[9] Now, Sukur history is also tied into Gudur in several ways,[10] but the point is that for the Kapsiki smiths, the village of Sukur is mentioned as the "fons et origo" of their craft, not the renowned Gudur. This holds for villages with a tradition of eastern

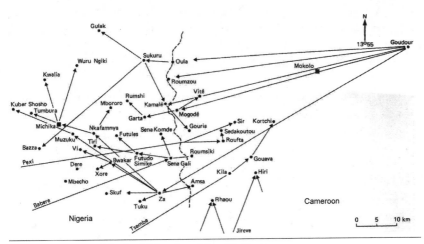

Map 5. Provenance of the (*melu*) founders of Kapsiki villages

provenance as well as for villages tracing their roots from the west. Not mentioned on the map is the village of Sirak, which in several tales of origin was a stopover in the smith migration from Gudur to the Kapsiki area; the village is just north of the Kapsiki territory and bears a close relationship, also culturally; for instance, their boys' initiation is part of the Kapsiki/Higi ritual repertoire.[11] In the village of Rumsu (or Roumsou), smiths relate of their coming from Sirak, claiming that they were the first to settle in the village with iron bows, and iron spears, and carrying their proper shrine, the sacrificial jar.

THE QUINTESSENTIAL OTHER

Up to now the smith story has been about social position, and historically about migrations, the point of origin of smith families. What is still missing are the tales of how the smith echelon as such originated, the myths of *rerhɛ* origin. For the Kapsiki, a society without smiths is unimaginable, and the tales of origin all relate how people in a certain village became smiths in order to fill the necessary social position of *rerhɛ*. In all tales the smith category already existed, and I have not been able to find any tales about the change from a society without smiths to one with *rerhɛ*. Characteristically, the tales start with a village in crisis: there are no smiths! Their absence puts the people in a quandary: if someone dies, who is going to bury the corpse? Iron is seldom mentioned; instead, the role of the undertaker is stressed. The gist of the tale is the manner in which someone in the village distinguishes himself as "different" and is then assigned to the smith category. I give three examples, one from Kortchi, one from Mogode, and the third from Kamale.

> Long ago, here in Kortchi, there were no *rerhɛ* in the village, which was awkward at burials. People knew that other villages had smiths, and they wanted one for themselves. So the chief of Kortchi butchered a goat, roasted the meat, and called all men to eat the meat while it was still hot from the fire. They agreed that the first one who would blow on his fingers and lick them because of the heat would be a smith. And so it happened, and the first one blowing on his fingers became the smith of Kortchi.
>
> When the village of Mogode was still on Rhungedu (now the sacred mountain), two brothers, Tizhè and Zra (respectively, the first- and second-born sons) took care of the funerals in the village. The first one took care of the dance and

hosted the strangers coming in for the funeral, and the other butchered the goat destined for all attendants [the funeral goat, one per dancing day]. Once upon a time, there was a death and the usual division of tasks was followed. However, one of Tizhè's children was ill, so he stayed home. He saw that Zra butchered the goat, as he should, but then ate all of the meat himself without sharing. When people saw this, they decided that Zra had to become *rerhɛ*, so his behavior would become regular. Tizhè went to Tlukwu [the village to which death is ritually chased in the wet season[12]], and he was the one who taught Zra the tricks of the smith trade. From that time onward, all the children of Zra became *rerhɛ*.

In Kamale there once was a man with several sons of the same mother. One of the sons was different from the others: he ate anything the others threw away. That is why people called him the *rerhɛ*. After that, *shala* (god) has taught him to do all the things that the others were not able to do. So the *rerhɛ* bury the dead because they eat things the others shun. The smiths want to do things the others refuse to do, so if the *melu* do not want to perform a task, they ask the smiths.

Someone called Rerhɛ saw his fellow men struggle to cultivate with wooden and stone tools. They hardly made a living. So he called upon them to collect *visu*, the black shiny sands in the brooks [magnetite], dug a hole, lit up a hot fire, and produced iron. While the others watched with amazement he began to shape a hoe, which he presented to the chief. Maze decreed that henceforth the people should support Rerhɛ, and he would make them tools.

The second part of this same myth has the same Rerhɛ observe how his fellows handled a corpse: they simply dragged it to his grave: "How unworthy and disrespectful!" So he took the deceased on his shoulders, danced with him to the grave, dug a proper tomb, and buried him in style. In this way he became close to the chief, and his descendants kept up his work. To honor them, the others gave the *rerhɛ* people the right to eat any kind of animal alive, also those that were taboo for the others. So, smiths stood out by their intelligence and knowledge that makes life easier for the Kapsiki today.

This *rerhɛ* tale was told by Maître, the son of Kwada and the present chief smith,[13] and is probably new. It underscores two aspects: a higher self-esteem of the smiths, and a more recent focus on their core work: iron and burial. The same informant maintained that many *melu* secretly ate a lot of meat that is considered strictly smith-food; whether this is so is questionable, but his remark highlights his own appreciation of the smith position. Though we shall dwell at large on the smith as the "internal other," it should be borne in mind that the smiths do have their own "esprit de corps," and may

be proud of their cultural heritage. And the emoluments of the trade are not to be slighted either.

> The smiths defend their ritual territory with some force, if needed. In 2008 a problem emerged as the smiths refused to bury Zra Ja'a: the women were mourning but there was no music and the corpse lay unattended. The chief smith, Maître, explained that they wanted a cow, instead of the usual goat, as payment. Why? A few months earlier, Hamadou, the Islamized brother of Zra Ja'a, had eaten donkey meat and the smiths heard about it. So, when Zra Ja'a died, they told Hamadou to exert himself in everything the smiths have to do: music, dancing, burial, the lot. If he wanted smith meat, he better act like a smith all the way. The mourning family of Zra had to come up with a cow to calm the wounded smith feelings, who are not to be slighted, especially not at funeral times.[14]

When he was telling me this story, Maître commented also: "If the *kaper-sunu* [the Fulbeized Kapsiki] keep marrying our girls, we will do our work no longer anyway." Also endogamy has to be defended.

All villages have variations on these themes: the people who became smiths were the ones who ate differently, who made music, or who were smarter, sometimes shown in their ability in divination. As mentioned above, the iron craft is only just recently mentioned, never before. The Kortchi tale does mention heat, but there the relationship is inverted. Blacksmiths who forge iron have an extremely hot, sweaty job, and their hands are well adjusted to the heat of the forge. In the tale this is the other way around: the one who could not stand the heat became a smith. So the "tales of origin" are essentially tales about "otherness," using minute details and ordinary, daily situations to "explain" a fundamental social difference between people. The message of these tales indeed points at the dialectic between belonging and otherness, zooming in on the most crucial task of the smith—funeral— but using the stereotypes that the *melu* have constructed about what a *rerhe* "is." For the *melu*, the smith is "one of us who is different," the one assigned a task that nobody wants; he has the job because he is somewhat different, while the job makes him different again. This "otherness" demands knowledge, though, and the new smith has to be taught the tricks of his new trade.

Tales of smith origin in other Mandara groups show similar characteristics: abnormal behavior, either by eating or by voluntarily doing the work of the mortician, leads to the definition of one as a smith. In Mafa, it often is an older brother who becomes a smith.[15] Some scholars try to read this as a tale on the political history between smith and nonsmith groups,[16]

but as Langlois cogently argues, this would negate the main focus of the tales—that is, funeral and pollution.[17] The Kapsiki/Higi smiths clearly are endogamous; in other groups, such as the Mofu-Diamaré, cross-occupation marriage occurs in principle, but not so much in practice. In my view, the main issue is not endogamy, but professional closure, a wider and more inclusive package of traits. And this closure leads to and results from the fundamental definition of the smith, the quintessential "general specialist," engaging in "iron plus," or for that matter, "funeral plus." The myths express an ontological difference defining a minority that is a crucial part of the community as the "internal other."[18]

As the nonsmiths are the large majority, they have the power of defining "otherness," and the smiths will be described using the stereotypes the *melu* maintain about the *rerhɛ*. First of all, notions of pollution are crucial in *melu-rerhɛ* relations, especially in food sharing. Smiths are considered dirty, both by virtue of their divergent food habits and their role as undertakers. The *rerhɛ*, in Kapsiki eyes, more than anything else distinguish themselves by their food: "They eat anything." In fact, the smiths do not heed a series of food taboos *melu* consider essential. Smiths do not shun the meat of, for example, reptiles, donkeys, camels, horses, predators, birds of prey, carrion birds, and cicadas, which all are taboo for the *melu*, or at least are considered inedible by them, *wushi ŋererhɛ*, or "smith stuff."

> Gamache Kodji, a Kapsiki from Mogode, was raised in a city in the South of Cameroon, then studied anthropology in Norway, and for his MA thesis made a film on the Kapsiki blacksmiths in his village of birth. He is a *melu*, but for his film had to "walk with the smiths," and eat their food. He describes his ambivalence when his fellow villagers started to avoid him, and especially avoid eating with him: he had turned a *rerhɛ*![19] He writes: "People seemed rather to walk into the thorns, than to confront me"; they even closed their noses to him and his smith companion, and he was understandably upset. However, smiths are normally not shunned or avoided that much, but here was a *melu* who had more or less turned *rerhɛ*: he had become an anomaly, unclassifiable, which is, as we learned from Mary Douglas, worse than any other stain.

Between villages it is almost standard to chide the other with "eating smith food": the boy initiates in Rumsu, in 1988, sang: "The people of Sir [a village in the East] slaughter a donkey to hand out the meat," donkey being smith food.

In the next section I address the cultural logic behind these different food habits; for now, the focus is on the consequences in daily life. Smiths

and nonsmiths eat and drink apart, one of the main reasons I compared the Kapsiki system to a caste system. Eating and drinking together is the ultimate symbol of togetherness and communion—in fact, it is the root meaning of the word "communion"—and a powerful symbol in Kapsiki religion. *Melu* sometimes rationalize this refusal for commensality with: "Smiths are messy eaters, have dirty fingers and long fingernails, and always exude a strong odor." But here the appreciation of table manners clearly follows social categorization; I never could distinguish a smith by the way he ate, but easily by the vase he ate from and his distance to the *melu*. For instance, in the core ritual of the house sacrifice, all those who belong together eat and drink together at the sacrificial meal and beer, and vice-versa: all who eat and drink together belong together. But the smiths eat and drink separately, so they do not belong—at least, not really, as their separateness is culturally defined. The rule is that the *melu* do not eat smith food, but the smiths eat *melu* food, though not from the same vessel. Hierarchy, based upon the notion of pollution, is never as clearly and visibly expressed as when, in a gathering of men, the chief smith produces his own drinking vessel, a plaited drinking cap, *dzakwa*, that he carries on his head and has filled after all others have drunk from their calabash. In ritual gatherings, all *melu* pour a little from their calabash into the smith's *dzakwa*, visually underscoring the collective supremacy of the *melu* over the *rerhɛ*.

In daily life no nonsmith will ever eat at a smith's home, while a smith who eats at a nonsmith's house has either to take his own utensils (such as the *dzakwa*) or is given a disposable potsherd to drink and eat from. Similarly, smith women who brew beer can sell it only to their kinsmen, for even the beer from a smith woman is out of bounds, "dirty." So, individual eating and drinking defines the smith as polluted, while collective eating and drinking defines the smith as a communal property, someone who "belongs in the margin," a member of a crucial category but essentially a nonperson, a notion I return to at the end of this section.

> An old man in Mogode, according to my assistant who one evening comes home with this wonderful gossip, is known to be severely henpecked. Old and poor as he is, his wife continually reminds him of the fact that he should be thankful that she does stay with him. That evening Gwarda, the chief smith, came by to drink. The old host offered him beer, as he should, because one can never refuse a smith a drink. But then his wife intervened: "If you offer the smith my beer, I will leave here and now." Shocked, the old man immediately sent Gwarda packing with his *dzakwa* still full of beer. My assistant roared with shocked laughter: "To send away *mazererhɛ*! Unthinkable! How henpecked can you become?"

For the *melu*, the pollution of the smith is also connected with death. One of the burial customs, burying on the third day after death, accounts in large part for this stereotype, when the smiths carry a corpse on their shoulders in the first phase of decomposition. Although the *melu* believe that the eating habits of the smiths explain their "filthiness" adequately, analytically it is difficult to disconnect the strong pollution sentiments from their role as undertaker, as has often been mentioned in the literature on the smiths in the Mandara area.[20] Characteristically, in the Kamale tale of smith origin given above, this link is reversed: the smiths bury the dead because they eat anything. Of course, this is essentially a chicken-and-egg question, but the association between funeral tasks and notions of pollution is rather strong. Whatever the direction of the causal chain, dietary rules are a splendid expression of an already existing social division. Even the fundamental endogamy—which is never explained in the myths—is expressed in terms of danger and dirt:[21] if a *melu* sleeps with a *rerhε*, the Kapsiki say that the belly of the *melu* will split open, and all the intestines will come out and burst, delivering a horrid stench. Death, decay and smell go hand in hand.

This, in fact, constitutes the solution of a theoretical quandary that has emerged in the Indian literature on untouchables. In my approach of the smith as an internal liminal group, I follow Mary Douglas in her analysis of the danger and pollution of border cases. In doing so she makes a direct connection between anomaly and pollution, and as Sekine notes this link is far from obvious.[22] The answer is that a position of anomaly or institutionalized marginality leads to—or in the myths results from—acts that are considered inherently dirty: the street sweepers of India, and—in the case of the Kapsiki—the undertakers of decomposing bodies.

Ambivalence has the notion of pollution but also of a certain kind of power. Smiths are considered dangerous as they have a threatening side. *Melu* are careful not to hurt, thwart, or insult a smith, as his revenge is feared. Though *melu* recognize that a smith is slow to take offense and that *rerhε* anger has a long fuse, when a smith finally takes action he is to be feared. One source of their power is their expertise in medicine and magical knowledge, but their close association with death not only taints the *rerhε* but also endows them with the ambiguous power of the other world.

My research as a friend of the *rerhε* evidently brought me into intensive contact with these smiths. One part of my work was a genealogical census of all the smiths in the village, with questions about family, provenance, property, livelihood, specialization, marriage, and friendships. My (*melu*) assistant Sunu Luc

was quite worried at the start: would the smiths think that we wanted to "control" them and wanted to "do something" with this information? If so, it would be dangerous. During the research he saw that we enjoyed quite an amount of goodwill with the *rerhɛ*, and his fear was assuaged.

The chief smith habitually wears a dark blue gown; in itself this is a standard dress, but his gown is made of small pieces taken from the sleeves he took from the death gowns during the funerals. So he is dressed in a host of death gowns, and this is one boubou that will never be stolen. Strips of death gowns are also used when he wants to leave some property out in the field, such as firewood. He simply ties such a strip to his property and is very sure that it will still be there on his return. When a lot of smiths are together, the *melu* will hesitate to enter their midst; the best example is the burial of a smith woman I witnessed. The dances in this funeral were completely dominated by the smiths, showing off their medicine vials, ritual bracelets, and cow's horns with "stuff"—in short, their *rhwɛ*, magical means. Though the *melu* also had their "kinship" ties with the deceased, not one of them ventured into the dance: this was a smith affair, and therefore dangerous.

Smiths are considered to be smart. *Ntsehwele* is an important quality in Kapsiki thought and indicates a wide array of dealings between people.[23] The central meaning is "cunning," "intelligence"; being smart in the sense of outsmarting the other but also trickery and even some charisma are part of the signification. Someone with *ntsehwele* gets his way despite resistance, always has something "up his sleeve," and is able to fool other people into believing him or doing something against their own will and interest. *Ntsehwele* indicates "intelligence" not in the sense of theoretical acumen, but of being cleverer than the other, an admirable and productive faculty. It is a relational concept: one has more *ntsehwele* than the other, shown in success at the market or at one's job. Once established, it is difficult to lose.

Ntsehwele is an important attribute of smiths. The *rerhɛ* are thought to be more cunning than nonsmiths, the latter always feeling that the *rerhɛ* lead them by the nose, tricky and resourceful as they are. One of the many tales of origin zooms in on their smartness, in a story that never fails to produce laughs:

> Once upon a time the people thought the vulva of a woman was a wound, and they tried to heal it, applying large bandages to the gaping "wound." But they never succeeded in closing the gap, and finally someone got the idea that one could do "other things" with it [which are then described in more or less graphic

detail, depending on the audience]. That man was the inventor of the *vatle-kwendekwe* [the Kapsiki euphemism for coitus, a term meaning to dig out sweet potatoes from their bed[24]]. The other people were full of admiration for such a smart move, and told him: "You have so much *ntsehwele*, you will be the *rerhɛ*."

It is difficult to know whether smiths are in fact cleverer, but it is easy to see how such a stereotype remains in force:

> Close to my house, a few kids are wrestling, a favorite pastime for boys. One of them is a smith boy. My assistant calls my attention: "Look well, that boy has more *ntsehwele* than the others, look closely at what he does." And indeed, the small *rerhɛ* fights more cleverly than the others, makes them tumble, using tricks rather than strength.

The notion of *ntsehwele* has a minority sense about it; in the folktales, the weak animals have it, relying on cunning in their eternal struggles against the large, powerful creatures. In these tales, the quintessential "cunning" one is the ground squirrel, *meke*, hero of the folk stories of the Kapsiki as well as of all groups in the Mandara Mountains.[25] This cute little animal is in constant battle with the big-but-stupid panther or hyena (almost the same name in Kapsiki language). Cuddly though the furry *meke* may be, its bite is vicious, both in actual zoological fact and in the folk tales: as hero-trickster the squirrel ruthlessly skins, burns, and tortures his large enemy, kills his cubs, and destroys his home. But he never succeeds in really getting the upper hand for a prolonged time, as the big brutes stay what they are, big and powerful. Smiths are often likened to the squirrel, and one of the main blacksmith tools, the tongs of the forge, is called *meke*, handy, smart but with a mean bite. *Ntsehwele* is the cunning of the small against the large, the vicious bite of a small animal, tricking and leading astray, without ever upsetting the fundamental order of things; in short, *ntsehwele* is the "power of the weak."

The combination of danger and cunning leads to secrecy and ambivalence. For the *melu*, smiths form a closed society, a world within their world. Whereas the affairs of the *melu* may be private, those of the smiths are imbued with secrecy. A certain sense of irresponsibility is part of this picture: smiths cannot be trusted with public affairs or representations of the public good as "one never knows what a smith will do." Though privacy is important in Kapsiki life, private affairs are well known and easily discussed in the family or the neighborhood, but with smith affairs this is different, as these are shrouded in secrecy. If not secret, they are quite public; after all,

the work of the smith is quite public, and his many functions are all in direct service to the community, service functions in fact.

As indicated, there is a notion that smiths do not get angry as quickly as the "normal" Kapsiki. Quick to take offense, the Kapsiki *melu* have a standard of verbal aggression that is not equaled by the smiths, who are considered calm, aloof, and who stay out of the fray. Of course, being the masters of magic, they are easily suspected of settling their disputes in secret through their medicines. But they should not fight and formerly did not participate in wars directly, only by furnishing weapons and poison. In disputes, their social role is to clap their hands (*mpi dzeve*), asking for silence: "If there are no *rerhε* present, people never stop talking." In my opening example, Gwarda admonished his son to behave according to this kind of expectation.

This sort of personality characteristic fits in with one related idea about smiths: the notion that among smiths there are no "peculiar people," such as *mete* (witch), *kelεŋu* (clairvoyant), or *hweteru* (those who possess an "evil eye"). Here both smith and nonsmith are in agreement, for different reasons. According to the smiths, there simply are no smith women with those characteristics, as these are considered to be inherited matrilineally. On their part, the *melu* think the smith's knowledge of *rhwε*, magic and medicine, is a sufficient counterbalance to any inherited characteristic. The same seems to hold for twins, by the way, which is more difficult to explain, but the Kapsiki think that smiths seldom have twins and that the case of Kwanyè Made, a smith-twin, mentioned later, is exceptional.[26]

The *melu* realize well that being a smith is not easy, and that the smiths' birthright of cunning and insider knowledge carries a heavy price tag. So one more notion seems to redress this "birthdoom," and that is the idea that smiths live long. "Formerly smiths died hardly at all," an old informant explained to me, "god saw them suffer and gave them a long life." There is obvious proof for this thesis, according to the Kapsiki. First, when people have health problems they go to the smith, so he can—or should—also be able to solve his own quandaries. But more spectacularly: smiths crawl into and out of the grave without any problem, so they must be the familiars of Death (in Kapsiki called *Mte*, a divine being), more or less his kinsmen. Nowadays, things have changed, but smiths still are reputed to live long, an idea I have been unable to test. Only when they engage in black magic are they at risk, but so is anyone dabbling in this kind of the occult. Though they live not as long as they reputedly did in the past, they also do suffer less than in olden times. Now they can set their own price for their services, whereas in the past they had to wait for what the *melu* decided as remuneration.

Even in a society with a clear-cut working ethos, the smiths stand out as

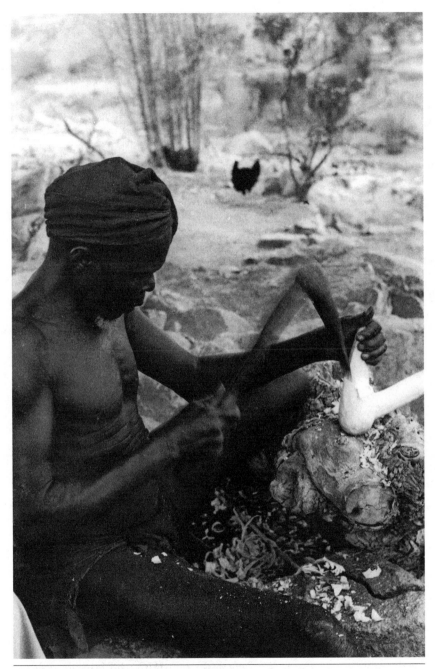

Figure 8. Chief smith Gwarda making a hoe handle

hard and indefatigable workers. Their hands are never idle, their work is never done. The smith women have all the normal tasks of a Kapsiki woman, plus their pottery and medicinal specializations. The men farm as much as they can in addition to their various crafts. When the fields are cleared by communal work parties, the smiths take pains to be exemplary laborers; for one thing, when their *melu* friends reciprocate the work, they cannot receive any food prepared in the smith's compound. Internal smith discourse is full of admonitions to work hard, harder than any nonsmith. Laziness is considered a valid reason for divorce among smiths, while for *melu*, among whom divorce is far more frequent and who cite lots of reasons or excuses for the termination of a marriage, laziness is never mentioned. One reason for this ethos might be that smith work is less dependent on the seasons than that of the male *melu*. Most *rerhε* products are needed throughout the year; for example, leatherwork, a specialization of most smiths, is not season-bound, nor is, evidently, medicine, while music is for every season, though with different instruments.

Not only do the smiths work hard, they are also quick to accept new developments. New techniques are easily adopted with a highly pragmatic attitude by smiths, their social marginality rendering them receptive to innovations that often open up new avenues of social mobility. One instance was the arrival of Christian missions, both Catholic and Protestant.

> In the early phases of the Catholic mission in Sir, in the late '50s, the church in Sir quickly filled up with *rerhε*, who dominated the convert body. With about a total of 140 converts in 10 years, the smiths filled the benches. They quickly acquired the new skills of building European style, carpentry, masonry, etc., so the mission enjoyed a quick initial success, which then halted after the mission buildings were finished. Only later the missionaries realized what had happened and started to focus on the nonsmith majority, for the *melu* were hesitant to enter such a smith-associated institution. Not until much later did the mission succeed in getting a more representative sample of Kapsiki in church.[27]

Two social characteristics of the smith are particularly striking. First, the social position of the smith is that of a nonperson, someone neither responsible nor accountable, considered unreliable, even if this cannot be held against him. Smiths are "children of the village." We saw that in court cases. At any official function smiths are neither expected nor allowed to answer for themselves, and a smith's *ndemara* (the nonsmith who is responsible for them) will represent him. Second, many of the smith stereotypes resemble those of women. Of course, *melu* women heed the usual food taboos, but

they too are considered occasionally unclean, dirty; though Kapsiki society is not overly concerned with menstruation, some pollution does emanate from the monthly period. Cunning, *ntsehwele*, is attributed to women as well as to smiths. According to men, women are always busy fooling their own—and other—husbands. No man can ever fully trust a woman, both because of her inherent (according to men!) unreliability—just like the smith—and because of her cunning. Though men try to hide things from their wives, they acknowledge defeat in this arena.

Women are closely linked with smiths anyway. For their problems, they resort much more than men to the services of the *rerhɛ*, so they are the main clients of the smith-diviner and of the smith-herbalist. Men rely more on their sacrificial jars and protective measures that do not depend on smiths; women go to the smith, especially for problems relating to fertility and child-bearing. So in many ways women and smiths present the same picture, but inversed. Neither participates fully in the public men's world, but both have their own world well separated from others' eyes, their own secrets, and their own strategies to protect their private spheres. But women are the new life, whereas smiths represent death. They are each other's ritual opposite and as such need each other. The fertility of women demands the constant attention and the protective and healing powers of the very people closely associated with death. The smiths are the "feminine" category that holds power of and against death, just as women can give or withhold life. In their wedding rituals the brides are decked out in iron, the power of the smith becoming part of her procreative powers. Together, the "feminine" smiths and the "iron women" hold the very powers that the men can never have, despite all their public dominance, those of beginning of life and ending it.

EATING ONESELF, SMELLING THE OTHER

The smith as the "internal other" proves to be a delicate balance between a lower ranking and a better situation in life, between being dependent on and looking down, a balance that fits in well with this segmentary society where people strive for individual autarchy and tend to reject the imposition of authority. The model of Dumont with its "encompassing hierarchy" is quite apt here,[28] albeit that here the center is the smith echelon with a lower, not higher, general status, our model of the inverted bowls, the *melu* bowl covering the *rerhɛ* one. The smith group serves as a focal point of gravity in

Kapsiki culture, with its essential and crucial contributions to ecology and religion, the *rerhε* being an indispensable group from which the nonsmiths can only claim some independence by its assignation of a lower status.

This dialectic between belonging and othering shows in two fields of expressive Kapsiki culture. One field consists of exactly the food taboos I mentioned, the other is the cultural definition of the senses. First, the anthropology of food. As discussed earlier, smiths and *melu* have different food proscriptions, as smiths eat foodstuff—animals—that the nonsmiths do not consider edible. But contrary to what *melu* state, smiths do not eat "anything," as they too draw a line at certain animals. Food taboos are an old fascination of anthropology, a major focus in the debate between symbolic and ecological analysis. In my search for some cultural logic in the Kapsiki food taboos, I follow the lead of Mary Douglas, trying to ascertain the logic of classification inherent in the taboo system. The taboos only concern animals, so what follows is a study in ethnozoology,[29] to glean how animals are loaded with meaning, part ecological, part symbolic.

Using ethnoscience methods I collected all animal terms in Kapsiki language, had my informants sort them out in clusters and subclusters and label these, and through sorting tests had my informants generate an emic, zoological system. Then I collected the information on edibility, by *rerhε* and *melu*, of all these animals, as well as their symbolic properties. All of these characteristics were matched with the ecological and economic importance of the animals, though the number of domestic animals is but a fraction of the total number of species. These categories and systematics generated notions of the logic of the emic classification, ideas that I checked with a few key informants. Thus I collected 295 Kapsiki terms for animal species, grouped into seven major classes, named by my informants and divided over the categories of edibility: edible for all, edible only for smiths, and inedible for *rerhε* as well as *melu*. I myself categorized the clusters of species within the cells ("reptiles," "felines"), and though these cover terms are approximations, they serve to make the system manageable; in each cell the total number of emic species is indicated. This results in the ethnozoological Kapsiki classification given in table 4. Clearly, the stereotype that "*rerhε* eat anything" is incorrect, as only 20 percent of all species are specific smith food, about one-third of the number of inedible species. But what are the characteristics of these sixty-one species, in contrast with the other two columns?

Though at first glance there is no obvious distinction between common food and smith food, the animals in the columns do differ in a systematic fashion. This is easy to see in Class 4, the "water animals," where the division runs to some extent parallel to Western classification;

Table 4. Kapsiki ethnozoology

Class	Common food	Smith food	Nonfood
1. "Leg walkers"	Ruminants, pig, hares, porcupine, ruminants, elephant, chicken, Guinea fowl (29 sp.)	Monkeys, felines, horse, donkey, camel, hyena, weasel (24 sp.)	Dog, bush dog (2 sp.)
2. "Flyers"	Seed eaters, cranes, cow-heron, colored toucan, walking birds (46 sp.)	Birds of prey, fishing birds, carrion birds, raven, black toucan, black heron (22 sp.)	Flies, bees, mosquitoes, wasps, beetles, butterflies, dragonflies, bats, woodpecker (44 sp.)
3. "Crawlers"	—	Water iguana, boa, water python	Poisonous snakes, millipedes, lizards, gecko, blind worm (14 sp.)
4. "Water animals"	Fishes, hippopotamus (14 sp.)	Reptiles (except snakes), crab (6 sp.)	Amphibians, mollusks, arthropods (except crab) worms, leeches (17 sp.)
5. "Mice"	Field mice, house mice, mountain and "holes" mice, hedgehog (14 sp.)	Flying fox	Shrews (2 sp.)
6. "Locusts"	All locusts except cicada and specific "nonedibles" (17 sp.)	Cicadas (2 sp.)	Scarab, "nonedible" locusts (6 sp.)
7. "Ants"	—	Woodworm	Termites, ants, worms, caterpillars, spiders, flies, lice (29 sp.)
Total	120 sp.	61 sp.	114 sp.

there fishes (and the hippo!) are food for both smith and *melu*; reptiles—such as monitor lizards—are food only for *rerhε*; while amphibians are considered inedible for everyone. The hippopotamus and the crab are—for Western standards—strangers in this class, the hippo being a stranger anyway as it does not live in the Kapsiki area; it is found in the river

valleys of the Benue and the Chari, far south and north of the Mandara Mountains. The crab is important as the main divination animal; the smiths being the main diviners, their association with this animal makes ample sense. So reptiles are "smith animals"; when asked why, my informants point at their contact with the earth, and—as always—their food. Though classified with the "water animals," they are "earth animals" that crawl or glide over the earth's surface and dig holes. The core species is the savanna monitor (*Varanus exanthematicus*), which is fairly common in the Mandara Mountains and considered paradigmatic smith food, together with the tortoise. Also, reptiles "eat ants" (read: insects), deemed inedible. Smiths have an intimate relationship with earth: in metallurgy, in pottery, in medicine, and of course in burial; and, indeed, smiths eat things the majority deems inedible. Amphibians, in contrast, are neither eaten nor killed, for different reasons; for instance, the frog, as the paradigm amphibian, is associated with a woman's vulva—a common folktale tells about the exchange of these body parts between a frog and a girl— and killing a frog is believed to provoke an abortion.

Another common denominator of the middle column is the fact that it houses most of the carnivores. With the exception of the dog, all carnivores are smith food: felines, weasels, hyenas, snakes, and so forth. In the bird class, this comes out best: all birds of prey, all carrion eaters, and all fishing birds are *rerhɛ* food. The left-hand column contains herbivorous animals, such as ruminants, rodents, and seed-feeding birds. The hedgehog and the porcupine belong in that class too, notwithstanding the symbolic properties of especially the porcupine. But their quills are symbols for everyone, and the rationale is not the symbolic potential of the individual animals but their position in the animal kingdom. Inedible animals eat insects, earth, blood, and wood. Some classifications are strange to Western eyes; for instance, the woodpecker is considered as a sort of insect. This makes sense once one realizes that the whole system is based upon food: according to the Kapsiki, woodpeckers eat wood, just as insects do, so they are classified as insects. In Class 1 ("walkers"), when distinguishing between horses and ruminants, the Kapsiki point at the hoofs: even-hoofed beasts are common food, while odd-hoofed beasts such as horses and donkeys are classified as smith food. This rather Old Testament criterion is not related to cud chewing, as in the Leviticus classification,[30] and does not lead to notions of polluted animals or "abominations," but is just about edibility. The pig, in Kapsiki, is considered excellent food for all. The question now is, what is the Kapsiki rationale for this division between odd- and even-hoofed? This seems to be the notion of a herd: the horses and donkeys contrast with the cattle, goats,

sheep, and even pigs, as the former operate not in groups, but alone or in pairs. As individual animals they perform special functions and—though valuable—are not the animals by which wealth is expressed, and thus are not used in bridewealth. They are the "individual" animals that represent another kind of value.

In the class of the "flyers," not only the distinction between carnivorous and herbivorous birds is relevant but also that of color. All noncarnivorous birds associated with smiths are black themselves, whereas the *melu*-birds are multicolored. The case of the cicadas deserves special mention. Of all twenty-five species of *hegi* ("locusts"), only those two species are considered smith food. And cicadas have one outstanding characteristic: they are the musicians among the locusts. Their Kapsiki name, *rhɛdɛ*, in reduplication is the name for the one-stringed violin, *rhɛdɛrhɛdɛ*, a musical instrument that Kapsiki smiths—and only smiths—play. Five locust species are considered inedible because they "stink."

In Classes 3, 5, and 7 the smith animals are the ones that do not really "fit": the snakes living in water; the flyers among the "mice"—that is, the bats; and the "ant" that lives inside wood, the woodworms (considered a different species from the beetles of which it is the larva stage). In Class 5 (the "mice"), the only nonedible species are the shrews, because they "stink" and are considered poisonous (which is correct: they carry poison in a groove of their teeth).

Summing up the main criteria for distinguishing those animals eaten by the *rerhɛ* but not by the *melu* are: carnivores (including carrion)/black/ musicians/individual animals for special tasks/"odd one out." A famous German expression runs "Der Mensch ist was er iszt" (people are what they eat): choice of food is self-definition. Different food customs are an obvious way of "othering," and culinary habits offer an easy tool for putting down a neighboring group: the English as "Limeys" (eaters of limes—against scurvy), the French as "Frogs" (frog eaters), the Germans as "Krauts" (sauerkraut), and of course the Dutch as "Kaaskoppen" (cheese heads).

The same holds for the smiths in Kapsiki culture, and the general trends in the food taboos effectively read as self-definitions of the *rerhɛ*. Smiths are often chided for being *zhidewushi* (meat-lovers) by the *melu*, and smith women are known to refuse to make a sauce without meat. That is more *melu* discourse than actual fact, but the smiths also avow that they love meat more than the *melu* do, and it is evident that they do in fact eat more meat: the *rerhɛ* are the carnivores among the Kapsiki/Higi. They eat more animal protein than the *melu*, as do the Mafa smiths.[31] Of course, the bulk of animal protein comes from the ruminants and

chickens (not a bird, according to the Kapsiki!), but the *wushi ŋererhε*, smith food, is a valuable extra.

> The Kapsiki have few horses, but the Fulbe do keep horses, and do not eat them either. So whenever a horse dies among the Fulbe (often Fulbeized Kapsiki), the smiths are called in for the meat. The division follows the habitual rules for the division of the burial goats: the chief smith gets one leg, the head, half of the breast and the testes. The rest is divided among the other smiths. The same holds for donkeys, which are less scarce: when a donkey dies, the smiths are called in to take away the meat.[32]

Carrion eating is considered a normal part of meat-eating, but carrion is also associated with the burial goats. The smiths are responsible for the funeral proceedings and receive one goat for each of the days the funeral lasts, usually three. This is "their goat," and for the relatively small group of the *rerhε*, this amounts to quite an amount of extra protein. With twenty to thirty funerals a year in a large village, my estimate is that these goats add 20–30 percent to the habitual meat intake of the smiths. Carnivores indeed, including "carrion."

The color black is quite straightforward. Especially the male *rerhε* are the "men in black"—that is, in the dark blue gowns of the funeral—and their association with the color black is strong, the blackness of death. The same holds for music and the fact that they eat the only real musicians among the insects, the cicadas. Smiths are the musicians, both in the funerals and in other social settings, the bards, the praise singers, as well as the drummers and flute players. So, indeed, they eat the cicadas. Finally, the more general indications of individual animals with specific functions and animals that are the "odd ones out" characterize the general position of the smiths inside Kapsiki society: they are not part of the "herd," they work as individuals serving the village, and while being part of the system they do not really belong—they are indeed the "odd ones out."

Thus, the ethnozoology expresses the "otherness" of the smith, the animal kingdom symbolizing the cultural perception of the social reality. In defining edibility, the social characteristics of the *rerhε* are stressed, as the differences between animals are used to highlight analogous differences between people. Food taboos may sometimes be good for eating or reflect ecological wisdom, but here they are mainly "good for thinking," in Levi-Straussian terms. Thus, smiths eat those animals that have an analogous position in the animal realm, and "eating like a smith"—the theme of quite a few myths of origin, as we saw—is indeed almost identical with "being a smith." Still today, people stress, one can become a *rerhε* by eating *wushi ŋererhε*.

These symbolic dimensions of this system are not obvious to my informants, and they explained the taboos simply by defining the animals in question as "unsuited for consumption," unsuited for them as *melu*, that is; after all, some things seem so self-evident that no emic theorizing is needed. However, when confronted with my analysis, they easily recognized it, agreeing on the characteristics as given above. So *wushi ŋererhɛ* are "good to think," if only in retrospect. Levi-Strauss used this expression in his analysis of totemism, but that is not the issue here: Kapsiki culture knows no totemism, and the relation between smith and food is actually the inverse. In totemism the descent group abstains from eating the related animal species, prohibited by an overt discourse on kinship between group and species. Here the opposite holds: the smiths eat "themselves" in the animal realm: they "are what they eat" and they "eat what they are." In the end, the logic of the system defines them as the black individual carnivores of death, on the one hand, but that same logic does provide them with more protein than the higher "caste": "good to think" here runs definitely parallel with "good to eat."

And now for the senses, one of the themes running through the smiths' occupations—in this case, smell. Kapsiki smiths are considered "dirty," first because of their food, but evidently also because of their role in funerals. Dirt, which Mary Douglas routinely defined as "matter out of place," is most convincingly expressed in olfactory terms, through cultural definitions of odor, of stench in fact. Nothing puts down a minority as absolutely as having them defined as "stinking," a discourse that brooks no opposition and leaves no room for maneuver. Stench may simply be an "odor out of place," but that is probably taking relativism a bridge too far. As the Kapsiki do define *rerhɛ* as dirty and indeed "point their nose at them," we shall glean how their notions of odors impinge upon the dynamics of "othering" to which the smiths are subjected.

Why is smell important? Western culture has a low appreciation of smell, as Helen Keller remarked, naming smell "the fallen angel."[33] Odor, in our present age and culture, is something *not* to be noticed. Nevertheless, a small digression into the anthropology of the senses shows that smell has quite a special place, being highly evocative, and easy to use in ethical and aesthetic judgments, both positive and negative:

In his *Soliloquies, Book 1*, Augustine, Bishop of Hippo, expressed his yearning for the Lord in a desperate plea for a total renewal of life: "Give me a new sense of smell, or the sweetest smell of life which hastens behind the

odor of your most precious sweetness." This was 5th century North Africa, but both the link between smell and the sublime or the abhorrent would remain strong in the Christian tradition. Camporesi, who gives this quote of Augustine, comments on the Baroque culture of southern Europe: "The mysterious powers of the sense of smell run vertically, and can climb towards the Empyrean or dive down into the terrible abyss. Paradise and hell threw open their doors to delicate trails of smell." The combination of the stench of hell and the sweet smell of saintliness made for a powerful discourse on virtue: [on a particular saint] "He even reached the point of giving off such a pleasant, singular and unusual smell from his body that everyone called it the smell of virginity. . . . Those infected with filthy carnality who came for absolution . . . recognized the power of his odor."[34]

Smell is important because of its highly evocative powers. One famous example is the smell of a madeleine in Proust's *Recherche au temps perdu*, but the most compelling novel is *Das Parfum* (*Perfume*), a gem of German literature in which Patrick Süskind describes an (anti-)hero who can smell extraordinarily well but who produces no odor himself. This alone sets him apart from the rest of humanity, and though he is an expert on perfume, when he sets out to create his ultimate perfume he is completely "outside" humanity, as the perfume is an amalgam of a series of horrendous murders.[35] According to Classen, Howes, and Synott, one of the attractions of the book is the "confirmation of the validity of many of our most cherished olfactory stereotypes—the maniac sniffing out his prey; the fragrant, hapless maiden; the dangerous savagery inherent in the sense of smell."[36]

Different societies have varying olfactory histories. In his trailblazing study of odors in French history, Corbin describes the stench that must have pervaded French cities, and the transformation of society made possible by and through the "deodorization" of France. Smell in France was a bit like noise in our cities: the absence of smell or the presence of a pleasant one was a mark of election, of wealth and power; hence the tremendous importance of perfumes.[37] The West has been deodorized in what Classen, Howes, and Synott called the "olfactory revolution."[38] Smell went from a tolerated background, to social discrimination, and in the nineteenth century became an inconvenience.[39] Some societies elaborate on distinctions by smell and are what Almagor calls "olfactory societies," in which smell is not suppressed but utilized to make social distinctions. Almagor reported that among the Ethiopian Dassanetch, a deep distinction was made between cattle owners (smelling like cattle, so wonderful!) and their lower-ranked fishing compatriots "reeking of old fish."[40] And both groups do wash frequently, as do

the Kapsiki, smith as well as nonsmith. Among the Serer Ndut of Senegal also, similar equations are made between smells and types of people. For instance, Europeans smell like "urine" to the Serer Ndut; indeed, people hardly smell themselves but turn up their noses at the foreign other.[41] In this sense, the Kapsiki are also an olfactory society.

One major problem with smell is that it lacks a referential grid. The number of chemical compounds detectable by our (mediocre) noses is both enormous and amorphous: "Odors have consistently defied attempts at rational (or 'objective') classification, and probably always will."[42] This renders smell elusive but at the same time open to the influences of our cultural history. So we have to rely on culture-specific distinctions, in this case on the emic distinctions the Kapsiki make between smells, through their special vocabulary on smells. European languages usually have very few words for different smells, and those few relate either to taste (sweet, sour, bitter, salt) or opinions (rotten, foul). In contrast, the Kapsiki/Higi language has fourteen lexemes indicating smells, most quite explicit, referring to the smell of something specific. The referent is usually an object: "it smells like . . ." and the words belong to the class of ideophones, expressions of specific actions or observations. In fact, the Kapsiki language is quite rich in ideophones,[43] using different ones for actions such as "walking away," "almost tumbling," and so forth. The Kapsiki smell ideophones are:

1. *heshese*:	the smell of roast food (peanuts, meat)	
2. *kamerhweme*:	the smell of old grain in a granary	
3. *zedʼe*:	the smell of edible food	
4. *rhweredlake*:	the smell of fresh meat	
5. *vɛrevɛre*:	the smell of the civet	
6. *dufduf*:	the smell of white millet beer (*mpedli*)	
7. *'urdukduk*:	the smell of milk	
8. *shireshire*:	the smell of animal feces	
9. *rhwazhake*:	the smell of urine	
10. *mɛdʼɛke*:	the smell of various animals	
11. *ndriminye*:	the smell of rotten food	
12. *kalwuvɛ*:	the smell of human feces (*wuvɛ*)	
13. *ndalɛke*:	the smell of a (three-day-old) corpse	
14. *dzafe*:	the fleeting smell of something that is noticed just for a moment	

I was surprised at the ease with which all informants came up with all the fourteen lexemes on the list and the general consensus on these terms. Lexeme 14 indicates a characteristic that can apply to any of the other odors and has been kept separate. Again using ethnoscience techniques,[44] I grouped and contrasted these terms. Smells concerned with edibility are grouped together (1, 2, 3, 4) and likewise smells for bodily secretions (7, 8, 9), or for things that of themselves have what one might call a "musty" smell (5, 6). Quite apart stand 10, 11, and 12, which carry a notion of "absolute inedibility": rotting food, smith-food (for nonsmiths), and feces. In the group of smells concerned with edibility, the definition of smell follows the lines of the food taboos between smith and other. The same holds for smells associated with "absolute inedibility," where 10 especially shows a clear distinction between *melu* and *rerhɛ*: the smiths define the animals with this "smell" differently from the *melu*; essentially this is the smell of inedible animals. Finally, the "loner" among the smells, the worst of all vile odors, is 13, *ndalɛke*, the smell of putrefaction, the smell of the corpse. For the *melu*, a corpse smells worse than anything else, a vile, putrefying odor polluting anything in its vicinity and anyone touching it; the *melu* tend to include the smiths themselves in this category as well. From their side, however, the male smiths do not even mention the corpse among the connotations of this smell, though when pressed by the *melu* will admit that a dead body does smell, a little. While for the *melu* the real stench in life comes from a corpse, which smells even worse than shit, the smiths define *ndalɛke* simply as rotting meat. So the men from both groups do share the same cognitive grid, but define the terms differently. Women, though, seem to take intermediate positions in the valuation of scents; *melu* women define "smith things" less as malodorous, *rerhɛ* women view the corpse as somewhat *ndalɛke*. But then, women do not carry corpses.[45]

The whole "smell machine" runs on the fact that *melu* think that smiths smell awful, from the things they eat and from the corpses they carry. Thus, a fundamental contradiction at the heart of the Kapsiki funeral comes to light in these odor terms. To say a proper farewell to an honored fellow member of society, a protracted funeral is needed: the social relations between kinsmen and villages in Kapsiki society demand a corpse that is on show for at least three days. The rationale for keeping the corpse around for so long is the logic of the funeral proceedings themselves, the mourners having to see the deceased and the deceased having to "see" them in return. These three days allow an ever-widening circle of relatives to attend the funeral: the first day immediate kin living nearby, the second day the whole village, while the third day is for "strangers," the neighboring villages. Then the

burial can take place. For that very reason I expected, at the start of my fieldwork, the Kapsiki not to mind the smell of the corpse, viewing the central position of burial procedures in this culture. Surely, as one has to dance with the corpse for three days, the penetrating sweetish odor of the corpse would be quite acceptable. But the reverse holds: the smell of the corpse is detested. So the three days of dancing turn a beloved one into the foulest smelling thing on earth.

The solution to this cultural quandary lies at the heart of the "casted" nature of the *rerhe*: a distinct group of "different fellows" that should solve this contradiction. But, inevitably, the very smiths who bridge this divide and make the burial and a decent farewell possible turn into "stinking people" themselves, a lower caste of corpse carriers. So the smell of the smith is the smell of ambivalence, of "people out of place." Kapsiki society is divided in two by the nose: smell is a compelling metaphor for hierarchy, and the discourse on smell is hard to counter. Thus, the smiths are caught in a positive feedback loop: because they are "different," they are defined as dirty and have to perform "dirty duties"; because they do dirty tasks and as a consequence smell, they are put down as different, inferior, the people of ambivalence.

Hot Iron and Cool Pots

PREPARING THE FORGE

AT THE START OF THE DRY SEASON, MID-JANUARY, THE WARD CHIEF cries out in the early evening that all people from the ward have to come tomorrow to the smithy of Vandu Dawela to repair the roof: "and bring straw and rope with you." The people from the ward have been notified before that this *meshike*, work party, will be held, so they have reserved some bundles of grass. Early the next morning a dozen adult men show up, representing the households that make use of the services of that forge. This repair of the roof has to be done every other year and is a typical ward function. The ward chief arrives as well, accompanied by the *ndemara gedla*, the one who "commands" the forge, Deli Dumu. Deli directs the proceedings, which are not particularly complicated. A few men sit down to plait the straw rope used in roofing, and the others loosely bind the long grasses into a string of straw. Two younger ones take down the old straw, put it aside—to be used for lighting the fire inside the forge—and rearrange the wooden beams on top of the forge. It is a low and wide building, so they can easily put the skeleton of the roof just right. Vandu and his son take care of the old straw and crouch at the side of the working party, softly clapping their hands to thank the ward members. The two young men rearrange back in place the long bundle of twines that spirals over the beams, as this feature, crucial to a good roof, is still good and there is no need to replace it; this spiral provides an even support for the straw. When the plaiters are finished with the grass strings, they wind them on a stick and then start the actual roofing, unwinding the stick with the straw from the top of the roof downward. They work quickly, as the forge is lightly roofed—not only rather low but also sloppily decked to allow for ventilation

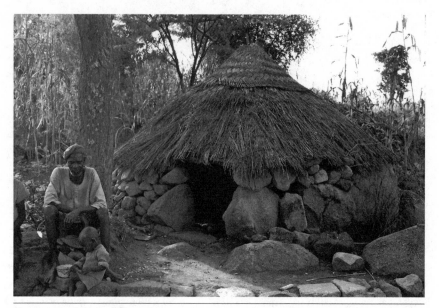

Figure 9. Vandu before his smithy

in the roof. To finish off the roof, Deli has the usual top covering, the *dlerekwe*, put on top of the roof, and the work is done.

From the various compounds in the ward, women arrive with some white beer for the men, but before they set out drinking, the *ndemara* has to perform his sacrifice. When the forge was built, long ago and also by a work party, the smith had his wife make a sacrificial jar. At the start of the forge, and now at each reroofing of the low structure, the *ndemara gedla* will use this jar for the sacrifice. Deli Dumu has brought along a rooster and a calabash with red beer—which he has prepared himself earlier at his own home—and puts the jar and the calabash beer next to the U-shaped oven, the heart of the smithy.

Silently Vandu waits next to the oven, while Deli takes the calabash and pours some beer on the jar: "*Shala ta d'a, shala ta d'a, kwelɛŋu mbeli. Jigelafte, mbe zhi ke daŋkwa*" (My god, my god, let the people be healthy. God, let the wounds stay outside). He spits a mouthful of beer over the jar, some over the sitting smith, and a little bit over his breast. Then Deli Dumu holds the rooster over the jar, Vandu Dawela holding its head—like a son does at his father's sacrifice—plucks some feathers from the neck, and cuts its neck, the first blood dripping on the *melɛ*, the sacrificial jar. Similar words are repeated: "Let us be healthy, let the forge work well, and please: no wounds." Smith Vandu receives some beer in his *dzakwa* (drinking cap),

waits until all the roofers have drank from the calabash, and then drinks himself. Deli plucks the rooster, gives Vandu one leg for that evening's sauce, and takes the remainder home to eat tonight with his family as the conclusion of the sacrifice. The smithy and the forge are ready for another season. The smith being the "child of the village," the smithy is a place that also belongs to the whole village, and its upkeep is in the definite interest of the whole community.

This chapter goes into the most emblematic craft of the *rerhɛ* portfolio: blacksmithing. The blacksmith, in many ways, is the icon of a craftsman, as this endeavor is farther removed from daily African life than any other of the human exploits—the heat, the fire, the hard and sturdy iron, for everyone it is clear that this is a job one has to learn, and to learn by doing, by a long apprenticeship. The craft is difficult to master, but its products are for everyone to judge, as nobody can do without the blacksmith's wares. It is also a heavy, sweaty job that is visibly difficult. Blacksmithing always creates a heavily structured place, a definite craft shop, the smithy, with the trio of fire, bellows, and anvil at its center. The spot for the blacksmith is clear, the remaining positions of the client or the audience are also indicated, and the place is full of tools, scrap metal, a water vessel, half-products and finished ones. It is a thingy place, imbued with some strangeness, where specialists ply their skills and outsiders can just watch. But it is fun to watch. As the senses go, this is a place of eye-hand coordination primarily, but multisensorial. Here one has to look, to learn to watch the fire, viewing the rod of iron heating up, for a blacksmith has to gauge the heat by looking at the color of the glowing iron and then act quickly when the red glow shifts to yellowish-white. Then he keeps banging until the last reddish glow disappears. When hardening the iron, he dips the glowing object into the muddy water of the *tsu* (hollow stone), listens to the hissing sound and watches the bellowing smoke, gauging when the hardening is sufficient.

The smithy is a place of visual contrasts: usually quite dark inside with only some light coming in through the low door openings, in the smithy the eye is drawn to the glowing coals of the fire, throwing soft gleams on the body of the smith when he hammers away at the sturdy metal. The second impression is one of heat, the small enclosed space more than adequately heated by the ever-present fire, heat rendered visible by the profusely sweating blacksmith. But there are also sounds galore in a smithy, the strange hissing sound of the bellows, and the soft whisperings of the fire itself, in between the explosive banging of the smith's hammer. Some talk

accompanies the sounds of the smithy, but not much; for the outsider, it is a place to watch more than to comment, and working on the iron the smith has little breath left for chit-chat.

With a colleague from Utrecht University I once discussed that as anthropologists in the field we tend to revisit our childhood, an introspection triggered by a PhD defense. He was fascinated by the cityscapes of South America and related that to his upbringing, while I explained that for me studying the smiths was indeed a revisit to, or rather an accolade of, my youth. As I mentioned in the preface, I grew up with stories about stainless steel, about flatbed rolls, about plaiting and polishing—in short, a youth in steel. Casting came in later, called precision casting, which was done in the same factory for small objects though not in brass or bronze, but in stainless steel. So when I turned toward the smiths in Kapsiki, it was a walk down memory lane, and I always felt immediately at home in the smithies. I entered Kapsiki society as a *melu*, for various reasons. First, my aim was a general ethnography of the Kapsiki, which cannot be done from a smith identity. Second, my entry followed the links of the mission, in my case the Catholic mission in Sir, who guided me to Teri Puwe in Mogode, the ward chief of the Camp de Mission. He became my adopted father, and he remained a crucial informer as the great authority on Kapsiki traditional history; so I became an *ngace*, a *melu*, and a smith friend. But throughout my fieldwork, coming into the smithy still gives me a gentle thrill, which I cherish. In the smithy I feel part of the deep technological history of this world, part of a craft that shaped humanity, a witness of the mystery of metal.

Of course I tried my hand at forging, but real apprenticeship was not on the agenda, and anyway would not fit my identity as a *melu*. However, I did pick up enough smithing skill to practice it with my anthropology students. For years when I taught at Utrecht University, I organized a yearly excursion with the students of "Anthropology 101" to the Afrika Museum at Berg en Dal, Netherlands. The apogee of the excursion was "African smithing" in a Dogon smithy,[1] in the open-air part of the museum. Here we tried to make an iron piece, usually an arrow point. I counted myself successful when we fabricated a single arrowhead after hours of banging with umpteen students! It gave the students some respect for "low tech," a good experience for a computer generation. They appreciated it, especially the time when we were overly enthusiastic with the fire and the roof of the smithy went up in flames. In vain I tried to douse the fire from below, but the fire brigade had to come in and take over. No student that went on that trip

ever forgot it; but still it was, for some odd reason, the last time we went to the Afrika Museum. I recently dared to go back, and they have forgiven me. Not forgotten!

INSIDE THE FORGE

The smithy is not an imposing structure, just a low, rather wide hut with a sloppy roof, rather unprepossessing. The two entrances are low—one has to duck when entering—and most old smithies had no window openings. New smithies tend to be higher, more open, and easily accessible, and sometimes a smith sets up shop at the roadside under a straw roof only, but then as a dependence of his real smithy. The basic plan of the smithy is shown in map 6.

Forging is done sitting, and the main seat is just left of the entrance, a slab of stone with the patina of generations of smith bottoms. The oven itself is a low mud wall in U-shape, open toward the blacksmith, with an air duct coming in through a small opening low on the other side. The

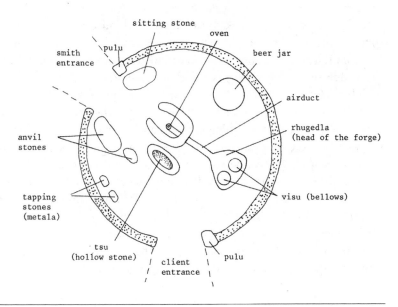

Map 6. Plan of a smithy

bellows, two pots set into the "head of the forge" (*rhu gedla*) with goatskin bellows tied to them, make for a flow of air into the fire. A large jar, of the type *wuta* (the largest beer jar), stores the water needed. The rest of the furniture are stones: a hollow one (*tsu*),[2] in fact an old grind mortar, filled with some muddy water lies right next to the forge and serves to temper the hot iron. Directly in front of the smith are the anvil stones. The Kapsiki traditionally use no iron anvil, as their volcanic stone is hard enough and quite unbreakable. Two smaller stones, *metala*, are used as massive hammerstones whenever two rods of iron have to be forged into one.

Forging iron begins with a customer who wants a tool, as traditionally blacksmiths work on request, not for the market. The customer, usually someone from the ward the blacksmith knows well, comes with a basket of charcoal and some iron bars. The client often stays at the bellows, called *visu* ("blow," both of the mouth and the bellows) and assists the blacksmith when two bars have to be joined, which demands heavy pounding with a large stone. When he has ordered a hoe or a sickle, the client may stay and assist; for small items, such as medicine vials or bracelets, which take relatively much work, the bellows are manned by an apprentice, or the wife of the smith, and the client simply comes back later when the object is finished.

The blacksmith has a limited toolkit at his disposal; the most important tool is his oval-shaped hammer, *ndevele*,[3] an item that is highly prized by the craftsmen, inherited through the generations. A pair of tongs is indispensable, often made by the blacksmith himself, and called *meke*, like the ground squirrel, the hero of the folk tales. A poker, called *metekekumu*, completes his toolkit. Modern-shaped hammers are also beginning to appear, but often as an addition to the *ndevele*, as well as iron anvils. Figure 10 shows Cewuve with his *ndevele* at his feet, the tongs and poker inside the forge.

When a client orders, say a hoe, his wife brews white beer, for the two men have to "eat" well; blacksmithing is a hard and sweaty job, and no blacksmith will work without a steady flow of beer. The smith pours the first beer on the oven, *wusu shala ta d'a* (the stuff for my god) and both drink and resume the hot job. The exigencies of iron handling make for considerable homogeneity in the various activities within the smithy: heating, hammering, reheating, more hammering, forced cooling in the muddy water of the *tsu*, sharpening the cutting edges on the stones—the basic procedures are quite alike for all smiths in the region. They follow the material, and the good blacksmith "has a feel for iron." But specific techniques are used for special products.

Cewuve makes a *jaŋate*, a fire iron, for a neighbor. Most of the work is forging the tool blank into a thin oblong shape, of which 15 centimeters is cut off and

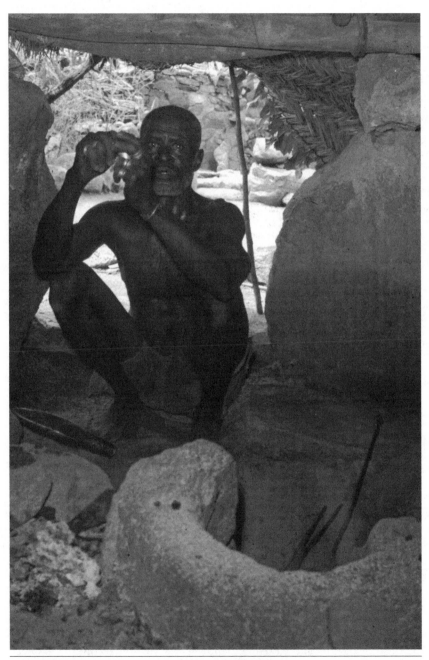

Figure 10. Cewuve at his forge, with hammer, tongs, and poker

curved into a U-shape. As it is the iron to make fire with, it has to undergo a special treatment. Instead of cooling the iron in water—which would make "the fire go out of the iron"—it is covered with iron filings, and heated intensely for a last time in the forge. Cewuve then buries it in the sand, letting it cool down very slowly, "to preserve the fire in it." If done slowly, the fire will "come out" when struck with a flint. Cewuve himself has a *jaɲate*, also called *tsurhwu*, to heat the fire in the forge.

So for the Kapsiki, making fire is a potential quality of iron, one that reciprocates its own genesis from the fire—the material reproduces its origin. The usual production of a smith consists of hoes, knives, sickles, adzes, axes, and spear heads, objects not overly complicated to make because the basic iron supply, the tool blank or *duburu*, is exactly geared to these types of objects: one *duburu*, one sickle. The small objects are most difficult to produce: pincers, needles, bracelets, medicine vials, arrow points, and iron pearls. For these objects, the blacksmith has to render the *duburu* into a long, thin, wirelike piece of iron and then hammer this out into a thin surface that can be bent over into a vial, or twisted into a torque shape, such as for bracelets. For large objects like throwing knives, *duburu* have to be welded, demanding the assistance of the client, who hammers at full force with a large stone. With the modern scrap iron that today forms the bulk of the raw material this welding is often not possible, as most of the scrap is a variety of alloys. So the smiths now use more chisels than in the past.

Of course, some blacksmiths are more proficient than others, and they tend to work for the market, producing their own charcoal and furnishing their own iron. Making a stock of agricultural implements is usually profitable, as the Kapsiki tend to check their cultivation tool kit more or less at the first rain; so at the start of the rains, there is a large demand for smith products. These blacksmiths engage in hardly any agriculture themselves, while others work only occasionally, on demand, and tend their fields like their covillagers. In addition, the market-oriented smiths are continually looking for new techniques in blacksmithing, adding new hammers and tongs of varying sizes. The main area of innovation, however, is the bellows, as the traditional cup-shaped bellows with just a piece of goatskin attached are not very efficient. Gradually, with the more professional craftsmen, these bellows are being replaced by a more sophisticated goatskin bellows, one that can be opened and closed. Recently, a new air-flow technique has been introduced, featuring a fan driven by a bicycle wheel. With these smiths, no longer do the *duburu* furnish the iron, but the omnipresent parts of stranded cars now provide African blacksmiths with iron all through the

continent, albeit—according to the blacksmiths—iron of a lower quality. Another important source of iron are the rods for concrete reinforcement, very much sought after for digging iron and other heavy-duty tools. The complaint by smiths that the car iron is of lower quality than the old *dub-uru* is just as widespread as the use of the car wrecks. In the 1960s and 1970s, some blacksmiths went back to the traditional iron when making high-quality products. But the concrete iron rods now provide a viable and easy alternative.

IRON AND SURVIVAL

Many African societies with iron technology both smelt and forge iron, and the prime attention both in the literature and in symbolism focuses on smelting. So the Kapsiki situation seems slightly unusual, as here the metallurgy is dominated by the forge, not the furnace. However, viewing other major concentrations of iron production, such as the Bassar and Banjeli,[4] more African societies must have known a similar dependence upon an outside source of raw iron and just have—or mainly have—blacksmiths who forge and do not smelt. Archaeologists are understandably fascinated by African iron smelting, considering its very early start, but this focus on the furnace may well put the forge in the shade. So, in a way, this treatise on the Kapsiki blacksmith aims at redressing a bias in the literature, installing the forging smith in his proper place in society; even if the symbolism of the forge is nowhere near the level of that of the furnace, the symbolism and ritual functions of the forging smith are vast and pervasive, as we shall see. It seems as if the clustering of specializations is much more prominent among "smiths of the forge" than among "smiths of the furnace," so the cultural significance of the forgers counterbalances the technological brilliance of the African iron producers.

Be that as it may, the Kapsiki/Higi draw a hard and fast distinction between the people who smelt and the ones who forge iron. The first are the "people of Sukur," as according to the Kapsiki, "all the people of Sukur smelt iron," which makes it not a smith occupation at all for the Kapsiki, *melu* being numerically dominant, also in Sukur. It might be the former Kapsiki dependence on Sukur iron that makes them dissociate the smelting of iron so clearly from the work of the blacksmith. It is from Sukur that the raw iron originated, both in the form of blooms straight out of the furnace and as *duburu*, the iron staves that formed the raw material

for most blacksmiths. The Kapsiki blacksmiths themselves also transformed the blooms into *duburu*. The very fact that Sukur provided the metal essential for survival may have generated some discourse on ritual supremacy, which led to the erroneous notion that Sukur must have been a major political center,[5] a hypothesis laid to rest through the researches of David and Sterner.[6] Yet in the realm of ritual (for example, installation of a new chief), of smith provenance, and of general respect, Sukur retained its special position rather well. Now that scrap iron is everywhere and smelting is no longer performed, that prominence has eroded; but in matters pertaining to ritual, Sukur still comes in as a good second after Gudur. So here we will look into those products the Kapsiki/Higi blacksmiths fabricated out of half-products, sometimes from bloom, but more often from *duburu*.

Iron products come in four categories[7]: agricultural tools, weapons, clothing and decoration, and religious objects. A new development among the tools is the digging iron, made from a rod of concrete iron; a shorter digging iron, shafted on a pole and called *jala*, is more traditional.

The tool kit made by a Kapsiki blacksmith contains for instance the following items:

Wudʼu—hoe, with a special lexeme, *deɓe*, for a hoe that is worn out, and
　tleregwa, a small hoe to sow sorghum

tsiyε—ax, with *dzeŋeru* as a small pickax, and *hwete*, a sickle

hwa—knife, *hwa kwatla rhu kaŋka* (cut-a-chicken knife) kitchen knife with
　wooden handle, also called *vεra*, and a special knife for old men, the *hwa*
　rhu, an all-iron knife with a round headlike handle. Smaller instruments are
　mpidʼi, a razor, as well as needles (*mentiyε*) and pincers (*muntiɓu*). Furthermore, the chief smith has a *vu*, a small smith knife to operate on a corpse,
　plus a special needle to sow the death gown of the deceased.

Weapons have been crucial in Kapsiki history, as mentioned. Essentially, the weaponry of the Kapsiki is of the bow-and-arrow type, fitting a nonequestrian warfare. So besides the iron objects listed below, the Kapsiki had a

Figure 11. The tool blank, *duburu*

bow, poison for their arrows, a leather shield, and a wooden club (mainly for in-village fighting). All of these were in principle smiths' products, though not necessarily of the blacksmith. Characteristic for the region, among the iron weapons, are the throwing knives, among the most spectacular African weapons. They come in two shapes, several F shapes, and a three-quarter circle with point, respectively *ŋgalɛwa*, *ŋgerepa*, and *kwaderekwa*. A fourth shape is the *kwadzarakawa*, a long, straight knife. The name "throwing knife" is debatable, as Westerdijk already showed;[8] they are not thrown in battle, but are slashing knives in war and bush knives—against serpents, for instance—in peace. The Kapsiki simply laughed at the notion of throwing these knives: "Much too expensive."

Crucial items for war were the barbed poisoned arrows (poison is only used against the Fulbe and in wars with nonrelated villages), while spearheads are hooked or barbed. Swords have been introduced, not so much for war as for dancing; after all, swords are essentially Fulbe weapons, adopted by the Kapsiki after the slave-raiding years, and Kapsiki smiths fabricate them only occasionally.

The Kapsiki have two kinds of clubs, used mainly for fighting between related villages or when the village fights between its opposing halves as they are meant to stun, not to kill. The wooden ones are also used for the communal hunt, while the iron club, *geta lɛ*, is for fighting.

The third category of iron objects, decoration and attire, is mainly for women, especially girls' pubic covering. By far the most important item of iron clothing is the *livu*, the iron skirt worn by the brides at their first wedding. This highly symbolic bridal outfit is also important in mourning the dead. The *livu* skirt is in fact a series of chains, tied onto a rope or leather strap. Some of the small cache-sexes worn by girls are just that as well, a few iron chains, or a string of empty medicine holders. Most decoration is brass, but some iron bracelets adorn feminine wrists, while in the dances of the harvest rituals, *la*, the bridegroom wears the *hwahwa*, the rattling iron at his ankles.

THE POWER OF IRON

Iron is both wealth and power, and our fourth category of iron objects embodies that notion. Though the main expression of Kapsiki wealth is in cattle,[9] iron has a role to play. Some of the women's bracelets are just that, iron, and as such an indication of wealth. Limited-purpose money in the

form of iron bars, both large and small, used to circulate in Kapsiki society, and in a way still does. As elsewhere in Africa,[10] iron is associated with power, in this case the power of the patriline. In the segmentary organization of Kapsiki villages, the accumulation of power is quite limited, but it is still discernible. A village chief, *maze*, at his installation receives a chief's bracelet, *takase maze*, with three medicine chambers in it, while in some villages—for example, Mogode—he also receives after his formal installation a bifurcated wooden staff with three iron rings (*geta meleme*, staff of the village), reputedly stemming from the chief of Sukur. The staff, kept hidden most of the time, can be read as an expression of the gentle dependence some Kapsiki villages felt on the chiefdom of Sukur, and especially on its iron. Though it cannot be construed as a sign of political domination of Sukur over adjoining areas,[11] for the Kapsiki the "village staff" symbolized both the power of the chieftaincy and its legitimization by a ritual authority from beyond the Kapsiki area. Thus again, iron objects are used mainly in the transfer of power, the transformation of an individual Kapsiki into an officeholder—in fact, into a public person. Any Kapsiki headman is expected to become a quite different personality when he becomes a *maze*.[12]

Power always has a religious aspect, and iron objects are used in rituals more than any other material. It is mainly the rites of passage that display iron items, and especially the first wedding; the bridal transformation to full femininity is replete with iron. The bridal skirt is the core iron element of the marriage ritual, but the *duburu* are still used ceremonially in bride-wealth payments. During the wedding rituals, the groom's mother's brothers make a collection of money, but some *duburu* should also be part of the presentation. Some miniature bars should also be added, small iron strips just 7–9 centimeters long. According to informants, both the large and the miniature bars had in former times a wider economic relevance, but to what extent iron was used as money is difficult to establish.

Though the boy initiates, *gwela*, have a closer relation with brass, they do have an iron-tipped lance on which an iron bell dangles. These two objects also link the boy with the bride. Leaving his parental house, the boy takes his lance and bell for the first time, a moment called *wume gwela* (to "marry the young boy"; as a verb *wume* means "to mature" and also describes paying the bridewealth). When all boys put their lances together just before performing their main "tests" of masculinity (jumping a ditch, pulling themselves up by their arms), again the term *wume gwela* is used. The same holds for the moment when the *gwela* is offered a calabash with ritual food in which a large iron bracelet is hidden, *takase kwasa rhwempe* (bracelet to drink the sauce), a symbolic hint that he has to marry.

Not all transformations are engineered with iron. Burial is an exception, a transition for which, by the way, the smiths are responsible. Smiths are more central to burial than to any other ritual complex in Kapsiki culture, and their part in these proceedings is dominant. In burial, however, iron is notably absent in the ritual. Though the mourning nonsmith men may dance with swords, spears, or long knives—and the women always dance with their iron skirt—the corpse is dressed with all kinds of adornments except iron. Sashes, scarves, porcupine quills, grasses, and occasional cows' tails may adorn the head of the well-dressed corpse, but no iron objects. The intricate clothing must hold itself in place, and pins or needles may never be used. Although the chief smith dressing the corpse uses an iron sewing needle, the corpse, man or woman, carries no iron implement or ornament. Similarly with the digging of the grave: to dig the burial chamber in the stony ground, iron-tipped implements such as digging sticks, hoes, and adzes are used. Once the grave is complete, their wooden handles are left behind on the pile of earth after careful removal of all iron tips and blades.

Only once during the actual burial is iron used. When the corpse is half-entered into the chamber, the chief smith in charge of the burial cuts some fibers from the cord that keeps the corpse's jaw in place and ties these to an iron bracelet (*takase kwetere*) the deceased's sister has given him. He then puts the corpse in its proper position in the chamber, and, emerging himself from the tomb, touches the left shoulders of the mourning family members with this *takase* and fibers. They throw some earth in the tomb and leave the burial site. The next morning he returns the *takase* to the deceased's sister.

Not only transitions but also the fragile balance of health is protected and restored with the help of iron implements. The birth of children, in particular, and the risks and dangers to the parents are protected by iron, but then connected to medicine. Most medicines of the Kapsiki have to be stored in an iron holder, *mblaza*, or a bracelet, *takase*, which are or contain a small pocket for the medicine in question. Brass holders, on the other hand, though also smith products, are never used for medicine, only as ornament. The iron *mblaza* contain mainly medicines that protect against witchcraft, miscarriage, and any curses that others may hope to inflict. Men and women wear them at their waists under their clothes. One *mblaza* is not even a container, but a visual symbol in itself. If groom and bride are too close kin for comfort—that is, part of the same clan but of different lineages—or if they are second cousins,[13] a *mblaza kwamanehe menu* is made, a "bracelet to separate close kinsmen," in order to avoid bad luck for their offspring. Its symbolism is quite straightforward: the object expresses two people that are kinsmen but very close.

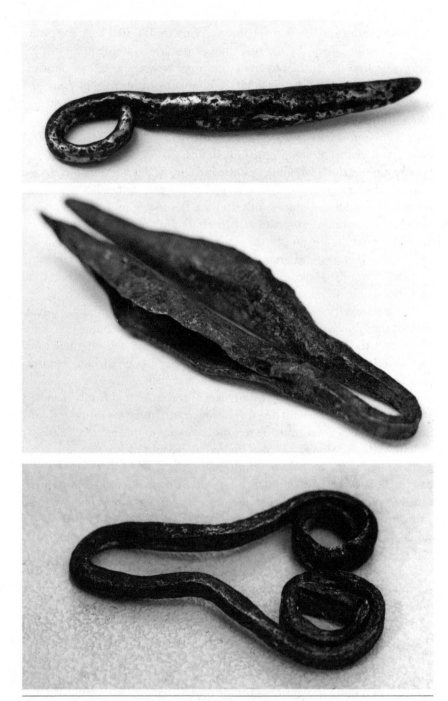

Figure 12. Types of *mblaza*: regular, double, to separate kin

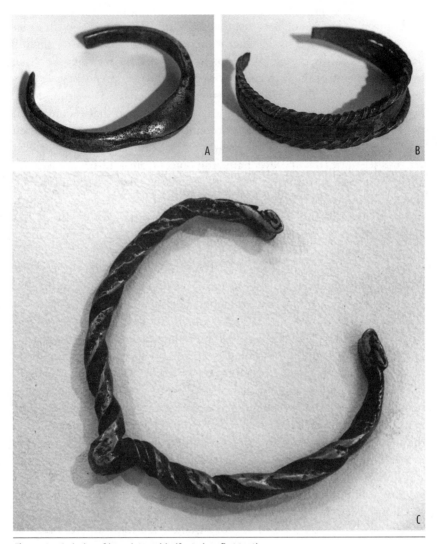

Figure 13. A choice of bracelets: midwife, twins, first tooth

Iron bracelets with medicines often indicate special abilities and powers: a midwife carries a *takase* containing a piece of a dog's placenta (figure 13a); a smith woman's bracelet holds the collection of herbs that enables her to "dig out objects"; the parents of a twin wear a special bracelet (figure 13b), as does any young mother after a breech birth or when a child gets its first teeth in the upper jaw (*takase tlene pelɛ rhu*, figure 13c). In fact, almost any danger connected with birth or children is averted either by medicines

held in iron or by iron objects themselves. With their system of birth-order names,[14] the Kapsiki consider one of their offspring (the fifth) as slightly dangerous, both for the child and for its parents, so a *takase kwetere* (the birth-order name of the fifth child) is worn till the next pregnancy.

It is, however, the "small medicine" that is encased in iron. *Rhwɛ* (a generic term for any medico-magical object or stuff) that is considered truly "large" is of a different sort, not embedded in iron and most often not worn. For instance, special "great medicine" offers protection against war and when worn will prevent any iron object from entering the wearer's body. Both protection against sorcery (*beshɛŋu*, clearly distinguished in Kapsiki from witchcraft, *mete*) and the use of *beshɛŋu*—at least according to the stories told about the latter—involve no iron objects,[15] but are stored in cattle horns, leather, or pottery. Sometimes the medicine is simply wrapped in leather, also a smith job.

For some time already, since the 1990s and increasingly in this century, the Kapsiki blacksmiths have been giving way to urban iron production. Both can be called traditional industries, but the urban one has gained a clear competitive advantage, as David and Robertson have shown for the Mafa smiths.[16] The local blacksmiths in the mountain villages simply cannot compete with the more professionalized and specialized urban setup. Most villages do still have their forge and the blacksmith who attends it, but his work is more limited than it used to be. Standard equipment as hoes, adzes, axes, and the many sorts of knives are bought cheaper at the market, where the merchants sell the urban products, than commanded at the local forge. However, for the objects described above—the medicine holders, the special bracelets, and the ritual objects—the local blacksmith is still the obvious venue. This, however, only occasionally gives him work to do, and he needs just a small fire, without much assistance. The rainy season sees him busier, as he has to repair torn hoes and blunt axes on the spot, and fit new handles to the tools. For instance, the forge where the ritual crop protection is done stands idle during most of the year. The blacksmith Mbekewe, who was in charge of that ritual, had no children, so his nephew Dzule now tends the forge, but only during the wet season. In fact, he belongs to the wrong clan, *makwiyɛ* instead of *ŋacɛ*, but until the latter have their own smith again, he will perform the needed ritual. The medicine for the ritual is still there, anyway. A young *ŋacɛ smith* lives close by, performing his bout as apprentice. Shortly he will take over, and Dzule will build his own forge. But it will never be a full-time job for him; he cultivates and makes much more money playing drums at funerals than forging, and as a leatherworker making sandals.

In the opening of this chapter we saw the forge as an object of communal interest, but it is still one blacksmith family that runs it; without them, the forge stands empty. Even if they are the "children of the village," the other "children" have no rights to their forge. In Mogode, for instance, at least three forges are temporarily abandoned. The beams of their roofs are used elsewhere, and the low wall quickly is overgrown with long grasses, rendering them invisible within a few years. Yet for the Kapsiki this situation can quickly be turned around. For instance, the forge where we saw Cewuve work now is abandoned. His son died young, just some five years ago, and one little boy remains, Cewuve's grandson, who still has to learn the trade. His mother has carefully removed the tools of the trade from the forge, keeping the hammer, tongs, bellows, and poker in good condition until he becomes an apprentice at another forge. These tools are much more valuable than the building itself, which can easily be rebuilt; it just takes a working party. Or not, if he decides not to take up the job.

LEATHERWORK

Anybody can do leatherwork, but the smiths must work with leather for some of their products. Sacks of various formats, for a woman or to load a donkey with, and a skin to sit on form the everyday products. The traditional clothing used goatskins for male clothing, baby slings, and sheep skins worn at the left side (*dleke*), but those have disappeared for over a generation. These items of clothing were made by anyone needing them, but usually by an old man who knew how to handle skins. Usually the leather was only lightly tanned. The goatskin baby slings for a first marriage were part of the marriage proceedings,[17] but were replaced first by cloth replicas of these slings and later by the pan-African towels and cotton cloths.

Tanning can be done by anyone, so any bride's father can make the sling for her first baby. Likewise, anyone can make goatskin trousers, the standard traditional male attire. Though not worn in daily life any longer, they are still in evidence in initiation, when the boys "tie on the skin"—that is, wear these pants of old during the weeks of their *gwela* period. The end of their liminal time is signaled, among other things, by a change in leather: ousting their old goatskin pants, they put on new ones, preferably of antelope skin, for their coming home from the bush during their reintegration rituals.

Rites of passage also generate other leather products. The *makwa*, brides, wear a leather belt that their helpers make from the hide of the bull their

groom has slaughtered; the *gwela* of Wula Karantchi sometimes carry a plaited leather whip.[18] Leather is used in several pubic coverings, either in straps between the women's legs or covered by some brass or copper in the cache-sexes that has become iconic for traditional Kapsiki female clothing. Not only any brass covering is of course smiths' work, but any special work with leather, such as the *mblaza* strings, is for them. Most of the special leatherwork for the smiths, however, is in weapons or medicine. Knives and swords are sheathed, and making sheaths is not a specialized skill, but one that any blacksmith has to master if he is to sell his knives on the market. Sheaths for large blades are more difficult to make, but so are the blades themselves, so few blacksmiths venture here. Handles of swords often are made of plaited straps of leather, sometimes interspersed with strands of plastic. Throwing knives, the other large arms, usually have a leather handle, but these are seldom complicated. Much more intricate are the coverings of the real *rhwɛ*, medicines. The iron *mblaza* may be worn on a belt or kept uncovered in a sack, but if they are more "heavy," more potent, a leather covering is called for. This is not sheathing but a covering of knotted leather straps, *katsa rhwɛ*, covering the medicine, forming a leather basket around the medicine holders that adds to the power of the object. Not all medicines are contained in iron: the larger ones use horns, and these display the most intricate "leather basketry."

For a *baŋwa*, a protective medicine, one has to invite a smith to do or repair the leather covering, preferably a smith from another village, to keep the secret. On the whole, for other leather products the Kapsiki rely on the much more skilled Fulbe leatherworkers, residing in the cities, such as Maroua; their leatherworkers are the real specialists in "covering the *rhwɛ*."

POTTERY

Until now I have spoken only of men's work, but smith women have their own work and specializations, which are not distributed according to the threefold grouping of *rerhɛ* men. They all make pottery; in fact, as in most of the Mandara Mountains, pottery in Kapsiki society is an exclusively *rerhɛ* women's task. Among this pottery, most of which is of daily household use, are also the ritual pots men use in performing their offerings and sacrifices, pots that they receive in their first form during initiation. The smith women make these on demand. In addition, most *rerhɛ* women have one or more medicinal specializations. All but one of these involve cures for

children's diseases, ranging from the treatment of "fever" to small operations on the child's anus. The one other cure is *kwantedewushi*, "the digging out of things," a technique to remove assumed objects from a patient's body.

Pottery is made without a wheel, the main instrument of the women being the *ndaderhweme*, a piece of wood hollowed out at both ends, in two different ways—in fact, the mold for the pots (see figure 7). Potters work mainly on request, but some produce larger quantities to sell at the market. At the waterholes on the plateau, clay is easily available and soft enough for the coiling technique the Kapsiki use. As the production is never very large, burning is done by heaping straw, some small wood chips, and a little bit of cow dung—for blackening—on the pots and firing it. Neither the making nor the burning is ritualized. In fact, only the making of the *mele*, the sacrificial jar that is at the heart of Kapsiki religious practice, has ritual overtones.

A man—*melu* as well as *rerhe*—has his sacrificial jar made when one of his parents dies, and it serves as the point of address for that parent, and thus for *shala*, the personal god.[19] Before that time one has another type of *mele*, usually a flint stone the size of a fist. Boys get such a stone from their fathers, girls from their mothers, and during initiation the boys get a proper *mele*. As with any pottery, it is the smith women who make the *mele*. One simply orders one made, with the specifications (there are various types of *mele*). When ready, the smith woman gets a fistful of sorghum flour, mixes it with water, and pours the mix on the jar with the words: "Let everyone be healthy," a rite also called *batle mele*, the same as a sacrifice proper. Later the client has to give a large bowl of millet flour to the smith woman; if he forgets it, she will harass him at his home, claiming that she is "so very hungry"; she should also be invited during the first use of the jar, at the end of the funeral rites, when it is inaugurated as a sacrificial jar. Compared to the pottery of neighboring groups, Kapsiki pots are undecorated; only the *mele* refers to a person, but then more to his sacrificial jar than to him personally.[20]

Kapsiki pottery comes in five types: large beer vats, a series of beer jars, cooking bowls, meat bowls, and a large variety of vases. The largest pottery—and most difficult to make because of their size—are the beer vats, both the *derhwete*, the large cooking vat, and the *wuta*, the largest of all, which is dug into the earth, used for storing the beer. The *wuta* is also ritually important, being home of some revenge magic. Not all *rerhe* women know how to make a *wuta*, so among the potter women it is a sign of mastership if one can make such a large vat well. At present both the *wuta* and the *derhwete* are gradually being ousted by the imported iron 200-liter drums, which can serve both for storage and as cooking vats.

Beer jars, which include the *melε*, have the generic name of *rhwelepe tε*, all of them used for brewing the red beer, the ritual drink, *tε*. The beer jars, *rhwelepe tε*, vary in size, but all share the perfect round body with a narrow opening. Those jars made as *melε* have a decoration of earthen cones around the neck, and a gender symbol on the body. Some *melε* have a three-pronged opening—this type of jar is called a *gumeze*—indicating that the owner has killed someone or hunted a special bird. A *rhwelepe* with a wider neck serves for hauling water. With a still larger opening, the jar becomes a *durhwu*, a cooking jar, open enough to allow for stirring the mush, with a smaller variant (*wumbete*), a neat little pot women use to serve their family with the white beer they have brewed (figure 14a).

Meat bowls, *shaga*, are for cooking the sauce—that is, the meat—and are either with or without legs. The three-legged kind is the most characteristic one, *shaga kwacihake*, used by the husband to cook his own meat (figure 14b). For instance, he buys meat at the market, and at home he lights a small fire, cooks the meat in the three-legged bowl, and then calls his wives and gives them sauce. This is often a bone of contention, as the division of meat sauce over his women makes the husband vulnerable to the accusation of favoring one wife over the others, of having a *kwajuni*, a favorite wife. Women cook their meat in a *shaga* without legs; after all, the women command the family hearth with its ubiquitous three stones, so they need no legs on their pots.

Any open vase is called a *helape*, and they come in various forms. The *helape wulekε*, divided in two (figure 14c), may be used in sacrifices, but has a wider array of functions, mainly for small dishes that are not the standard sorghum mush and sauce. The other vases are not divided. A vase with decorations along the rim, the *helape za*, is used for sacrifice as well as for the husband's food. A small vase, *helape kwadεa*, is for minute portions only, in fact for single people. The largest variant—in the form of an enlarged *helape za*—is used in divination. Two *helape* have a specific function. A large one with a cone-shaped opening at the bottom serves as a funnel to fill beer jars; the other has a pierced bottom, a filter for endogenous vinegar.

Pottery has been crucial in Kapsiki life, but is losing its central place, with plastic containers and aluminum cooking pots coming in quickly, as in most of West Africa. Beer-brewing is the clearest example. The many women brewing for the market now cook the beer in large iron drums and bring it to the market in brightly colored plastic vats, which are, after all, lighter, more standardized, and easier to clean, and of course break-proof. Fewer and fewer smith women make pottery these days, and even the demand for pottery that still exists is not fully met. In some villages like Mogode, some

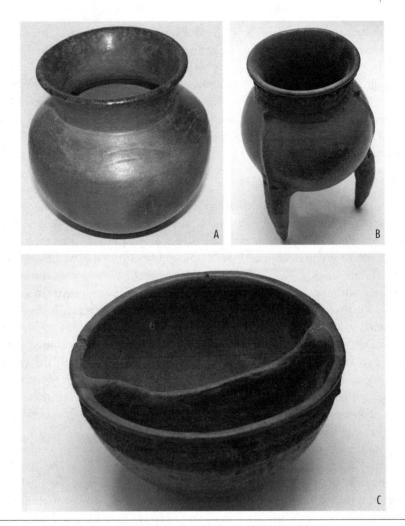

Figure 14. Types of pots: *wumbete, shaga kwacihake,* and *helape wulekɛ*

Mafa potters have also come in, smith women who, like all smiths, easily cross the ethnic boundary that for them has never been very relevant to start with. They fabricate the thin-walled large pots of Mafa tradition, a type that the Kapsiki really like. Beer jars, the standard *rhwelepe*, are the ones that are still in demand, not so much because of the sacrificial jars, but because of a change in brewing. Formerly, the men brewed the *tɛ*, the red beer essential for sacrifices, while the women made *mpedli*, the white variant, the quicker marketable beer.[21] In the 1990s this changed when some women took up red beer brewing for the market and in doing so shortened the procedure,

introduced some improvements in the brewing process, and produced the—tastier—red beer in large quantities. These women usually sell their beer from their homes, advertising by putting a stick with a paper at the roadside. Red beer is best when the last fermentation stage is done inside a *rhwelepe*, so this commercial *tɛ* production creates quite a demand for the narrow-necked jars. When beer, white or red, is brewed for the weekly market day, it is taken to the market in plastic containers, and the classic *wumbete* has become rare.[22]

We started out with the multisensory experience of the forge, and now are into a completely different activity, which is yet somehow closely linked to ironwork, at least by the association of women potters to ironworkers. What senses luxuriate in potting? Shaping clay into usable forms offers a feast for the haptic proclivity of mankind, touch. Humans are uniquely endowed with sensory feeling in their hands—about the only sense in which Homo sapiens stands out among all the animals—and this tactile expertise is reveled in when potting. Getting your hands wet and muddy when feeling the sensuous clay stray from your fingers . . . indeed many potters have described the sensual pleasures of groping with their fingers in the weak, yielding substance. All the greater is the contrast with the firing of the pots, applying intense and prolonged heat to the fragile forms, which then turn into the some of the hardest of all human products: pottery. In the broken form, as shards, they are, in archaeological terms, eternal.

The strong correlation of metalwork with potting probably has more to do with the economics of time and the whole notion of incipient specialization than with sensorial experiences, but the experience of the fire does unite the two skills. Both use fire for a fundamental transformation; the combination of both products, iron and pottery, is absolutely crucial for survival; and together they form the core of what the Kapsiki define as a *rerhɛ*. Even if smiths' cultural position in Kapsiki society is more informed by their work as undertakers, it is the iron-pottery combination that makes these smiths comparable to other cultures and gives them their unique place in the cultural history of Africa.

Yellow Wildness

A WOMEN'S CRAFT!

I HAVE KNOWN THE AMSA BRASS CASTERS NOW FOR FORTY YEARS, BUT I never fail to go over and see how they are doing. Our relationship started out with a bell I ordered in 1973 from their husband Puku,[1] the smith who more than anyone else in the Kapsiki has kept the brass casting tradition alive in the Kapsiki area. *Les bronzes Kapsiki*[2] are famous in the tourism in the area, but in fact brass is more important among the southern neighbors of the Kapsiki, among the Bana, Fali, and Vere. Still, brass is very much part of Kapsiki culture, especially in initiation. Puku died in 2007, and since then his two widows, Masi and Kwada, have continued the business, doing very well, actually developing the range of brass products. In order to glean some of the peculiarities of brass, and to introduce a little-known technique that is nevertheless known by specialists all over the world, let us follow the production of one piece, a bracelet, as observed in January 2012.

The first stage is making a wax model; beeswax is what Masi and Kwada use, modeled on a smooth wooden plank, *ndlu visu*, the bed of the cast. When warmed a little, wax is pliable, can be rolled into a thread and molded in any shape, in this case the bracelet. Threads and small dots form the main decorative elements on Kapsiki brasses; a favorite is a small spiral, cut into two halves. This wax model, here mounted already on a clay core, then is gently covered with soft clay, mixed with chopped twigs of *Hibiscus cannabinus* (kenaf, *zhiŋweli*)—the plant the Kapsiki/Higi use to reinforce their adobe granaries—with a few holes to let the wax out and the brass in. Earlier Kwada had explained to me that she had to use the "red" earth because a cast of black earth would break in the fire. Kwada is the more sculptural one of

Figure 15. The wax model and the mold

the two cowives, and she likes the touch of the wax and especially of the wet clay. She is good at model making.

Kwada lets the mold dry for a night together with some other molds she made. The next day her cowidow, Masi, the "fire lady" of the two, softly bakes the mold in a small fire; she is a good judge of temperature, and when the mold blackens, she turns the mold to catch the fluid wax in a tin; beeswax is expensive and hard to come by, and some of it can be reused. Kwada then finishes the mold by attaching a small crucible filled with some pieces of brass at the bottom, the spruce. The mold with the crucible is either dried or, as in our case, hardened over the fire.

Both women then set out to the field, some 400 meters away, where under the shadow of a tree, an open air oven is already the center of attention of a throng of children, always interested in a cast. Kwada has her mold and a pail of water; Masi carries charcoal and a shard with glowing embers. Male casters use a fire iron, but women are more practical: there are always the remains of a fire in the house. Masi charges the furnace with charcoal, and ties the bellows' skins to the pots, lights the fire with some embers, and sets the mold in it upright with the crucible containing the brass fragments at the bottom. Kwada starts the rhythmic bellows beat that characterizes a good smith. Within a quarter of an hour the temperature has risen enough to produce a red glow of the crucible, but Masi needs a higher temperature still. She covers the fire with straw, and Kwada increases the stream of air. The crucible turns yellow and with her *meke*, the same tongs an iron smith uses, Kwada takes the mold, by now containing molten brass, out of the fire.

In one smooth movement she turns it upside down; at one end some metal pours out, and she quickly fills the hole with wet clay. Removing the glowing mold from the furnace, she carefully sprinkles water over it to cool it slowly, then breaks open the mold and sprinkles water over the cast before submerging it in water. After breaking off the casting cone, she hands the piece to Kwada, who files away irregularities and scrapes the baked clay from the bracelet's interior. The piece is finished.

As in potting, the sense of touch is also paramount in the other metallurgical craft, brass casting. This is a skill requiring a fine touch—a keen eye of course, but especially a soft manipulative touch: the delicate bees-wax has to be molded, rolled out into tiny strings, wound up in minute spirals, cut through meticulously; major forms should have a completely smooth surface and consistent thickness, while small dots have to be applied with great precision. When the wax model is finished, the surrounding clay mantle needs to be put on softly and delicately, assuring an intact wax model yet completely covered with clay. Of course, knowledge about wax, about the proper mix of

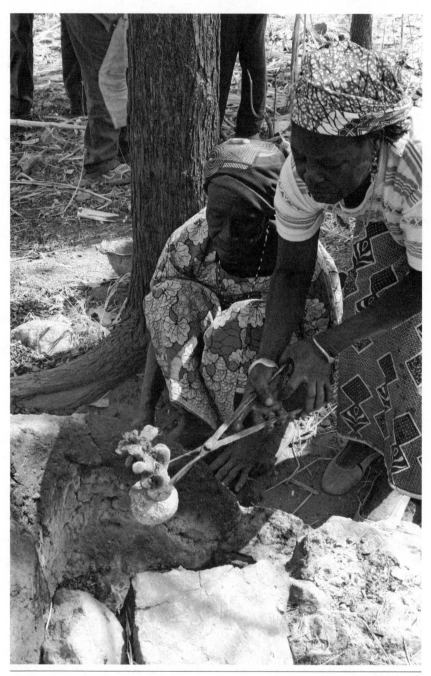

Figure 16. Taking the mold out of the oven

clay and straw to achieve a way out for the air but inaccessible for the molten brass—all that knowledge and experience are required. But the main work, as in blacksmithing, is learned by doing, by making mistakes, and improved only by experimenting. One advantage of casting is that the metal can always be reused, and a miscast is routinely used again in a new cast.

Everywhere the touch is accompanied by the eye, as the molder is continually looking at her wax model; after all, this is a way of casting where one sees, actually and very precisely, the form of the eventual product in wax. The movements are sparse and precise, with the rapid small finger motions that characterize the experienced craftswomen. Finally, the eyes guide the caster in the final phases: the first burning of the cast to melt the wax, and the final heating of the cast in the oven. The smith looks at the color of the underside of the cast, in order to gauge whether the brass is molten: when the underside of the cast, with the brass, shines a fiery yellow-white, the time is right to turn the cast. The rest is almost routine: the hissing sound when the cast is cooled in water, the soft hammering to break the mold away until the rough cast remains. Then the casting cone has to be cut off and sharp edges filed off, until the object is perfect.

BRASS IN KAPSIKI

For the Kapsiki, brass is mainly a show of wealth, something to boast with, as the brass objects are mainly for decoration. Copper is used in its pure form mainly for bracelets, but people prefer the yellow color of brass. Aluminum is also occasionally used for ornaments. In fact, only a limited number of objects are made in brass. They come in three categories: the *wushi fege* (status objects, literally "things to boast about"), women's ornaments, and *wushi geske* (the brasses worn by male initiates—see figure 17d). The first category includes the most expensive and spectacular objects. The largest and most valued of all is the brass sword—actually a short iron knife in a brass sheath. The iron knife is usually not even sharpened, and drawing the small knife from the long sheath is an anticlimax indeed; it is meant to stay inside! Just as rare—and expensive—is the brass chalice. Other objects in this category are the brass pouch, a metal replica of the habitual leather Kapsiki/Higi pouch, and the—more accessible—brass medicine holder. Other such items are the special bracelets, and—for the happy few—a brass pipe and tobacco vial, these two also used during initiation.

Not only wealth is displayed by brass but also beauty, as the second

category consists of women's ornaments. The majority are bracelets, rings, beads, bells, and some other decorations of the following sorts: *takase*, bracelets of various types, rings, *teli wudu* ("navel")—that is, a bell attached to a short shaft, even worn as a girdle of brass bells, as well as a small brass bell called *ŋkwini* (figure 17a). The *jɛpinɛwu* is a special ornament worn by women, also worn on a girdle (figure 17b); finally, two types of lip plugs are made, and brass beads.

But culturally more specific is the third, and for our purposes most revealing, category, consisting of those objects that have to do with initiation. The *gwela*, the male youths undergoing initiation, are decked out in an array of decorative brass objects, the *mnze gwela*. The most distinctive is the *paya*, a small triangular decoration worn on the forehead, plus a broad brass bracelet and an even broader one called the *sebe*. Important for the *gwela* are two types of bells, a larger and a smaller one (figure 17c), plus a brass medicine holder, *mblaza mnze*. One last very crucial and characteristic brass object is a *matlaba*, a four-cornered plaque worn by young assistants of the initiates on their left hip (figure 17d).

The *matlaba* does have a curious shape, which no informant could explain. Two possibilities present themselves. The Kapsiki see the *matlaba* as an equivalent for an os frontalis of a bull; at least when a *matlaba* is lacking, they replace it with that piece of bone. So the shape might reflect the general shape of a skin, either cattle or goat. The second association feeds on this likeness. Early Middle Eastern copper production (twelfth century BCE) used ingots with about the same shape as the *matlaba*, viz a rectangle with elongated corners. These ingots were called "ox hide ingots," and even served as the base for statues of deities.[3] Thus, an association between cattle and the *matlaba* is defendable.

BRASS AND THE BUSH

This last type of brass suggests that brass objects can be more than just visually pleasing or advertisements of one's wealth, as it also holds a position in the Kapsiki/Higi worldview. Iron, after all, has a strong association with the village, with the fertility of women, with permanence, and with the authority of the patrilineage. The forge is central in the village, a public place where people meet, have their hoes repaired, and chat and watch the blacksmith perform his fascinating work. Iron is for war and women, for brides who should not leave the village, and for the men who like to think

Figure 17. ŋ kwini, jɛ pinɛ wu, bell, *matlaba*, brass phial

they command them; thus, iron is indispensable in the scheme of Kapsiki values. Brass is a quite different matter. First, it is used in the form of status objects by those who wish to distinguish themselves from their peers. The same holds to some extent for women: brass is the preferred metal for ornaments for adult women, for those who are no longer brides and who wander and adorn themselves at their own sweet will.

Let us have another look at the ornaments of the *gwela*, as they do give us some view on the "message of brass," crucial as the brass objects are to deck out these youths undergoing initiation. It is after they have been separated from their kinsmen during the first phase of the initiation that they start to wear brass bracelets and the other paraphernalia noted above. During their initiation, they are "like bees," roaming everywhere in the bush. Decorated with brass and armed with spears, they accost strangers coming into town and ask for a contribution to their beer fund. Thus, the main association of the *gwela* is with the bush, *gamba*, the wild and uncultivated environment where wild animals live (or rather lived, for most have been hunted out), where enemies lurk (-ed), and where *gwela* have to roam each night from the first month of their initiation (April) until their festive reintegration with the village at the end of the cultivation season (December).

This notion is strengthened by other items of their outfit, as not only brass decorates the boys; they also wear cowrie girdles, grass head decoration, rooster feathers, strips of a palm (*peha*, cf. *Phoenix reclinata*), and necklaces of red glass beads or other beads, and are armed with lances and shields. A special headdress with rooster feathers singles them out as future compound chiefs (the *ŋulu rhɛ*, the main rooster of the compound, is an important symbol in Kapsiki/Higi religion), their other decoration as rich men and successful warriors.[4] They are masters of the bush, and it is only fitting that they wear the most special brass accoutrements. These signal wealth, success in hunting and war, and an ostentatious presence. In ritual and especially in individual magic, both protective and aggressive, the effectiveness of brass objects is much less than that of iron: for real protection, iron medicine holders should be used, not brass. Interpersonal as well as magical power is associated with iron, not brass.[5]

So brass has an association with wealth and distinguishing oneself from others, but foremost with the bush. Brass is bush matter, just as bees cannot be domesticated (according to the Kapsiki) but live in and from the bush, bringing the riches of the bush home to their hive, which, in Kapsiki, are seldom man-made. So the location of the brass casting furnace is fitting and right: it has to be in the bush, and not in a cultivated field but in a spot never cultivated. The relation of brass to cultivated cereals is fraught with

danger. If, during the process of casting the metal, the smith should come into contact with crops in the fields, that year's crop will not *serhe*, will not be plentiful in the granary. *Serhe* means the chance that one happens to get more than expected; a good *rhwɛ* will give that option, but the brass caster will destroy that chance. Brass makes the harvest "boast" with a false appearance of riches. As a consequence, people who cultivate do not wear brass in the field, although iron rings and bracelets may be worn. Brass does not mix with food. Finally, brass should only be cast during the dry season after the harvest, which happens to fit in nicely with tourism. Actually, this gentle tension between brass and harvest is the reason that in some villages the casting of brass is forbidden, because "it brings famine."

> When Zeme, a smith in Sir, stimulated by the Catholic Mission took up brass casting, the elders of Sir were not too happy, afraid it would harm the harvest. Not so much the harvest in the fields are under threat, but the harvest that is already inside the granary, so Zeme had to do his casting well into the bush, like Puku in Amsa.

On the other hand, the brass caster can be called upon for a ritual to protect against crop theft or crop parasites. Tizhè Tange, a former brass caster from Mogode, stresses the distance brass has to keep from sorghum stalks, but when crops are stolen from the field, it is the brass caster who sacrifices on his jar, compelling the thief to return the stolen goods. Also, if *mcafcɛa*, a specific crop sickness, attacks the sorghum, making it yellowish, it is again the brass caster who has to save the crop. He takes sheep fat, a *manciha* fruit (indigenous "eggplant"), a medicinal onion, cooks this into a sauce, mixes it with *shikwedi* (gombo) and some of the yellow sorghum, and rubs the mixture over some stalks in all affected fields. This is usually done in August, at the heart of the rains, and the mastery of the ritual reputedly stems from Gudur.

Thus, our lady caster Masi insists that all ovens should be in the bush, far from fields and habitation, chosen by the smith but agreed upon by the *ndemara*, the *melu* who is overseeing the smith—as in the case of the forge. Everything is done privately, without an audience. This has a curious consequence: nonsmiths know very little about casting, and in fact have no clue how the casting is done. I came across this the first time my assistant Sunu Luc saw the smiths in Amsa perform their craft. "It cannot be true," he said, "there is something in between! It is not the wax that turns into brass, another metal is involved!" He had just witnessed for the first time in his life the smith of Amsa cast a small shafted bell in brass. Like most nonsmiths,

Sunu had believed the wax was itself transformed into the shining yellow metal the Kapsiki/Higi use for their ornaments. He commented: "Nobody ever sees it, it is always far away in the bush; only tourists and smiths ever see it. We know that they use wax, and we see the objects; we never knew the smith puts in some metal himself." As bees, beeswax, and brass are all called *mnze* in Kapsiki, this misunderstanding is not so strange. What is characteristic is the hidden nature of the process of brass casting; as Sunu mused: "The forge is public, the *mnze* is secret." Maybe not a well-kept secret, but as it is practiced out of sight and by very few specialists, people simply do not know.

Back to our *gwela*, the boys of the bush. The bush odor of the brass objects is reinforced by the other elements of their accoutrement. When explaining the particular outfit of the *gwela*, the Kapsiki stress that the boy is now the real *katsala*, warrior, and a rich one at that. His goatskin defines him as an adult; the cowrie shells form a general decoration for any festive occasion, even if they lack the specific connotation with money they have farther to the African west. Informants distinguish between brass objects and other decorative elements, singling out especially the *peha* palm[6] and the cowries. There is a persistent story that this part of the outfit came from heaven: at an initiation people told me how during the days of Hwempetla, the village's mythic culture hero, a man fell out of the sky clothed in just cowries and *peha*.

> Here, as a Western anthropologist, I expected to hear how he had taught the Kapsiki about the ornaments, maybe about the whole *gwela*, the start of a splendid myth. But they were much more down to earth: He was dead, of course, for when you fall from the sky, you are quite dead.

Anyway, since then the Kapsiki added both to their initiation outfit. The *peha* bears a connotation of liminality; for instance, twins wear them continuously. The implication is that the brass elements are older than the *peha* or cowries, and that is just what informants confirm. This means that the brass-iron distinction is older than the other decorations. Of course, everything of the past is routinely attributed to Hwempetla, as he is after all the culture hero,[7] but the relative age may be correct. Whether brass objects in the past were made of iron is a disputed topic, but at least for the *matlaba* (see figure 17d) that seems to be the case. First, during my visit to Amsa in 2006—the last time I saw Puku alive—the brass smith showed (and sold) me a very old *matlaba* in iron and explained that it was the older form. My assistant later doubted this and thought the brass

object was older. I am inclined to give the smith credence, also because of a technical consideration: actually, the form of the *matlaba* is very much one that easily results from forging iron bars, while it is hard to cast. In addition, brass objects are an imitation in metal of objects in other materials, such as the wooden tobacco vial, the leather sack, the wooden pipe, and the iron medicine vial, and not the other way around.

In her distribution map of lost-wax casting, Renate Wente-Lukas showed the very uneven diffusion of brass casting in northeastern Nigeria and northern Cameroon.[8] While widely known in the plains south of Lake Chad, it is not practiced in the northern Mandara Mountains, for example, by Lamang, Guduf, or Mafa. The concentration of the craft is to be found along the border, reaching south to the Vere of the Alantika Mountains. The majority of groups in the area do not know the technique (although some may have lost it in earlier times). The southwestern part of the larger Mandara region is inside this diffusion area, from the Kapsiki/Higi south to the Cameroonian Fali just north of Garoua, and to the Bata northwest of Poli. This pattern of distribution has little to do with the availability of ores, as most of the brass is imported from the south, at least as far as the Kapsiki brass smiths know. As for the provenance of the metals needed, copper and zinc, the smiths simply state that they obtain their material "from the south." And they obtain it as an alloy already, in the form of other brass objects, usually from other smiths down south.

Although Wente-Lukas shows the whole Kapsiki/Higi ethnic unit[9] inside the brass casting area, the actual dividing line of the distribution runs through Le Pays Kapsiki. The northeast has few brass casters, while the southwestern part has both iron and brass smiths. Throughout the area iron is far more important economically and ritually than brass, but brass has its place in the ritual palette.

TOURISM

Since the 1970s tourists flock to the heartland of the Mandara Mountains, the Kapsiki plateau, in order to regale their eyes on the beauties of the volcanic landscape with its rugged mountainsides. It is a tourism of the wilds, one of a spectacular scenery with its volcanic plugs, a scenery in which the classic straw-roofed huts of the Kapsiki fit well as the icons of "real Africa." As one of the minor attractions, *les bronzes Kapsiki* are well known on the tourist circuit, a countervailing element to the nature orientation of the

tourist visit.[10] The Kapsiki experience combines a prime photo opportunity with exposure to a traditional society, or at least one described as traditional in tourist handbooks. The Cameroonian Kapsiki villages, mainly Rumsiki, but increasingly other villages that can be accessed from there on a hiking tour, provide traditional flavor, and as such Kapsiki culture has become more than a sideshow in the tourist encounter.

One essential tourist occupation is buying souvenirs, so traditional objects are part and parcel of the tourist experience and are sold in Rumsiki shops and hotels, and by the brass casters themselves. Tourists habitually make a short *sortie* from their hotel to Amsa some 10 kilometers to the south, where the brass smiths of the chapter's opening vignette have cornered the tourist market. They cast on demand, normally on a regular basis with the tour operators acting as mediators. Small groups and individual tourists can easily order a casting, though most visit the smith's compound to buy directly from the producer. Over the years Puku had already diversified a little; for instance he produced more and larger bells. One major "innovation" is a brass statue of radically different style that he used as a showpiece for the tourists and—in vain—tried to convince me was made by his father. He later admitted to buying it when traveling in Foumban in West Cameroon. Though his own production is standardized and little changed from when we first described it in 1973,[11] the Rumsiki trade has diversified and now includes objects made in Maroua and Mubi. Even if still on a very small scale, Rumsiki now offers the experienced tourist some objects that fall into the category of "airport art."[12]

Puku died in 2007. As described in the opening vignette, his wives, Masi and Kwada, have taken up the craft as they have no sons. Moreover, two sister's sons of Puku are determined to learn the technique and eventually establish themselves as casters; after all, the steady stream of tourists guarantees good cash income, in addition to the internal Kapsiki market. Both widows have established themselves as able casters and are in the process of diversifying the objects for the tourist market, ready also to take on some new forms; one of them is a miniature cooking pot, another a brass calabash. They also have reintroduced old Kapsiki objects of some renown, such as a brass cup, and for the first time in a long time made a *matlaba* (figure 17b is their product) and a brass sword. Their authority in casting is evident, viewing the deference paid to them by the younger kinsmen. The commentary of my nonsmith Kapsiki friends was telling: "The blacksmiths have always obeyed their wives." At least, husband and wives routinely cooperate in brass casting, and increasingly do so also in iron forging.

In 2012 each of the wives had developed her own line of brass production,

with some division of labor between them. Kwada seems the better of the two in modeling the wax and producing the mold, while Masi is the master of the forge who judges the color of the cast, seeing when to turn the red-hot mold. Both know their own products well, selling them individually to the tourists. The provenance of their brass itself has not changed, as they use older brass objects and casting rests as the main source of the metal. In fact, when prodded, they are not aware that *mnze* is an alloy; as they buy raw brass coming from the south, in fact they need not be cognizant of the alloy characteristics at all. Their main problem is getting the metal, plus procuring enough wax. Kapsiki country does harbor wild bees, but not nearly enough to furnish the amount of wax needed for casting. So their wax comes from south of the Benue, from Adamawa, the region that also furnishes the much more extensive casting industries in West Cameroon with wax.

Not only have Masi and Kwada somewhat broadened the array of brass products, they also cater more closely to the tourist market, producing some figurines—antelopes and some humans—but also a dancing adze inspired probably by Vere brasses, as well as large pipes and bells and a pointed brass "hat" that is probably modeled after the Fali. Tourism has, as observed elsewhere, preserved some cultural items and processes that might, without tourist interest and revenues, have gone out of fashion.[13] Whether in the case of the Kapsiki/Higi this holds for much more than brass casting is debatable, but at least Amsa—and thus Rumsiki—is secure in brass production. In Guili, the major Bana village to the south of the Kapsiki area, a caster from Daba country has recently set up shop and has transformed his entire household, involving three wives and several daughters, into a brass production unit, turning out a steady stream of brass beads, all for the internal market.[14] So, even if brass may be relatively rare among the *rerhɛ* trades, neither knowledge nor practice is dying out. As long as they are sought after by tourists, brass items will continue to be available to the Kapsiki.

Now, what do the Kapsiki in Rumsiki and Amsa think of tourists? For the brass casters, the presence of the white tourists is a self-evident boon, and Masi and her cowidow make good money out of their presence, and the white clientele are appreciated as good customers. After all, nobody comes all the way to Amsa without buying something. To close this section, a mythical tale addresses the differences between white, Fulbe, and Kapsiki, as told by an old blacksmith who is not a brass caster:

When the mother of *shala* [God] had died, *shala* called for the white, the Fulbe and the Kapsiki.[15] The white man came straight away, the Fulbe one day later,

but the Kapsiki waited till it stopped raining; he sowed his fields first and then showed up, much later. The next day, *shala* gave his ruling on the three: the white man would remain nicely cool in the shadow, enjoying luxury and leisure. A large measure of *ntsehwele* [cunning] will be his. The Fulbe, who came slightly later, will not have that measure of luxury, but will rule over the Kapsiki. He will get the horse, so will not have to work, yet will eat well, with the lance as his symbol. The Kapsiki just gets the hoe handle: he will have to suffer for the other two, who rightfully rule over him. He will have to work in the sun, and "just look with the eyes"—an expression of silent suffering.[16]

The old smith from Rumsiki who told this tale pointed at the hotel in front of us. Long ago his father was buried on the terrain where the hotel now stands, and this son was very pleased: "I do not know what my father has arranged with the white people, but look what a wonderful house the white people have built for him. He has even made the *Nasara* [white people] put up a large fence of *hwulu*[17] [euphorbia]. Even the chief does not have anything remotely like that."

During my research I prided myself on being at home in the smithy, but in researching brass casting I found it hard not to be counted as a tourist. With the brass casters I did feel at home, but that feeling was less clearly reciprocated, and I had difficulties getting through the tourism barrier. Working in Rumsiki and Amsa, I was classified as a tourist first and then had to work through that barrier. The only way was to come back, time and again, but that meant almost inevitably buying things. So my role was that of a regular customer, like a rich Kapsiki. The "fly on the wall" notion was here impossible: I simply had to have some depth in my pockets. And speak Kapsiki.

BRASS IN THE MANDARA MOUNTAINS

As noted at the start of this book, Africa is into iron. Brass comes in at quite some distance, and never has been ecologically as important as iron. The absence of a bronze age still is characteristic. As a consequence, the literature on brass and bronze is a fraction of that on iron,[18] and if the blacksmith used to be underresearched,[19] this holds even more so for brass and brass casting. There are some good reasons for this lesser attention; iron is crucial for survival and imbued with symbolic and ritual importance. The technology of iron smelting is complex and also spectacular. Though lost-wax casting is

a finely tuned and delicate procedure, it generally demands less labor input and organization and was never as industrialized as was iron production, for example, at Sukur.[20] In addition, the casting of cupreous alloys was never as closely or as widely associated with a particular social group or "caste" as ironworking. The notions of pollution, transformation, and endogamy are associated much more with iron than with brass.

The opposition copper-iron is almost embodied in the work of Eugenia Herbert, who wrote a book on copper as well as one on iron in Africa,[21] tracing in both the metallurgical, social, and symbolic implications of these metals. According to Herbert, both metals appear to be "gendered,"[22] which is implied by the metals themselves and their ramifications through and expressions of social distinctions. Iron is a thoroughly sexualized metal, especially in the melting process, but also in the forge, closely linked as it is to "rituals of transformation," meaning transformation of earth and ores as well as transformation of human beings, the rites of passage. Copper elsewhere in Africa has its links with the stages of life.[23] Boys may use copper in puberty rites as indication of their liminal status, or the odd circumcision knife must be exclusively made from copper,[24] but usually it is the girls who wear copper ornaments during their initiation indicating nubility and fertility.[25] Herbert relates this function of copper in marriage rituals to the more general association of copper with wealth and power, exemplified by the enormous amount of copper in grave goods throughout Africa. That element of wealth is present in Kapsiki, but the other symbolic associations of brass are different.

In the two previous chapters we have witnessed the Kapsiki use both metals as vehicles of a symbolic and ritual opposition that is in fact a special case of what one might call the "Herbert thesis." First, the usual association between iron as male and copper as feminine is inverted here, iron being "tied into brides" (or symbolically tying brides), while the association between brass and boys is not related to color but to the provenance of the wax. We saw the amazement of my assistant that there was a metal ore at all and not just the wax that transformed itself, and that is at the basis of the Kapsiki symbolic classification. Second, both metals are included in the ritual oppositions, whereas often in other cultures just iron or copper is targeted as one symbolic medium. Herbert elaborates on the combination of copper and iron in "objects of power," such as swords, highlighting the fact that the combination of the two increases notions of power,[26] but the combination of the two metals in Kapsiki is not about power, but about marriage, the joint coming of age of the new adults in society. Third, the symbolic associations are not tied into color

symbolism,[27] as there are other ways of attributing meaning: the opposition bush-village, as well as the central place of iron in food production and thus in the reproduction of society itself.

All this means that the Kapsiki/Higi case, as a rare variant on the patterns of ascription of meaning to metal, is atypical, and there are historical reasons why this is the case. As the Kapsiki/Higi live at the very edge of the copper diffusion area in West and Central Africa, brass casting has never gained the prominence it has in the coastal areas. Although copper products are found in a wide variety of societies, the spectacular developments of lost-wax casting are found in the more hierarchical and monarchic traditions, with Bamum, Benin, and Oyo as the artistic high points. The craft demands a high expertise, even professionalization, which is not easy to realize in acephalous societies such as the Kapsiki. Second, brass casting among the Kapsiki/Higi cannot be very old, not nearly as old as iron production, which goes back, as MacEachern shows, to the first millennium BCE.[28] The limited archaeological data from Mundur[29] and the DGB sites near Mount Oupay[30] suggest that brass was very unlikely to have been imported into this region before the fifteenth century, and even then in very small quantities. It subsequently found its niche in a culture area where blacksmiths had, we may reasonably infer, already formed a definite subculture and been assigned a crucial and symbolically charged position. The Kapsiki/Higi constitute an instance where the lost-wax casting technique overlaps with a full-blown "transformer pattern" as identified by Sterner and David.[31] The distribution of brass casting among the Kapsiki/Higi confirms the traditions of the brass smiths, which state that the technique is a relative newcomer from the southwest.

Considering this and the Kapsiki tales, my guess—but definitely a guess—would be mid-seventeenth–mid-eighteenth century. As such, it had to fit in with the existing social organization of the *rerhε*, finding a niche as a special if quantitatively unimportant function of one section of the smithing fraternity.[32] The length of occupation of the mountains has been well established by now, not only by archaeological remains in general but also by specialized massive constructions in the area.[33] The ground and polished "Neolithic axes" found in the area constitute another, nonmetallurgical, form of evidence; they are used by the Kapsiki as magical stones to procure health for the village. Thus, in the context of the deep history of the mountain cultures, brass has just recently appeared in this area.[34] Brass casting entered a scene where the main symbolic oppositions were already well in place, stone for deep history, iron for power and fertility. Thus, it occupied a symbolic niche opposite these two, that of bush and wildness, and thus of

male initiation. The relative public ignorance with the casting process and its danger for the collected harvest not only underscores its recent arrival but also enabled the association with free roaming bees to take first place, and so brass, notwithstanding its association with wealth, came to signify the bush.

The Kapsiki/Higi region thus represents a marginal case of brass casting. The techniques used are similar to those of other casting groups, but the exigencies of the lost-wax process are very clear-cut. A comparison of objects shows craft production to be relatively straightforward. Small objects, utensils, and jewelry are made, but no statues, no masks, and no very large pieces, the brass "sword" and the cup being the high point of local technique. Segmentary Kapsiki/Higi society lacks the dynastic traditions that in other groups form a powerful stimulus for figurative casting,[35] and status differences among Kapsiki/Higi are still very limited. This evidently had much to do with the long history of slavery and slave raiding and with the efforts of the Kapsiki to "stay out of history," to keep slave raiders at bay and thus survive the onslaught of the Muslim emirates with which they had to cope.[36]

Yet, marginal objects can be loaded with signification, and thus brass objects still give a touch of wildness to the *gwela*, enhance the beauty of adult women on the move from husband to husband and from village to village, and separate the haves from the have-nots.

CHAPTER 6

Of Whistling Birds and Talking Crabs

WHISTLING IN THE DARK

As the "internal other," the smith is ideally situated to act as an intermediary between the common Kapsiki and the "other world." He forms a ready channel for communication between this world and the "other" one. His social status as a "nonperson" gives him a headstart in divination, a specialization that in the end does give him considerable clout. Even if Kapsiki divination as a craft is not strictly reserved for smiths, they do dominate the scene. The main divination technique in Kapsiki culture is crab divination,[1] which I deal with at length in this chapter. But in order to highlight some crucial aspects of the Kapsiki smiths' involvement with divination, I start with a rare technique that I have not yet seen reported in Africa: the *kwahɛ*, the "whistling bird." And this specific technique is "only for smiths."

Some smiths "live together" with a "bird" that tweaks in the dark, thus answering the questions posed to it by a client. This *kwahɛ* divination is either done at night or during the day in the dark of a hut, in a séance where one only hears the tweaking but sees no bird. The client states his problem, then a distinct but soft tweaking is heard from the far corner of the hut. Kapsiki is a tonal language, with a two-tone lexical system, and in fact the "bird" produces the tonal layer of a sentence, which carries more information than in the case of a nontonal language. The smith then interprets the "bird" tones as a sentence, which is the answer to the question, making for a direct communication in which the client presumably talks directly with the "bird." So the client speaks, the *kwahɛ* tweaks back, and the smith translates the tones into sentences with the same tonal structure. An example of such

a conversation on the problem of infertility shows its main characteristics, which seems like a kind of word-fencing between client and "bird."

K = kwahɛ, as translated by the smith
S = smith speaking for himself
C = client

S: Did you sleep well tonight?
K: Who took the people, what do they come for?
C: I want to speak, I come here for my *makwa* [his son's bride]. She has been married now for three years and still is not pregnant.
K: Many people like you. She has a problem. If you want to solve, you come here for medication. If there is another place, then you go there. I know what ails her. Her problem is the curse and also bad spirits [*gutuli*].
C: Who has cursed her, a mother, a mother's brother? I do not know.
K: The women who is in her house [cowife of mother is often indicated this way].
C: The woman who came to her house.
K: That is the one.
C: Has she cursed her?
K: Yes, she has cursed her.
C: Is it Kwayèngu Deli?
K: Yes it is her.
C: What should I give to Kwayèngu Deli?
K: You must pray to her [K uses a Fulfulde word indicating Muslim prayer]. Give her something, beer, a chicken, whatever.
C: Did her mother curse her on the tomb, like people say?
K: That one does not harm her. What did you say?
S: She has many problems, he says. [The smith explains what the "bird" has said.]
K: People think about you, you understand.
C: I do understand. What do I give her?
K: Give her money.
C: Do I have money? [An African way of negating]
K: God will give it to you.

The session entails more than one question, and the client can bring up any item he deems problematic. The client in this particular session[2] asked for advice on three issues: for a friend who was traveling: was he going to travel well and meet all of his dear ones in good health? [Answer: he would get wherever he wanted, but encounter a minor problem back home]; for a brother who was looking to get a new wife [Answer: he would get one, but

for a short time]; and finally, for his own work [Answer: people were jealous, but only God could help].

The *kwahɛ* is called Kwarumba, the name of the third-born if female, but other *kwahɛ* can have different names and identities, but always female. It is she who calls off the conversation stating that the "word is over" and leaves (according to the smith). As mentioned, the *kwahɛ* is never in sight, and the smith is always between the client and the sack where the bird is supposed to house, made from the fur of a bush cat. During the conversation, the smith pulls the tail of the fur and shakes the sack to stimulate the *kwahɛ*. Before the session the *kwahɛ* has to be called from afar; this time we had to wait fifteen minutes before she "arrived," but then she started immediately. The smith in question is traveling around, a stranger in the village peddling indigenous medicine together with his divination.

This particular *kwahɛ* was very direct with her indications; usually, when it comes to naming persons, divination is reticent about naming specific persons or recognizable relations. This shows in another séance, where the *kwahɛ* is addressed as Masi, the second-born girl. Sunu and his wife Kwafashè want another child; the first son is already five years old.[3] After a long wait, the "bird" makes herself known by a gentle tweaking, and Sunu greets her, chatting about where she has come from (a neighboring village) and how the beer is at the market.

C = client Sunu
K = Kwahɛ Masi

C: I am tired of asking, but she is still not pregnant, that is why I came to you.
K: There is another woman.
C: What other woman?
K: That woman over there.
C: What did she do to her?
K: Wait, I have to consult with god and whatever he tells me I will tell you.
 Also when she will not get pregnant again.
C: I listened.
K: Wait. . . . I have come back. It is about your own wife, isn't it?
C: Yes, my own wife.
K: Another woman did this to you.
C: What other woman? Do I know her?
K: Maybe, I do not know.

C: Will she show herself?
K: It is she who has begotten him or her or her sister, I do not know.
C: Where is that woman now?
K: In our village.
C: Alive or dead?
K: She is dead.
C: What did that woman do to her?
K: Not much.
C: Well, you cannot tell me much, Masi, that is bad. It seems like a curse. Now, what do I have to do, where is that woman? Does she have a brother here?
K: Yes, here in Mogode.
C: She has begotten whom? And who is her brother? Or is it the wife of my brother?
K: It is the woman who is there. And also your wife's brother.

This goes on for some time, the client trying to pinpoint the culprit, while the *kwahɛ* avoids giving a clear identification. The clearest indication is that it concerns a "big woman." Sunu then asks what he can do to lift the—presumed—curse. He is told to take some flour and meat or fish, and give it to that woman. It slowly dawns upon the client that *kwahɛ* might hint at his mother-in-law, whose curse is routinely to be feared; however, he happens to have a quite good relationship with her, and she lives in another village, very much alive. The *kwahɛ* gives detailed instructions about what Sunu's wife Kwafashè has to do: go with sorghum flour to her parents' home, get some fish and sorghum grains from them, buy some meat, grind and mix all in an old woman's house, and then take earth from the middle of the road, return home in the next morning, put some of the mix on her jar, and throw the remainder out of the compound.

C: What if the old woman is not home?
K: She will see an old woman somewhere, anywhere. Does not matter who it is. Any kind of sorghum will do also.

The client then asks about his own troubles with someone in the village he has quarreled with, and gets a recipe to solve that problem, involving a ground cockscomb, which he has to put on his jar, with sorghum from the beer market.

The *kwahɛ* divination is a curious case, as the "bird" is supposed to be an animal, but never observed (and ventriloquism could produce a similar

sound). The Kapsiki consider the *kwahɛ* as akin to some small birds that they do observe, such as the *kwelakwela*, a small grayish bird with a white belly that lives in hollow trees or nestles in the crevices of a hut, or the *pidagwa*, similar but slightly bigger; the *kwahɛ* is their little sister. In *kwahɛ* divination there is no trance involved; the smith is completely clear-headed and hardly needs any preparation. The nonsmith Kapsiki are very much aware of the smith's reputation for trickery, and realize that there is precious little room for verification, and in fact prefer the séance during the day as people are aware that they can more easily be tricked at night. So daytime *kwahɛ* has more status.

Communication with the *kwahɛ* is very direct, but the control of the diviner is still very great, even discounting ventriloquism: he can initiate the sequence, fill in the sentences, and end the séance at will. The directness of the communication for the clients precludes client-smith communication, as there is hardly room for a friendly consult between smith and client over the signs and signals of the animal. This type of divination is rather rare, and though people do consult a *kwahɛ* diviner, most of these diviners are itinerant, just passing through the village occasionally. This direct communication has peculiar aspects, as the client can try to take control in persevering with a line of questioning, like when the client tried to get the name of the particular culprit old woman. In other techniques this is no option, and it renders this type of divining vulnerable for the diviner, as clients sometimes realize the reticence of the *kwahɛ* when she is put under pressure for specific details. When my assistant Sunu Luc and I were working on the recording of this last divination, he noticed the evasiveness of the *kwahɛ* and concluded that the smith had tricked us. Typically, this eroded his confidence in this particular smith with this particular *kwahɛ*, not in the technique itself: "The smith did not listen well." Such a dependence on the smith in several roles, as "master of the *kwahɛ*" and as interpreter, might well be the reason why this type of divination never became very popular, remaining only on the margins of the crab's popularity.

The *kwahɛ* raises a crucial question about the smith himself; assuming that some ventriloquism is performed, the client definition of the technique and the way the smith sees it have to be quite different. Does the smith really trick his clients, or does he believe in the "bird" himself? Or on the contrary, is this question not correct as such? Are there processes in operation that allow for a shared definition of this process? In order to address this question about individual belief, we need more insight in divination, in the diagnostic process in Kapsiki, and in healing. So we first look at the dominant way of divination, not only with

the Kapsiki but also with many other groups in the Mandara Mountains: divination with the crab.

As the senses go, divination is about the ear and the eye, about hearing and seeing. The *kwahɛ* is just hearing as a part of speaking; the crab—below—seems to be for the eye only, as are the techniques with the stones and the cowries described at the end of the chapter—"seems," because what the smith will say to the crab is that it has to "speak," with his legs, sure, but "talk, say the truth." The truth in African divination, such as these Kapsiki examples, is verbal; not sight but words are the main vehicle of deeper insight. The anthropology of the senses has long engaged in a battle over the primacy of either vision or hearing, but cultures do differ in cognitive style, assigning various weights to the different senses.[4] We experience the transference of sight toward hearing in divination discourse as a metaphor, but it may just as well be synesthesia, the well-established experience that the senses impact on each other,[5] an illustration of the general embodiedness of our perception. When speaking about learning this craft, smiths stress both senses—seeing the traces, hearing the talk—but also the interaction between the two: both what one hears and what one sees have to be verbalized, put into words, not just for an eventual client but also for oneself. In the end, one has to hear oneself, and vision and sound have to be translated into each other.

THE CASE OF THE INFERTILE WIFE

Zra Mpa[6] explains his problems to Cewuve, the smith: "You know my first wife, Kwangwushi. She came to my house five years ago as a bride from our own village. She has not been pregnant in all these years. Could you see why?"

Cewuve, never talkative, silently arranges sticks, reeds, and pieces of calabash in the wet sand on the rim of a large pot. Carefully he positions all the pieces, explains to Zra which represents what, touching them with his fingers. Then he takes a crab from another jar, spits on its belly and says: "Crab of the jar, crab of the jar, tell us why this woman is not pregnant. Tell us, tell us the truth." He puts another bundle of calabash shards into the sand, positions the crab between the loosely arranged shards, and covers the pot with an old piece of a beer jar. After a quarter of an hour

the smith opens the pot and looks at the way the crab has rearranged the shards. He mumbles something about "a woman," takes out the crab, spits, and formulates the question more pointedly: "Is it jealousy, a witch or what?" Five more question-and-answer sessions follow before the answer is clear. "Maybe former divinations have told you it was jealousy or a witch that has closed the womb of the woman, but that is not the case. Your wife is out of harmony with the other world. Her *shala* [personal god] has closed her belly. So you have to sacrifice your *shala*. She has to look for a black billy-goat, and take a smith with her into the bush. There the smith will break the legs of the goat, and both will leave the animal behind without looking backwards. Afterwards you will perform a sacrifice in your compound [implying brewing beer, another goat to be sacrificed on the client's personal altar, and inviting the neighbors to drink] and your wife should become pregnant at last."

The Mandara Mountains are home to a wide variety of local cultures, each with its own religion and forms of divination. In this mosaic of cultures, each of the groups has several techniques of divination, which are not usually restricted to just one of the groups. The divination technique described above with the crab is the most widely known in the mountains. The Kapsiki have more divination techniques, like the *kwahɛ* described above.[7] A second technique is the classic West African one with cowrie shells,[8] and a third is with stones,[9] all of which have their own interethnic distribution in the region.[10] Itinerant diviners also occasionally arrive with their own techniques. Other incidental, quite idiosyncratic techniques have also been observed, but these have never made it beyond the confines of one particular village. One of these uses calabash shards that tumble on a string.

The most general and widely known technique is with the crab, *dlera*, and in fact, all divinations are called by the generic name *dlera*, so consulting a smith diviner in Kapsiki is expressed as "hearing the crab," while any diviner regardless of his technique is the one who "builds the crab" (*kaŋa*[11] *dlera*). The animal itself is the land crab that lives in the small pools on the Kapsiki plateau that retain water during the dry season. The crab is not seen as a direct representation of the supernatural world, nor is it essential in rituals or sacrifices; it is just an animal whose traces can say something about hidden things. Each crab "knows," the diviners say, but some are quicker than others in speaking, and the "slow speakers" have to be replaced by faster specimens. Each crab lasts but a few months in divination and is

fed some grains of sorghum every few days. Some folklore is attached to the crab in the form of a *rhena heca* (folktale). An example:

> In olden times the crab spoke differently, not in the compound but in the bush. The diviner went out and after sunset spoke to a crab, as people speak among each other. On the edge of a rivulet, the diviner communicated with this single crab and could ask anything he wanted. Then disaster struck: a woman took the crab and ate it. Since that time, diviners have had to take crabs from the bush and keep them at home, and have to make do just with their traces. At first, only the direct descendants of that diviner could perform the *dlera*, but nowadays anyone who wishes to do so can learn the trade.

By virtue of his identity, a smith has a natural authority in any divination, either with the crab, the stones, or the *kwahɛ*. He performs divinations in his own home. The smith in the above-mentioned example is also an ironworker, and his crab is kept in the smithy, which stands separate from his compound. Other smiths keep their animals just inside their compounds under a granary.

The standard procedure is as follows: a client comes early in the morning and asks for a consultation. The smith obliges and gets his paraphernalia out: a large pot (40–50 centimeters in diameter) filled with sand, a broken pot for a cover, a jar with one or more crabs, and a sack with sticks and calabash shards of several sorts and with various decorations. He heats up a fire to warm the water for the crab and then pours the lukewarm water into the large pot. Along the rim of the pot he stands straws upright in small bundles with a calabash marker in front of them: these represent the client, his family, the various buildings in his compound, the persons he is asking about, and the ward and the village. In the middle of the pot he buries a small round fruit, and behind another calabash marker a small cord. He then places five round and six oblong pieces of calabash loosely on the wet sand, each decorated differently. Finally, the smith takes a crab out of a smaller pot that he keeps in his smithy. Holding the crab in his hand, he explains to it the matter at hand and what is expected of it. The crab is put in the pot, the lid is closed, and the client and the diviner wait patiently, chatting away amicably. After fifteen minutes, the smith looks to see how the crab has rearranged the loose pieces of calabash, interprets this as a first answer, and then asks a more precise question, puts the pieces back in the same order, and the crab has another go. An entire session involves asking four or five questions, and lasts a few hours. The final answer usually offers an analysis of the problem and a means of solving it: often a sacrifice of some sort, a small offering of some foodstuff or an occasional chicken, put either on the sacrificial jar or on the crossroads (a favorite place for offerings).

To close the divination séance, the smith puts the crab back in his pot, feeds him some grains of sorghum, pours some water from the divination jar over the feet of the client, and then empties the rest of the jar in the four cardinal directions. The diviner takes the loose pieces out of the jar, and the client takes the straws that represent himself and his kin from the rim of the jar. The diviner receives his fee, about cfa 100, and the client goes home to perform the sacrifice that has been suggested. Finally, the smith rubs some *rhwɛ jivu*[12] on the crab, a medication to prevent any bad luck that could stem from interacting with people who might be cheating on each other. Curiously enough, that problem seems to have disappeared in the last decade, our informants observe. Why is hard to say, because no one would dare to claim that nowadays all husbands and wives are completely faithful to each other. Rather, one of them observed, adultery has become so common that no measure will ever help any longer.

COMMUNICATING WITH THE CRAB

To illustrate the precise arrangements and processes of crab divination, I use the same client. So we will stay with Zra Mpa, who is now asking about his other wife, who has a similar problem. Again he goes to Cewuve, the smith: "My third wife, Kwashukwu, the daughter of the chief of Rumsu [a neighboring village], was my *kwatewume* [runaway bride] six years ago. So I had to pay a large bridewealth, as the first husband asked for his money and goats back. Kwashukwu is a good wife; she did not run away in all these years—at least not really; only once did she run away, and then she came back to me within two weeks. But she has no rest, for she has not been pregnant in all these years. We have often asked the crab, but she is still not pregnant. Could you see what the matter really is?"

Zra Mpa is anxious to get some answers from Cewuve, the smith, who is a next-door neighbor. In fact, his own explanation of the household situation is unnecessary, as Cewuve knows exactly why Zra Mpa has come. The short, stocky Cewuve is one of the best diviners, and his reading of the crab is famous in the village—but the smith knows very well what the problem is in Zra's compound and proceeds immediately. The morning is still chilly when he takes the large pot from his granary and checks whether the crab is still alive. The open pot is filled with sand and is placed just outside the compound wall, where the séance will take place.

Cewuve pours some warm water in the pot and arranges small calabash

shards, straws, and a little rope in the pot, making a circular plan of the problem situation. Bundles of straws by the rim mark the actors in the arena: Zra Mpa, his father's brother Zra Kangacè (me), his half-brother Sunu Ma with his wife Kuve, and of course Zra Mpa's three wives: Kwampa, Kwangwushi, and Kwashukwu. The other fixed items that are always present at such a divination are the village, the granary, some huts in his compound, the graveyard, his sacrificial jar, and the burial drums. The loose shards are put in the middle of the pot. With the crab in his hand, the smith explains to the little animal what might be the reason behind the problem: "Kwashukwu is childless. Is it something her former husband did? Has he 'spoiled' her with magic? Tell me, do not lie." He puts the crab in the wet sand and closes the pot. Crouching silently, both wait for a quarter of an hour. Cewuve takes off the lid to inspect how the crab has walked about. "Nothing special. Some bad news from Teri's fields." What is it? The crab gets a specific suggestion this time: "Kuve and Sunu Ma: maybe they should sow some sorghum in the field, dig it up again, grind it and put it on their jars to avoid problems?"

Another fifteen minutes go by, and as the sun warms up so too do both men, chatting about the village and their neighbors. The crab's second "answer" is clearer: nothing is wrong with Zra's wives, but there is some "noise" with Sunu Ma and Kuve. Again the crab is addressed: "Should Kuve

Figure 18. With the crab in his hand diviner Shange arranges the pot

take sorghum, walk along the road, take some sand, grind it, and make a sacrifice? And should all the women give her some ground peanuts?" While the crab works on the problem, Cewuve remarks: "If *shala* [god] wants it, Kwashukwu will be pregnant soon and have a son, but Kuve will get *matini* [two pregnancies in a row]."

The third opening of the pot offers a new angle. Cewuve, thinking aloud, says: "He is to be attacked by diarrhea, maybe from the serpent, maybe a normal illness. At night, he says, it will come at night, with fire. Why fire? People take the drums if it comes." Addressing Zra Mpa: "He tells us that Sunu will be ill but the rest of the people in the ward are healthy. But if Sunu Ma falls ill, you will have to get him." (Cewuve knows that Sunu Ma is planning to travel.) Some specific questions are called for now. "Crab of the pot, crab of the pot, yes. The man is spoiled. Take some residues of red and white beer. Mix it, take ground peanuts, gather everything in the courtyard and pour it all—splash, splash[13]—on his own *mele* [sacrificial jar]. Say: 'Here, God in heaven, he is not the one who started traveling, please let him return.' Then Zra should take ground peanuts and put them on that man's [Sunu Ma] stone, saying: 'May I hear that this man is in good health. Why he? He has to return.' Crab, if you do not answer, I will give you another question."

The fourth opening provokes little comment. The smith repeats the message: Sunu Ma will fall ill, but the proposed sacrifice will not work well, it seems. So the smith adds a suggestion: "Crab of the pot, crab of the pot. He takes some meat from a male animal, mixes it with the other things mentioned above and sacrifices it on his jar. He is not happy about his brother. If you do not want this, then separate those things [the calabash shards]." Again the two men chat for the next fifteen minutes, dwelling on the upcoming elections.

The fifth and last answer gives more specific information. Indeed, it is Sunu Ma who has to do something. He has to get sorghum from the chief, grind it, and put some of it on his jar. Kuve has to throw the remainder on the road. All Zra Mpa's wives will get some of the sorghum, wrap it in cloth, and bury it. After one night, they should dig it up, add some sand, grind the mixture, and put half of it on their jars. They should put the rest of the flour back in the ground where it was buried.

In the usual fashion, Cewuve pours the water from the pot onto his client's feet and then in the four cardinal directions, removes the loose shards, and lets Zra remove all the straw signs.

Zra thanks his old friend, pays his fee, and tells his compound to follow the crab's instructions the next day. Sunu Ma made his journey in good health, and a few months later Kwashukwu was pregnant, not with a boy

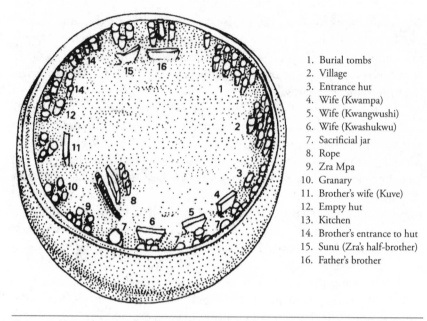

1. Burial tombs
2. Village
3. Entrance hut
4. Wife (Kwampa)
5. Wife (Kwangwushi)
6. Wife (Kwashukwu)
7. Sacrificial jar
8. Rope
9. Zra Mpa
10. Granary
11. Brother's wife (Kuve)
12. Empty hut
13. Kitchen
14. Brother's entrance to hut
15. Sunu (Zra's half-brother)
16. Father's brother

Figure 19. The arrangement in the pot for the séance on behalf of Kwashukwu

but a girl. Zra Mpa did not complain. Later in life, Kwashukwu would have four more children: two boys and another two girls; the last would be born when Zra had died.

SIGNS AND SYMBOLS IN CRAB DIVINATION

The representation of the people in the pot is quite iconic (see figure 19). Each person or group of persons is represented by a stalk of grass. Men are shown by a stalk with a node at the end, wound with a piece of cloth if it has to indicate a Fulbeized man (or a European, *nasara*). Stalks with the node in the middle indicate women. There are usually three for women and four for men, but this may vary. The stalks for the village, huts, granaries, and sacrificial jars do not have a node, while the burial tombs are indicated by small wooden sticks, representing the sticks with which the tomb is dug. Just in front of the groups of stalks, the diviner puts a triangular calabash shard in the sand, with notches indicating the type of relationship with the client, while the client himself is marked by a broader shard, shielded

against easy uprooting by the crab by four stalks pushed deep into the sand. Just in front of this, the diviner's client puts a small piece of cord in the pot, and in the middle of the jar he buries a small round fruit (*kwakweme*, the fruit of *Strychnos inocua*), representing the funeral drum. The wet sand in the middle is almost totally covered with eleven loose shards, five round and six oblong ones, each with specific markings. The rope represents a gift, a loan, or any object of value that changes hands, although this meaning can be reversed: if the piece of rope is brought from the client's marker to the "grave," the client will die. The round fruit is the *dimu*, funeral drum, the central symbol of death among the Kapsiki. The main social categories of Kapsiki society are thus represented in the jar. The rim is the client himself with his kith and kin, the graveyard, his compound and the ritual elements of the house, the entrance, the straw-plaited granary, his sacrificial jar, and the empty hut that represents his future wives.

The items in the middle are movable objects that represent the mobile elements in society, women, all kinds of visitors or people in the village at large (see figure 20). So the fixed items near the rim represent the main elements of social organization: the house, the village, and the graveyard. In the house, the entrance hut symbolizes the wall and the privacy that characterizes the Kapsiki house; the empty hut indicates how women come and go and the possibility of having a new wife;[14] the cattle pen evidently means

Fixed (along the rim)	Mobile/transient (moveable shards)
Village	burial (drum)
Graveyard	loan/gift
Compound	wound, accident
Entrance hut	red beer (sacrifice)
Empty hut	chief
Kitchen	smith
Cattle pen	millet and offerings
Fields	woman with children
Sacrificial jar	old woman
Specific persons	mature women
	young child
	old man
	adult man

riches, and the jar plus the granary are at the center of the Kapsiki house-based religion. In short, the house, the clan, and the village are fixed around the rim. Death, the drum, is intermediate between fixed and moveable: in principle very moveable (a small round ball), it is buried deeply—it should not be moved, but someday will be.

The real movables are the transient elements in society, mainly women in different categories. The distinction represents the ideology of patrilineal virilocal Kapsiki clans: the girls are daughters of the patriclan, but from marriageable age onward they are the transients in the Kapsiki villages. As such, the women form the main links between the clans as well as between the various villages, while transient men are usually interpreted as "strangers"—that is, men from other villages. The village itself is represented by the chief, the chief smith, and the red beer, for the Kapsiki a perfectly logical combination. Beer indicates sacrifice, and in divination, the smith, the chief, and the village officiator (*mnzefɛ*) are considered identical, all representing the village as a whole and expected to put communal interests before their own. This is in contrast to the normal image of a *za* ("man" in Kapsiki), who has to be fierce and stand up for his own rights.

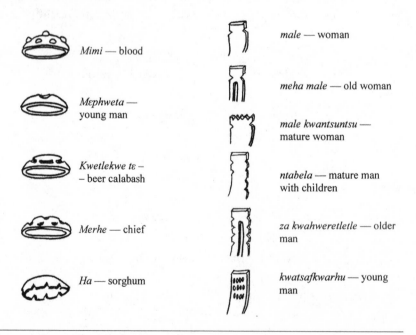

Mimi — blood

Mɛphweta — young man

Kwetlekwe tɛ – – beer calabash

Merhe — chief

Ha — sorghum

male — woman

meha male — old woman

male kwantsuntsu — mature woman

ntabela — mature man with children

za kwahweretletle — older man

kwatsafkwarhu — young man

Figure 20. The mobile calabash shards

A (nonsmith) diviner told me: "The chief, *mnzefè,* and the smith—all are the same. All drink from the *dzakwa* [plaited smith's cap]; none of them may brag about himself because that would spoil the village. None of the three is a private person."

In ritual practice, the red beer unites the larger patrilineage,[15] linking the individual compound with the rest of the village. The drum is the instrument of death in its social aspect, representing the communal dances that form the smith's main task during the funeral. In divination, the symbolic drum is buried deep in the sand, and the crab has to exert itself to dig it up. The client often puts his own signs on the rim of the pot himself to be sure they are correct and to hide information from the diviner. The smith always places the eleven loose shards himself and, of course, the crab. The small shards in front of the stalks have more of a mnemonic than symbolic character and serve as a reminder of who is who, especially when the diviner has more than one client at the same time.

PROBLEMS IN THE POT

Each society has its own particular problems, but not all problems are taken to a diviner. Like many African societies, Kapsiki culture has a strong preoccupation with health, but direct afflictions, illnesses, and somatic disorders are not usually taken to the crab, as they are treated with traditional or modern medicines first. Only if the problem persists is it put to the crab. The Kapsiki who know something of Western medicine compare the crab with an X-ray: the crab—and divination in general—can see through the symptoms to the real problems below. Both X-ray and crab see beneath the surface, both need expert operation, and both require knowledge to interpret the findings—in short, divination is about "reviewing reality."[16]

A minority of the problems addressed are therefore somatic, with the majority being either of a more general or more social nature. And like many African divination systems, crab divination aims first of all to unravel social problems, implying that the session will deconstruct a somatic illness in terms of relations. In fact, its whole apparatus is geared toward solving social puzzles: the social world lives around the rim of the pot, the oblong shards represent the categories of people, and the round shards the relationships people have. Infertility is one of problems that is most frequently discussed, but there are also other problems, such as wives who run away

from their husbands (marriage instability is a major issue in Kapsiki society), troubles between close kin, and the insecurities of life in general.[17]

So the problems put to the crab reflect the existential problems of the Kapsiki, often focusing on fertility and child mortality. The Kapsiki region has long been characterized by a high pretraditional child mortality rate of 66 percent among those under five years old,[18] and the diviner's clientele reflects this concern. Even if, since the 1990s, child mortality has dropped significantly, Kapsiki culture is still very pro-natal, so fertility problems are quickly set before the crab. Various reasons are given by diviners for infertility. In our first case, the crab indicated that the woman was out of balance with her supernatural world, but the father, mother, or a mother's brother may be indicated as the cause of infertility, even if it is usually due to a problem reconstructed within the woman's personal history. Sometimes more complicated reasons are found, and the remedies will then also be more complicated. Let us now consider a number of different cases.

The Case of the Three Sisters

Kwarumba, a widow about forty-five years old, comes to see Cewuve early in the morning. Her daughter Kwanyè, who is married to a Fulbeized Kapsiki, has a bad stomachache, and Kwarumba is worried. Her older daughters have left the village after getting married, and young Kwanyè is the only one still at home. She is afraid that people "spoiled" her youngest child. Cewuve puts Kwarumba, Kwanyè, and the other daughters in the pot, each with her village ward (Mogode) plus the graveyard.

First question: What is the matter with my daughter?
First answer: When she walks in her sister's village, she gives food to the god of the
 market there. But the market is very "hot [dangerous]."
Second question: Why?
Second answer: Her body is well, in good health. There is no need for her to
 travel, better to give her the last good meat, and then perform her sacrifice.
Third question: What about the sisters?

The third answer zooms in on Kwarumba's oldest daughter, so it gives just the prescription, not the actual diagnosis:

> Kwetere has to mix the residues of white and red beer. She has to sleep in front
> of her hut. And early in the morning, without washing, she has to mix some

flour with the beer residue and put a little on her jar. She will make the rest into a ball, put some of it in the middle of the road, and then go to see her sister [a two-hour walk to another village], offering morsels to her *shala* on the way. At her sister's compound, Kwetere will give her some of the mix to put on her sacrificial jar. And finally, she will take some flour from her sister's compound, mix it with her little ball of paste, and put that on her own jar back home.

The Case of Chronic Illness

Deleme, from Wula Ward in Mogode, is at Cewuve's to ask why his illness is not abating. His diagram in the pot is quite simple: his own compound and his father's and mother's *mele*. It takes several openings before the crab really "speaks," as it starts out by saying that there is not really a problem: the man is in good health. The diviner then becomes impatient and switches to another crab. After many openings, it then becomes clear that his daughter is the one running risks, and without a sacrifice she will die. Deleme has to sacrifice a mixture of peanuts and sorghum, sorghum from the chief's clan, and some beer residues at the door opening in the wall. It seems that Deleme's illness is a reflection of his daughter's danger.

The Case of the Aspiring Bachelor

Kwada Kwefi's last wife ran away about two years ago, and he has not yet found a new one. Since remaining a bachelor (even if he has a teenage son) is a bad thing, he goes to visit his neighbor, the smith. The crab comes with bad news: "Everybody is returning from the bush crying." The crab then tells Kwada that if he meets a woman, his son has to grab her arm and pull her home. Between openings, Kwada Kwefi complains to the smith that the crab is not very good at getting wives: "I have done the crab now many times, and still have no wife." Cewuve retorts: "Last time the crab told you not to put your sorghum in the granary right away but you did it anyway!" The next message from the crab is threatening because the drum is unearthed: "The boy's mother will come home [from her new village] in tears." This raises questions, which are answered in the next opening: "The mother of your son [she disappeared into Nigeria] has to come back holding a chicken in her hand, and her son has to guide her into his father's home. There she has to sacrifice the chicken with the residue of some white and red beer." It appears that Kwada's son has to go and fetch her from the other

village. If the son brings a new woman into the house, she will stay. A month later the runaway wife has done as indicated and did indeed stay with her son, solving Kwada's problem (at least for the time being).

These examples address more or less structural problems inherent in the Kapsiki way of life and social organization. However, not all problems are endemic or inevitable. Incidental problems and experiences—that is, the contingencies of history, as described below—also abound.

The Case of the Nightmare

Kweji Mte asks for a general divination for his son who has joined the Fulbe quarter of the ward and thus, as a new convert, cannot in good faith consult the crab himself. He puts his son's world in the pot: his son, the fields, the graveyard, the bush, people in the "river," his son's wife, his own ward, his own entrance hut, his wife's (empty) hut, his cattle pen, Kweji Mte himself, his son's hut, Kweji's compound, Kweji's wife's present hut, grain, and the ward. The question is about general well-being.

Cewuve asks Kweji Mte whether his son's bride is coming to Kweji's house soon. (The move of the bride to her husband is the wedding proper for the first marriage of a girl.) Kweji replies: "If my son was still with me, she would have already been at my house." Cewuve again addresses the crab: "Crab of the pot, crab of the pot. Why are they crying in broad daylight? You showed me the drum earlier instead of the cooking pot. Does this man have to take the residue of white and red beer and put it on the jar? Does the wife need to take some sorghum she earned with her white beer and put it on the wall, and take some sorghum from a smith, with the bone of a female animal, and put the whole lot on the child's jar? Tell me the truth crab, do not mislead me."

After two readings, the diviner notices contradictions in what the crab is saying and questions Kweji about his reason for coming. Kweji Mte then reveals his real agenda. "I had a dream last night. I sat in the square in my ward and it was full of dead people. I was the only living person. A huge dog from among the dead wanted to kill me, but I wrestled it to the ground again and again. The last time I picked it up and smashed it on the rocks near the dead people; the dog shattered into tiny fragments and I was covered with blood. The dead people encouraged me in my battle against the dog. They had homes there at the sweet potato patches we make [high furrows of about 1 meter high]. I woke up, told my wife, and she advised me to consult the crab. She had also had a dream: her son who was among

the Fulbe had come to her, dressed in white. She asked him what he had brought her, but he answered with just a smile. Other youngsters, also in white clothes, asked him for his robe but he refused. They retaliated by saying that they would stop him from going to Mubi [in Nigeria]. His mother came between them, and then his father told him the youngsters were just joking. At that point he woke up, reason enough for a consultation!" The divination proceeds, and in the end Kweji Mte goes home, comforted, and planning to sacrifice the chicken the crab has ordered.

The ambivalent position of the smith makes him a prime diviner, but can also be part of the problem.

The Case of the Wrong Burial

At the compound belonging to Danja—a famous diviner who is not a smith but a *kelɛŋu* (clairvoyant)[19]—a woman from the village of Sir asks why, since the death of her first child, she has not been able to get pregnant again. At first the crab indicates a problem with her father, but the second and third openings show another reason. Her first child was buried in the wrong fashion by the smith: he put the small body in the wrong position and cardinal direction and—according to the crab—not by chance or mishap. He tricked the woman into leaving the burial site for a moment and then performed his foul deed.

The solution is to go back to the smith in question and make him rebury the child at the very same time of day that the original burial was performed and, if possible, without giving him anything. Since he tricked[20] her, she should do the same, and not give him money. Before she goes to see him, she has to sacrifice a chicken on her mother's *melɛ,* with sorghum from a smith and from herself plus some goat's bone, and throw this mixture along the roadside on her way to the smith's—if possible at a black ants' nest. Then the smith has to bury the child properly: sitting upright, facing east, and with both hands on the top of his head, imploring God to make his mother pregnant again. If this is done correctly, the woman will get pregnant again, the crab says.

During the session, Danja, who is performing three divinations at the same time, talks about a similar case of a woman who had to force a reburial by a smith and ended up with two babies: a boy and a girl. Though smiths are indeed reputed to be cunning and have a social right to some trickery, some of the general mistrust of smiths shines through in Danja's stories.

Most divination séances aim to solve individual problems at any time of

the year. However, at certain times, the crab also has to be consulted, such as before a boy's initiation or a girl's wedding, as in the next case.

The Case of the Bride's Farewell

The details of any major happening are thus indicated by the crab. In one ritual "calling of the bride," the groom's cortege comes with an assortment of sacrificial items for the parents of the *makwa*. At the bride's compound, the old woman in charge of the cortege explains what the crab has told the groom: the bride has to take the meat of a female animal to her new home, with the meat hidden under the wings of a chicken. At her husband's home, she has to install her new jar (which the cortege brought along) and slaughter the chicken with the meat still under its wings. She then has to cut its throat and throw the head away outside the compound wall; after cooking the rest of the chicken, she must eat it all herself. This is quite complicated advice from a crab, but the bride's father has consulted his crab as well, with the following outcome: the bride has to take the meat of a sacrificed male animal in one hand and a chicken in the other to her "marriage father."[21] She will then proceed to her husband's with the chicken's neck and feathers and throw them away just outside his wall. Finally, she has to cook and eat the rest of the chicken by herself. Both parties compare their crab consultations in whispers, content that the two crabs have said almost the same thing. If not, the groom's divination would have prevailed, but consensus between the two crabs is better, and the small differences are easily squared.

SMITH AND CLIENT

Client and smith are in constant communication with the crab, addressing it as "crab of the jar" or "crab of the earth," an animal that just "knows," and never as a supernatural being. The smith explains the problem to the animal, at least as far as his client has disclosed it. If he has any private knowledge of the deeper sources of his client's problems, the smith will save this for the final verdict at the end of the session. In interpreting the signs of the crab, the diviner notes two sets of signals. First of all, he observes the new position of the shards. The oblong ones are slightly curved, and the direction of the curve is significant: those parallel to the rim are a positive sign;

the other way is threatening. The second group of signals are the traces the crab makes in the sand: diggings, traces of sand on the stalks, and traces from a person to the graves. The worst sign is when the crab digs up the drum: then the death of one of the fixed persons is imminent. But usually the little fruit is buried so deep that the crab does not get at it. So the diviner has an interpretation system at his disposal that is sufficiently ambiguous to be open to multiple interpretations. The composition of the shards and the traces in the sand give him ample room for his own interpretation, depending on his definition of the situation.

Sometimes the smith-diviner answers a different question from the one posed, and clients are aware of this possibility. In the second example, Zra Mpa sought to redress a problem for his wife, but what he received was advice for his younger half-brother Sunu Ma. Stealing a wife within the village, as was the case here with Zra's wife, generates a lot of tension in the village, so the diviner could easily have zoomed in on this source of hostility between two consecutive husbands. However, he—or at least the crab—concentrated on Sunu Ma. At the time Sunu Ma was a happy-go-lucky person who showed little concern for his social duties, even enjoying a wife without ever paying a bridewealth. People liked him but deplored his lack of social conscience. Later, after the untimely death of Zra Mpa, he settled down and became a courtier of the canton chief in Mogode. Divination no longer targets him.

In the end, the smith describes in detail all the sacrifices necessary to redress matters, usually small offerings at the crossroads in front of the compound. The cases are relatively homogeneous in the treatment recommended: sorghum grains from a special source, such as from the clan chief, from a young boy, or from a smith—that is, from a nonperson. Seldom is a major sacrifice called for, at least not initially. Small gifts for injured kin or the smith are frequently recommended, as are gifts for children. Getting sorghum or other ritual items from other people is, however, not simple. The chief and the smith are used to these demands, being predominantly "social persons," and getting sorghum from kinsmen or friends can also be easy. But nonkinsmen will be reticent, afraid that a gift of food will be used against them. During the sacrifice, all "evil things" are routinely sent away, outside the compound wall, so when using food a neighbor has given, "bad things" may follow the trail of the food to its donor.

The major ritual elements of the compound are the sacrificial jar, the wall of the compound with its one opening, the entrance hut, and the plaited granary where the jar is stored. Beyond the wall, the road and the crossroads are often mentioned, as they are the Kapsiki indications of the outer

world beyond the confines of the compound wall. If the village as a whole is involved, it is usually through the chief or a kinsman of his clan, the chief smith, or the children of the ward. Whenever the brewing of red beer is indicated, a goat has to be sacrificed on the personal *melε* of the client. Beer indicates the need to invite all of one's friends and neighbors for a social celebration of the sacrifice in the front courtyard of the house, while a big meal for guests and family is prepared inside.

The crab is not a robot that just answers the questions, and neither is the smith a purely technical diviner. Above we saw that the results of the divination diverged from the question at hand. Also, the smiths go quite quickly from question to specific instructions for offerings, and are themselves instrumental in suggesting possible types of sacrifices. Divination is a way of getting under the surface reality and at the real and deeper reasons and problems, but the construction of the knowledge is done by the smith, in constant interaction with the polyvalent signs that the crab produces. One means is to deconstruct the problem put to the diviner, and the process of divination does in fact quite often entail a rephrasing of the question, as the following example demonstrates:

A smith woman, Kwateri, comes to Cewuve for divination. Of course, she could ask her husband but, traditionally in Kapsiki family relationships, no woman would ever do so, as she would reveal too much to her husband through the crab: "One cannot tell one's husband everything," she said. And it seems that she does not declare everything to Cewuve either. Her question is indeed a domestic problem, as her husband does not let her go to her daughter's compound to take her clothes. Her daughter lives in another village, as is usual among smiths. From the start, the crab answers a different problem, the deeper one hidden in the woman's discourse: "Why do you want to leave your husband?" She emphatically denies this hidden agenda, and then the crab foresees a piece of bad news arriving at the woman's hut: "She would run away in tears." The woman asks whether her mother-in-law has cursed her, but according to the crab her own *shala* is in disaccord and blocks pregnancy.

At that very moment the client's husband, Vandu Bake, happens to pass by. Cewuve tells him not "to cultivate alone," exhorting him to keep his wife in his house. Vandu Bake says: "That woman is not the staying kind. She is just here to try to have a baby. Even in full daylight she may run away." He struts off angrily and immediately Kwateri explains: "It is not true that I just want a baby here in this village. A week ago, Vandu's brother consulted the crab for me, and came out with the fact that my mother-in-law had cursed me. Vandu was instructed to give his mother some meat and a chicken and to have her

spit on me to remove the curse. He did not want to do that, and I wanted to know whether the first divination was correct." Cewuve answers that it is not correct: "You have to take some sorghum grains from this ward and from your own ward and mix them with the residue of red and white beer, and leave the mix outside your hut overnight. Early in the morning you must put it on your sacrificial jar, with Vandu's children present. You have to put the remainder at the crossroads." Kwateri nods and goes on her way.

Smith diviners do not stress any inspirational authority but claim just to "read" the crab's traces. In many cases the smith has enough background information to rephrase questions and redefine problems, and habitually does so. But sometimes this is not sufficient, as strangers may come in, often for a second opinion. Or an anthropologist, for that matter.

> On an impulse, during a session with a neighboring Kapsiki diviner in January 2006, I put my father-in-law in the crab's pot, even though he had died in 2001. The diviner took a quick look at the arrangement in the pot, and pulled out the shard representing my father-in-law, saying: "This one is dead. Nothing can be said about him." I was astonished, as I could not fathom how he could know this. Afterward I asked him. He shrugged and said: "I just knew."

Actually I was more than astonished; I was a little bit shaken. Up to that point I had routinely assumed that the smith was weaving wise advice round the legs of the crab, based upon his in-depth knowledge of village relations. But this experience, as well as some others elsewhere, took a swing at that easy positivistic stance. Yes, of course, many of the outcomes of divination can be explained quite easily as a clever adviser giving a cautious and ambiguous response, but somehow the diviners seem to have access to a little bit more information than just that. Not everyone, not always—but just sometimes. For many anthropologists, this intuition-like aspect comes as a self-evident feature,[22] but not for me. I have to get used to it.

For the Kapsiki, those "psychic powers" are either related to the smith, a natural in-between, or to a category of people who "know" anyway. And indeed, not all diviners are smiths: divination with the crab is also done by people called *keleŋu*. They claim special knowledge from their "night walks," when, in their sleep, their spirit leaves them and travels to other villages on all kinds of heroic pursuits, like making war with spirit walkers or stealing sorghum.[23] Through their spiritual encounters, they gain special knowledge about future events, especially deaths. So while smiths do not cite inspiration as information but do use it to some extent, the *keleŋu* use

it as the basis of their authority. And almost all diviners who are not smiths are *kelɛŋu.*

> However, that special angle on information does not hold for themselves, it seems. Being *kelɛŋu* may reveal information, but it heightens one's risks as well, as these night walkers make their own nocturnal battles, with their concomitant risks. For instance, Shange, who was so sure about my father-in-law being dead, three years after this session suddenly fell down, and could neither speak nor see any longer. He remained in a coma for six months and then died. As he was reputed to have a hoard of money stashed away, people suspected foul play by one of his close kin. However, he had revealed the whereabouts to nobody. If he has given it in custody with his wife, she surely never has told anyone.

On the one hand, divination is a means of eliciting information already at hand in the social interaction in the village, as diviners are predominantly part and parcel of the village community and often well situated to know the relational problems firsthand. On the other hand, their knowledge and authority stem from other sources, increasingly called intuition.[24] The client counts on the diviner having additional information that has not been furnished to him, and remains cryptic in his own definition of the problem, trusting but also testing the diviner to see whether he really understands the situation. However, as Graw points out, the very process of divination produces information, or at least options for knowledge. The divination pot and the crab is not only a technique for producing answers; but it also forms an "intentional space," a place where clients and diviners meet with a common wish to review reality and embark on a mutual redefinition of the problem at hand.[25]

PEBBLES AND COWRIES

Most Mandara groups have more than one technique of divination, and so too with the Kapsiki. In addition to the crab and the *kwahɛ,* two other divination techniques are used: pebbles (used by smiths) and cowries (used mainly by nonsmith women), but traveling diviners will have their own techniques. In principle, techniques are open, exchangeable, and do travel.

Pebble divination, called *ndwɛdɛ* (pebbles), is performed throughout the region as a secondary technique and is similar to techniques mentioned in the literature, such as the many kinds of pebble divination Danfulani

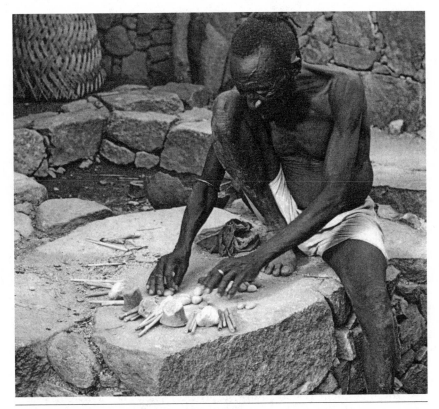

Figure 21. Smith Vaɓela, Sir, performs pebble divination

concentrates upon in the cultures on the Jos plateau,[26] or the divination used by cultures far away in Chad.[27] Yet the Kapsiki version shows some specific elements that link it with crab divination, the dominant form.

As shown in figure 21, the diviner sits in front of a flat surface rimmed by a semi-circle of straws and pebbles. The straws represent the brewery, the ward, the huts in the compound, one husband with four wives, children, and the village. The pebbles between the straws may represent the *veci*, the sacrificial jar of the person in question. Characteristic are the iconic character of the small straws, such as the Muslim/European with a wrapped head, or one wrapped with a fiber, the *sekwa* (debt collecting magic) and the strong tendency to picture the various kinsmen in their relevant distance from the client. The basic procedure in pebble divination is simple. The smith translates the problem of the client into a question calling for a yes-no answer, then takes a random number of pebbles out of the whole heap, and starts taking pairs out of it. If he ends up with a pair, the answer is "Yes"; a

single pebble remaining means "No." During the consultation the diviner keeps a constant sotte voce conversation with the pebbles, explaining and asking questions.

Most Kapsiki smiths have added personal items, such as some pebbles of a peculiar shape or color. These may roll toward one of the bundles of straws, and then produce a more direct indication of a problem or a solution. A black and a red pebble are almost standard, indicating *gutuli*, local spirits, and blood; other special stones are brown (death), pure white ones (white things to sacrifice, like white sorghum, rice, eggs, white chicken), and pocked ones, representing immediate evil like serpents or smallpox. These wayward pebbles allow for a more general and flexible interpretation and thus offer a chance to build a richer story; eventually, all divination sessions have to end with a plausible tale, believable for the client, and convincing for all concerned, a tale that indicates how the wrongs of the past should be righted.

A session with a pebble diviner, Vaɓela from Sir (figure 21), featured Jean Zra Fama, my initial assistant. The problem put before him is a general one: what to do to have an auspicious future. Jean Zra's social universe is depicted in a similar half-circle in front of Vaɓela: the brewery, Jean Zra himself, a girl, his wife with his children, his entrance hut, and the ward, all divided by pebbles, several of which represent the various *veci*, sacrificial jars. The first announcement is not a huge surprise for Jean Zra: "Foreigners have come to you. You have to give your father-in-law whatever he wants as gifts from you: give him if your wife is to stay healthy." So far so good, but then Vaɓela-and-the-pebbles continue: "Jean Zra has to sacrifice on his *veci*, or he will die. I Vaɓela, will give you a goat if you are still alive when the sorghum is one foot high. Or do you think you will remain healthy because you attend the Protestant mission?" And pointing at a pebble on top of another: "Look here, there is Jean Zra being carried around by a smith [funeral]." Thus, Jean is told to walk through the village with a chicken, collect meat from other men in the ward, and then sacrifice the chicken on a flint stone (the usual sacrificial spot when one does not have a proper jar) and divide the meat among a host of guests.

Jean Zra is skeptical, as earlier in his life he was told by the crab that he would die young from a snakebite, and that has not happened. But he still asks a few specific questions about some urgent issues. He is careful to ask in French, which Vaɓela does not understand, so he cannot influence the answer: "Will I pass my next exam?" The answer is "No." And he does get some additional, unsolicited information as well: "There is one mother's brother who feels hurt and has tried to harm you." That bit Jean Zra does

recognize and he knows exactly which uncle. Vaɓela continues: "But *shala* [god] shall keep you well, I, Vaɓela am telling you!" The girl in the layout is one Jean covets, but the pebbles warn him that she is after his money, and not serious about marrying him. This information is not very welcome, but Jean does not reject it out of hand. Then the diviner puts in the straw with a wrapped top, Zra Kangacè (me). "He will leave again." Everybody recognizes that as an evident truth, but Vaɓela continues: "Many white people will come, who will disturb the black people. The black people are not content, when the white man becomes chief again." Jean Zra interprets that as the tourist situation, and the others agree. In Rumsiki, the tourist hot spot of the Kapsiki area, the manager of the hotel is French, and in fact runs the village, which does generate some tensions. But Jean did pass his exam.

In Sir, Vaɓela's village, a complicated version of this technique is used at the end of the boys' initiation. The wide half-circle before the diviner then consists of three sections: at the right-hand side the various villages, at his left all dangers threatening the youngsters, and in the middle the real values in life: crops and people. The crops are nicely specified into five major sorghum/millet cultivars, plus peanuts (an important cash crop), goats, sheep, and cows. The people consist of all the kinship categories and the village wards, but more interesting are the various ills and dangers that may beset the new initiates. These are the knife, arrow, snake, diarrhea, cough, smallpox, tree (to fall out of), and finally the new risk, the car. In this divination each of the boys gets personal advice for his next course in life: whom to marry (which for the Kapsiki implies the choice between a girl, *makwa*, or a woman who has already been married, *kwatewume*) what villages and journeys to avoid, what crop to cultivate in his first year as an newly independent cultivator, and especially what major risks are lurking in the shadows of his immediate future.

This type of divination allows for limited interaction between the diviner and his apparatus, in two ways. First, he may phrase and rephrase the question itself, but then has to await the verdict, which can be checked by the client. Only the special stones and their frolics during the session offer him a window for a more creative and in-depth analysis of the client's situation and needs. Pebble divination is considered a viable second opinion after the crab. In Kapsiki culture, the place of the crab is secure and central, and any other divinatory technique would have a hard time getting established, another reason why *kwahɛ* divination never became widespread. If the all-knowing crab does not know the answer, what other animal will? But pebble divination does fit the bill for a second opinion as it is a completely different technique, and also does command a certain authority by being widespread.

The same holds even more for cowrie divination, which is almost ubiquitous in West Africa.

Cowrie divination is women's business—some of them smith women, but most not.

> Masi Kweji learned the technique from the *gutuli*, the bush spirits; she was fifteen at the time, and when she walked through the bush, the *gutuli* "put the cowrie in her head"—that is, gave her the knowledge about cowrie divination in a revelation. She uses twelve cowries, which have to be supplemented if some are lost, and has embellished her performance with a little mirror and a hairpin. The mirror is first for screening the coins the clients give her: she puts one cfa 100 coin on its side on the mirror and looks how its turns and which side it falls on, indicating the side on which she will start her divination. Masi Kweji puts her hairpin down, to "speak to the cowries," throws her shells herself, and immediately starts the explanation: "An old man has come into the house during the first of January to drink but did not find anyone home, so he went away. He did not take anything, and nobody saw him. Also, the two women of the house are very close, and all will be well." She then throws a few times till a specific arrangement of cowries remains, and explains: one vertical in the hollow of another is the *shala* of that person, and one resting against a second one indicates husband and wife.

Pebbles, cowries, and the crab have their own historical dynamic. The crab is slowly giving way to cowrie divination; the animals are ever harder to find now that people live everywhere; also the cowries are associated with Fulbe lifestyle, so with modernity, and many young Kapsiki associate the crab with the past. In the Nigerian Higi part, the crab still holds its own, as in Rumsiki. So in the cities, like Mokolo, cowrie divination has taken over, both among the nonsmiths but also among the urbanized smiths themselves, who with their move to the city have exchanged the crab for the cowries. Also, where in the city can one find a crab? Pebbles have their stronghold in the eastern part of Kapsiki country and still are the dominant form in Kortchi and Vinde Gawar.

AMBIVALENCE AND UNCERTAINTY

Not only the diviners but also the clients have their own strategies. For the clients, withholding information is a crucial means not only of testing

the diviner but also of minimizing the influence of the clever smith, for clients want to retain as much agency as possible. Although they trust his performance and the profession, at least to some extent, they frequently choose to get a second opinion, sometimes right after a certain treatment has been recommended. If, in the long run, neither of the treatments is successful, the proliferation of opinions and treatments calls for another explanation and other processes to deal with the situation. One strategy is to start making a distinction between valid and less-valid divinations—that is, between the professional status and the credibility of various diviners. For instance, if some of the failed recommendations came from traveling diviners, their performances are easy to discredit. The social credit they start out with can erode quickly, when it seems they have tricked a client. But then, they can move away. For the village diviners, the situation is more complex. They may suffer some loss of credibility, but their position as smith diviner or as *keleŋu* is ambivalent anyway. So ambiguity, or some doubt or uncertainty at least, is an intrinsic part of the whole divinatory process.[28]

Not only the diagnosis but also most of the medications stem from smiths, rendering the *melu* quite dependent on smiths. In a society like the Kapsiki one, with its norms of self-sufficiency and privacy, being dependent on a peer is not viewed well, but a smith is not a peer. We saw that in the eyes of the *melu* smiths are dirty, dangerous, and full of mischief, but in fact this fits with their knowledge of occult matters, magic, medicine, and also divination. On the one hand considered the "children of the village," they are also dangerous—not yet fully adult but still powerful and unpredictable. Above all, they are the intermediaries between the common man and the supernatural world. The smith category, being not fully part of society, thus comes in handy. For the smith, his expertise in ritual matters and the revenue he accrues from it help balance his lower social status,[29] but for nonsmiths their dependency on a third party in medicinal matters is eased by the fact that these specialists do not really belong to their circle.

This ambivalent view of the smith makes it also possible to separate the expertise from the specialist, and the knowledge from the technician, and provides room for agency for the patient. As the social superior of the specialist, the client or patient can cherish his independence from the specialist and feel free to reinterpret the lack of confirmation along the fault lines in society: of course the smith has said so, because he is a smith and not because it is the truth. If predictions pan out, the technique is correct and the belief is justified; but if they do not materialize, the smith is as irresponsible as any smith and out for his own gain. Of course, the mastery of various techniques differs between smiths, and being smiths they always tell

the *melu* that they are the best. The patient should thus be wary about trusting his specialists' claims too much and be ready to differentiate between specialists. The "internal other" is in an excellent position to issue advice on the deep causes of problems but can easily be replaced by someone of the same ilk.

In contrast to the relative openness of divination, the acknowledged complexity and multiplicity of causes, and the ease of getting a second opinion, the diviner radiates confidence during his sessions and gives his conclusions with great certainty and aplomb. Even if it is obvious during the session that he is groping for the signification of the signs, the resulting verdict will be given in clear and unmistakable language. He formulates the treatment not in terms of trial and error but as a sure way of redressing the problem: he exudes authority. He may make comments about fellow diviners, but this is not usual.

> Cewuve once said something during a crab session (where most of the time is spent waiting) about another infertile woman who had consulted a smith. Her therapy was to have sex with a smith, which is highly taboo in this society. When she started for home, puzzled by this advice, the smith called after her: "Why wait, am I not a smith?"

But these stories are told about faraway places, not about fellow smiths in one's own village. The diviner bristles with confidence and certainty, and the client reciprocates by listening carefully, asking a few questions for clarification, and performing the recommended sacrifices at home. When consulted for a second opinion, diviners are usually aware of this fact, even if they do not usually know the specific outcome of the first divination. They tend to ignore the first opinion and routinely deny the validity of any initial diagnosis. One reason is that clients usually tell the diviner the first verdict only at the end of the second session. Divination as a process is recognized as being complex and open to multiple interpretations, so disconfirmation of the first diagnosis is deemed quite normal by both the smith and the client. The second opinion often uses a different divination technique. The example below is the case of Kwafashè, who already has a son but wants a second child.

> Her husband, Sunu Luc, first consulted a pebble diviner to ask about his wife's (relative) infertility. The diviner suggested a curse but the answer was "No." Then the client himself suggested a possibility. Some time ago, the child had fallen off his wife's back: a bad omen. In such a case, another woman should

first slap the mother and then tie the child back on. Kwafashè, however, tied her child on again herself, as no other woman was present. The diviner came up with the following advice: she had to go back to the same place with an old woman, let the child fall off her back, and then follow the correct procedure. While gently slapping Kwafashè, the old woman had to say: "You must become pregnant again" and then tie the child back on. Some red beer had to be given to the *shala* of that spot. The diviner even said: "If she does not become pregnant again, I will pay you a goat."

After this, Kwafashè's mother consulted the crab in her village. According to the crab, she had to go to that spot at night with a chicken and with her child and a smith. She should let the child slip off her back; the smith then had to cut the chicken's neck, with Kwafashè and the child holding it, as if offering it to the *shala*, leaving its head at the same spot. Then the smith had to tie the child on its mother's back again, with a small slap on the mother's back. The smith should then eat the rest of the chicken.

Kwafashè followed the latter set of instructions because of the crab's renown and her respect for her mother, but mainly because the presence of a smith added to the efficacy of any ritual. At present, decades later, Kwafashè still only has one child, but her son has given her many grandchildren, so the problem has been solved in a different way. However, the diviner never gave her a goat.

The crab gives a broad analysis but with a clear focus on the social position of the client. Both the causes of the affliction and the solution have a high relational content, and relations with kinsmen are crucial in crab diagnostics. In a sense, this is an "insider technique," used for and between people who know each other well, and is a first resource whenever there is a problem. Crucial is that the client can discuss the meaning of the messages with the smith. It is a technique clients can gradually learn if they consult a smith frequently; at least they should learn enough to check on the diviner. After all, a smith is never to be fully trusted.

The option of redress is crucial, and a divination that would not lead to a road for a better future is useless. At present, few crabs are available, at least no *dlera* crabs. What remains on the ever more populated Kapsiki plateau is another type of crab, called the *tɛndɛ*, a yellowish crab that can predict past and future just as well. But with one major snag: he "tells the truth without *mele*." Whatever he says will happen, but there is nothing one can do about it anymore. That, for the Kapsiki, is utterly uninteresting; much better to have the *dlera*, or any other means for divination, that offers a chance for betterment. The *tɛndɛ* may, according to the tales spun

around it, dig itself in and even sing out from its hole in the sand with a voice that sounds like the hammering of the iron by the blacksmith; this is still a useless animal.

Finally, the problem of disconfirmations and contradictions relates to a general aspect of Kapsiki views on what forms important events and serious misfortune in life. Contradictions, of course, do occur—but are seldom seen as a serious problem. Patients do not expect a unanimous verdict from specialists, but a discussion. As variations in divination advice are deemed normal, one diagnosis is not considered sufficient. After all, serious afflictions, it is reasoned, seldom originate from one source or have only one cause. Not only can a type of illness or problem stem from various afflictions, but any problem may stem from more than one reason. In fact, a serious problem demands more than one explanation: why this affliction and why now? And sometimes: why me? Each of these basic questions may have its own answer.

Complexity is inherent in illness and other problems, and more than one option should be explored, with trial and error as the main strategy. As Werbner has indicated, calling divination the ritual of rituals: "It opens our understanding of the people's own interpretative process, for in a sense divination is a ritual that, to a greater extent, operates on a reflexive meta-level."[30] It is the "blind man's stick,"[31] and for anyone walking blindly, it is wise to expect problems. So the general tendency for the diviner is to predict misfortune, and for the client to expect his present misfortune to be a constant companion. As one diviner said: "I'll tell you what the crab tells me. And that is often misfortune, because misfortune is what really happens." This is an important part of the Kapsiki ethnophilosophy: the real happenings for which one has to prepare oneself contain misfortune. Good things, plentiful harvests, harmonious relationships, and good health do not call for an explanation. Divination starts with some misfortune, which is the very reason for the consultation, and then moves into more of the same—that is, disaster, unless the recommended precautions are taken.

Of course, this reduces the problem of disconfirmation. People will not complain about their good luck if possible misfortune does not arrive. If disaster does strike anyway, then divination can be vindicated as clients can always be accused of not having performed the recommended sacrifices correctly. Predicting disaster is, however, not a conscious strategy to avoid disconfirmation; it is more a general attitude toward the future. One of my neighbors told me: "I always go to Cewuve for the crab because he predicts a lot of mishaps. And then you are sure what will happen."

The normal world is one of uncertainty: life is not to be trusted. So divination exudes a certain mistrust of the world at large and the future in particular. Only through a constant revision of one's past, of yesterday, and its consequent rearrangement of today can one hope for a reasonable opening toward tomorrow.

Smith and Ritual

THE CHIEF AND HIS SMITH

A VILLAGE CHIEF IN KAPSIKI IS BURIED IN THE DEEP OF THE NIGHT, completely hidden from the curious eyes of any fellow villager, let alone stranger. Under his *tame* (plaited granary), so inside the compound, his sister's son digs a grave, a deep tomb where his son puts the board that has served as his dead father's bed. *Maze* has to be comfortable, above all, but is surrounded by symbols completely different from the standard funeral. When the tomb is finished, the clan elders gently put the dead *maze* upright, clothed in his largest gown, his head adorned with the red cap of power and a forked walking stick in his right hand. The chief smith beats the sand-hour drum (*deŋwu*) as the elders keep the dead *maze* upright, and slowly walk him to his grave. "Thank you chief, thank you chief," they whisper, and then sing, not a dirge, but the *geza*, the song of war, of victory. They sing softly, for no one outside the compound should hear it. There is no dance, no communal mourning; neither are the traditional three days heeded between death and burial: *maze* is buried quickly after his demise, out of eyesight, out of earshot. The chief smith descends with the corpse into the tomb, and puts *maze* upright, sitting on his bed, his head still below the surface. The smith then climbs out, and all the notables help fill the tomb with charcoal they have collected when coming to the forges of the village. When the tomb is full, the chief smith shuts the narrow opening over the tomb with a flat stone, and all help him in dispersing the dug-out earth over the whole compound. Finally, the *tame* is put over the grave again, so nobody can see the grave. The following morning the dances start, the mourning for the chief. His body is never shown, evidently, but the dances last for six days.

The final rites for the funeral are held after these six days, also in the dark of the night.

Two aspects are of interest here: first, the chief's burial is almost the complete opposite of a standard funeral: hidden, at night, no dancing, a completely private affair, whereas—as we shall see—a normal funeral is long, loud, and very public. The second element, which is crucial for my argument, is the charcoal. In Kapsiki/Higi culture, charcoal is associated first and for all with the forge, and actually with little else. Not only is the chief smith directly involved with *maze's* funeral—which is standard— but the dead chief sits in a tomb full of charcoal, and that is not standard. Though also the rainmaker is buried in charcoal, the only other functionaries buried this way are the chief smith himself and the blacksmith in charge of the main forge, *maze gedla*. So the village chief and the rainmaker, both definitely *melu* (nonsmith) and both representatives of power,[1] are buried in the dominant symbol of the forge, one of the cores of smithhood.

This symbolic relation between smith and political power is not an isolated case, in fact. As mentioned, toward Central Africa one sees an increase of metallurgical symbols for kingship, both iron and brass or copper.[2] But also in this Mandara Mountain area, with its general low status of the smith, links between power and smith are present and acted out symbolically. Kapsiki/Higi culture knows a clear association between the smith and the chief. The chief blacksmith and the village chief perform rituals together (see below), have complementary roles in court sessions, and their positions share some structural features. James Wade has elaborated on this latter aspect for the Nigerian Fali,[3] arguing that the "wife of the village" (the chief smith) has a complementary, almost mirrorlike relationship with the village as the chief does, even if in the case of the Fali the main comparison with the smith is with women.[4] Vaughan, for the Marghi with their petty kingdoms, the next-door neighbors of the Higi, elaborates on the many bonds between king and smith, and concludes: "The king's ties with them [the smiths] emphasize the completeness of his realm."[5] Also the "royals" among the Marghi in some instances eat together with smiths. One of the symbols is a breach of endogamy: the king has to marry one smith woman, a similar rule as in Sukur.[6]

The Kapsiki village chiefs are less distinguished from the common people than in Sukur and surely than among the Marghi, but still the Kapsiki consider the chief smith and village chief as a natural duo; together they are responsible for *kahi meleme*, to organize the village, meaning to perform all necessary duties for the general well-being of the community. Such duties include the performance of the proper rituals for the village,[7] and to mediate in disputes. Their role in these are complementary. In the rituals the village

chief is responsible for the sacrifices that pertain to the whole village, in which he is assisted by the chief smith, while the latter is in charge of the rites of passage, when the young boys have to become adult men. In disputes their tasks contrast even more. *Maze* is the one who does the talking, *mazererhɛ* the one who remains silent, as the chief smith sits at the background, softly clapping his hands when the chief speaks, with an occasional "*niveri, niveri*" ("lion, lion") as general support. When there is a dispute and people talk at the same time, he claps his hands again, until the discussion is on track again with one speaker at the time. "If there is no smith, people will never listen," a Kapsiki proverb runs. The silence of the smith underscores the verbal power of the chief. An iconic rite illustrating this position of the chief smith as a kind of counterchief happens during the funeral. When the smiths have adorned the corpse for the dance, they settle for a drink at the *pulu ŋeza*, the place of honor, in normal times strictly off limits to them. There the *dzakwa ta maze* is served: the chief smith fills his cap to the brim and circulates it among all smiths present, all taking a sip before the chief smith finishes the drink himself. This loosely resembles the chief's calabash, but that is a calabash and is served first, not last, so the *mazererhɛ* serves as a liminal chief during funeral.

In their complementary functions, both the village chief and the chief smith have to act for the general good. The village chief, as we shall see below, is to some extent a nonperson, whose personal interests have to take second place after those of the village, and whose personality characteristics should not shine through in the performance of his calling. The chief smith, likewise, should never be angered, always level in his moods, performing all the much-needed rites of passage with equanimity and good humor. Both Wusuhwahwele, the chief of Mogode with whom I have worked all these decennia, and Gwarda, the chief smith who features regularly in this book, were good friends (Gwarda died in 1993), and the people of Mogode took comfort in their good relationship.

Kapsiki villages have village chiefs, but with a limited mandate and power. Though they are recognized as such by present-day Cameroonian and Nigerian administrations—which does add to their influence—their main function is a social and ritual one, more than political or judicial, more one to create harmony than to pass judgment.[8] There is no traditional authority beyond the village level, other than the Fulbeized Chef de Canton in Cameroon and district chief in the Higi half in Nigeria. But these functionaries have no ritual functions, serve as the first level of official courts, and are embedded in national administration. Any dispute settlement by the village chiefs is done informally, though in those villages farther from the administrative centers, Mogode or Michika, the village chiefs have a larger

mandate. But given the autarchic attitudes toward power in Kapsiki/Higi culture, the deference paid to any authority is small; the village chief has to establish his own personal authority on the basis of his performance as a mediator.

This limited centralization of power is not the rule in the wider area. The Mandara Mountains host a wide array of political organizations combined with a similarly large array of smith positions. The political systems vary from small kingdoms (Mofu-Diamaré, Marghi), major chiefdoms (Sukur), and village-based chiefs (Kapsiki) to acephalous societies (Mafa). Smiths have an important place in all of them, but a varying one, and the level of political centralization does not seem to covary with the association of smith and power; however, centralization of political power does render links with the specialist caste more obvious, with Marghi and Sukur as the clearest examples. Trying to make some sense of this variation, some scholars have posited a historical layer of societies with "smith-kings" as an early phase, which survived in these burial customs and the links between chief and smith.[9] The great variety of smith-*melu* relationships in the mountains then should result from the historical interactions between those smith-king societies and communities where the smith has a lower status. The various scenarios of a smith group arriving in a preexisting village, or a *melu* group immigrating into a smith village, would account for the variations.

One major objection to these scenarios is that they require a historic reading of myths of smith origin. Considering the character of these myths of the Kapsiki and the other groups, I see little reason to view them as statements of origin and surely not of migration, as they are much more salient as statements of identity. So most anthropologists, me included, think that there is no need to read this link between iron and power in terms of historical phases. Instead, metals form a powerful metaphor for many aspects of life in a host of societies[10]; we have seen the brass-iron distinction as a ready pair of symbols in Kapsiki/Higi culture, suitable to express fundamental oppositions within the society. That does leave specific aspects of the smith position, such as the varying levels of endogamy, unaccounted for; however, throughout this book I have viewed the dynamics of smith status as variations on a theme—that is, the theme of "iron plus," with the dynamics of occupational closure, external influences, and ecological constraints as the major factors within the contingencies of history.

Viewing the deeper history of the mountains, the development of the smith position in this area coincides with the waves of jihadist states from the fifteenth to the nineteenth centuries. In order to stay out of history, the smiths tended to be defined stronger as the "internal other," in whatever specific articulation between them and the local powers.[11] Wade,

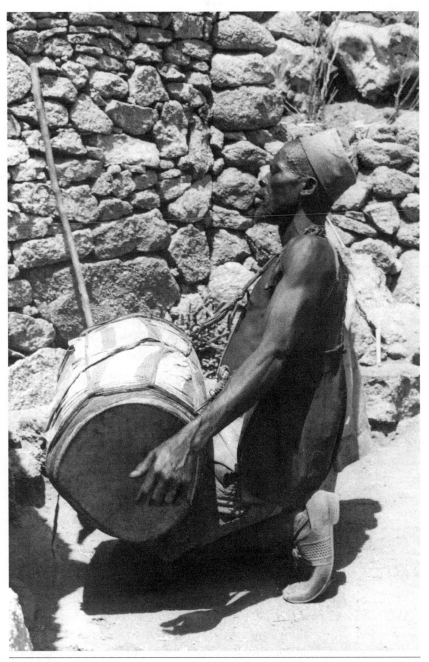

Figure 22. A smith greeting the chief

in a seminal article,[12] ties in caste formation with complexity of the local community, viewing the caste of the smiths not just as a division in society but also as a joining element within a larger community and even between communities.

I started this chapter with a chief's funeral, but the crucial function of the chief smith in the coulisses of village power shows even more in the rituals surrounding the enthronement of the next chief. Both rituals I never witnessed, as my good old friend Wusuhwahwele, the chief of Mogode, was in office when I arrived in 1972, and he is still chief of Mogode, and is reportedly doing well in 2015. He was chosen and installed just before my first appearance on the Kapsiki plateau. Choice of the chief is in the hands of the clan elders. Though all chiefs have to come from one clan, the *maze* clan, succession is not automatic: first, the clan is large and includes quite a number of able men eligible for the position; and second, the Kapsiki prefer someone at the helm who can be expected to look after their well-being, so they choose someone with a fitting personality.

After the burial of the former chief, at least one to four years are allowed to pass, as a chief may not be replaced too quickly. Not all men of the *maze* clan want to be chief, and those who are interested pose their candidacy in a clear, unambiguous fashion: they have their wife brew white beer and present it to the elders of the various Mogode clans, as these are the notables that choose the new functionary. In an informal meeting the latter discuss the candidates, and when they have made a provisional choice, the *ŋacε* clan elder *mnzefε* takes the name to the chief smith, as the crab will have to have the final word. The question is put to the crab, mentioning the indications of the defunct chief, who in his *mid'imte,* last words, should have given a hint to whom "the stick should pass"—that is, the stick of the chief. The crab is asked whether this is correct and should be followed. When the divination is favorable—it usually is—*mnzefε* informs the candidate, and the elders and the aspirant chief brew red beer, *tε,* for the ritual.

In this ritual both "chiefs," *maze* and *mazererhε,* are close, the chief smith forming the background of the proceedings. For such a public functionary, the enthronement is a private affair, attended only by those directly concerned. A group of clan and lineage elders sits in the *derha,* the forecourt of the candidate's home, while hidden from curious eyes the candidate, two members of the *ŋacε* clan, one of the *zeremba,* the wife of the candidate, and the chief smith sit together behind the *tame,* the new chief's granary. The two *ŋacε* are the *mnzefε,* who is of the *jirivi* lineage of that clan, and a representative of the *majiwedawa,* the second of the three lineages that make up *ŋacε. Mnzefε* pours a calabash of red beer and hands it to the candidate:

"Here are the things of the village. If you want to be the man of the village, take them and guard them. If not, then do not accept them and give them back, as there are enough others." The new chief takes the calabash and lets all others drink first, as a good chief should do, and then takes a sip of beer himself. *Mnzefe* then hands him a large gown and a second calabash with the chief's paraphernalia: the *pele meleme*, the village stones, usually old Neolithic bifaces, a small *mele* for his sacrifices, and some weird-shaped calabashes, also for sacrifice. The chief smith finalizes the enthronement proper by shaving the head of the new chief, leaving a small tuft of hair in the middle of his skull. This "sacred tuft" is a symbol for chieftaincy all over this part of the Mandara Mountains; for instance, the Marghi kings wear it, as do the Sukur chiefs.[13] In some groups the chief shows it openly, but the Kapsiki/Higi chiefs always keep it covered with their caps.

The installation over, the festivities start. In the *derha* the elders start drinking and singing *geza* (war songs), and the drums of the younger smiths pick up the rhythm for the dances. Inside, the new chief is dressed in a very elaborate fashion: he is wrapped in bands, cloths, and blankets combined with sashes, tassels, and cords. Thus, he is ready to make a splendid appearance, but he is so stiffly wrapped that he cannot move. One of the notables makes a dent in the wall, and one sister's son of the new chief takes his uncle on his shoulders, while the chief's wife, a cow's tail in hand, climbs over the wall after him.

> The latter is the "wife under the chief," and forms a crucial argument to choose her husband as chief: the elders wanted to be sure that she will never leave her husband for a man in another village—which is a normal feature of Kapsiki marriage. If she did, all women would leave the village, so the elders have to have full confidence in her. For this reason the chief may marry a close kinswoman from another lineage of the *maze* clan, which normally is not allowed, but in this case close kinship is deemed to give greater loyalty between the spouses.
>
> Actually, the wife of the present chief did run away at a certain moment, but to a new man within the village. Immediately the elders went after her and brought her back, carrying her on their shoulders, just as the chief is carried during this installation and as the corpse is carried during a funeral.

The nephew dances with the new chief on his shoulder toward the dancing ground, and all villagers surge toward the new chief, dancing around him, brandishing their lances and swords, and shouting support for their new *maze meleme*, singing the *geza* that belong to all great occasions in Kapsiki

culture. After many rounds of dancing, they put the new chief, who is still unmoving, in the *tsu*, the grind mortar in his outer courtyard, with a large stick in his hand. His head is wrapped, with a tiny slit for his eyes, and all come to pay their respects to him. He never moves and never answers, not a sound. No stranger may be there—that is, no one from another village. This is a strict village affair; should a stranger be detected, he will lose an ear, which is why I could not attend the change in chief in any other village. For eight days the chief stays inside a straw hut, which is built against the outer wall of his compound, where he receives the gifts that all the adult men and women will offer him. The chief smith is one of his faithful companions, as is the *mnzefɛ*.

The whole ritual closely resembles a funeral: the outfit of the chief, being dressed by the chief smith, being carried on the shoulder, all the dances and songs. It resembles in fact much more a funeral than the actual burial of the dead chief does. One clear symbol is seating the chief in a grind mortar—a hollow stone that holds water for the goats at the entrance of the house, a spot without any ritual status—instead of at the place of honor, where a corpse rests during funeral times. So the chief is depicted as a low-status corpse during the festivities, and indeed the Kapsiki explicitly state: "The chief has to die as a person in order to become *maze*." During these eight days in the straw hut, which in themselves are reminiscent of the eight days' seclusion of the *gwela* boy initiates, the chief chooses his *tlewefe*, the adjunct chief, a close friend who will assist him in his duties, all but the ritual ones. With him and with the chief smith, the new *maze* will stroll through the village for the following months, to visit all the wards and ward chiefs of Mogode.

So the chief has to become a nonperson, just like the chief smith, or for that matter, any smith. In one of his speeches, Wusuhwahwele explained what is expected of a chief, any chief:

> "You have to be like the rubbish on the garbage dump.[14] When people throw rubbish on the dump, does the dump complain? Does it protest? No, it remains silent, quietly accepting what is thrown on it. Likewise, a chief has to be, silently swallowing what people say about him, while doing his job. And his job is to range the village, telling people what to do but never making commentaries on how they do it. Just be silent, just be quiet."

The parallel to the advice Gwarda gave to his son is striking: both highlight first the autarchic character of Kapsiki political organization but also the position of the smith in politics and ritual. Throughout, the smith is at

the background of the ritual, offering essential but not very captivating services, both as part of the meeting of elders that chooses the next chief, but mainly as a close companion of *maze*.

So it is for the village chief very important who is the chief smith, and indeed he has a large say in the matter, when a new *mazererhɛ* has to be chosen. The smiths being quite mobile, through their generations, most of the smiths' families are *ndenza*, immigrants—that is, from other villages. Gwarda mentioned this fact in his little speech to his son, as the difference between immigrant and autochthonous villager is at the back of everyone's mind during ritual times; for "normal" times and actions it does not make much of a difference. Those smith families who have stayed long in Mogode, for many generations, are slightly more eligible, but the exigencies of the position come first. Gwarda was the quintessential *mazererhɛ*, reliable, good-humored and even tempered, and a very good friend of the village chief.

After his death in 1993 his succession remained undecided for some time, as the village chief could not really make up his mind. Waɗepe was the one from the proper lineage, but he neither drummed nor played *shila*, and had no sons who did; anyway, he was not overly interested in the demanding job, whatever its prestige. And finally, he lived comfortably in one of the outlying wards of Mogode and had little inclination to build a new compound again at the center. So at the meeting chief Wusuhwahwele had organized, Waɗepe was offered the job by handing him over the "stick of the chieftainship," a forked walking stick, not unlike the one the village chief has. Waɗepe stood up, thanked the chief for the offer but said: "My older brother is here. I came, but he came also and his should be the chieftainship." He then handed the stick to Teri Kwetèkwetè, the oldest of another smith family—and older than Waɗepe—but a family of immigrants, like Gwarda. Teri being a respected person, a smith who is a good musician, a crab diviner, and a healer of repute with a sizable family, the other smiths nodded their consent. Wusuhwahwele was quick to accede so Waɗepe took the *dzakwa*, the plaited drinking cup of Gwarda, filled it with white beer, and offered Teri Kwetèkwetè the *dzakwa ta maze*, as a symbol of investiture. Teri drank first, then Waɗepe, then all the other smiths. The village chief did not drink, as this was a smith cap with smith beer, and so a smith affair and out of bounds for him as a *melu*, but he handed Teri the stick of the chiefhood.

In fact, Kwada, Gwarda's son, was very much interested in the position, but was considered not yet as mature as his father had been. During the funeral of a suicide death, just before Gwarda died, emotions among

the smiths ran high when some of them accused Kwada of maneuvering too much for the upcoming chieftaincy. Kwada defended himself ferociously: "If I have at any time done something improper, people should say so, and anyone who can carry the body better than I can, who can drum better, should simply show it. Show it!" Wusuhwahwulu told me later that he would have preferred Kwada to react more calmly, "cooler." So Kwada was not chosen at that time. After the death of Teri Kwetèkwetè in 2003 Kwada finally became chief, but he died rather young, in 2006. His cousin Ngawa was chosen, but he did not function well, sometimes being absent at crucial times. So in 2009, at the funeral of one of the elders responsible for the village sacrifice, Wusuhwahwulu sent Ngawa packing and made Kwada's son Maître chief smith of Mogode. Indeed, Maître is an able director of funerals, a good drummer, and a good healer as well. But some people have their reservations: a true *rerhɛ*, but, as my assistant assures me, "not like Gwarda."

SMITH AND SACRIFICE

The core of the Kapsiki ritual consists of sacrifices, in which in principle a family performs a house sacrifice. The model is the sacrifice in one compound done on a regular basis whenever circumstances plus divination dictate. In principle the proceedings are private, not secret—as everybody knows exactly what happens during a sacrifice—but they are not open to outsiders. Just the family. This type of sacrifice is performed at several echelons, the compound—usually a nuclear or extended family—the ward, the lineage, and the whole village, as described above. The proceedings always center on the sacrificial jar, *melɛ*, on which a chicken, goat, or sheep is killed, after which the meal is prepared and all eat. In the larger sacrifices—in fact, in those involving at least a goat—beer is also brewed, and afterward, either that evening or the next morning, the neighbors and lineage brothers are called in to drink the beer of the *melɛ*, thus celebrating the ritual. The guests then praise the home owner for his efforts to keep his house and the community healthy and in good shape, thus socializing a ritual that is basically very private.[15]

During an actual sacrifice, no strangers may come in, with one exception: the smith. Smiths, men as well as woman, are routinely invited to participate, as they add luster to the occasion. Usually, a neighbor smith is invited, and he or she can come in during the ritual, joining in at any time, always welcome.

The sacrifice of Tlimu Vandu is already well under way, the chicken killed, plucked, skinned, and roasted, when a neighboring smith woman comes into the house and she loudly ululates and praises Tlimu for his efforts in keeping the house in order. Later her husband joins us to drink from the *melɛ*; he has been helping with building a hut and brings some rice from his daughter's wedding, for the family to taste. When the men, Tlimu, smith, and me gather to drink the beer around the *melɛ*, the women in front of their hut speak with the smith woman. The beer in the *melɛ* is almost finished when Tlimu calls us to witness the "*mekele melɛ*" (lifting the jar), so the smith and I watch him tilting the jar upside down to empty it. This signals the end of the sacrifice proper, with the oldest one, Tlimu, in this case, drinking first of this last calabash. The smith drinks last, from his own *dzakwa*, and softly claps his hands after the final drinking, praising the host. Finally, Tlimu puts the meat and mush in the divided vase belonging to the head of the compound, *helape wulekɛ*, and all finish the beer and eat, clapping their hands to thank *shala*. The smith couple then take their leave, after Tlimu thanks them for coming.

The smith's involvement in sacrifice is emblematic of his status in society. Of course a smith has his own house sacrifice with the same liturgy of the other sacrifices, and then it is through his own deceased father that he addresses his *shala*, his personal god. Never can a smith perform the actual sacrifice on behalf of the *melu*, as the nonsmith home owner has to do it himself, but he is the only outsider one can never refuse at any sacrifice. In his private home, a smith is just a Kapsiki, but beyond the perimeter of his compound he is no longer a private person. For any smith, all sacrifices are open, not because he belongs there as a person, but because he is the "child of the village" and lacks a definite adult social persona. He does, however, add to the occasion, as his presence reinforces any existing social group; so in his position between the living and the dead, the smith strengthens the sacrifice without being an intruder. In short, he is welcome in this private ritual because he is an in-between.

In the village sacrifice the smith is closer to the center of power, the chief and the clan elders who form the core of the corpus of officiators. But here, as well, he will be shown to be a nonperson, ultimately. The village sacrifice is in effect the reenactment of the house sacrifice of the primordial family, that of the village founder and culture hero Hwempetla, held once a year, in Rhungeɗu, the place where the founding family of the village lived.[16] It starts with the village chief consulting the crab, if possible with the chief smith, but not all smiths divine; Gwarda does not. The village chief receives a black goat from the representative of the *makwamte* clan,

a goat that has to be caught. Very early the next morning the five elders assemble at the house of the clan elder of the *ɲacɛ*, the *mnzefɛ*;[17] the man from the *gwenji* clan carries water, the representative of the *zeremba* brings along the black goat, and *mnzefɛ*, *maze*, and the chief smith follow with flour, salt, and firewood, all with their bows and arrows. They follow the tracks that the mythical hero and village founder Hwempetla made on the ancestral mountain, and at a hollow stone they change into the traditional goatskin pants. A short climb up the mountain brings the officiators to the old ancestral compound of Hwempetla, at the southern edge of the mountain. There a large heap of broken pots all but covers the real village *melɛ*, two small pots 30 centimeters in diameter, an old, broken pot, and a new one. Gwarda waits for the chief to indicate the start, then *mnzefɛ* takes the goat and he as chief smith the knife. They both hold the goat still over the *melɛ*, and *mnzefɛ* slits its throat; the blood should pour over the *melɛ*. Mnzefɛ pours some water in an old cup and puts water in the goat's ears: only then does the goat die.

Neither of the men speaks when the two officiators skin the goat and cut it into pieces. The *mnzefɛ* takes the skin and the breast, Gwarda the head of the animal, and the rest of the meat will be cooked before being divided among the other men. With the water and wood they brought along they cook the goat and make some mush from the flour. When they are ready, the *gwenji* elder takes some mush and cooked liver in his hands, and while all crouch around the *melɛ*, he puts the food on the jar:

> "*Shala*, we come to greet you. Here is some food. We brought you some food today. Give us all the good things so we will be good in your wake, and we shall be able to bring you food again, greeting you again like we do now. If there are evil things, keep these from us, and let only good things happen. We do this now but it has been done of old."

Four times the officiator then puts some of the mush and liver on the *melɛ*. The others speak softly with him and clap our hands: "*Hana shala, hana shala*." The *gwenji* elder then hands out a piece of mush and liver with both hands to all—but not to Gwarda—each of them saying: "Let us be in good health and let the *melɛ* be good," and they put the food in their mouths, the liver and mush all at once. Finally, the *gwenji* representative puts some *safa* (Combretum) leaves on the *melɛ*.

The main sacrifice is now over, and *zeremba* takes the remainder of the mush and the meat from the pot and divides it up; now Gwarda also gets his portion in his special plaited cap, the *dzakwa*, and all eat. The four *melu*

get the goat's legs and Gwarda the neck; he then hands a leaf with some goat blood and excrement to three clansmen for the *mele* of their clan ancestors. Smiths have no proper clan, so Gwarda has no jar to sacrifice on; also *zeremba* has none, so he and the smith wait for the others to finish. Each takes the mixture of blood and cud on the leaf to the *mele,* and utters: "*Shala, shala pele rhweme*" (I want to be healthy), then puts it on his *mele.* Gwarda takes some half-digested food from the goat's third stomach, and all men smear their breasts with it, around the heart, thus bringing the sacrifice to an end. The five collect some grasses, take their bows, and list the enemy villages: "This one for Sena, for Rumsiki, for Sir, for Sirakuti, for Kamale, for Rumsu." For each of these villages a stalk is fired off "in order to shame them." Then they chide their enemies: "Ah that man is dead; thank you, my child. Sing a song of rejoicing." After mimicking the killing of enemies, they make their way down and put on their clothes at the hollow stone. At home they distribute the sacrificial meat among some small boys.

After a month the men prepare the second part of the proceedings, the sacrifice at the place called *shala*—in fact, the burial place of the village culture hero, Hwempetla. Again the chief "hears" the crab, and informs the village. Ten compounds of clan elders gather the sorghum for the beer, which *mnzefe* uses to brew the beer for the ritual. At the appointed date the five officiators assemble in the house of the *mnzefe* and set out for the bush. Well before the burial place they undress and put on their goat's skin. Farther along the path two tombs are hidden in a small stand of trees, Hwempetla's is the higher one, and the lower one belongs to his wife. The men carefully cover the two mounds with branches: no stone may remain in sight. The ritual is simple: the *mnzefe* pours beer over both tombs and fills two grind mortars with beer: "Let us be healthy, *shala*. We have given you food to eat; we gave you enough, now you give us enough to eat." The five then drink themselves, the four *melu* from a calabash and Gwarda from his plaited *dzakwa*. Gwarda again collects some mud, and everyone puts this on his chest. They dance home, singing songs, and put the mud on the entrance of their wall, a ritual spot in each compound.

The next morning a collective drinking feast at the *mnzefe*'s house calls in a large crowd, the young men gathering at the lower end, the old men at the higher male side of the forecourt.

Here I was present. Kezha, the *mnzefe*, takes from his compound two jars of beer, one for the elders and one for the youngsters, and explains why we are all together: "Our business has been done. Like the sorghum is gathered, so are we here, as always. Even if the beer is not very good, we drink anyhow." The men

softly applaud: "Thank you, thank you," and then the first beer is poured by a young clan brother of Kezha. Every drinker pours a little into Gwarda's *dzakwa* sitting near the jar, as all clans should contribute to the smith. When the two jars are finished, Kezha brings out his own *melɛ*, also full of fermented beer, and the old men continue drinking.

In this session of the village sacrifice, called the *tɛ ba* (beer of the epidemic), the young *ŋacɛ* distributing the beer uses not a calabash spoon but a *dzakwa* like the smith's made by Gwarda, which belongs to the *mnzefɛ* paraphernalia and is used only at this *tɛ ba*. Kezha receives the first cap of beer, then the leader of the ritual hunt, the chief, and the other clan representatives of the sacrifice, while the chief smith gets the last one. Only then do the others dare to drink. The youngsters prefer not to drink any from the *dzakwa*, as ritual beer carries an inherent danger, not called the beer of the epidemic for nothing. The *mnzefɛ* spits into the beer and pours into it: "Keep my compound and the village well in case of war; this cap has to protect all people going out into the bush."[18] As usual, drinking calls for speeches, by an old man:

> "Thank you, *mnzefɛ*, thank you. It is fast! When the right time is there, one has to honor *shala* and not delay. At the start of the dry season, the *tɛ* has to be drunk, quickly. Why wait? We always have to think of *shala*, so why wait for his sacrifice? Now *shala* will say: 'My people have thought of me, I shall give them all they want.' Thank you." Of course, everyone agrees.

The smith was a full participant in the first part on the mountain, but in the second part his role is limited—in fact, just his cap is important. At no other occasion will the *melu* drink from a smith's *dzakwa*, and even here it is a special one, reserved for the occasion, and it is used only in scooping up the beer. That inversion highlights the special occasion, and though this "beer of the epidemic" has a smith association, it also reduces the role of the smith himself to his paraphernalia; the notion of the smith is present, but now he is a complete nonperson.

In the sacrifices at the various echelons, the smith is the absent-presence, the one in the background who is either the right-hand shadow of the chief, as in the village sacrifice, or just any smith, as in the house sacrifice, or just the idea of a smith, as in the *tɛ ba*. Here he is not the transformer but blends into the background, the silent one. But in the rituals that intend to transform—the rites of passage—the role of the smith is much larger, and that is what we will see in the next two sections.

AN IRON WEDDING

Weddings are important occasions in Kapsiki culture, and the smiths have a variety of functions in them, both in the traditional and in the modern versions of the festivities. Marriage being one of the foci of Kapsiki social organization, both the gift exchanges and the rituals are complicated and lengthy[19] and here will be touched upon only to highlight the role of the smith and his products. First the wedding, in which one primary blacksmith product, the iron skirt called *livu*, plays a decisive role. We will follow the course of the *livu* in the wedding of a *makwa*, bride, in Mogode and the trail of iron in weddings in general.

One day in April the bride's father invites the wives of his other sons to prepare the *livu*, the *makwa*'s iron skirt. He bought it some weeks ago from a smith across the border, in Nigeria, where many things are cheaper, including these iron skirts. Yesterday evening the groom brought four jars of beer and told his father-in-law that the wives of his clan brothers would come the following morning to prepare the skirt. The women arrive, more than willing to do their part. Theirs is a simple but important job, and it is well remunerated, as there is a lot to drink and the groom will give them presents. Later, the groom will add the price of the *livu* to the bridewealth. The skirt only needs minor modifications: a rope has to be replaced by a string of cow hide, and the number of small iron shields has to be rendered even, in this case reduced from fifteen to fourteen. Of the six women present, two busy themselves with the task at hand, while another makes a bundle of bean fibers that will serve as the bride's intimate cache-sexe, the *rhuli*. This is another important symbol of womanhood, and it is wearing this particular *rhuli* that helps to transform a girl into a woman. When finished, the four oldest women, the bride's mother's sister among them, take a large draft of beer and spray it over the *livu*: "You must repay the bridewealth quickly, so get many children." They then leave for the groom's house to receive their presents (of food) and pester him for more beer. Later they will try the same at the houses of their respective husbands, the groom's brothers.

Each bride is decked out in iron, for the skirt is not the only piece of iron she wears. Iron bracelets adorn her wrists and sometimes also her ankles, and she has iron rings on the fingers of both her hands. Her bridesmaid wears a girdle of iron beads, as may the *makwa*. Iron beads, according to Kapsiki blacksmiths, are among the most difficult shapes to forge, and, as a consequence, they are quite expensive, much more so than brass beads.

The modification of the *livu* opens the wedding preparations. Throughout the proceedings all parties involved consult the crab—that is, the

diviner-smith—for specific instructions on details of the ritual: whether there has to be "amusement"; how exactly to perform the sacrifices; what both the groom's and the bride's family have to sacrifice; and—important for both family heads—how to avoid problems when the bride enters her new abode. The diviner's role of the smith is crucial in the preparatory phase of all large rituals, marriage, initiation, and funerals, as well as during the year festival, *la*; but there are also other roles, especially roles that follow the trail of iron that runs through the wedding—and for a large part that is the trail of the *livu*.

> Just before the "calling of the bride," the moment of transfer to her new home, the bride and the groom have their heads shaved in their nearest smith's compound. That evening, the last one in her father's compound before her marriage, the bride calls in her *mehteshi* (female companion or "bridesmaid") and ties the new *livu* around her companion's waist. Both set out for the well; the *mehteshi* washes the *livu* on her own body; the bride washes too and then, for the first time, puts on her newly cleaned iron skirt.

The *livu* is indeed important; it is the bride's central piece of adornment. She will wear it when called to her husband's compound that very night and on all festivities in the year to come until the next harvest season. During the *verhe makwa*, the wedding feast, she will wear nothing else. Her husband's mother's brothers will bless the marriage by spitting red beer over her body and the skirt. Later, when visiting her new father-in-law with a ceremonial gift of millet mush, she will just wear the *livu* and cache-sexe. On the closing days of the boys' initiation, when the future brides (*makwa*) of the village gather on a mountainside for a two-day singing contest, their *livu* will again be all they wear.

But this is the first time that she will wear her own *livu*, at her own wedding. When the groom's delegation arrives, accompanied by a smith with his guitar or one-stringed violin, she is ready, and so is her father. The groom's representative has five small jars the groom has ordered from a smith woman (on the orders of the crab divination, the larger number of jars is what is called "amusement" in the divination). One of them is the new *melɛ* for the bride and is hidden in the calabash.

Arrived at the house, the children start to sing: "Give us the women, the ones calling her are already under the firewood [which lines the low forecourt walls]." They have to wait long for a reaction. The bride's mother's sister comes out of the house and accepts the calabash and the gifts: she will be the *kweperhuli*, the bride's guide, an important functionary in

Figure 23. The bride decked out with the finished *livu*

the proceedings. The bride's father then calls in all the family, the *kweper-huli,* and a little boy who will accompany her, to attend the sacrifice at the entrance to his hut, following, again, the directions of the smith diviner. The moment is tense, and people are careful to follow the smith's instructions to the letter.

Well after midnight the bride appears, clothed in her *livu* and *rhuli,* with a plaited straw cape over her head. She kneels in the wall opening, facing inward. From inside the house her father, in the quiet that suddenly reigns, gives her his blessing and advice, usually directed at being obedient to her new husband and conceive children. He then takes a mouthful of red beer and sprinkles it generously over her. Quite wet, she walks with her mother's sister and a little boy toward her husband's group, and, after some additional ceremonial skirmishes, eventually enters his compound and her own new hut.

The trail of iron indicates the most intense ritual moments of the complex wedding festivities. In the afternoon of the next day, the crucial moment is the blessing of the bride by the groom's mother's side of the family, the *ksugwe* (in Kapsiki, both types of kinsmen are indicated with the same term, *ksugwe,* but the distinction between the mother's brother—the great *ksugwe*—and the sister's son—the small *ksugwe*—is still crucial). With some invited friends they all eat and drink, while the groom brings along four jars of beer, one of which is his *mele.* This has to be the best beer, and he thanks them for their presence, telling them they have to be content and happy, and that they agree to this marriage. They tell him not to worry and hand over money and tool blanks (*duburu*) as a special gift, in addition to some small pieces of iron, *wudu makwa,* which are passed on to the *kweperhuli.*[20] Together they help the groom out with a dozen bars and cfa 4000. The first calabash is for the village chief, who is always among them. He pours some beer on the ground:

> "She has to bear a daughter and then again a daughter. We give to the people who are dead. If there is anyone with evil wishes and thoughts, let him stiffen. Let the groom marry more women and all be healthy."

The groom pours beer for a second time from his *mele* and passes around the calabash. Everyone present spits in the beer, and then two of them, often the initiation father and a classificatory mother's brother, walk over to the *makwa,* who kneels in her door facing them, clothed in just her girdle, her plaited cape, and, of course, her *livu.* The groom's initiation father takes a large mouthful of beer and sprays it over the bride, saying: "You have to be

healthy, bear a lot of children and pay the bridewealth. Bear children right after one another." Then the second man, a *ksugwe* (mother's brother), does the same: "Bear children one after each other, fast," and he sprays the beer over her. He then hands the calabash with beer to the *makwa*, who is supposed to drink it all. As the beer is full of spit, she pretends to do so and douses herself with the rest of the beer, or she may give it to a smith woman to drink if one is present.

The last item on our iron wedding trail is less ritual but just as crucial. That evening, close friends stay until nightfall; one of them brings two jars of white beer, for the *kwageze rhena* (literally, to say the word—that is, intercourse), and with other friends seats himself on the doorstep of the bride's hut. From inside, the *makwa* throws her iron bracelet toward her new husband: "Here are your things." He tosses it back to her, and they both throw the bracelet once more, and then "start talking," meaning verbal and later sexual intercourse. Outside the hut and listening to the proceedings inside, the friends drink beer, happy when they hear muffled sounds coming from the hut. The bracelet will remain with the bride and feature in her burial rites.

The smiths play an important part in the playful proceedings that gradually have accrued to the wedding, the *hirdɛ* and the *amalɛa*: shows of conspicuous giving in which the smiths play the roles of musicians and "interpreters." Here we follow the smith's involvement in the ritual that follows the wedding proper, the initiation of the girls at the "singing rock."

The wedding completed and the bride integrated in her new family, she and all her cobrides from that season wait for the boys to be initiated, which also for her means the next phase of her "becoming a woman," her initiation. This is done as a group. The girls have witnessed the start of the initiation rites of the boys, *gwela*, but will as a group participate in the rituals that end the boys' confinement. With their girl helpers, *mehteshi*, they head for the chief smith. Each *mehteshi* wears a string of iron beads and at the smith's takes off four beads, which she gives with some of the food as payment to his wife for the operation the smith is about to perform. First Gwarda shaves the hair of the *makwa* and then makes three vertical incisions in the underbelly of the *makwa*. Some terrified girls just get a stroke with the back of the knife, with the brave ones looking on in some disdain: they are sure of receiving their family's and husband's admiration later. The small incisions have to become scars. The girls are "operated" on according to their husband's clans: *maze, ŋacɛ*, and *makwamte* go first, and then the other three clans. No distinction is made between smith and nonsmith girls.

Figure 24. The *makwa* getting her incisions from the smith

Around ten o'clock this year's brides have their incisions and go to Rhwemetla, the initiation mountain. At 100 meters to the west of the out-crop the girls kneel and eat the food their assistants have brought, grouped according to their husbands' clans. After finishing, the girls take off their cache-sexe and walk to a flat boulder some 30 meters from the entrance to the cave, wearing only their *livu*. Again they kneel down, now in the order of their marriage date, the first-wed at the front. Clothed in just their iron skirt they crawl in single file toward the cave, slightly wary because the mountain's *shala* is reputed to catch witches. If one of the *makwa* turned out to be a witch, Rhwemetla would grab her and keep her immobile until she made a substantial offering of iron beads. She would also suffer a severe loss of face in front of the whole village.

This ritual approach of Rhwemetla is the high point of the day, the rest of which is a kind of song contest. So the *livu* features in all the stages of a wedding, as it will in the *la* feast at the end of the season. But the skirt also remains important long after a girl's *makwa* days. Her father had actually bought it "for the dance," meaning his own funeral dance, and any father who has not given his daughter a *livu* will be chastised after his death in her funeral chants. At her wedding, her husband later will reimburse his father-in-law with one or two goats for the skirt or, in the past, several *duburu*. Any groom who fails to give money or goats for the skirt will hear his father-in-law remember him loudly for this central debt. This blacksmith's product has become easier to produce, as iron from abandoned cars is abundant now, even though it is still considered a "tour de force" for the sheer amount of work involved. Girls want to have a *livu*, and although they may borrow one, they want their own.

At some point later in life, a woman will take the *livu* out of her chest on festive or ritual occasions, smear it with ocherous mahogany (*Khaya senegalensis*) oil, and dance wearing it. When her son is leaving the seclusion of his initiation period, she will honor him by wearing it. Just as her son is born "from the *livu*," as some Kapsiki women put it, so on his return from the bush will he be greeted with it. The most common reason to dance in her *livu* is the burial of kin. When mourning a deceased clan member (male or female), her husband's clansmen or a friend's kinsman, she once again ties her iron skirt around her waist. During funerals the skirt serves as a musical instrument as she beats out the rhythm of the drums by hitting it with a calabash while the smiths lead the dance to commemorate the deceased. At her own death her daughter may inherit her *livu*, as she herself will not be buried in it. Rust will set in, and her daughter will wear it at the concluding rites of her mother's funeral. If it is not worn out by

then, the daughter will use it as a second *livu*, wearing it under her own to dance in at her marriage.

Weddings have changed dramatically in Kapsiki society, but the *livu* has withstood change better than most of the other parts of the ceremonial costume. Brides no longer wear just their iron apron, and nowadays they are decked out in their finest dresses, as is their entourage. But the *livu* is still there. In the 1980s, brides began to wear their *livu* over their other clothing. After 2000 it was sometimes worn under a dress or even just carried inside a calabash. The groom's *ksugwe* still spit on the *livu*, even if they no longer spray the bride with beer.

Why is there so much iron on the bride? The Kapsiki offer two interpretations for iron. The first is wealth. Although the main expression of Kapsiki wealth are cattle and brass, iron also has a role to play. Some of the women's bracelets are iron and, as such, are a small indication of wealth. In the marriage proceedings the flow of iron follows that of the bridewealth. Marriage presents a new kind of wealth for the groom, namely offspring. The Kapsiki language distinguishes between two types of wealth: *ncɛlu* and *gelepi*. The first refers to wealth in material things, the second to riches in people. Marriage, through the payment of bridewealth, is precisely the transformation of the former type of wealth—goats, cattle, and money, all of which are considered fleeting and unstable—into the latter, the true and stable form: related people. The bride's iron gives symbolic expression to that transformation.

A second, more pervasive association is that of stability and immobilization. Medicine and magic tend to "walk away" if they are not in iron containers, slaves used to be put in iron clamps, and likewise the *makwa* should be decked out in iron to have her "stay." Iron, in short, is the central symbol of belonging, of the bride belonging in her new social network, the symbolic means of creating stability in this union and transforming the fleeting nonhuman wealth into stable human wealth. Strips of bull hide used in decking out the bride are part of this symbolism. One string of hide is put into the *livu*, and the larger forms the girdle that the *makwa* wears during the rituals. Symbolically, she wears the link between the two families—her husband's and her father's—through the bridewealth and the wedding. This piece of hide is later used as a symbol of mourning, and, when her father dies, the former *makwa* wears the hide for a whole year as a *shiŋli* (a mourning band). She is the link between families, and her attire testifies to this. She just has to stay.

SMITH AND INITIATION

While in the wedding procedures the smiths are mainly present through the iron and a small operation done by the chief smith, in the boys' initiation their role is quite different. First it is not iron but brass that shines on the boys; and second, the smiths are the main instructors of the initiates during their liminal times—in fact, their link with the past.

> At the first day of the initiation both the *gwela* and his helper head for the smith to have their heads shaved. As this is their last day of mobility for the next week, the initiates use the occasion to pick up two pots from the smith woman, which they need for the ritual that night. When all the *gwela* are present, the chief smith starts shaving: the first three clans first, the other moiety next. He has to use a traditional knife, even if razor blades would be easier, and he also shaves their eyebrows. The *mehteshi* are also shaved.

So let us follow a *gwela* who decorates himself. He ties a brass triangle on his forehead, and chains of glass beads in many colors, if possible old mosaic beads and pendants made of old medicine vials set with red berries, add a feminine touch to his outfit. He slips a few shiny brass bracelets over his arms and ties on a cowrie belt with a brass bell in front and at the back a brass medicine vial. His head is decorated with strips of plaited *peha gamba* (cf. Phoenix reclinata); his brother ties an inverted U-shaped piece of *peha* with some leather strips to both his calves. Finally, he takes his lance and a small shield as the final accompaniment to his outfit. A brass or iron bell is tied with cowhide to the lance, as are some brass medicine vials.

No distinction is made between smith and nonsmith, and any smith *gwela* participates just like the others. The whole ritual is one of communitas, of equality between all participants. Most rituals are performed by the lineage elders, but the smiths come into their own at the end of the initiation days, when the *gwela* have to be shown the deep history of the village. After the public rituals, the boys take a farewell of the crowd and head for an old smith who "knows." Lined up with their lances in hand, they follow him in a course around a series of special spots, to remember the people of old. Hidden in the long grass lie old grind mortars, remnants of old houses, and in each of these the *gwela* put their lances and sing the first lines of songs of the wedding, the harvest, and the funeral.

Under the guidance of the smith the boys pursue their initiatory trajectory. Their final destination is a sloping rock where the chief *gwela* takes up the highest spot with the others close to him. The rock is called Kwatladlerevè

("the place to chase the dragonfly"), and that is exactly what they do. The *gwela* put down their lances, and the *mehteshi* make a line at the bottom of the mountain and beat the grass with branches to scare the dragonflies. It is difficult to see in the dusk, but the spectators as well as the *gwela* keep very quiet waiting to see what happens. The first try seldom succeeds, but after a few times at least one dragonfly settles on someone's lance, and the smith has to ascertain on whose: that boy will marry quickly and have many wives and children. Some years there are plenty of dragonflies, some years none at all. The smith told me that if there are none in sight, after three fruitless attempts he himself will announce the lance the insect has landed on, as by then it is so dark that nobody can see it anyway.

After the initiation all new adults have to cultivate during the next rainy season, and the initiation proper ends at the year festival, called *la*, where again the smith takes up his role as a guide for the boys, finalizing their transition.

It is December now, and the high point of the *la* festival, called the *dzirhwa* or crossing the river.[21] In their homes the *gwela* assemble for the final rites of their initiation. Everyone is in full dress now: antelope skin, brass objects, and cowrie shells, carrying a lance decorated with the only addition to their outfit, the neck hairs of a ram. Their fathers give them a blessing when they leave the door: "You have to work hard, marry women, get children, and have respect for your father. Avoid the lazy people, do not follow a bad example."

Their *kweperhuli* accompany them, carrying sorghum stalks, and so do the older brothers who first tied their goatskins, loudly banging on the shields they carry. Their *mehteshi*, young helpers, also come along. At the gathering place close to the rivulet called Kwanjakwanja (little calabash), chief smith Gwarda waits for them with his hourglass drum. Each time a *gwela* arrives, amid the loud shouts of his troupe, he joins Gwarda, and they dance in a small circle, singing: "*a kwanjakwanja, a kwanjakwanja*". Gradually the line of *gwela* gets longer, while a few hundred meters up the hill the villagers gather, waiting for the big moment. The ritual elder of the *ŋace* clan warns the boys not to stay in the river too long as they have to finish before sunset—and if anyone stops them, they should stab him with their lance. In fact, the brothers of the *gwela* help their own brothers but sometimes try to trip other boys up. Those *gwela* who are not "real Mogode"—that is, who are descendants of immigrants—skirt the crossing and go straight to the chief on the hill: it is not "their" brook! The *ndegwevi*, the autochthonous boys, bend over and walk behind Gwarda to the river, crouching as a sign of humility (as Gwarda explained to me). Silently and cautiously the boys approach the riverbed,

which is just a trickle of water, while their helpers wait for them on the other side flanked by this year's *makwa*, who watch the proceedings of their *mandala* (year-mates) with great interest. This is the boys' *kwaked aŋe*, last ritual, and now they leave their youth behind. Following the smith, the *gwela* quickly cross the river, the water hardly coming up to their knees, more a symbolic journey than a test, but that holds for most parts of the Kapsiki initiation. In any case, by crossing the brook crouching just behind the chief smith they become a man.

Sometimes, the smith not just follows tradition, he also instills it. In Ldiri in 1998, the chief smith uses the occasion of the crossing of the brook to instruct the women gathering around him. Some of them get impatient—this is very much a mother's feast—and come too close to the crossing place, so the chief smith instructs them:

> "Do you know what is buried there? Do you want the *gwela* to spoil? If so, tell me. If so, we will write a letter and we will see you in Mogode [at the court of the Lamido]. Do your job. I am the little one, but still I am older than you are. So surely women should respect that. You will respect me, even me being a woman [the notion of the smith as a village woman]. You, women, respect me, and let god then bless them with children twice a year."

His task is to keep the village "cool," prevent "heat," and this ritual should produce coolness, the living people who are cool, fresh, and vital. The language of the senses is also an emic one, even if the appreciation of the warm-cold distinction is just the reverse of what a European would expect.

THE INTERNAL "OTHER" AS A TRANSFORMER

Surveying the role of smiths and smith products in both initiation rites, four aspects stand out. First, the smiths mark the transition of the girls and boys from their home environment to their liminal phase by shaving their hair or by making incisions. The actual "rites of separation," as called in anthropological theory, are much more complex than just that, so in fact the smiths have a small role only. But it is a significant one because it is the small bodily change that marks the start of the initiation phase. So the smith marks the liminal time for both.

In the second phase, that of the initiation proper, it is not the smith himself who is important, but the smiths' products that are important: iron

for the girls, brass for the boys, just as the *dzakwa* (smith cap), was in the last part of the village sacrifice. The *gwela's* clothing and decorations convey the message of a successful warrior (skin, shield, and lance), with brass as a symbol of wealth as well as a link to the bush, as we noted. The *gwela* will be men of the bush, bringing home the wealth of others, like the bees do. The dragonfly ritual carries a similar message: masters of the bush. The symbolic opposition here is clear: stability and belonging versus mobility and danger; and in Kapsiki culture this shows in the two metals, which form the core of the outfit of both boys and girls.

Third, in Kapsiki culture the smith is primarily a craftsman, also in ritual. His role is more determined by birth-plus-craftsmanship, and less by notions of special power. In contrast, the Tuareg smith/artisan bases his ritual efficacy on a notion of supernatural power, as does the Mande smith. Both languages have a word for impersonal power, respectively *tezma*[22] and *nyama*,[23] which allows for an interpretation in terms of occult forces. In Kapsiki religion such a notion of mystic power does not exist, nor does Psikye have a word for it, so even if smiths can be considered dangerous by *melu*, this awe is not expressed in terms of inherent power. The smith can serve as an intermediary with the other world just because he is a *rerhɛ*, and the same holds for his artifacts, which are special because they are smith-things. The ambivalence of his position in society seems to be a sufficient explanation for the prowess of the Kapsiki *rerhɛ* as transformer.[24]

The final aspect is the link with history. In the boys' case, the smiths function as teachers and guides, leading the ritual ending of the second phase, where they imprint the history of the village on the boys, now men. So at the end of the initiation it is the smith, not the village chief or the *mnzefɛ*, who leads the boys through the water—a ritual that people try to charge with symbolic danger, even if it is in fact quite simple—the danger of the crossing highlighting a river crossing as the final symbol of transition. So, all in all, the smiths facilitate the transition from youngster to adult, especially when it is done collectively, transforming the fertility of the bride into a lasting presence in the patriline and defining the new young adults as "warriors" with deep roots in the past, dwelling in the mountain environment. At the final *la* rites in December, the new adults, young warriors, brides and also new grooms are feted and celebrated in what is effectively a "harvest of people." The transition is produced by the village as a whole, but never without the smiths. They are the ones who mark the beginning, they are the ones who furnish the music for the dances, and they are the ones whose products define the new adults in their new roles. So, finally, in the reproduction of society, the smiths are again the transformers.

Not much about specific senses in this chapter. Yet the role of senses as transformers brought together most facets of the smiths' crafts we have seen up till now, through iron, pottery, brass, drumming, and divination. In their ritual functions the smiths work with the results of their various trades and behave more like the *melu*, the nonsmith, than in their individual special-izations. Inside the rituals they are important and even essential, but not prominent. In fact they are present on a larger scene dominated by the *melu* majority and lack their own "place," the circumscribed space separated from normal life through a specific craft. These rituals define a public space in which smiths have to fade into the background, as service providers without their own territory, as "children of the village" indeed.

CHAPTER 8

Masters of Healing

DIGGING FOR "THINGS"

KWASUNU THOUGHT I DID NOT BELIEVE HER, AND SHE WAS RIGHT. During my first visit, this smith woman from neighboring Guria had explained to me how she treated her patients: she rubbed their body and then extracted the foreign objects that had surreptitiously lodged themselves inside the patient or victim. The Kapsiki call this *kwantedewushi*, digging up things. Bone splints, stones, or even small animals were sometimes projected into the victim's body. Sometimes it was a question of contagion, as when walking over a spot with small frogs that entered one's foot and multiplied in the body. Somehow she sensed my skepticism, which in true anthropological fashion I did try to hide—for an informant is always right, and doubt should never be obvious. So I did not hide well enough the second thoughts any anthropologist has in viewing this worldwide medicinal technique of taking foreign objects out of a patient's body, leaving no wound, no scar, not even a drop of blood. The diagnosis that someone is ill because of objects projected into his body is also near-universal, and the two are a continuous challenge to the methodological stance of cultural relativism in anthropology. Alright, I failed in hiding my doubts. Kwasunu felt challenged and said she would invite me when she had a patient so I would be convinced. That was, of course, very welcome.

So here I was again, and the smith woman was treating a boy of about twelve years for such an affliction: he was very thin and had a swollen abdomen, and her diagnosis was *kwankwerekwe*: little frogs (the name is onomatopoeic, in fact an ideophone) that had entered through his feet and were amassing in his belly. She had to take them out. The boy kneeled

before her, a large bowl with some water between her feet; she rubbed his belly vigorously with some special leaves[1] and suddenly showed him—and me!—a little frog. Alive or dead, I could not see. She put the frog in the bowl, seemingly pounded it with a stick, took a scoop of the muddy water with the leaves and rubbed again. In the course of an hour she had "extracted" some twenty frogs from the belly. Afterward, she gently reproached me: "Last time you did not believe me, but now you have seen with own eyes." Yes, I had indeed seen it, even taking pictures.

My doubts had not disappeared; I might have seen the same frog twenty times, as with some legerdemain she could easily scoop up the animal with the leaves in her left hand. But Kwasunu was convinced that I was convinced, so that part I must have played well. In fact, I wrestled with the Western idea that I had to take the boy to the hospital; he probably suffered from some amoeboid infection, and my role in the village anyway was to be an ambulance. Getting the child to the hospital would fit in with this; but then he had to ask. After much soul-searching I did not, as nobody asked

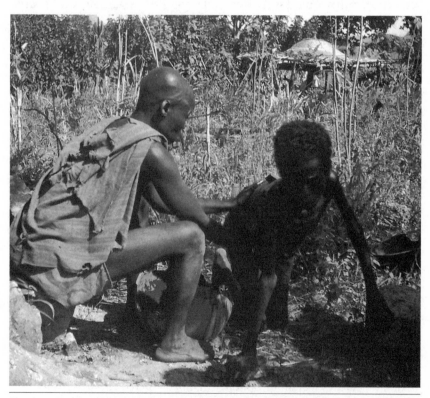

Figure 25. Kwasunu "extracting frogs" from a boy's belly

me, and usually the Kapsiki were not slow in demanding my transportation services. So I left. I later inquired what happened, and the answer was very straightforward: the boy had stayed two weeks in this treatment, getting "extracted" three times a day, and in the end got better and went home to his village in Nigeria.

This is one issue where questions do remain, difficult questions about belief. Lévi-Strauss pointed out that the situation is complex, as not only faith in the treatment is evident in the boy and his "therapy group," but also belief in the explanation. I am the doubter, but it is difficult to imagine that I am the only one. The healer in question, Kwasunu, must use a fast hand and a clever tongue to convince the boy and the bystanders that real frogs are coming from a real belly. How conscious is she of her dexterity? Lévi-Strauss argued that in this common shamanic technique the sleight of hand of the shaman hardly distracts from his own faith in the treatment and in the essential correctness of his explanation. In our terms, this kind of healing is also a craft, which has been learned, internalized, and stored in the less accessible parts of one's brain. In the end I did not try to pierce the gentle wall that Kwasunu had woven around this treatment, and I respected her discourse. The boy did heal, after all, a huge relief.

THREATS

For the Kapsiki, an illness is an unwelcome but expected guest. The etiology of affliction is complicated and often vague in Kapsiki, as in many African cultures.[2] In anybody's life, illness is to be expected and in itself does not call for an explanation but for treatment. On the contrary, continued well-being and health do require explanation, as does a persevering illness.

As Kapsiki explanations of afflictions go, in principle there is no hard and fast distinction between somatic and nonsomatic afflictions, one reason that the word for medicine, *rhwɛ*, has a much wider meaning than just medicinal applications, encompassing also all magical means. What, then, does affect a body? First, illnesses as such are recognized, somatic afflictions resulting from some contagion, infection, or other disease factor, a natural invader. Malaria is one and lung diseases are another of these invasive diseases. Some of these infective diseases are more than just a presence and accrue a personality. First, Death itself is a person, *Mte*, portrayed in a large number of traditional stories (*rhena heca*), sometimes with his wife. *Mte* is portrayed as a one-legged black man (a usual picture in Africa[3]), but there are few other details about

his looks. The only thing that is absolutely certain is that nobody can hide from him for long: everybody is eventually found. The village cultural hero Hwempetla is the model in this case: even he, with all his powers, could not escape Death. But *Mte* is less active for anyone who follows the rules and heeds his obligations toward his fellow men. An annual ritual, *berhemte*, is performed to chase *Mte* from the village, a ritual that in fact links the Kapsiki with their northern neighbors.[4] This ritual is aimed at *Mte* in its most threatening form, the instantaneous collective death—that is, the epidemic (*ba*)—and this has to be chased away at the heart of the rainy season. So as a special manifestation of *Mte*, *ba* has accrued personality characteristics. One epidemic that is often mentioned is the meningitis epidemic, which every few years hits the Mandara area in the cold season.

Two other types of epidemics are personified even more: smallpox and measles. They are feared as no other. The most important is *Damara* (smallpox), which is particularly feared by the Kapsiki even though of course the last epidemic was a long time ago. *Damara* knows the good and evil of any person and kills transgressors. Those who do no wrong will not be infected. So anyone who has the signs will confess publicly and then withdraw into the bush to await death. All those infected will assemble in the bush, trying to survive and trying to avoid contact with the village. They will bury their own dead without help and without smiths. Medication against *Damara* is possible but extremely difficult and tricky.

> Teri Puwe remembers a smallpox epidemic that took place a long time ago: Someone from Nigeria (Higi) came over to heal; he stayed over there with Depeɗa and treated the whole village. People collected *kwantereza* leaves (*Cassia singuena Del.*), and he mixed them with his own *hwɛɓɛ*, an onion (*Crinum sp.*). It was a miracle: he kept cutting pieces and more and more came off: a whole heap. Only when one turned around, it disappeared! He soaked the mixture, took his knife, and cut into the air. A terrible yell sounded, as *Damara*, attracted by the mixture, had approached and was stabbed in the belly. All the patients brought a goat and were washed together with that goat. Then the goats were slaughtered, and the water with the smallpox got in the goat's stomach. The medicine man told the people that only one would die, and so it was. The village gave him a lot of presents, especially his host Depeɗa, and people think he now has a piece of that *Crinum*.

Each village has its own measures against *Damara*, all different. In Rumsiki, for instance, someone has a stone against smallpox, which is oiled with ocherous oil regularly to keep up its strength.

Shasha (measles) is a similar being, bringing an epidemic that takes a large toll on children's lives. He is sometimes called "the sister's son of small-pox," but he does not look for transgressions. Confession does not help, but against him there are similar medications to those against *Damara*. Measles is still very much present in the area. During my first research period, it killed most of the children in an orphanage in Mokolo.

Measles and smallpox are invisible beings with power, just as *Mte* and *Va* (rain), but there are less details about their appearance. They are not gods; the dominant presence in the Kapsiki "other world" is *shala*, god. In Kapsiki, *shala* is a complicated notion, which is highly relational. Everybody has his or her personal *shala*, but there is also a *shala pelɛ rhweme*, god in heaven. Furthermore, a group of people has its own *shala*, as has a particular place, while the burial place of Hwempetla is called *teŋkwa shala*, the *shala* place. So the "identity" of *shala* is flexible, and the notion easily adapts to the people present at the discourse. Like so many supernatural beings in local religions, this one is also quite ambivalent and ambiguous. One's personal *shala*, viewed somewhere "in the above," can be a source of luck and wealth, but just as well a source of afflictions. Whoever is out of harmony with one's *shala* gets afflicted. Similarly, the *shala* of someone can also be harmful, dangerous for one's own health or the health of one's children.

This ambivalence of *shala* is embodied in the *gutuli*, spiritual beings mainly described as small black creatures, about a meter in length. The men have long black beards, and they are often very dirty. According to some informants, these are the children of *shala* who did not understand *shala*, and were therefore let loose in the bush. Normally they are invisible, but special people can see them with special medicine, or they show themselves when they want to. They live in houses "just like white people," nicely made of pottery, like inverted beer vats. *Shala* and *gutuli* form a continuum in Kapsiki thought: for the more local reference points, the term "*gutuli*" is dominant; for the more "elevated" references, it is never used. The sky and mountains (same word in Kapsiki) are always *shala*, never *gutuli*; the *shala* of a waterhole is *gutuli*. But these beings do form a continuum. In fact, *Damara* and *Shasha* are sometimes called *gutuli*, while another such being, *Va* (rain), is closer to *shala*.

These *gutuli* can also cause problems; for instance, *gutuli* may possess a person, which can lead to serious psychic disturbance. Against these dangers a special medicine, known only to a very few specialists, must be taken. The Kapsiki distinguish several kinds of *gutuli* possession: some *gutuli* inspire the one they possess to behave dangerously, others make him play without stopping, or send him out to steal.

Teri Nza recounts a month-long illness. Weird things happened: he saw chickens and goats nobody else could see. A *gutuli* came to his bedside, an old black man with a beard half a meter long, who told him that he was not going to die. He took Teri's hand, put it in the fire four times and then back on his heart, and put a large bundle of medicines around his neck. No one else could see these. The *gutuli* told him to keep those medicines hidden from others (which was not very difficult) and that he, Teri, would heal when his wife died. Indeed, soon afterward his wife died, and Teri got better. Later the old *gutuli* came along for his medicines, and told him a prescription for this kind of illness: something with a *kwelemede* tree (he could not remember).

Gutuli may just "attack" a person, for instance, as *gweleba*, paralysis, which calls for a divination session to establish whether it was caused by a *gutuli*. If not, no remedy is possible. If yes, against this affliction a standardized sacrifice is called for, at the spot where that *gutuli* lives. A sheep or goat is sacrificed on the spot, sometimes just by breaking its legs and letting it die. A smith has to perform such a sacrifice, and depending on the crab, may be allowed to take the carcass home and eat it. *Rerhɛ*, the Kapsiki say, are less afraid of the *gutuli*, and anyway cannot refuse a sacrificial duty, even if risky.

Humans, though, are just as dangerous as any supernatural being. Many afflictions are explained through strained relations between mortals, as we saw in the divination cases. A disgruntled close relative, especially one with some authority, can cause problems, even without knowing. But the dead can also be tricky. A recently deceased relative, who may think himself inadequately mourned, can cause some serious ailments, like miscarriage or leprosy. If the crab indicates the deceased as the cause, a very private redeeming sacrifice is called for. In the middle of the night, the man of the house, usually the son of the jealous dead, with his wife (if she is a woman who can hold her tongue, my male informants assured me; if not, another wife), just in their traditional goatskin and cache-sexe go to the grave. They tell no one, should encounter no one, and walk crouched toward the grave. The chicken they carry should make no sound and must be killed also without any sound. At the actual killing of the chicken, both should be completely naked.

But the living are usually worse. The direct, overt threat of hostilities has abated these days, with the continuous warfare between the villages a thing of the past. But it is definitely the not-so-distant past, as discourse on warfare is still a favorite topic in men's gatherings. In the *rhwɛ* sphere also, war is still present, in the so-called *baŋwa*, the particular type of *rhwɛ* aimed at protection against enemies. Most *baŋwa* aim at protecting against iron and produce

a magical hardening of the skin, so that iron objects, say spears and arrows, cannot enter the body, furnishing a welcome protective shield against enemies. Some of these *rhwɛ* protect another "skin," the wall of the compound, prohibiting anyone with evil intentions to cross its boundary.

Baŋwa come in all shapes and sizes. The most common ones are seeds and small animal parts placed in the iron *mblaza* containers, and in fact most *mblaza* can be classified in this category. The intention is generally protection, like the *mblaza kwamanehe menu*, a means to avoid bad luck when marrying too close of kin. The large *baŋwa*, however, often have a name and enjoy some fame, and are much too large for a simple iron container, so they are stuffed in cows' horns, often amounting to veritable works of art. These are all smith work, of course. Some *baŋwa* mainly consist of an animal part, like a swine tooth wrapped in leather straps.

A real *baŋwa* cannot even be bought, but must be stolen from an enemy; after all, the best are those that have been used and sacrificed upon for a long time, worn by a *katsala* (real warrior), and then one has to steal it from him. But how to steal an object that gives such a wonderful protection to its owner? If possible, by force; but from a real *katsala*? Zra Mpa, the son of a famous *katsala*—hence his name, meaning "war"—recounts how his father, Mpake, obtained such a "protection against iron." In a former battle against Sir, he had spotted someone with a huge, complicated *baŋwa*, which he always wore. Someone from Sir told him that the amulet had a name and was famous in the village. In the following weeks, Mpake set out very early for Sir to spot the man. Finally, when the man was bathing in one of the pools on the plateau, he took off his amulet. Mpake ran from the bushes, snatched the amulet, and ran like hell back to Mogode. Afterward he wore it in battle, including the last one against Sirakuti. (The amulet is shown in figure 28).

Zra Mpa, who was also my cook, sold me this amulet, because, as he said, its force has dissipated. I protested, but not too strongly, that such a wonderful medicine should remain in the family. "No, the force has gone," Zra assured me, "I will test it." For a moment, a vision of an attempted stabbing shook me to the core, but Zra Mpa had a much better solution. He took a large melon, hung the *baŋwa* on it, and with all his force rammed a kitchen knife into the fruit: the knife disappeared to the hilt, juice splashing around. "See," Zra explained, "the force has gone. If it was still there, the blade would have broken at the hilt." So I could buy it, and I still use this story to explain this kind of "magical thinking." Thinking in terms of *rhwɛ* is extremely practical: either it works or it does not. And if not, then an explanation is always at hand: here the power has gone, elsewhere

another force has spoiled it, or someone else is just stronger. This foolproof character of magic has long been noticed, and Kapsiki is no exception. But it does give the owner confidence, while furnishing a ready excuse when things go wrong.

It is not always iron that attacks: the threat from people can be much less tangible. Two kinds of people are inherently bad, both with abnormal *shinaŋkwe* (shadow, spirit): *mete* and *hweteru*. The first, *mete*, is more or less the classic African definition of a witch. Their *shinaŋkwe* resides in their belly and leaves their sleeping body through the anus. Red as fire and with a tail like a bush cat, it sneaks through the night, often flying to eat the *shinaŋkwe* of the heart of sleeping victims, usually children. A victim whose heart is eaten will become sick, asthmatic, weak, and listless. If the *mete* does not relinquish the heart, the victim will eventually die. *Hweteru* is perhaps best translated as "evil eye." They suck blood from their victims, be they human or animal, who as a consequence "spoil" and become weak and unproductive without energy. If *hweteru* look at millet it will not ripen, chicken they covet will not lay eggs, and children that arouse their jealousy will not grow up properly. *Hweteru* is usually not thought to result in death and is mainly dangerous for children. There is little cure against *hweteru* or *mete*—just prevention, but luckily this is not difficult to find, as each smith has preventive medication, especially for children. However, as *hweteru* and *mete* are mainly triggered by jealousy, the best remedy is to put any object that arouses greed out of sight.

People can also be intentionally harmful, through sorcery. The Kapsiki call most sorcery simply *rhwɛ*, "means, medication," involving all kinds of conscious acts, using objects as well as spells, that influence the course of events for themselves and others. The concept covers both medicinal and emphatically nonmedicinal applications. Influencing events can be for better or worse, as magic is first and foremost the means to further one's own individual cause, which may or may not be to the detriment of the other. Much of it is not very complicated. My opening example, the extraction by *kwantedewushi*, is often explained through magic. Someone who wishes a woman ill takes something of her possessions and buries it on a *gutuli* place in the bush, an action called *ŋa redʼa*, "build filth," resulting in her barrenness. She then seeks redress through *kwahɛ* divination; the little bird finds the object and retrieves it to her.

Life is risky, especially when confronted with the most harmful of all people, those who practice *beshɛŋu*, "black magic." Characteristically, these people are considered not to be *rerhɛ*, smiths, but *melu*, nonsmiths. Though smiths may occasionally be feared, this stems more from the ambivalence of

their position in the eyes of the *melu* than from any evil intentions on the part of the smith. As the epitome of evil in Kapsiki society, this *bɛʃɛŋu* is practiced by someone who aims at harming others, killing or rendering them infertile. The term "*bɛʃɛŋu*" denotes not a specific object or combination of things but a great number of different ways of harming other people. Some of these are well known (for example, the whiskers of the leopard); others are very secret and known only to the specialist. Making *bɛʃɛŋu* is a specialist's job, done professionally by smiths mainly, even if they do not use it. A number of ways to make the *bɛʃɛŋu* itself are given by the Kapsiki, all in the most general terms, because everybody emphatically disclaims having any such knowledge. The main fascination centers on the distribution of the stuff: sorcerers are reputed to train flies to bring the *bɛʃɛŋu* over to their victims, bury it in the footpaths, or change themselves into flying creatures in order to administer their wares. The Kapsiki are sure that all "important" men have such a *bɛʃɛŋu*, bought from a smith specialist in another village. However, it is not the possession of *bɛʃɛŋu* that is evil, but its use. So the defense is against possible attack, and several kinds of *rhwɛ* can be used for protection. In many ritual texts and public discussions, curses are formulated against the users: "Anyone who walks with *bɛʃɛŋu* [that is, who carries it with him in order to use it], let him drop dead in his tracks." Still, according to some informants, these curses are often mouthed by the very people who at least own the stuff.

> The most feared *bɛʃɛŋu* is peculiar and characteristic for the Mandara Mountains as a whole, that is, *shinti derhwava*, the whiskers of a leopard. The leopard is an important symbol in the Mandara area, one of the mainstays of the authority of the chief of Gudur, the almost mythical place where most Kapsiki villages trace their descent from. That particular chief "commands" the leopards, animals who have been abundant in the mountains in the past and are very rare in the present, and whose skin had to be given to the chief of Gudur from ethnic units all through the mountains.[5] Also, the leopard is an important player in most of the *rhena heca*, the traditional stories that have the ground squirrel as their hero. Characteristically, in those tales the leopard is the dumb bully against the clever underdog of the squirrel. But its occult power is uncontested, with its whiskers as the foremost symbol of dangerous power. Whoever drinks some beer or eats food with even the smallest part of a whisker in it, will die a terrible death: the whisker keeps reduplicating itself, till the whole belly of the patient is full of hairs. Medication is difficult, sometimes deemed impossible. But, at least in theory, also this arena has its loopholes, and people tell me that there is, somewhere, a remedy for this terrible affliction. A special *hwɛbɛ* (onion) from

a smith specialist, together with a host of other plants, is given to the patient, while his kinsmen sing and dance around him; he then becomes extremely scared, and sweats out the hairs through his skin.

The threat of *beshɛŋu* use does not come from inside the compound, as witchcraft does, for people think of this kind of sorcery as coming from the outside; however, it does not really come from far away either.[6] *Beshɛŋu* is, in the ideas of the Kapsiki, sought after by people who are kinsmen, probably agnates, who are jealous of their clan and lineage brothers or interested in their misfortune. A large inheritance may trigger the use of—so accusations of—*beshɛŋu* usually between the agnates vying for the same inheritance. Treating the resulting illness is difficult and must be done by the same type of specialist who can perform the harmful magic. These rites are very secret. The information available on this protection indicates that the content of the rites is highly idiosyncratic, varying from specialist to specialist. It also seems to be independent of ethnic identity, as knowledge of magic easily transcends the tribal boundaries; specialists from far away always are deemed more powerful and potent than those nearby.

Thus, affliction can stem from a variety of sources, human and spiritual, intended and unintended, retrievable and sometimes quite unfindable, many of which can be healed, but not all—definitely not all. This is what we will look at in the next section: how to heal.

WAYS OF HEALING

The first diagnosis in cases of illness anywhere is done at home: "Is this illness common, and will it probably heal by itself?" and the first response is "wait and see." Such "normal" diseases do not trigger divination or specialists' attention, and often no treatment is deemed necessary as most illnesses do indeed pass. If the affliction needs attention, any response to ailment first begins from a common pool of cultural knowledge about usual illnesses and their treatment, the domain of folk medicine, and as most afflictions do eventually heal, this often suffices.

Part of healing is dexterity. For the Kapsiki in their mountain environment, small injuries such as sprained ankles are common, and someone who is able to heal a sprained ankle is valuable. Usually they are smiths, not because others may not do it, but simply because it is expected of them.

Gwarda told how he started out in manipulative techniques: "When a small lizard fall through the roof of the hut [as often happens] it sometimes remains still, dazed from the shock. Often it has a sprained leg. Then you gently pick it up, feel the little legs and joints and try to put the leg back into place. Once you know you can do this, you ask someone who is proficient to teach you how to do it on humans."

But the bulk of medicine is in plants, and the common knowledge about medication concentrates mainly on plants. In my research I collected 622 plant specimens,[7] comprising an estimated 40 percent of the total Kapsiki botanic system,[8] and established the practical, medicinal, or religious use. Of the 622 randomly collected plants, 84 (12.7 percent) were medicinal. Of these 84, about half aimed at human somatic ailments, one-sixth aimed at animals (including hunting), and one-third were of a more magico-religious nature. Characteristically, the attribution of medicinal properties to plants follows the line of symptoms, with "fever"—meaning for the Kapsiki, almost invariably, malaria—and "diarrhea" mentioned most often, and after that ulcers—including oral infections—and skin problems. The leaves and roots are usually pounded, boiled, and applied in a paste, while from trees, bark is the materia medica. Some typical examples:

- *wumbela kaja*, botanically *Kotschya schweinfurthii (Taub.) Dewit et Duriga.* Used against diarrhea and intestinal worms. The roots and/or bark should be pounded and cooked and the infusion drunk.
- *rhwε mezeke*, botanically *Haumaniastrum galeopsofilium (Bak) Duvign. et Planch.* Serves against itches. A paste of ground leaves should be applied on the itchy spot.
- *manda kwadeva*, botanically *Plumbago zeylanica L.* This medicine is hung around the neck of a child against bellyache and inflammation of joints.
- *lerhwu*, botanically *Nauclea latifolia L.* A well-known medicine for hepatitis (but also has other applications—see below).

Examples of the less iatric, more magical medicines follow below. In principle, the Kapsiki themselves do not make a distinction between somatic and nonsomatic medicines, and all are called *rhwε*, "means"—in this case medicine. So after "wait and see," the first line of medication is usually home treatment. Fever, itch, diarrhea, and constipation (greatly feared in large parts of Africa) are treated with this type of self-medication—"folk medicine." As the main focus is on the symptoms, the illness is in fact defined as the symptom.

Tourists visiting the striking Kapsiki plateau sometimes hand out medicines, in the mistaken hope of contributing to the health of the population. Usually the tourist then explains which medicine is against which disease, such as malaria, bilharzia, dysentery, or bacillary infections. The polite guide just listens and later asks us about the real use of the stuff: "What do I take with a bellyache; which one for a headache?"

One peculiar element of the Kapsiki pharmacopoeia is that they tend to link not only one plant species but even one specimen to one affliction. The most important medicines come from two plant species, *Crinum*[9] and *Cissus quadrangularis.*[10] *Cissus*, called *haŋgedle* in Kapsiki, has a broad symbolic meaning, but the first, *Crinum*, in Kapsiki *hwɛɓɛ* (in English, onion), is the most prominent medicinal species. In principle any of these native onion variants, and often individual specimens of *hwɛɓɛ*, form medication against a specific affliction. Each individual *Crinum* plant has its proper illness to heal. Well-known illnesses, like "fever," have more than one medicine: four plants are used with malaria, though the *Crinum* medicine is deemed the strongest of all. Often the specific aim of the onion depends on surface characteristics: a *Crinum* against smallpox is usually an onion with brown spots on its leaves. This homology between symptom and medicine is normal and well known in African medication: the medicine against *Damara*, smallpox, has to be drunk from a calabash with "smallpox" pustules on the exterior, *kwetlekwe damara*. But in fact this is already "specialists"—therefore "smiths"—territory. For medicinal plants other than the two mentioned, the relation is between one illness and one species. Knowledge about medicines against scabies, intestinal parasites, and hepatitis is quite widely known. The last example shows that symptom homology is indeed often a part of the medication, plus the central means that bears no symbolic association, illustrating the fact that the distinction between medicine and religion is not made:

> In cases of hepatitis, take the bark of the *ndewuva vɛra* (botanically *Ziziphus mauritiana L.*) and boil it with lemon and acacia leaves for two hours. Two calabashes with the bitter potion have to be filled. From one, the patient drinks in the morning; from the second, in the afternoon, for four days. Then recovery should follow without further medication.

In this first line of health defense it is the individual who is in charge, who tries to apply his own knowledge and search for additional knowledge on plants among kinsmen and friends, trying to navigate the pool of common

knowledge in the village. However, if the illness perseveres or seems unfamiliar, the second choice is in fact between two ways of accruing more knowledge.

The first question is to what "domain" the affliction belongs, to the one treated at the dispensary or not. In the Kapsiki area, the first dispensary came with the Roman Catholic mission at Sir in the late 1960s—it is still there—and later others followed, such as in Mogode. So these data on "traditional" medicine are set in a context of some availability of Western medication, usually at the dispensary level. Infected wounds, fever (routinely equated with malaria), diarrhea, and vomiting—especially in the case of children—are first treated briefly by home medication, but then quickly the ailing come to the dispensary if there is one nearby. For most, this involves a journey, a stay, and some expenses, the major parameters of therapy choice also elsewhere in Africa.[11] A hospital is available in Mokolo, some 50 kilometers from most Kapsiki villages, but transport is never easy. Here we shall follow the pathways in those afflictions that are defined as being beyond the scope of the dispensary.

If folk treatment is deemed necessary, the first line of defense is to use one's "own" medication, usually plants or a simple ritual kind of *rhwɛ*; as mentioned, the distinction between ritual and pharmacological aspects of *rhwɛ* is not made.

> Zra Mpa suffers from some headache, nothing to worry about but annoying. He finds a pottery shard, turns it around his head three times, saying: "Go, take all the bad stuff out with you," and throws the shard far from him. "So, that is finished," he tells me.

Illness is "normal," but persistence of an affliction is abnormal and asks for a response. Two ways are then open: one is to go into a deeper diagnosis, usually through divination. In Kapsiki divination this a common approach, digging up issues from the past, in fact constructing new layers of knowledge about the patient and his past. But some afflictions that persist have a clear somatic aspect and ask for a specialist healer, another kind of smith. Not a deeper knowledge about relations and mistakes in the past is called for, but a different kind of knowledge, of rare information about pharmacopoeia, especially about combinations of medicines.

The first choice is whom to consult, which smith or other healer. Each traditional healer has a limited set of medicines, meaning also that he or she can heal a limited number of illnesses. So the "therapy group," the people who surround the patient and are partner in his therapy choice,[12] inquires about which healer in their personal network might address these particular symptoms.

Starting out in their immediate vicinity, they contact one they trust, and wait to see if he deems himself capable of diagnosing and treating the affliction. Although each smith has indeed a limited array of medicines at his disposal, he tends to first diagnose the illness as belonging to his competence. Only when the treatment fails will he refer to more specialized healers. Yet most smiths are quite clear about what they can treat, and most of their medicines are related to general symptoms, like fever, diarrhea, bellyache, and so forth.

Some gender division prevails: smith women specialize in medicines for children and *kwantedewushi*, mentioned at the start. The notion that a foreign element has entered the body, through contact or sorcery, is not often invoked. In Kapsiki etiology, few ailments are interpreted in this way, but then especially for children, as in my opening example. The little frogs in question are deemed to live only in human bellies, but other items enter the body as well.

> A few years ago, Kwafashè suddenly suffered from a very stiff knee; she went to a smith woman in Sena, who extracted five small wooden sticks from the knee, white like with body fat. When climbing back to Rumsiki, the knee became very stiff again, and her husband wanted to reclaim the money. But the knee healed well, and he stayed home. Actually, that smith woman had learned it from a male smith in Sena; when he became chief smith he stopped practicing the procedure, as he could no longer roam the mountains to other villages. He could extract little worms from dental caries, he said.

The technique is not disappearing at all, but holds its position in the modern health market well. At present two smith women in Mogode practice it, while in the 1970s I had to go to Guria to find one. Also, their range of ailments and procedures has expanded. Not only caries, but also heart ailments are treated with this kind of legerdemain: the women "turn the heart" of a patient, from the outside, that is.

Another female technique is to remove small warts on a child's anus; most smith women have a special knife for this purpose and help out the children in their vicinity. Also bloodletting, another worldwide technique, is for smith women; in cases of a moderate but persistent fever or fatigue, they pierce the skin of the patient's back, light some quick-burning leaves in a glass, and quickly put this over the patient's back to draw out the "black blood." *Bemu* it is called in Kapsiki; the old technique used an antelope horn with a wax-covered opening at the end: the smith cut the skin, put the horn on the blood soaked skin, sucked a vacuum, and shut the hole with the wax. Today, they burn some maize leaves in a small glass and quickly put it over the spot.

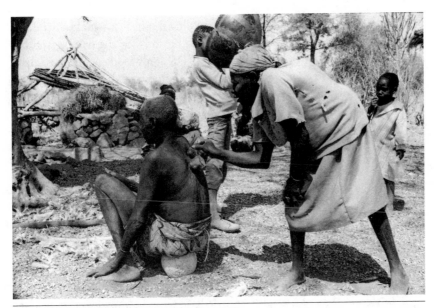

Figure 26. Bloodletting by Kwarumba, Cewuve's wife

Other kinds of treatment provided by the smith healers are more complicated. A healing session of spirit possession, an affliction the Kapsiki define as an illness, not as communication with the spirit world, may serve as an example of a specialist treatment. As with persistent somatic afflictions, the treatment is more complicated, demanding the expert knowledge of a real specialist:

> At six in the morning the smith cuts some leaves of *peha gutuli,* a wild aloe species, at noon some *zewe gutuli* (a wild grass), and at sunset some black ground nuts. In the dark he mixes these and rubs the mixture in his hands till it stinks. While rubbing he explains the medicine and the aim of the operation, who is ill and what should happen. The possessed person perceives the healer coming from afar, "even through walls," and tries to escape. His kinsmen have to bind him. Then the smith rubs his hands over the forehead, nose, mouth, and eyes of the patient, who falls asleep. The healer with his knife carves two incisions on the forehead, two on each shoulder, each hand and each foot, and finally rubs a special *Crinum* (in Kapsiki *hwɛbɛ gutuli*) in the wounds, murmuring some words to heal, "get better quickly." The next day the patient is better.

Compared with the agency the patient has in his first choices—which plant, which healer/smith—here the agency of the patient is restricted, and his

"therapy group"—in this case, his family plus the healer—makes his decisions for him. One reason for the restricted options for the patient and his group is the secrecy of expert information. The knowledge of the specialists is based upon the general folk knowledge of medicinal plants, described above, with an addition, a secret extra, at three levels: first, they have the specialized specimens needed for that particular illness; second, they know more details about the well-known plants; and third, they know specific plants or combinations of known medicinal plants. The first level depends on the insistence on the specimen level in *Crinum* and *Cissus*, that is, *hwɛɓɛ* and *haŋgedle*: everybody knows these plants are medicinal—but against which particular disease each of the individual plants serves, only the specialist knows. Some surface features of the plant may give a hint, but never more than that. What is secret here is the exact nature of each individual plant and the words to be spoken. Nonhealers have one or two onions for some general purposes, but specialists have many different specific ones, and only they know the purpose of each of them.

The second level of specialist knowledge resides in knowledge additional to that of the common stock of medicinal plants. Basing themselves on the general knowledge, they "just know better":

> In the case of the *lerhwu*, medicine against hepatitis, a healer confided that this could also serve for another problem: whoever has drunk poison and cannot vomit, should drink a potion of crushed *lerhwu* roots in order to vomit the poison after five days.
>
> Or, for the *rhwɛ mezeke* mentioned above, the same healer stated that this would be better if used with *ŋyi cɛnɛ* (cailcedrat oil) and ocher.

Some very common plants appear to have medicinal qualities in the hands of the specialists. One is *shikwedˊi* (botanically *Ceratotheca sesamoides*), a common cultivar used to bind the sauce. In the hands of the smith it becomes a means to reinforce the forge, for casting brass as well as for forging iron, as *rhwɛ gedla, rhwɛ mnze*. In other combinations it serves against *Damara* (smallpox) and debt curses. This is a plant that is deemed to reinforce each and every *hwɛɓɛ*.

The third level is the array of different plants and especially mixes of medicinal plants that are the most efficacious, and here each smith has his specific recipes. This somatic way of healing not only has more complex prescriptions, but it also separates the patient from the specialist. No longer are they kinsmen or village members, and no longer has the patient any idea of what the medication is made. One reason is secrecy, as the real specialists

are extremely secretive with this kind of knowledge; another reason is the danger inherent in healing, not only for the patient but also for the smith. A serious, persistent illness is a force in itself, and healing means that the illness has to go elsewhere. To paraphrase Mary Douglas, "Illness is evil out of place." In sacrifices, evil is chased from the compound to the potential detriment of neighbors, and the healing of one patient also implies risk for a bystander and, first of all, the specialist. So this level of knowledge can become dangerous, and a smith has to attain status as a healer first, before venturing into these hazards. During a treatment the healer communicates with the illness itself, addressing it as a person. Some illnesses are considered a personage as we saw, dangerous and wild, but they are still approachable—albeit only by someone who has complete knowledge. A serious illness is "the ultimate other," dangerous and erratic, but with a distinct identity, someone the healer has to "know." So the specialist keeps his distance from his patient, and secrecy is an effective means of separation.

Recent developments increase that notion of private information. Though the general public knows who has the most *rhwε*, the details who has what are less well known. A smith who claims to have the medicine against a certain ailment might be held accountable if things go wrong. Accusations of "malpractice" are starting to appear now. In 2010 a smith attempted to heal a seriously ill Kapsiki woman, and when her condition worsened instead of improved, the family accused the smith in the traditional court of the Lamido of Mogode. He paid back the money for the treatment. So now smiths have become ever more reticent about revealing detailed information about their healing range, increasing the distance between healer and patient.

A final reason for distance is the performance character of some of the healing, especially treatment dealing with the most persistent kinds of illness. This is crucial in many African afflictions; but even for the privacy-oriented Kapsiki, a convincing performance can be one of the additional means in the healing process. An example follows, also related to possession:

> For a tenacious case of possession, Miyi, the most famous of all smith healers in the region, is called. He arrives on horseback, and some bystanders comment on that; not only is horse riding rare in Kapsiki and reserved for the Fulbe officials mainly, but a smith riding in such manifest dignity is hard to swallow: the times surely have changed! Entering the hut he finds it full of neighbors of the patient, Tizhè. The latter sits on the floor tied with ropes and screams incomprehensible language. Miyi shaves Tizhè's head and makes some room around the patient. From his leather document case he selects a few of the small packages

of medicines and burns some of them in front of and behind the patient. He circles the smoking stuff around the patient's head, enveloping Tizhè in a cloud of smoke. Other mixtures of medicine are lighted all around his body, medicine is smeared on nose and mouth, and by now Tizhè has become very calm. His kinsmen and neighbors, including me, by now are quite a crowd, in awe we watch the proceedings; even the ones who are healers themselves cannot guess what exactly Miyi uses for this session. Meanwhile, Miyi works quickly, efficiently, and with full determination, allowing the crowd a full view of the proceedings. After half an hour of treatment, the patient sleeps, and everybody is convinced Tizhè is healed. Not Miyi, though, not the smith-healer. He leaves some follow-up medication with the family, warning that the affliction may come back. Miyi's very professional performance made a huge impression, and the relapse Tizhè suffered later did not erode the public admiration. In fact, the return of the "possession," which Miyi had feared, meant that the diagnosis had to be changed: not the *gutuli* (bush spirits) but a Fulbe marabout was the cause. So Miyi advised writing a letter to the marabout of a nearby Fulbe pastoral group, to ask him to heal Tizhè. And so it happened; in the end Tizhè did get rid of his "possession."

Thus, trust and uncertainty operate together in healing processes. Both are fundamental aspects of life: the trust *in* the specialist—which may be greater than the trust *of* the specialist—can make the insecurity bearable, and a good performance helps, especially when the healer shows certainty. Combined with the notion of the body as a fortress under siege, this show of certainty can have one peculiar result. People take medicines that give them a limited certainty of healing, but nevertheless the healing is deemed to be immediate. Medication is thought to work instantly, repairing as it does the hole in the body's defense, so further medication is not needed. In taking antibiotics this means that patients tend not to complete the five-day cure: after the first injection they consider their body healed. After being bitten by a poisonous snake, a famous—nonsmith—healer, a personal friend of mine, took just the first injection at the dispensary; the rest of the medication he sold. He died a week later. I was in the south at the time, deeply regretting that later.

In some *rhwε* applications not aimed at healing, performance becomes a purpose in itself, especially because the socially inferior smiths who dominate medication may boast their prowess in the field of *rhwε*. For instance, when a smith is buried, all *rerhε* flaunt their *rhwε*, and even beyond the ritual context some specialists may boast their prowess, at least verbally.

A healer once told that he took his "stuff" to the market in the next village during the dry season. When he sat down with his vials and stick, suddenly leaves appeared on the empty branches of the tree. Everybody was scared, he told us, running to and fro, shouting and pointing. The women were afraid to bring him beer and had to be forced to do so. When he stood up, all the leaves disappeared. The people of the village gave him money and chicken and implored him not to come back.

[One has to add, with some skepticism: a nice tale, but why make yourself unwelcome?]

Performance separates the specialist from his patient and his audience and generates a rigid distinction between knowledge and ignorance. Language becomes less important, knowledge about the variety of medications for the treatment all the more so.

Not only does the smith-healer put a distance between himself and the case, but the patient also puts a distance between himself and the healer, for several reasons. First, healing, as we have seen, involves a certain risk. Not only does the affliction have to move elsewhere, but the Kapsiki also hold that any intervention in the "normal" course of life has an inherent danger. Each attempt to change things with *rhwε* carries risks and demands costs, and if one relies on these means, one has to be prepared to deal with all the side effects; just a little knowledge and only a partial application are dangerous. An extremely complex example of such a chain of side effects is the following:

Marrying women is one of the foci of Kapsiki society. Women tend to leave easily and quickly, and men constantly seek to induce women to stay with them. Medicine, of course, is available. A complicated recipe tells how to do it. First, one takes a *keyitu* plant (*Grewia sp.*) from the bush and plants it in the compound, collects its fruits, mixes this with wild couch seeds, grinds the mixture and keeps it inside an old carrying cushion of a woman, long used to carry pots and other loads on her head. The cushion is well-oiled with peanut oil and kept in a pot. When a woman enters the village to look for a new husband—which is a common procedure—the candidate rubs the mixture, some dirt of the cushion, and some perfume in his hands. During their first talk he will flick his fingers against those of the new woman, inside a pitch-dark hut as is usual, and his "prepared fingers" will make sure she follows him that evening, shunning other candidate husbands.

She will follow the man to his compound and stay until the first goat is butchered on her behalf, but the side effect of the *rhwε* is that she will not stay

after the feast. Another *rhwɛ* has to guarantee her stay, binding her to the house. So the recipe goes on: at the marketplace the man takes some dirt from a stone where women have been seated selling mahogany oil, who wiped their hands at that stone. The man takes this stone home, puts it on the place of honor in the forecourt, with a calabash of peanut oil on top of it, for a night. In the early morning he anoints the stone with this oil and puts it on the sleeping mat of the wife. Now she will never leave. But then the other women will become jealous, another side effect. This can be helped: the man buries flowers of the *mazala* (botanically *Ficus populifolia*) and fruits of the *hwemeke* (botanically *Boswellia sp.*) at three spots: at the center of her hut, under the threshold, and at the spot where her water pot rests, plus the gizzard of a chicken in front of the entrance.

So now she stays, and harmony reigns, but other problems will surface later. She may prove infertile, but there are many means to deal with that problem. More likely, she will conceive, but her children will be unwilling to leave the house at their marriage, as children "born under *rhwɛ*" are bound strongly to the house. A daughter will turn down all suitors, unless another *rhwɛ* sets her free; in order to have her leave the house, her father has to pour water over the magic in front of the hut and put an inverted eating pot over it. When the girl is finally called over to her husband's at the wedding, during the farewell ritual she and her father hold a chicken, while he cuts its neck, setting her finally free.

With a boy it is even more complicated, as a boy "born under *rhwɛ*" will refuse to undergo his *gwela* initiation. During the day the boy's hut is being thatched—a central part of the ritual—the father slaughters a two-month-old male goat on a flint stone and puts the stone on the stuff buried at the center of the mother's hut. He adds a bowl with the stomach contents of the goat and covers everything with earth again.

Only then will the boy begin to "search for" a woman, and even then not all troubles are over: the boy has to marry a *makwa* (girl) first, not a *kwatewume* (runaway woman), meaning that his father has to put up a real bridewealth first; but the sanction is that if he marries "wrong," all his children—if any—will die young, and his *kwatewume* wife will never get another husband: all others will "view her as a dog."

This is a very complicated chain of *rhwɛ*, with side effects spanning a generation, which does raise some important questions. First, there is the notion of a natural course of events, that is, the normal course of life, of loving, losing, finding, and missing out. Anyone interfering with "normalcy" entails risks that are hard to foresee and difficult to counter, so any intervention is inherently risky and nonspecialists had better stay out. The sheer complexity of the medication sequences and the risks involved

induce the patient, and in fact any nonspecialist, to profess ignorance. In order to gain trust, the patient has to construct his own ignorance; he has to let the smith be an authoritative guide in the dark maze of medication so that, despite the fundamental insecurity, some trust can be salvaged. Thus, all parties—the smith, the patient, and the therapy support group of kinsmen[13]—have an interest in the "creation of ignorance."[14] The unequal division of expertise is productive in the healing process and, as such, a more or less conscious choice on the part of the patient. It should come as no surprise, therefore, that also among the Kapsiki, healers are the worst patients.

One wonders, by the way, about the timeline in this long series of medications. In theory, this would tie the client for a generation to the smith, which means they both have to stay alive and in place, remembering the treatment received and given. That is asking a lot from both fate and memory. So in all probability, this complete chain of medicines is seldom actually given as such, but in fact consists of a loose chain of individual means for specific problems tied into a larger chain. Thus, this recipe, given to me in quiet privacy by an old healer who was indeed a good friend, has one additional value—viz. to establish expertise. To some extent, such a recipe tends to be more discourse than practice, a discourse that establishes the healer as a full-blown specialist and the client as dependent on him. In short, the purpose for such a discourse is to advertise authority.

Modern life has made *beshɛŋu* more easily available, while rendering accusations of use punishable in court. So more and more traditional healers are zooming in on protection. Anyway, protection against *beshɛŋu* was always more important than treatment, and still constitutes an important focus of daily Kapsiki religion. Especially when one has gained some social prominence, one must live carefully in order to minimize the dangers. Protection against this threat, which is difficult to realize in any way, focuses on the protection against intrusion: how to keep the trained flies away, how to protect the compound against flying creatures, and so forth. A constant vigilance is needed, and the protection against *beshɛŋu* must be kept in good shape. Let us have a look at these defenses against *beshɛŋu*. The first line of defense is against poison; for instance, according to some smith healers, *lerhwu* (botanically *Nauclea latifolia L.*), which is well known as a medicine against hepatitis and also used in the brewing procedure, can also serve as a medicine against poison. Whoever has drunk poison and cannot vomit should drink a potion of crushed roots and will vomit out the poison after five days. Another medicine is *tserhwe* (botanically *Canavalia virosa*); according to the same specialist, its root pounded and mixed with the bark of

two other trees serves as medicine against *beshɛŋu*. An overview is found in the sidebar.

As with any activity aimed at the supernatural, the use of *beshɛŋu* carries a risk, as any powerful means can turn against its owner if he is not very careful. Ambivalence is the norm in magic, and anyone who owns the stuff runs a number of risks, not least for his own family. We will see how in the next section.

Throughout, healing is for a considerable part a socioreligious process. The healers themselves successfully compensate their lower status as smiths with their healing expertise, even if they have no absolute privileges or monopoly on healing and alternative healers can be found. But, more important, all serious healing is set inside a social and a religious framework. Healing addresses not just the illness but also the patient, not only his somatic but also his socioreligious definition of self. Thus, the divination redefines symptoms into a reconstruction of the patient's past, which is in fact a partial redefinition of his social "persona." Diagnosis is discovering secrets about the patient, about his social relations, about mistakes made by or against him, about his relation with the other world. Western medicine

Examples of Kapsiki medicinal plants

lerhwu	*Nauclea latifolia L. (Rubiaceae)*	Crush roots and drink	To vomit up poison
tserhwe	*Canavalia virosa (Roxb.) Wight et Arn. (Compositae)*	With *balepale* and *daskwa*	Against *beshɛŋu*
rhwɛ gepe	*Euphorbia convolvuloides Hochst et Bent (Euphorbiaceae)*		Medicine against sorcerers
gwenzu ha	*Cucurbita pepo L. (Cucurbitaceae)*		To prevent someone being called to Wuta
hwɛɓe ŋ'yɛ	*Crinum sp. (Amaranthaceae)*		Against poison in beer. Makes one vomit. Against leopard hairs
nduŋwu	*Tribulus terrestris L. (Zygophyllaceae)*		Traditional poison that killed the people of Guria

entails a parallel process: symptoms are not what they seem but result from deeper-lying processes; but there, the processes are somatic and the secrets are inside the body, the healer's expertise dealing with the somatic intricacies of the patient. In Kapsiki traditional medicine, as in many African medicinal systems, the struggle is outside the patient's body. One line of approach is to reinstate harmony in his social body, in the relations with people, spirits, and gods, with the walls of the compound as one of the shields. Another line is to restore the integrity of the body limits, the shield of the skin. Treatment thus reinforces that perimeter, and lets something out of the body (blood, "evil," and frogs) more often than putting something into it. Medication is directed at externalizing the affliction, not internalizing it. A healthy being is someone who is able to successfully balance conflicting claims of sociability and privacy, claims of the other world and kinsmen, of autonomy and dependence. Being healthy is a result of well-administered agency.

What is the relevance of the senses in healing? Healing is a multifaceted way of interacting with the environment and one's clients. Smell is important in diagnostics, as one healer told me, for a healer with a cold has problems with diagnosing. "You smell not a particular illness, but you smell that something is not OK," he said, "and when I smell something like that, I let my mind go, and then try to feel in what direction the problem is heading." However, even if smell is crucial, the focus is not on the nose but on the eyes, as seeing is the main discourse, seeing "through" the apparitions that meet the eye. The healer has to look "behind" the symptoms, even has to look at things the client wants to hide from him or her. The principal sense is the eye—and not the naked eye, but the "knowing eye." Of all crafts, healing is the one in which dexterity is subservient to cognitive knowledge, as a healer has to "know." But the build-up of that knowledge, the ways of acquiring and accumulating medicinal know-how, is by vision: a healer has to go out into the bush and observe the behavior of animals, what they eat, how they react, how they heal when ill. And vision is more than just having one's eyes open. The "eye of the shadow/spirit" is crucial, as when dreams give information. But for someone who has that "eye," someone-who-knows, plain viewing is also different from the occasional observations of a passer-by: they look through appearances. Though much of the knowledge of the world is expressed in terms of "words," the healer's knowledge is discussed in visual terms. Intuition is crucial, the "sixth sense" as it is called in the West, but an intuition that goes hand-in-hand with the knowledge built up during the course of a healer's life, through seeing behind the screen of apparent

reality. That knowledge, and its transmission, is what we encounter in the next section.

TRANSMISSION OF MEDICINAL KNOWLEDGE

One medicinal dynamic that is difficult to explore is the actual transmission of medicinal knowledge. In principle, smiths state that this is done between kinsmen, usually father and son, or grandfather and grandson, with the mother's brother often also playing an important role. Some elements are clearly transmitted between kinsmen and kinswomen, the most

Medicine list of Gwarda, chief smith, 1973			
Crinum specimen	*Cissus* specimen	Other plant species	Other means
Bɛʃɛŋu	Witches	Bellyache of child	
Sekwa (guilt magic)	Epidemic	Snake bite	
Childbirth		Intestinal parasites	
Too rapid pregnancy		Senility	
Headache			
Stomachache woman		Scorpion sting	
		Cold	
Traveling abroad		Foot infection	
Threshing sorghum		Hepatitis	
Prevention of revenge magic			
Against poison			
Against *bedla*, curse			
Leprosy			
Lack of milk in woman			
Toothache			
Wounds			
Smallpox			

obvious being those treatments that are mainly technical, such as the manual extraction of *kwantedewushi* and bloodletting, or small operations. These are mainly the women's specializations, the male smiths' occupations being more cognitive and more private. The transmission of these latter elements is much less clear. Young smiths do claim that their (grand)father tells them everything. However, speaking with the older generations, I got the impression that they may be reticent about imparting their knowledge, judging the youngsters too immature for the accumulated knowledge. My recent research indicates that the process of preparing one's son or grandson for the arena of healing is quite complicated, and these new data indicate that there might in fact be hardly any transmission of precise knowledge content at all.

This sounds strange in the field of traditional medicine and questions the very notion of tradition. My thesis on the major transmission processes is that the actual content of medicinal plants or means is not transmitted, but reconstructed in and by each generation. What is transmitted is the way to construct this knowledge, the pathways for how to discover what plant does what and what mixtures are effective. My data here are longitudinal, as through my long involvement with the Kapsiki I could collect the medicine lists of different generations within the same family. As an example, I give the medicine list of the chief smith in 1973 and his grandson's list in 2009 in the sidebars.

One would expect that, in a traditional society, knowledge is handed down over the generations, and the private knowledge of medicine especially should "run in the family." After all, this is what "tradition" is about: handing over the accumulated wisdom of the past, from the ancestors to the present. But this is not at all what these lists teach us, as they hardly match at all. In order to be the same, two medicines must have the same goal and

Medicine list of Maître Kwada, grandson of Gwarda, 2009			
Crinum specimen	*Cissus* specimen	Other plant species	Other means
Bɛshɛŋu		Worms (bark of tree)	*Gutuli* (stone)
Adultery of wife		Bilharzias (mix)	Weight loss of child (lizard)
Too rapid pregnancy		Against curse	Miscarriage (2 means)

the same actual plant, so at least be in the same column. That, in fact, occurs surprisingly seldom.

The medicine against *bedla,* curses, is present in both lists, but clearly in different ways. All other medicines are different. So of the twenty-six medicines Gwarda had, his grandson "inherited" maybe just two, that is, against *beshɛŋu,* sorcery and against a too-rapid pregnancy (*matini* in Kapsiki, a pregnancy with no previous menstruation). However, both are *Crinum* types of *rhwɛ,* which means they probably are different specimens anyway. After all, even if both Gwarda and his grandson use *Crinum* against sorcery, it is highly dubious whether it will be the same line of specimens. Viewing the age of individual plants, it is highly improbable that they actually are the very same line. *Crinum* specimens do not last that long, and the bulbs are seldom brought to bloom; most of the bulbs are found in the bush, dug out, and planted at home, so transmission of a lasting line of *Crinum* medicines is very unlikely. So the only really transmitted medicine may be the one against worms/intestinal parasites.

The list of Gwarda is much longer, but then he was older at the time I compiled the list and a long-established chief smith, on whom people depended for their health, while his grandson is younger than Gwarda was when I interviewed him. The question is whether this partial transmission of knowledge is the rule or the exception, or whether it can be seen as a sign of erosion of the smith's function as medicine man. For the latter option, we can compare the lists with that of a smith of the same generation as Maître, Dzule.

Dzule seems to have a larger overlap with Gwarda, even if he is neither his descendant nor close kin, but most of the similar ailments are met with different means, such as epidemics, snakebites, headaches, poisons, and

Medicine list of Dzule		
***Crinum* specimen**	***Cissus* specimen**	**Other plant species**
Beshɛŋu	Witches	Arthritis
Poison		How to steal unnoticed
Epidemic		Headache
Chicken pox (+ other plant)		Childbirth
Snakebite		Miscarriage
		Gutuli spirits

childbirth. Both have medicine against *besheŋu* (sorcery)—any smith will have that—but the actual medicines may well differ. The younger generation also has means against the bush spirits, *gutuli*, which Gwarda does not have. Protection against sorcery is common discourse and has not changed much, but the notion of the dangerous bush spirits is quite recent, and probably an influence of Christianity. In 1973 medicine men claimed to have learned their trade from *gutuli*, in what has become a more or less permanent relation:

> Dègu has regular contact with a particular *gutuli*, he says. Every other month or so this *gutuli* visits him in the form of an old man with a white beard and hair hanging half-way down his back. He then tells Dègu what is going to happen in the village: who will die, what twins will be born, what sacrifices Dègu and his brothers have to bring, and so on. This relationship stems from a long time ago, when Dègu was a youngster, sent out in the field to collect leaves for his mother's sauce. There he found a group of *gutuli*, in various sizes and colors (except white) dancing under a tree. One of them had died, and was decked out like any corpse. They wanted to kill Dègu, but an old *gutuli* protected him and let him have his leaves. At home Dègu fell ill, and lost consciousness. In the following days the old *gutuli* came to his house and treated him with leaves of a plant which had stood next to the trees whose leaves he had plucked for the sauce. Dègu healed and the *gutuli* kept coming.

This kind of provenance of medicinal knowledge is not mentioned any longer. Formerly, *gutuli* were more or less equated with *shala* (god), but Christianization made them into small, black demons, and they no longer serve as a source of knowledge—so protective medicine against them is called for.

Drawing a conclusion from these lists is not easy, but some trends do run parallel to processes already mentioned in Kapsiki ethnomedicine. The first is that of secrecy, keeping the actual relevant information very close to one's chest, even—we might say now—among kinsmen. Healers, both smith and nonsmith, stress the fact that getting the information involves suffering, sometimes money, but always also their own strenuous effort and research, trying out their own hunches. What is important, one healer explained, is to look carefully at what wild animals eat and in particular what food they spurn. Then one takes that plant, showing it to someone who knows about it, if one can find anyone; in any case, one tries out the plant following one's own intuition and so produces new medicinal knowledge. Smith healers produce this kind of knowledge by actively looking for specific new

cures or capabilities, and each of them has a small list of types of medicine they still want to obtain. For Dzule, this is the medicine for flying. Again, these tales and the lists suggest that knowledge is not transmitted but reinvented in each generation; this kind of secret knowledge is produced, not reproduced. Actual specialist medicines seem to have little history, and what is traditional about them is the process of constructing the knowledge, rather than the knowledge content itself. In this case, tradition has no content, only method. It should be remembered that even if the list shows a medication against the same affliction, the medicine itself might well be different—a different *Crinum* specimen, for instance. What is "traditional" is the fact that Maître Kwada explicitly states that "all his medicines came from Gwarda"; in actual fact they did not, but his grandfather taught him how to construct the knowledge. So tradition is not the transmission of knowledge, but the way to reinvent the knowledge. The notion of tradition itself, in such a case, serves as an invocation of authority: invoking the past gives credence and weight to one's construction of knowledge, more an "argumentum ad autoritatem" than actual direct transmission.[15]

In short, the healers use two discourses: "I learnt it from my (grand) father," and "I suffered for it in the bush." They tell the truth, in my view: their grandfathers told them how to suffer for it in the bush. The patients, for their part, need the certainty of ancient wisdom more than private invention, and they support the discourse on transmission of content over generations as their evident best interest. So the first discourse on inheritance is dominant and fits well into folk notions of tradition, seen as the unchanged legacy of wisdom from the deep past, a common mystification of African's past. The second discourse emerges mainly under inquiry, either by the patient or by me, and serves as a second order ratification.

Such a procedural knowledge system is very flexible but has little accumulative learning. It might well be that these processes of reinvention preclude the construction of effective medicinal knowledge, as practical testing of medication is limited to one generation. Secrecy, which after all is part of this process and is widely associated with traditional medicinal knowledge, is not a productive pathway for testing knowledge. Thus, as I have argued elsewhere,[16] the folk medication probably is somatically more effective than the specialists' prescriptions. The large majority of folk medication comes from different plants, a fact that easily emerged from my botanical collecting. I checked with healers a list of forty folk medicines they held in common; of these, five were *Crinum*, one was *Cissus*, five were not plants, and twenty-nine were plants recognized as medicinal for specific ailments with straightforward recipes, which were the plants

everybody knew. But, of course, we should not underestimate the extrasomatic effects of dramatic iatric performances by the specialist, as we know placebo effects to be important and real.

So traditional medicinal knowledge is vulnerable, and erosion of the smith position in healing is indeed discernible. The *Cissus* species seems to be on the retreat as medicine, which is in tune with the general retreat of traditional religion; after all, *Cissus* is a plant loaded with symbolism in many rituals, not only for the Kapsiki but also in the wider region. The medicine against witchcraft—that is, those particular *Cissus* plants—is widely known anyway. In the next section, we will see some medicine lists of nonsmiths, *melu*, and see that the smiths are losing out on their virtual monopoly in traditional medication: the younger smiths have less medication, and others are taking over. The market has been broken open.

NEW HEALERS, NEW MARKETS

Thus far we have zoomed in on smith-healers, but the healing arena is in principle an open one. At the time of my first field stay, *melu* healers had already been establishing themselves, and one of them, Kweji Hake, is a good example of the dynamics in this field. He was the one who gave me the complex series of prescriptions on "how to marry a wife," which already shows one trend: at that time *melu* healers zoomed in what we would call the more magical side of *rhwε*. When we look at his lists of medicines, this difference is clear.

The majority of his *rhwε* in table 5[17] is not for any type of physical complaint, but for increase, gain, protection, and harm, even for amusement or showing off. While *melu* Kweji Hake may not be of ambivalent stature

Table 5. Overview of *rhwε* of Kweji Hake, nonsmith

	Somatic	Nonsomatic	Total
hwεbε	1	5	6
haŋgedle	—	7	7
Other plant	4	14	18
Non-plant	1	10	1
Total	6	36	42

himself, his *rhwɛ* surely are. Also, the balance has shifted from the traditional medicinal plants, *Crinum* and *Cissus*, to other plants and means, and as a whole they are more complex. Kweji was widely known to be a *nderhwɛ*, a healer/magician, and often was called Kweji Rhwɛ, a name nobody would use for a smith. The irony of fate had it that it was this very same Kweji Hake who died of a snake bite, against which he used both his own medication and a cure he got from the dispensary, which he sold after the first injection.

This trend away from somatic healing to magical dramatics may also stem from an increased competition of traditional healing with the western type of medication and is probably more pronounced among *melu* healers than with smiths. However, it is countered by one that is focusing on healing as a separate profession. The rather clear distinction between Western and traditional healing in recent decennia has become more complex through a process of professionalization of African healing, which not only ties the processes of healing into regional and national cadres but also tends to exclude the smiths as healers. First, the market of divination, as one important means of anamnesis, has diversified and moved out of the near-monopoly situation of the smiths. Divination by cowrie shells, a widely used technique in West Africa, has become important as a technique, especially by and for women. Second, crab divination has also gradually moved from the hands of the smiths into the *kelɛŋu*, the "clairvoyants" or spirit walkers. They are *melu* but with a special connection to the "other world." My last divination session, in 2010, was with this category of diviner.

Not only anamnesis is changing; healership itself is increasingly also becoming an open profession, and part of that appeal is the remuneration of healers. As for the latter, people generally complain that being ill has become more expensive than ever, as both the dispensary and the native healers have upped their prices. In fact, it has never been very cheap to begin with. Admittedly, divination does cost just a few coins, cfa 100, and that has risen little. But the treatment, with whatever medicine, was quite costly also in the past, usually as in-kind payments (chickens, an occasional goat), rarely monetary. So it is partly the monetization, and thus the commoditization, that gives the impression of rising costs, partly an expanding medicinal repertoire. In addition, of course, some new illnesses have appeared, and last but not least, the new healers.

New healers are both men and women. Formerly, smith women had some specializations, as we saw. Present-day woman healers are *melu* and have a wider array of expertise. As an example, take Masi Kantsu, who performs divination (with cowries), is a midwife, and has her own array of

medicine as seen in the sidebar. Compared with older medicine lists given earlier, the list in the sidebar is still quite traditional in its definitions of illness and its use of *Crinum*. The main dynamic is the fact that this concerns a *melu* as well as a woman, which is a double opening-up.

The more important changes in medication proper, in terms of new medicines being added to the Kapsiki corpus, come from new male healers, and here I use the example of Haman Tizhè, an important man among the new healers.[18] Haman learned his craft in Michika, the regional center of the Higi part of the Kapsiki/Higi. From there he ventured out into the bush, where he made the acquaintance of the healers in the area, usually smiths or hunters. Investing much time, money, and energy in those relations, he was gradually introduced to the secrets of Kapsiki medicine over a wider area. And of course, as mentioned above, he watched the wild animals feed. He still spends a lot of time in the bush with old hunters and healers but also meets them in Sokoto, Aba, and Gaitan (all in Nigeria), and in Niger; he even communicated with Islamic healers from Mali when he was in Sokoto. One needs to travel a lot as a new healer, so Haman is frequently away, though more so in the past than today because now that he is established, people come to him.

Haman has developed a new array of medications. More than in traditional settings and more than the smiths, he addresses new problems in one's daily encounters: how to pass exams, how to achieve success at work, or how to get revenge on one's enemies, using both the word "voyance" (knowing the future) and "blindage," making one's enemies socially "blind." Traditionally, voyance resided in divination, but Haman does not perform divination himself; he just makes diagnoses, basing his assessment on the client's somatic complaints. As the basis of his healership, he treats a large array of somatic ailments, easily encompassing all illnesses mentioned in the lists cited.

List of Masi Kantsu, woman healer, nonsmith

Crinum specimen	*Cissus* specimen	Other plant species
Beshɛŋu		Bellyache (root)
Poison		Childbirth
Gutuli spirits		Pregnancy
Protection (+ root + perfume)		
Success at market		

Figure 27. The sign of the practice

But not all new problems are somatic. For example, to have good luck in your car, you have to take some chameleon eggs, and then you will not have any accidents and people will see you coming. Evidently, as a new healer, HIV/AIDS also has his attention; he claims to be able to cure it only in its first HIV stage: a client is tested as positive, then gets "calmage" (by this he means his version of antiretroviral treatment), and then he can give the patient his treatment for three months. The patient is then retested, and if negative, has to continue both treatments and then go for another testing, preferably at another hospital. He insists that with HIV/AIDS, healers have to cooperate with the local hospitals and dispensaries, and he considers any healer who refuses to send his patients to be tested for HIV first at the hospital and get antiretroviral medication, a "charlatan."

Haman has developed what he calls a "passe-partout," a general medication with a broad spectrum. This is a composite medication made up of five plants, which have to be taken within five minutes of each other. It aims especially at treatments by phone and at a distance, another important new development. When a new patient calls on the phone, Haman asks what the ailment is, where it hurts, and what the problem is. However, he has to check what people have eaten recently and whether women are menstruating, as both preclude certain

products. If the patient has no diarrhea, he sends him or her his passe-partout by mail, with some instructions per phone text and waits for its arrival. In the next call he indicates which product has to be taken first and what the waiting time between products should be, and then tells the patient to call back within four hours. If the problem abates a little, he instructs the patient what to take for the rest of the week and to call back in six days. If the medicine appears to have had no effect, another product is tried, but this evidently takes time. He is now also using this passe-partout with patients at home, where the feedback is quicker. Such a passe-partout is not an easy thing to come by, and he is proud to have it in his collection. But like anything in medicine, one has to exert oneself to get it or develop it. In his words: "Only a real healer who has genuinely 'suffered' has such a passe-partout."

Despite his proliferation of medications, the general principles of Kapsiki medication still hold for him. *Crinum* is still a basic resource in his pharmacopoeia, with *Cissus* as a minor player. However, in his hands, not only is a specific *Crinum* or *Cissus* specimen important, but it is always mixed with other herbs, roots, barks, and concoctions of various compositions, stored in plastic bottles, cups, and other paraphernalia from the Western system. Although many of his basic medicines include well-known folk medicines, these are also treated, mixed, and made unrecognizable in his prescriptions.

Once the clients appear to be healed, he sends no bill but asks them to "send whatever Allah has provided them with," and to send it via Western Union, MoneyGram, or MTA transfer—but only what they can afford, as, in his words, a patient should not become poor because of medical treatment. This way he has built up a wide circle of patients in the south of Cameroon and even in Norway and Paris, all of them Africans, an extension of the circle of clients for which he needs a wider array of medication but which brings in many more clients and much more remuneration. That, at least he claims.

Haman calls himself "tradi-praticien," has initiated the "Association pour les tradi-praticiens de Mayo Tsanaga," realized its membership under the national umbrella organization of traditional healers in Cameroon, and also received recognition from the OISA, the "Organisation Internationale pour la Santé en Afrique." This has not yet led to standardization of practice or pricing, as Haman is still able to dominate the organization and to set his own agenda. Transcending the ethnic border, he has also built up a practice in Mokolo, the regional capital of the "prefecture." He divides his week between the two places—three days a week in Mokolo and four in Mogode—spending market day in Mogode in his residence just across the road from the dispensary, while his house in Mokolo is just around the corner from the hospital. These

choices of location indicate his desire for respectability from and cooperation with the Western medical system. The local infirmary at the Mogode dispensary is less impressed, and when speaking about traditional healing, including Haman, complains about the delay in "real" treatment these healers seem to cause. "People start first with the traditional healing and then, too late, appear at our door," a much-heard complaint of cosmopolitan health workers. As for the Association, the health worker comments that it is probably beneficial to Haman, echoing a remark of Masi Kantsu in the same vein. The woman healer, mentioned above, declared that she had never seen anything of the government money that should have been distributed among local healers,[19] and in fact had never seen any return from the contributions she had to pay to the Association. So she opted out.

This extended case shows that in this field the smiths are losing out and ceding their first place to *melu*. Why? Usually smiths are the ones to pick up quickly on new developments and adapt quickly to new technologies and markets, but not here. I think the answer lies in professional status and its linkages with the outside world. Healing was always important but quite ambivalent: healing in Kapsiki was associated with low status, and the process itself fraught with danger—including danger for the healer. Though not typically a "wounded healer" type, the Kapsiki smith/healer still ran the risk of attracting the affliction he cured his patient from. With the coming of cosmopolitan medicine, this changed. Healership, all over Africa, has increased in status, while diminishing in risk. The link with the dispensaries and hospitals was always tenuous and fragile but has grown stronger, and these prestigious institutions now furnish the model, setting the standard to emulate.

Officialization by the government in the form of registration and the genesis of professional associations heightens the status even more, drawing it closer to cosmopolitan organizations, a result explicitly aimed at by a government intent on combining the two systems. Smiths find it difficult to participate in, let alone lead such official bodies as *rerhε*. Finally, prices rise, including those of healing, and being a healer has become a rather lucrative profession, much more so than in the past. The combined effect has been that the status of healer is rising slowly but surely out of reach of the "internal others"; after all, "internal others" are very much the "local others," and the advantages of their underprivileged status are not transferable to a higher social echelon, while their lower status remains intact. In short, they lose on the national scene the relative but restricted advantage that their intermediary position as ambivalent people offers them locally.

A Sense of Justice

THE FEAR OF REVENGE

GWARDA, THE CHIEF SMITH, CONSULTS HIS FELLOW *RERHE* CEWUVE about a personal problem. A long time ago he killed someone in Sena, a village on the Nigerian side of the border. Now he has heard rumors that the people from that village are planning something against him, and he is worried, as he has to make a trip into a village close to Sena and senses danger. He is especially worried that the *hwa ta Va*, lightning (literally, knife of Rain), will strike him as revenge for this killing and has heard that the people of Sena are already looking to approach Rain (a divinity in Kapsiki religion) to do so. His old killing has never been paid for nor has a counter-raid been possible (owing to the arrival of "pax colonialis").

The crab allays his fears: there is no danger of lightning, but there is definitely a threat of illness. To travel safely a sacrifice is called for, as danger is definitely present. After that information, the consultation mainly addresses how to prevent being struck by lightning, which can be avoided by the right sacrifices. Eventually, some dialogue with the crab establishes the exact nature of the sacrifice necessary to avert the threat.

This chapter is about notions of justice, revenge, and "evil," and thus about protection against harm other people may inflict. The first question is who that other is. In Gwarda's case, it is the traditional enemy of the other village, which makes it highly credible but also manageable; confronting the enemy village provides a handle on how to counter any threat, as the long history of hostility between villages has generated a host of protective "medicines." The danger specified here, revenge by lightning, is only one possible option, but there are many more ways to inflict harm, often magical. This divination between two

specialists and friends did not elaborate on possible supernatural threats, as both are well aware of them. So Cewuve deems it unnecessary to warn against harmful magic, as he would have done to someone else. Gwarda is even more of a specialist in this than Cewuve, so they do not discuss the main threat at all, omitting it as self-evident. In the end Gwarda traveled to Sena, brought along his defenses against *beshɛŋu*, conducted his business, and came back in one piece; actually, he lived in peace and health for another twenty years, and at his death was feted as a very respected and admired chief smith. But religious specialists also do not know the future. In this case the other is the traditional enemy, the other village; in this chapter, who is the "other" will vary from the enemy to the own village, from unknown people to kinsmen.

CURSES

Revenge was Gwarda's scare, and revenge is indeed to be feared, in several ways. Especially between close kinsmen, many forms of revenge are possible. Kapsiki society is not a harmony-oriented culture in which competition and rivalry remain hidden from the roving eye, but more an arena of social relations, some harmonious but the majority not, some with parallel interests but most not. There are classic fault lines in Kapsiki society. For instance, the relationship between half-brothers is paradigmatic: sharing the same father but with different mothers, they lack the close emotional bond that in Kapsiki culture comes through matrilateral links, while they compete for position, inheritance, and wealth. So they are both each other's model and obstacle,[1] resulting in a precarious balance between bonding and strife.

Although misfortune—evil, for instance—can come also from outsiders, it is more potent when it comes from the inside, for if the one who should be benign is actually fiendish, who then is the ally? The central notion here is the curse, *bedla*. A curse can come from any kin: father, brother, father's brother/sister, initiation-father, or even mother, but from the mother's side is the most powerful. After all, the Kapsiki reason, those are the people who should love you; so if they curse you, they will have a very good reason. For instance, as the closest relative is one's mother, an ill wish from the mother outweighs anything else. Her brother comes as a close second, for if a nephew does not show proper respect for him, he may resort to a formal curse. This does not involve a great deal of ritual but is simply spoken: "If so-and-so has misbehaved against me in that manner, then . . ." A wide variety of afflictions can be projected in this

Figure 28. Protective war medicine

way, and the closer the relationship between the parties, the more danger-ous the curse. The mother and her brother need, in fact, only to think of the curse. The image of a mother chewing softly on her nipple and whis-pering some threats is an image that frightens any Kapsiki, for if nothing is done, all children that drank from that breast will die. I never witnessed a woman actually do this, but when enraged they sometimes pick up a dangling breast as a not-so-veiled threat. Her children, including her adult ones, will then quickly calm down. Yet a mother will not want to ruin her children, as she is expected to love them: "Why would she have married, otherwise?" In comparison, the curse of a father or a father's brother is much more benign: "May your child be as disrespectful against you as you are against me."

A man's in-laws may also curse, a curse that will hit the marriage, mean-ing that their daughter will not remain with her husband, or—if against a daughter-in-law—that she will only be able to give birth in their son's home. Quite a few tall stories circulate about this latter kind of *bedla*:

> Tsahema told me that his wife had run away because his mother had cursed her so that she could only deliver in Tsahema's house. The wife had other plans, but though pregnant, could indeed not bear the child anywhere else; so after a preg-nancy of eleven months [sic!] came home, bore her child (a son), and left again.

A curse is more thought than spoken, often hardly conscious at all. "The heart curses," the Kapsiki say, and one may easily forget it, once the anger subsides. For instance, after the theft of an object, the thief will be cursed, and if a kinsman is the culprit it will be effective. But sometimes people utter them aloud and mean exactly what they say:

> Kwatake, the daughter of a neighbor, has left for a new husband in the next vil-lage. That in itself is pretty standard, but she has chosen an "enemy," someone who in the past has "stolen" a wife from her brother. Her mother is enraged and now curses this new marriage: "If Kwatake is my daughter, and if he has done evil against us in the past, I do not want her to stay with him."
>
> The marriage was over in three months, and Kwatake moved onward to a new husband, in yet another village.

Serious cases call for a collective curse. The family concerned, often a sub-lineage, unites, has some *tɛ* (red beer) brewed, and invites a smith. In the early morning they slaughter a goat—if indicated by the crab on a sacrificial jar—and proceed with the curse.

When Zra Mpa "stole" Kwangwushi, the wife of 'Yama, the elders of 'Yama's lineage united, killed a goat, and pronounced a curse over this marriage. The first attempt failed because a guest from Sir blundered into the meeting and "spoiled" the curse, so they did it a second time: "If this is our child [who stole the woman—that is, Zra Mpa] then he has to remain alone with that wife [and not marry other wives] and have no children." The smith was there to make the curse "heavier." He did not pronounce the curse, but just clapped his hands, a gentle tapping that underlines any ritual, charging it with the ritual efficacy of the smith.

The situation was complicated here. Zra Mpa was the sister's son of 'Yama's larger clan, but not of his sublineage (in which case, Zra would not have dreamed of "stealing" Kwangwushi). 'Yama belonged to an "immigrant" group who came from the Nigerian side, an adopted sublineage. Zra had inquired with his real mother's brother whether he could take the woman, and that uncle told him not to worry about the curse of that "remote" kin group.

'Yama's people tried the curse anyway, but without much success. Kwangwushi fell pregnant and had to go to the dispensary in Sir because of some complications. 'Yama's mother then asked Zra Mpa whether the child had already died. But, indeed, no lasting success, as after a first miscarriage Kwangwushi bore a healthy daughter, and many other children afterward.

For any curse to be effective, the notion of one's own guilt (*fete*) is crucial. As the formula used in the curse indicates, it is only effective in case of factual and serious misbehavior, of real *fete*. So the power is in the relationship, the guarantee is in proper behavior, and the means to inflict harm is through thoughts and words. Yet even if the relationship is dominant, some personal characteristics can also be crucial. One informant told me that he would never be able to curse effectively, but that the "strong words" of others were to be feared. And, of course, the "special people" among the Kapsiki have "special curses," so clairvoyants (*kelɛŋu*), twins, and evidently smiths are to be feared for the words of their mouth.

Curses are noticed by their effects, by misfortune of any kind—no children, women run off, no game in a hunt, cattle die—but in principle, curses can be annulled by a ritual that looks like the *bedla* itself: words of the mouth accompanied by spitting. So the afflicted has to ascertain both the cause and the remedy, usually through divination: the crab has to indicate whether it is a *bedla* and by whom. In such a case the crab may indicate

"a mother's brother," and the client himself has to puzzle out which one and why. If he thinks he has the answer, he brews some red beer and in the small hours of the night goes to his kinsman.

> At 2.30 A.M. a sister's daughter of Sunu Luc comes to his home to have a curse undone. When she left her husband Terimcè, a friend of Sunu, he had tried to get her back to his friend. She refused and he was angry. Now she was pregnant but had lost a lot of blood and consulted the crab: she should go to Sunu with *te* and a chicken. Handing the chicken to Sunu as a gift, she explained her predicament. Kwafashè, Sunu's wife, also woke up, ground some sorghum, and mixed it with the *te*. Sunu took a large scoop and doused his niece with beer: "May god help me and may you become pregnant. Thus you know I have put you straight. I do not cry over you; be healthy and give me my *hwelefwe*[2] because I have said so."

This simple ritual of redress is called *mpisu* (spit, technically exsufflate), and spitting is indeed the usual way of redressing wrongs, as it is in giving blessings, such as during initiation and weddings. The kinsman in question, like Sunu, cannot refuse, as he is expected to clear the relationship. If he wants to keep the curse intact, he should wash before the *mpisu*. That is why the "cursed one" arrives suddenly in the middle of the night and does not let the "curser" out of sight. But usually, the latter is hardly aware of the curse; in fact, most examples I have collected feature "cursers" who were blissfully ignorant of their eventual *bedla*.

> The wife of another neighbor, Kwada Kwefi, had left, again. The crab told Kwada that his father's wife [his mother's cowife] had cursed him, for whatever reason. He brewed *te*, invited her to his house, and she came at night, spat on him, spoke the words, and took the beer home. Ten days later his wife was back.

The *mpisu* does not always work.

> Sunu's wife Kwafashè did not get pregnant after her first child and learned during an earlier pebbles' divination that her father's brother had never agreed with her choice of first husband. So she and Sunu took some beer over to him, he put a little bit of flour in it, took a mouthful, and said her: "I was not content about your choice of husband. Maybe that is the reason why you did not become pregnant any more, but this is the only way we can know. If this was the reason for your infertility, then that reason is finished," and he spat on both Kwafashè and Sunu.
> She did indeed become pregnant, but only after later divinatory sessions with the crab and sacrifices.

The crab can go back into the past, as in the last case, and the "culprit" may have died. The *mpisu* then becomes the ritual of *kadza ŋkwa* ("go to the place"). Again, the smith diviner indicates the exact procedure, usually involving a small offering of beer dregs and some sorghum or meat. In the middle of the night, the "cursed one" takes this in a bowl to the grave of the kinsman, makes a small heap of stones, puts the offerings on top, and explains the reason for coming. The deceased, who has already indicated through the crab which smith has to represent him, then is expected to take away the *bedla*, in the same way as the *mpisu* does. The same ritual, always involving a smith, is done when two cowives have quarreled, or when the illness or barrenness of a woman is attributed to adultery. Then it is not just a grave, but the one of culture hero Hwempetla, the real *ŋkwa shala*, place of god. The smith and woman take a goat along to the spot. The smith explains to the *shala* of that place what had happened, the woman may confess, but the main argument versus *shala* is: "Here is your food; now forgive her." The smith slaughters the goat, leaves the blood on the grave, and both return home, the smith with the meat. For the Kapsiki, this is in fact the same as *dzerhe melɛ*, the sacrifice on the jar.

So *bedla* and *mpisu* are both discourse and practice; at least the *mpisu* is actual practice. Women especially have an intense discourse on *bedla* and tend to define their problems more in terms of curse and *mpisu* than men do. Responsible for their families, men tend to sacrifice more when misfortune strikes than depend on the reparation of relations, so they address the other world more than that of human relations. In any case, this is one area in ritual life where the smiths are not central, as the kinship relations are the core of both the problem and the solution, not the "other world"— so the smiths' role is limited to adding a little accolade to the relational problems. If invited, smiths say nothing and just clap their hands, asking for the attention of the people and the *shala* of the place.

OATHS

In their assertive internal communication, when trying to convince their fellow Kapsiki that they are speaking the truth, the Kapsiki tend to swear oaths rather quickly and easily. *Zeme fela* (eat an oath) is the expression, and they are always sworn on something, objects or happenings that should occur if the oath-taker lies; so *fela* is in fact a conditional curse. *Shala*, god, hears all and keeps the oath-takers to their word. Men tend to swear by the

lightning: "If this is not true, the 'knife of Rain' [lightning] should hit me." Women may take their oaths on a completely different risk, the *bama*, the sorghum explosion.

> When one is cooking sorghum mush, all flour is poured in one go into the boiling water. Sometimes, the flour remains in one ball, and the exterior cooks and shrinks, creating a large pressure on the inside. This can lead to an explosion of the hot flour inside the cooking pot, and such a *bama* then risks covering the woman with hot mush and boiling water. A woman with *bama* once showed up at my door in order to be treated for these burns. It indeed looked terrible: her head and torso were completely covered with blisters and burns. I took her to the hospital in Mokolo immediately. She healed well, with few scars.

Actually, this is one risk that has almost disappeared, through a change in cooking. The rather closed pots of old have been replaced by the ubiquitous open aluminum cooking pots, in which no tension can build up, and the maize mush that is gradually replacing the sorghum does not explode.

Oaths are also taken on places that are called *shala*, god, as well as special trees associated with *gutuli*, black bush spirits, such as the *wumbela* (botanically *Cassia nigricans*), *vɛmɛ* (botanically *Erythrina stanoides*), *hwemeke* (botanically *Boswellia sp.*), *heyintsu* (botanically *Dyospyro mespiliformis*), and *lekeleke* (botanically *Isoberlina doka*). The formula then runs that the beings of this place should hit them if they do not speak the truth. These *shala* places are usually places with much water, often associated with an accident in the past.

> One of these places is Kwandawuzha, "place that eats the girl," a well deep in the bush. Nobody came to haul water here, because a girl seems to have disappeared here in the past; maybe because of an oath, people wonder. Anyway, the combination of such a watery place with a major accident suffices to render such a place "powerful," thus an apt spot for swearing heavy oaths. I used this situation myself by taking water from this well for our family: the water was excellent and in this way our large water intake did not tax the other wells.

Thus, oaths are activated, or "enforced," by either special places or special objects, objects called *shafa*, on which oaths are sworn. Anything closely associated with death can serve as *shafa*, while the most severe one is sworn on a corpse. If suspicion arises that someone is killed by sorcery (*beshɛŋu*), the possible suspect may indicate to the smiths that he wants to take the oath on the corpse. The smiths then put the corpse next to the grave, and

the "suspect" undresses, swears that Death has to take him on the spot if he is guilty, and steps over the body. If his immediate family has enough confidence in him, they do the same: undress, swear, and step over the body. Most of the time, however, it is not that drastic, and an object linked with death is used. This can be a spear that has killed someone in the past, a part of the funeral shroud, the porcupine quills, the bean fibers used in tying the jaw, the arrow shafts from the corpse's head, or the iron bar used in operating upon a corpse or in washing the skin of a corpse. The most gruesome is the Achilles tendon of someone who has died in the bush, but that I have never seen. There is a definite time limit set on *shafa* oaths: any death occurring up to three months after the oath is considered a direct result of the oath. Crucial in *shafa* is that the oath has to be public, at least have some audience and witnesses.

Other oath objects are the *rhamca*, the goatskin that is the basic clothing of the corpse, or the bean fibers that shut the mouth of the deceased. Finally, some items that symbolize death in the bush serve the same purpose—the shaft of an arrow that killed someone, or the quills of a red porcupine that has adorned a recent death. In all cases, the oath-taker places the objects on the ground, states the accusation, and then swears that "if I have done that, you have to kill me" and steps over the object. Compared with these heavy *shafa* oaths, swearing on the lightning and—formerly—the *bama* is the light variant, done almost haphazardly. People say that taking oaths is diminishing, not because people tell the truth more than in the past—the opposite is considered to be the case—but because medicine against *zeme fela* has become more generally available.

COLLECTING DEBT

The power of relation is apparent in the curse and its removal, and the crucial factor is "being right," having no *fete*. In the ritual way to reclaim debts, a magical means is used, called *sekwa*, in which the same principle operates even stronger. In principle, *sekwa* is a means of ensuring the repayment of debts: when someone refuses to repay a debt, a creditor may put his *sekwa* in the debtor's compound, and death will strike that compound like an epidemic, wiping out the debtor's household as well as anyone else who has ever eaten there. This *sekwa* may be used as a threat but one that is seldom carried out. As it is in principle a means to ensure reciprocity of a gift, it is considered a perfectly legitimate means of enforcing repayment, and neither

its manufacture nor its possession or use bears any social stigma. Everybody is entitled to possess *sekwa*. There is in principle no remedy against it except paying the debts immediately. When applied, it is put in the middle of the courtyard, visible to everyone, but things rarely go that far.

Smiths are usually the ones asked to procure *sekwa*, but not exclusively so, as anyone who knows how can make *sekwa*. It consists of a bundle of objects, and its composition is generally known; however, again, the smiths have the most powerful ones as well as the largest array.

> Walking through the village I noticed an array of small objects at a house entrance: a strip of black cloth, two arrow shafts, and some bean fibers. Sunu Luc nodded: "Yes, this is *sekwa*. Walk on, it is not our business." The latter remark on ignoring the situation was not how an anthropologist would define his job, but I recognized the symbols of death, typical smith stuff, and we walked on. Of course I later inquired, discreetly; the debt was paid.

Sekwa is in principle the threat of death, so it is smith turf. The crux is that it only works in cases of a real debt, for without it the *sekwa* is just stuff that anybody can touch or remove. Thus, *sekwa* is one major means in judicial debates and is often used in bridewealth restitutions. The Kapsiki authority who hears most of the local court cases has forbidden the use of *sekwa*, under the pretext that it is a way to kill, not to administer justice. Of course, trying to do away with *sekwa* makes for more court cases, which suits him well, and in any case *sekwa* is always used as a threat, seldom really placed; the above example is an exception, hence my assistant's reaction. When the claimant walks alongside the house of the debtor, brandishing his *sekwa*, which is easily recognized by all, it should be enough. If they do not pay up, then probably the debt is not real, or at least not acknowledged.

If, on the other hand, deaths do occur in a house where *sekwa* has been put, it calls for serious reflection and countermeasures. According to the Kapsiki, the weakest of the family are afflicted first, the children. So after the death of a child and surely after two children die, a friend of the family will ask their father to reconsider his debts. If there might be a debt outstanding after all, they both go to the claimant, with a large gift of goats, sheep, begging for forgiveness. He then has to take his *sekwa* back and forgive them, in clear words. Back home they sacrifice a chicken on the *melɛ*, mix the blood with *hwɛɓɛ sekwa* (a specific *Crinum* specimen serving as a medicine against *sekwa*) they have asked from a neighboring smith, and smear all members of the family with the mixture. Then the problem should be over.

Several recipes for *sekwa* are on the market, involving either a mix of death-related objects or a specific mix of some herbs, some animal bones, and ocher.

One spectacular item in some *sekwa* is bone of the *dambatsaraka*, a bird that has an enormous reputation with the Kapsiki. It is the hamerkop, *Scopus umbretta*. The strangest aspect of hamerkop behavior is its huge nest, sometimes more than 1.5 m across, strong enough to support a man's weight. The birds decorate the outside with bright-colored objects. These birds are compulsive nest-builders, constructing three to five nests in their life whether they are breeding or not. Owls may force them out and take over the nests, but when the owls leave, the owners may reuse the nests. Snakes, small mammals such as genets, and various birds live in abandoned nests.

For the Kapsiki, this behavior is a nightmare: building a house for someone else, getting crowded out, and building again. So the bones of the *dambatsaraka* are very effective as part of the *sekwa*, a real threat, for anybody with "guilt" who touches the bones of a *dambatsaraka* will spend the rest of his life building, and whenever he has finished a building, others will claim it, force him out, and he will have to build again.

It is curious to see a wading bird, part of the pelican family, have such a central symbolic position, for the bird is rare in the dry mountains of the Mandara area. I had never spotted one before finally seeing one in Namibia in 1998, and few of my informants had, but they had the peculiarities of the bird completely correct. But then, there were some hamerkop nests in the area, and these are spectacular indeed. High up in a fork of the trees, the nest is an amalgam of all the odds and ends found in the vicinity, from mud, twigs, and leaves, to paper, cloth, and plastic.

The actual recipe is complicated. When one finds a dead *dambatsaraka*, one never takes any eggs from the huge nest, lest one keeps building for the rest of one's lifetime. For the same reason, the bird is never eaten, not even by the smiths, who are not exempt from its threat. Just the bones are taken and buried in the courtyard. An onion is planted next to it, and a cord from *pesekene*.[3] This rope, some of the onion, and some *safa*,[4] the general symbol of transition, are taken to the debtor and placed in his house.

Other types of *sekwa* follow the same logic but are more morbid. In one, a young puppy dog is left to die in a jar, and the body is buried with a *hwɛbɛ* next to it, along with the *pesekene* rope. The rope, onion, and *safa* again

serve as *sekwa*. A third type starts with a special kill of a duiker antelope: the arrow and shaft of the hunter should be lodged completely in the animal's flesh. The hunter cuts out the shaft, breaks it into small pieces, puts these in a jar with *hwεбε*, and then with the onion, *safa*, and *pesekene* cord we have another genre of *sekwa*. Thus, the logic of the *sekwa* zooms in on strange death, humanly inflicted, and is always combined with the central medicinal and magic plant of the Kapsiki, *Crinum*. *Safa* (a *Combretum* species) has a wide array of meanings, associated both with death and initiation, while *pesekene* cord, as a rope made from lianas, is easily recognizable.

As always, there are no absolutes, and also not in Kapsiki magic. There is, according to some smith specialists, a magical defense against the effect of *sekwa*, without paying. It consists of a very well-known plant, *shikwedʼi* (botanically *Ceratotheca sesamoides*), which is used to bind sauces, on the one hand, but is also part of various *rhwε* (magical stuff) for the forge, for casting brass but also in other combinations against *sekwa* and smallpox. This is a plant that is deemed to reinforce each and every *hwεбε*, onion. For *rhwε damara* (small pox): mix with *kwantereza* and *hwεбε damara*, then pound and sprinkle with cow's tail. For *rhwε sekwa*: mix with *hwεбε sekwa*, sprinkle the house of the afflicted with a cow's tail, and it will heal the effects of the *sekwa*. But that is only after repayment.

A related notion to *sekwa* is *jinerhu*, a kind of wager to establish who is strongest or most wily (as we saw, cunning is important in Kapsiki). Traditional folk stories often feature people who challenge each other in this way, often between husband and wife,[5] but it also functions as a means to prove who is right, just like *sekwa*: "If the other person stands in his right, he should be able to counter my strength, including the magical means I may use to protect my property." A case will illustrate this, and its relation to *sekwa*.

> Deli 'Yima quarreled with Kweji Riki, from another clan, about the ownership of a field. His father Adamou had given cfa 1000 to Kweji, and when Kweji Riki married presented him with a leg of beef. Much later Kweji's brother wanted to plant fruit trees on that field, but Deli prohibited it: "We have bought the field." So the brother gave cfa 3000 to "liberate" the field, and announced that he was going to plant maize. Deli still refused, went with Kweji Riki to the court of the Lamido. At the court he gave Kweji a stone from the field, invoking a *jinerhu* before the whole audience: "If he is strong enough, then it is OK. If not, then we shall see. Can he really use that field despite my force?" Kweji Riki pocketed the stone, started out on the field, and died within three days. The Lamido had Deli 'Yima arrested, and kept him locked during the five days of

Kweji's funeral. A few days after the release of Deli, the wife of Kweji died. Word was that Deli had made *sekwa*, and put it on the grave of Kweji; Deli did not deny this accusation, but said that it was only directed at Kweji Riki, to prove that he, Deli, had been correct in his claims. The children of Kweji arranged for the policemen of Mokolo to arrest Deli, and there the traditional court found Deli 'Yima guilty: the *jinerhu* had been an indication of ill will, and the *sekwa* was a means just to kill. So Deli went into prison in Mokolo, and there he died in a month. All Mogode was content: "There is your taste of death. God has done the *wuta* [revenge] himself !"

A curious, sometimes playful, way to perform *jinerhu* is called *mbɛza*: the challenger curbs his middle finger on his index finger, and dares the other one to hook into these fingers with his thumb and index finger and meet the challenge. It can be done with the pinkie and ring finger as well, and then can be a kind of small challenge game between friends. But it remains tricky, close to an oath, akin to *sekwa*.

REVENGE

There is a good death and there is a bad death. Dying after a long, eventful, and productive life, with your wives, children, in-laws, brothers, and friends mourning you, dancing frantically around you when you are seated on the shoulders of the smith, with the drums going at full blast and the clans charging each other with clubs and spears, and with the boys and girls amusing themselves on the sides—that is a good death. All people die, but they do have some right to a life. When you are robbed of such a life, when death is premature, and especially when someone has not only wished your death but actually produced it, when you cannot see your children grow up and your grandchildren enter this world—that is a bad death. I am speaking about this latter death here, for this is the one calling for revenge.

Suspicion of *beshɛŋu*, evil magic, as the cause of death, calls for revenge. Killing with magic is different from killing with *berete* (force, arms). In war any killing asks for a counterkilling or a settlement. Before the days of the Pax Gallica and Pax Britannica when a conflict got out of hand and someone was killed, the injured party could either kill someone of the culprit's lineage or village, or demand blood money.[6] The latter option was preferable, as it was not the lineage that exacted the money but always the mother's family of the deceased in the person of his mother's brother—or

another male representative of the mother's clan—who collected the huge sums. This, in fact, prevented feuds between villages, as a revenge killing aimed at the culprit or his brothers would simply produce a second money claim. But it does illustrate the notion that after an unexpected death something has to be done and that the families of both parties are involved, the culprit's and the victim's.

The problem with a death by *beshεŋu* is, evidently, that the culprit is unknown and therefore also untraceable, for the Kapsiki divination does not search out culprits of metaphysical attack, neither witches, clairvoyants, nor perpetrators of *beshεŋu*. So the revenge has to be a ritual and is called *wuta*. The name is the word for a large jar, used for brewing beer, but seemingly also indicates a village in Nigeria—that is, the village where the ritual is performed. Actually, no Nigerian village bears exactly this name, but the expression is *kadza wuta*, to go down to Wuta, and the village in question is far away, on the border with Kilba country. This is one ritual I never witnessed—never could witness, in fact—but which I am sure was actually performed, and I will use one specific case for its description.

Kwebete's son had died young, and the smiths had indicated evil magic (*beshεŋu*), a plausible diagnosis as the family had already suffered a loss: Kwebete's husband, Fashè, had died almost a year earlier, which made the family vulnerable. So she "went to Wuta." A smith, Marki, came along with Kwebete to show her the way, two weeks after the funeral. They left at night because nobody should know about the journey lest the culprit sorcerer would try to be there first. Kwebete brought along a lot of money, a large gown, iron bars, and a pair of leather sandals made from a *tla psekε*, a real Kapsiki bull, in addition to one thing belonging to her son, a medicine vial. At sundown on the third day, they arrived at the village, in the ward Bassala. On the road they had encountered people who had asked—a usual question—where she was going, and she had duly answered, "I am going to mourn someone." Any smiths and blind people she had met on the road, she had handed some money with the words, "*A shala keya ŋa*" ("may god guard you"). The man in the Kilba village, Tange, speaking her own language, welcomed them and immediately poured water in a large *wuta*, which stood out in the courtyard. She explained why she had come and gave him the money, the iron bars, the gown, the pair of sandals, and her son's vial.

The next morning the ritual took place. Tange came out with a calabash, a knife, and his *rhwε* hidden in a bundle of straw, and crouched by the jar with Kwebete next to him. He rattled his *rhwε* and shouted, "Come now!" Some tweeting sounds were heard from the water, which only he could

understand,[7] not Kwebete, for, as Kwebete explained, in the *wuta* the spirits (*shinaŋkwe*, shadows) of her son plus all living people around him were assembling. Tange went on to interrogate them; Kwebete just heard tweeting, but for him it was understandable language. He asked her son who had killed him, and when he learned the name, summoned the culprit's spirit, interrogated him, and extracted his confession. As everyone has to tell the truth in the *wuta*, the truth came to light quickly. Tange said to him: "Come and drink beer," and when the culprit's spirit rose to the surface, Tange wiped the dust from the water's surface with his straw, and stabbed his knife into the water. "It is finished," he told Kwebete, "do you want one dead or more?" It was now for Kwebete to decide how many people would die, and then he would stab as many times into the water. But she decided that only her son was dead, so only the real culprit had to die. And anyway, if too many people were to be killed by this revenge, death would not stop anymore but proceed as an epidemic. Tange told her the spirits of kinsmen of the culprit might try to protect him in the jar, but then they would also risk being stabbed. To finalize, Tange wiped the water surface to see whether the culprit had indeed died, and burned the straw under the *wuta*. Of the pair of shoes, he returned the left sandal to Kwebete, who then left him without saying anything and without looking back.

Back home, after another long journey, she shut herself in her own hut and stayed there for three days (for a deceased woman it would have been four days). On the third day she cooked a meal of beans and maize, central in the closing rites of the funeral, called in the children of the neighborhood, and had them eat it. Then she went to the smith and had her head shaven, a sign of mourning again. By now everybody in the village knew that she had been "to Wuta," and the great waiting for death started.

After such a ritual, people simply wait for the first death of someone who might be construed as the culprit killer. That can take weeks or even months, but each death is in principle suspect, and tension reigns in the village. In the case of Kwebete, it took three months, and she was in another village when she heard the news: Teri Wuvè had died, and quite a few members of his lineage were ill as well. Teri was in fact a lineage brother of her late husband, Fashè, so for Kwebete the suspicion of his involvement with both deaths came easily. Singing the dirges of mourning, she hurried back to Mogode, and there waited until the smiths had taken the body on their shoulders and came out to the dance. "This is the taste of death," she shouted, the standard expression of revenge. Immediately the smiths understood what she meant, and stopped the whole funeral.

It was a dramatic moment that I witnessed and will not quickly forget.

The drums stopped, the people around the body asked what happened and then stopped mourning: they put down their lances and clubs, spoke to each other in whispers, and quickly went away. After all, everybody knew that Kwebete had gone to Wuta, and the suspicion had already been voiced in the village. Within minutes the place was empty but for the smiths, the corpse—and me. The smiths quickly unwrapped the body, and two of them took the body to a nearby stand of trees—quite close to the compound, in fact. In haste, they dug a shallow grave, dumped the body in it, and filled it up, just covering the body with some earth and stones. To be honest, I was shocked with this abrupt ending of a funeral. In Kapsiki, your funeral is the best day of your life, an outpouring of grief that forms the highlight of village life, a celebration of a lasting identity of the deceased and the village. Suddenly, Teri Wuvè was not only found guilty of the ultimate transgression in Kapsiki life, he was defined as a nonperson, even a nobody, someone without identity who should not have "been there," who in retrospect had no right to a life. His name (*wuvɛ* means shit) now became an ironic commentary. The name had been given to him at birth for a completely different reason; but "nomen est omen," and his end did justice to his name.

What made matters even more delicate here was the close relation of Teri with the deceased. Fashè had been Kwebete's levirate husband, he had "inherited" her, so the immediate suspicion was jealousy between two "brothers of the same father," a ready locus for suspicion in Kapsiki, as these tend to be more rivals than allies. Accusations of *beshɛŋu* between half-brothers are not uncommon, so in this case the verdict was plausible: Teri had "done it." Yet in these cases some doubt lingers on, as the possibility that the revenge death was "accidental" can never be excluded: a strong *beshɛŋu*, if people accidentally touch or come near it, can hurt others than those intended, so there is a perennial risk of contagion.

Marki, who had accompanied Kwebete, tells of another case, from the village of Sir. That man's son had also died because of *beshɛŋu*, and he had taken it upon himself to revenge the death. After coming back from Wuta, he fell ill himself: he was the culprit, unknowingly and unwittingly. His own *beshɛŋu*, even if well hidden, had attacked the son and killed him. The man had tried to accuse Marki in a court case; but the village chief immediately dismissed the case because the man had *beshɛŋu* and thus called death upon his own house.

Death by *wuta*, revenge, is contagious. Though Kwebete had restricted the revenge to the culprit, some people are thought to be more vengeful and take out a whole family, and in any case, *wuta* is tricky, as it does not stop easily. It is, in principle, a small epidemic projected in a home, just as *sekwa*

is. As always in Kapsiki, there is a way to counter this threat of an epidemic, and that is where the left sandal comes in. When it has become clear that someone is killed by *wuta*, all the kinsmen rush to the one who has taken the revenge—in our case, to Kwebete. And that was exactly what happened, in her hut after the abrupt ending of the burial. All family members hurried to her, gave her some gifts, and begged her to help; she took out the sandal and with it tapped each of the family members on all their joints, from the left foot, over the head, to the right foot. As one of them explained, as a family they were intrinsically involved:

> If my brother kills someone and is summoned to Wuta, his shadow will struggle in the jar. Just like his brother, my shadow will also be called to help him. Maybe I am also wounded somewhere. If the claimant comes back, and my brother dies, I will gather money to ask him to stop Death. We really have to beg, and have to give a lot. If she agrees, she taps us with the real Kapsiki shoe.

Revenge death by *wuta* does not show on a body; in principle, it leaves no traces, though there is some talk that whoever is killed in *wuta* should have some puncture wounds from the sorcerer's knife. The same holds, by the way, for *beshεŋu*, which leaves no discernible traces either, just the fact that no other obvious diagnosis is possible. If a patient does not respond well to any medication and evidently does not die of old age, it must be this evil magic. Simply put, nobody dies without cause; so if there is no discernible cause, it must be "something else": *beshεŋu*. Post hoc divination may indicate black magic, but it never indicates a culprit; Kapsiki divination does not mention names.

Few specialists, usually smiths, can perform the *wuta* ritual, and few persons know where they are. Miyi, the smith we encountered in the possession case, was one (he died in 2006). Recently, more smiths have taken up this ritual, and it seems to be done in Mogode as well, but then for clients from other villages.[8] But the most potent performers, the smiths with the real power, reside outside the Kapsiki/Higi territory; Kilba is the group mentioned most, north of Uba in Nigeria. In the past Kilba was far away, but the motorcycles of today have brought the place much closer, which also means the ritual is performed more often. But one thing has remained: a *wuta* specialist is never consulted by his own village. This is one ritual that is always performed in a distant village, for several reasons. One is the general notion that magic elsewhere is stronger and that one has to exert oneself for this kind of ritual; another is that such an intrusion into other people's lives has to be done from afar. Kapsiki life is colored by the notion of privacy, and

wuta is a serious invasion in privacy. One's own village is simply too close. Also, the guide comes from another village. Marki, whom we saw feature in Kwebete's case, has specialized in guiding people to Wuta, based on a local knowledge he jealously keeps to himself. It is a lucrative business, and as such has to be earned.

> Marki is from Rumsiki, a village which has closer links to Nigeria anyway. He had learned the whereabouts from his father and is the only one in Rumsiki who knows. Some years ago he spent five days in Uba, the main town of the Kilba people, in order to get to know the actual *wuta* specialist. It had cost him three large gowns to get that information, in a trial-and-error procedure where he had to try out who was the effective *wuta* performer. Now he knows, and he gets one gown for each time he guides. He explains that a person can claim the services of *wuta* only once in his or her life. Actually, Kwebete later went back for another *wuta* consultation, but he refused her and sent her home.

Magic such as this is an arena with backdoors and side ways. First, the claimant seeking revenge can be evil: if he (or she) suspects a culprit, he puts seeds on the grave of the deceased, and takes these to Wuta. When the specialist puts these in the jar, an illness like smallpox will ravage the village. Marki claims that he refuses to guide someone who aims at doing this. But this is indeed an arena, and people hide their secret agendas. Each ritual specialist, especially smiths, knows means, *rhwɛ*, that will keep him from being summoned to Wuta, means about which tall tales circulate in the village, involving stealing honey at the market or staying over in a tree for a night, and so forth. A smith specialist came with a completely different recipe.

> One takes a melon, *gwenzu ha*, cuts it, and leaves the pieces in a pot with water for some months. When the melon has rotted, one drinks the liquid and buries the rest in a pot under the refuse heap. After a year one digs it up and makes a sauce out of the remains, and after eating that sauce one's spirit will not go to Wuta anymore. Also, it is a recipe for a long life.
>
> Melons, by the way, are an important symbolic item. When a girl has delivered her baby under her father's roof—which is definitely a large taboo—the groom (and presumed father) takes a similar melon, operates on it by cutting it open and removing the seeds, in order to sow these later. After all, one cannot operate on the mother. This ritual, in fact, constitutes the wedding ritual, replacing the wedding feast as well as the bride's initiation rituals, just leaving a small bridewealth to be paid.

At a funeral in 2008, people found a chicken egg at the rim of the dancing ground during the first day of mourning. Immediately this was interpreted as a means of the *beshεŋu* user to prohibit him being summoned to Wuta. In order to prevent this kind of immunity, the smiths took hold of the egg and buried it with the corpse; thus, the kinsmen kept the option open for Wuta.

Wuta is not the only ritual to avenge death, as this kind of revenge killing can be done more covertly. If immediately after the death or even during the illness the deceased's son suspects foul play and has a clear suspicion who did it, he puts some sorghum grains in the mouth of his dead father at the very evening of his demise; the next day the grains are soaked, and made to sprout. Then the son asks a woman in the ward of the suspect to brew beer from these sprouts, of course without informing her where the sprouts came from. The son of the deceased then secretly slips in some *nese* (earth of the tomb, sometimes called "excrement of the corpse") into the brew before she serves the beer or sells it. Any culprit who drinks this beer will die, but just he, not his next of kin.

AXES FOR THE VILLAGE, STONES FOR LUCK

We have seen plants in various combinations work miracles, but objects are also sometimes loaded with meaning, and these objects are not artifacts but *wushi meŋele*, miracle "things" one finds in the bush. The Kapsiki/Higi inhabit a landscape with a long human history, where Neolithic remains are not rare. Those remains with the clearest human traces—such as the *tsu*, the old grind mortars that lie dispersed throughout the Mandara Mountains and feature in initiation rituals and rain making—are embedded in their communal rituals and form one continuous remembrance of the embedded history of Kapsiki "dwelling" in their Mountains.[9] A spectacular one is the *gela kwaferafra*, a large boulder at the side of the Rumsiki-Guria road, also used in the initiation rites of Rumsiki and full of traces that are interpreted as the "hand of god."[10]

During the first months of my fieldwork, I sometimes wondered why I never saw any trace of a much older occupation in the form of Neolithic axes, as I had read that quite a few had been found in the Mandara Mountains.[11] Often, the literature read, these strange stones were considered as rain stones, used in rain rituals. My not-so-nagging question was answered one night. Deli Kwageze, the village officiator, invited me into his house,

Figure 29. Gela kwarafrafe, Rumsiki

in the early night, and then walked with me downhill to an old abandoned house. From under the old granary base, where ritual objects are always kept, he produced an old pot and slowly emptied it in the light of my torch. Suddenly a whole heap of special flint stones appeared before my eyes, Neolithic axes prominent among them. These were the *pelɛ meleme*, Deli explained, and they were in his care. He even wanted to sell some because he needed the money, and that was the reason for the disclosure. I was slightly shocked by this commercialization of religion, and it would take me a lot more exposure to African realities—and the influence of tourism—before I took this attitude for granted. In any case, the puzzle of the axes was solved.

These *pelɛ meleme* do feature in some of the rituals, but never prominently. Before the second part of the village sacrifice, called *melɛ shala*, the village officiator pours beer on the stones, in complete privacy and as preparation for the later sacrifice. Also, formerly, when the village went to war, a libation on these stones preceded a sacrifice on the personal sacrificial jar of the officiator. The Kapsiki consider them stones of Rain, descended with lightning and not human artifacts, but they are not central in rain rites.

Later in my fieldwork, in fact after coming back to the field, the new officiator, Kwada Kwefi, would again show me the stones, and this time not for gain. He

was my neighbor, we had a good relationship, and he was proud of the fact that he was officiator.

Neolithic stones with specific features have other magical dimensions. Thus, the *pelɛ duŋgwu* is an oval stone with a hole in it and is considered a "mother stone," which gives birth to other stones. Whoever finds one, of course with a heap of small pebbles around it, takes it home, puts an iron bracelet through the hole, and keeps it under the granary. From then on, when he goes on a hunt, no arrow will fall on the ground, provided he puts each arrow on the stone before leaving and sacrifices the feathers of the guinea fowl and the excrement of the duiker (favorite game for the Kapsiki) on it afterward. However, nothing comes free, so if the hunt is not successful, the failed hunter will have to put some of his own blood on the stone: it has to have blood. A larger stone with a lot of grooves is a *pelɛ riki* (stone of the path), and its owner will be well visited by strangers and grow rich through their gifts.

Other miracle objects are not man-made, and some are quite mythical. The most spectacular one is the *sasurgwa*, star. For the Kapsiki, shooting stars are a sign of Death traveling, and they avoid looking at them, shouting "*hè hè hè*" to chase them away. As for the star, my informants assured me that sometimes such a shooting star falls on the ground, quite visible, lighting up in the dark night. Especially when there are many shooting stars at the time the sorghum grows in the fields, this may happen (roughly mid-August is indeed the period of the Perseid meteor showers). If the star "agrees," one can pick it up and put it in the granary, which from that time onward will always be full. Whoever has a star just has to harvest half a granary, and the star will fill up the rest, so such a man is rich, assured of many wives and children. But, as always in Kapsiki thought, there is a catch, for the man will have only daughters but no sons.

Teri Puwe, my host in Kapsiki from the start of my fieldwork, told me he once saw a *sasurgwa* before him on the ground, as a bright light. When he tried to collect it, he could not see anything. He took some distance and suddenly saw it again, a bright light on four feet, running rapidly. Teri tried to catch it, but in vain. At another time, when he and his brother were walking at night in the field, Teri saw the star between his brother's feet. He warned his brother, and both tried to catch it but could not. One variant of this star, he told me, should be avoided—that is, a star with only one leg. Whoever has that one will have only one item of anything: one granary, one cow, one goat, one child, one wife.

Most of these miracle objects do not come from the heavens, though, but are chthonic. The most common one is the *nhwene ta gela* (literally, tears of the rock),[12] mountain crystal; at night such a crystal may light up like a lamp and closer up seem to be a shining finger. One tries to pull it out, and when the crystal will allow itself to be removed, water appears at its spot. Should anyone drink that water, then his body will be "hard like rock," meaning that no iron can enter, so he cannot be wounded in any war, "not even by a gun." The crystal itself can also be used as a war medicine. But again, there is the inevitable drawback, for the owner will not grow old.

> Zra Yite told me about his father, who had discovered such a *nhwene ta gela* and wanted to take it. He warned his sons that he would do so because he was old and had only a few years left anyway. "It does not matter for me." So he went, took the crystal, gave it to his sons, and died a year later.

When "real Kapsiki cattle," *tla pseke*, the small nonhumped bovine species that are native in the Mountains,[13] gather at one spot mooing intensely, then a *pele tla*, a cattle stone, must be there, a black stone that walks on four legs and looks like a cow. Only the owner of the cattle may catch the stone, and then not always. If he succeeds and manages to put it in his stable, his cows will have many calves, even twins, but his sons may not get children.

Finally, one miracle object is not a stone but a stick, the *geta pshi*, monkey stick. Monkeys sometimes use sticks to dig in the ground, and whoever manages to find one of these sticks will have luck with all of his animals.

In our survey of this array of miracle objects, the spectrum is almost complete. Together, the miracle objects increase sorghum, cattle, and goats; procure riches as well as game; and guarantee immunity in war. Thus, all male endeavors are taken care of with the exception of the central ones: having wives and children. In fact, these central concerns often form the price one has to pay for magical riches: fewer children, fewer sons, and a shorter life. And for these human riches one petitions *shala* at the proper place—the *mele*—and this is the wealth that has to be earned with hard work and proper behavior, and for which one is dependent in any case on the supernatural world. Magical riches are, in the end, costly, as we saw with the magical means to procure a wife.

In these *wushi menjele*, a concept like "the limited good" is operative: one cannot have both types of riches at the same time, at least not through extraordinary means; and for special magical favors one has to pay, sometimes quite dearly. This is probably why the discourse on these miracle objects is rather subdued; even the stones of the village are rarely talked

about, and many in the village would be hard put to tell where exactly they are: "*Mnzefe* [the officiator] would know." He does. Also, tales about the other stones are rare and usually full of the warnings for the existential cost involved: it exists, but beware! All this fits in well with the general ambivalence and ambiguity in which much of the supernatural world is perceived, both comforting and threatening, a fuzzy mix of good and evil.

SMITH AND JUSTICE

In this chapter I have overviewed the various aspects of magical means and their costs, of the ways to attain justice, to be proven right; in short, I have dabbled in the distinction between justice and injustice, even between good and evil. A few things stand out: the notion of inherent justice, and ideas about evil and human agency. First justice. All processes discussed in this chapter hinge on the notion that whatever means and supernatural power one may have, in the end its efficacy depends on being "right" or "wrong." Curses, oaths, and revenge only work under the umbrella of a sense of justice. Kapsiki are aware that people do not always get what they deserve and that life is not always fair and just—sometimes a far cry from being so—but in interpersonal relations a sense of interpersonal justice provides the ultimate basis of power. A sense of privacy, or rather autarchy, pervades Kapsiki society: whatever the support of the kin group, in the end one has to stand up for one's own rights and carve out one's own niche in society. Intrusion by others is resented,[14] and any processes or rituals that infringe upon someone's autarchy are delicate, demanding careful preparation and above all a good, solid, and correct reason. Magical defenses center on the skin of the individual and the wall of the compound, crucial borders delineating the threshold for outside interference. So the only excuse to interfere in someone else's life is when one is "right" and the other is "wrong," and this is exactly how the curse, the oath, redress, and revenge work in Kapsiki, always conditional and always subject to this sense of justice. This raises two general considerations relevant for traditional religions: the notion of "evil," and, more generally, the way the Kapsiki define their own agency.

Although ever since the publication of *The Anthropology of Evil*[15] the concept of "evil" has been on the agenda of anthropological interest, it never really did catch on, for several reasons. Wary of introducing Western notions into the description and analysis of religions, many anthropologists prefer to describe the religion under study in its own terms, an emic

approach that seems to preclude using the seemingly Judeo-Christian term "evil." For many, the term reeked of essentialism. Yet, as the Parkin volume testifies, there is ample reason for using it as a general analytical term to describe the various dark sides that can be found in any religion. Even if the term "evil" cannot be translated into many languages, those notions that are perceived as antisocial and abhorrent are easily subsumed under this blanket term. My assumption is that an opposition between good and evil, defined in whatever form, has been shown to be present in many religions and worldviews; given the near ubiquity of the opposition, it is probable that a notion or a cluster of concepts with the denotation of "evil" can be found in most religions.[16]

Now, what is the Kapsiki notion of "evil"? The general term is "*wushi ndrimi*," bad things, a vague and general "badness," mainly nonobjectified and impersonalized, that is brought about by specific individuals. It also includes *mehelegu*, taboos, that is, actions that are considered bad in themselves, even if they do not impinge on the privacy of others. Some of those things are self-evident; for others, the taboo element is hard to explain.

List of taboos
Whistle or cut grass next to a sorghum field
Sexual activities at a sacred (*shala*) place
Washing hands in the grind mortar at the house entrance
Killing someone with a lot of hair on his chest or in his ears
Enter someone else's house during sacrifice
Enter the granary at noon
Climb the wall around a house
Drink beer from the sacrificial jar before offering
Slaughter a pregnant goat or cow
Steal in the dark
Harvest somebody else's sorghum
Cultivate during a ritual
Cut wood at a sacred (*shala*) place
Allow a chicken to sit on one's head
Let a rooster crow on the granary

Some of these are evident, some understandable, and some stay in the dark. Respect for the fields is clearly there, with a well-developed notion of owner-ship. The two on the granary have to do with the equation of granary and tomb: a Kapsiki man is buried in a grave that not only looks like his granary, but in the deepest sense is one,[17] so neither sunlight nor the rooster can be

tolerated there; the rooster is also linked with the corpse's outfit. Respect for sacrifices and for the privacy surrounding Kapsiki rituals is also evident: climbing the wall, washing hands. As for stealing, the Kapsiki distinguish between stealing and "taking with force": the hidden aspect of stealing is dishonorable, while a show of force is admired. And respecting pregnancies simply makes sense. But why one has to make a redeeming sacrifice whenever a chicken lands on one's head is hard to explain. Some things are even bad because they are simply ridiculous. But any of them are common, every day, and can happen anytime, with or without volition.

So much for tabooed acts. As for "evil" persons, although people may be bad, they are still predictable, and the problems they inflict can be treated by their equals. *Besheŋu* forms the core of the emic definition of evil, an action by human agents that can be understood, and so prevented and healed. Vigilance and good defenses are needed, in which the knowledge of objects, like *wushi meŋele*, is crucial. So, there is some rhyme and reason in evil, which puts it partially under the regime of justice. But evil also has its own dynamics, for once it is generated it is difficult to stop, proceeding at its own force and impetus, whether guilt-triggered or stemming from an object. *Sekwa*, while in itself without any social stigma, may attack vulnerable persons like children and pregnant women, the very people it is deemed to protect or help. Magical means are inherently obstinate in character.

Against this unruliness of the supernatural world, the individual is a little helpless; he does not really master this world against the vast reservoir of unseen enemies. The individual is in an apprentice role, sometimes literally *l'apprenti sorcier*, the sorcerer's apprentice.[18] There is no security in protective rites, no guarantee of effectiveness. The very instant the rite is performed or the medicine taken, the problem is said to be solved, in a show of confidence that conceals a lurking suspicion that even the "right stuff" may not work. Risk has various faces, though, both in the magic itself and in the relations it generates. Someone who buys *besheŋu*, in another village evidently, has to state who the target is. The smith who sells the bad stuff can always warn the intended victim, especially if the buyer does not pay enough, and then sell magical defense to the target. At a second purchase— the stuff can only be used once—the smith will give false information to the buyer, who then will involuntarily target himself.

However, usually the image of the sorcerer's apprentice implies some innocence. Justice dictates that anyone who really dabbles in evil will be caught in its web. So the individual has to chart a cautious course between good and bad, between the unattainable ideal of good and the prison of evil. However, the very vagueness of these associated concepts enables one

to cope with life, as their definition allows for a substantive middle ground between the two extremes. The definitions of both good and evil imply that, in any phase and aspect of life, one must always live with both of them: coping with evil also implies coping with good.[19]

Afflicted people have to "surrender" to the specialist, emanating, again, innocence: they have nothing to do with bad things; they are on the side of the right, so they have to rely on the specialist. When they come to the specialists to search for protection for themselves, they tend to suggest that they do so for the first time (this is one reason the Kapsiki tend to switch specialists after consultation) and that they do not know the character of evil. They pretend to be unaware of the enemy, having gathered only recently some vague rumors about its threat. The language used is vague and full of evasions. The clients appear to be free of all evil, full of benevolent innocence, and reticent to learn anything specific about this dark side of the world. In fact, this show of innocence is a viable solution, using the model of the child in the face of good and evil in order to keep the options open both to make mistakes and to use magical power oneself. The possibility of this charade may be essential for living in any culture. If the space between good and evil is reduced, one tends toward a puritan or fundamentalist system, in which the slightest slip from the ideal is considered a grave sin, and where innocence is no longer possible. Kapsiki culture allows ample room for individual maneuvering between the two poles of good and evil; each person, in his or her own way, manages to shape not an easy, but a feasible way of life.

This brings us to the Kapsiki notion of agency, their theory of causation. Agency in social theory[20] involves a dialogue actors engage in with their structured environment, in which, on the one hand, the actions are informed by the environment and, on the other, by the dynamics of individual agency itself. Agency implies an external world that has structural features of recognizability and predictability and has some authority to which the agent is accountable for his actions. This means that some actions are more important than others and that the exercise of agency in some fields is more relevant than in others.[21] Agency is a theory of causation, an explanation of "why things happen," a culturally viable way of explaining in a particular culture why things are as they are. While the major features of society and culture have their own etiological explications, as in myths, the specific happenings and mishaps can and will be explained by referring to the agency of self or third parties—especially in the case of mishaps, and that is what is at stake here.

In times of hardship, people ponder their own agency versus that of others. Gell calls agency "a culturally prescribed framework for thinking

about causation," or, in short, "agents cause things to happen."[22] A temporal dimension is crucial. Emirbayr and Mische stress the projective and iterative elements of agency.[23] Agents expect the world to be predictable and events to more or less repeat themselves, to have some normalcy. So the expectations, hopes, fears, and desires of actors vis-à-vis their projected futures are rooted in their evaluation of the past, their assessment of the present, and the options they see ahead. And it is exactly at the intersection of past and present that the agency of the third party, the "other," receives full attention. No better—or at least no easier—explanation exists of "why things go wrong" than interference by an external agent.

We have seen that, for the Kapsiki, the agents of misfortune are manifold and varied; yet misfortune for the Kapsiki comes in recognizable, somewhat predictable forms, which means that the evil agents are not considered to have completely free actions: their harmful influences follow defined cultural pathways, and their arrival is accompanied by a sign of recognition. Misfortune is not an alien in one's life, nor is evil something inhuman; instead, in the kinship idiom of Africa, misfortune is kin and evil is distant family. This means one can do something about evil, something practical and possibly effective, more than just learning deep lessons through it.

> Not everyone will seek out reasons for misfortune. Some proud men state that it is better to "sit and look with the eyes" (*newe le ntsu*), in resignation and quiet acceptance of life's sorry facts. It is the women, they say, who consult the crab in order to know why, to know how, and to make an effort at redressing a wrong. Only for problems in and with the family men have to be more proactive. Yet even if "suffering well" is considered a commendable quality, acting well is better. "We see people as actors trying to alleviate suffering rather than as spectators applying cultural, ritual, or religious truths."[24]

As shown through the divination process and applied to practical problems, notions of agency are ways of signification, logical pathways to give meaning to events, especially to mishaps, mistakes, and misfortunes. The bleak side of agency that has been the focus of this chapter is the way people ultimately give meaning to the relevant happenings, events, and experiences in their lives. Agency, both of others and oneself, is the emic meta-theory informing that process of signification. For a Kapsiki, the world becomes understandable, events become humanized or at least imbued with value and meaning, through processes and problems that stem from ordinary daily social interaction. They live in a human world after all. If the world seems to be against them, to be thwarting their plans and rendering their lives insecure, it does

so in a human way with meaning and a comprehensible intent. The attribution of agency to the "other" assures them that in this world they are almost at home.

Now what about the smiths? In some of the sections of this chapter, they were present only in the wings and with some good reason. The message of these "private rites" was about justice—that is, about the separation between good and evil, about producing clarity in fuzzy situations.

> One curious ordeal-like ritual in which the smiths are central provides a good example. When a family is split over accusations of theft within the home, the whole party, accusers and accused, might go the nearby smith for the so-called *vutu*. The smith has some grasses, *tlidi* and *vutu*, in water. One by one, the accused are seated before him, and the smith softly rubs the wet grasses over his neck, from front to back. When suddenly the grasses stick and no longer glide, that is the culprit.[25]

It is not a ritual often performed, even if some smiths may have the grasses ready in their home. I never witnessed it, and heard about it rather late in my research, but it exemplifies the function of the smiths to produce answers in issues between *melu*. The *rerhɛ*, who are ambiguity personified, move between the means to heal and to destroy, being both transformers and entertainers, masters of the fire and masters of magic. As ambivalence incorporated, they clarify and inform the relations between the dominant others. The smiths themselves are never connected with any of these "miracle things," nor are they ever clairvoyant, have the soul of a witch, or endowed with the "evil eye." When they perform divination or *vutu*, they do so by force of their "smithness," not because of being *kelɛŋu*, which they resemble; when they make medicine, they are those who simply "know," and the same holds when they fabricate the evil stuff of *beshɛŋu*. In fact, they do not need ambiguous miracle objects, as they have other—equally ambiguous—means to produce what they want and need. And, being relegated to a lower status, they have already "paid" for their capacities and their ambiguous power position in society. The smith does have a series of specific functions in the administration of justice. Like his place in communal rituals, these stem more from his special place in society than from any particular skill, though of course he has to have the knowledge required for these duties. On the other hand, separating the position of the smith from his purported efficacy in these rituals is an analytic device of ours, as for the Kapsiki a smith's know-how simply stems from his being a *rerhɛ*. Position, power, and knowledge are

bundled inside one identity: *rerhε*. Smiths are the insider-outsiders of Kapsiki society, standing between the Kapsiki and the "other world," furnishing the *melu* with the means to cope with their misfortunes, with the consequences of their own deeds and especially of those of their fellow men. They represent the inherent danger of those living on the border of the two worlds, on the margin between good and evil, and on the brink between life and death. And that is what will occupy us next, looking at the function that is deemed absolutely central in Kapsiki society: the smiths' role as undertakers.

As the senses go, this whole chapter is about the sense of justice, a current expression in English but also in Kapsiki in terms of a feeling, mainly verbalized in terms of both taste and touch. The first embodiment is through the mouth, in speaking, as good and evil are primarily relationships between people expressed in words, in blessings versus curses, in benedictions versus the tweaking in the *wuta*. Spitting is the standard transmission of intent in ritual, upon the bride, the *gwela* initiates, and even the corpse, as we shall see, to remove curses, invoke fertility, and comfort the mourners. The "taste of death" is the rightful vengeance for purported occult crimes of the other, so the sense of justice appears as the proper taste in relationships. The other side is touch, as many of the actions in this chapter involve objects, stones, sticks, axes, plants, bones of birds, which are handled with care and caution, and often surrounded by words. The striking aspect of these objects is that none of them are man-made, all are natural objects found in the bush; they are part of the dwelling of man in a dominant environment. That is one reason why the smiths' involvement is limited in these matters: the objects are not the result of transformation, but lusus naturae that are imbued with meaning. Often the meaning of these objects is clear but the effects are ambivalent, as the material gain through these objects has to be paid for in terms of life itself.

The Smell of Death

BURYING A SMITH

KWANYÈ MADE, A SMITH WOMAN OF TEKI, A BUSH WARD OF MOGODE, has died, and the smiths have to bury their own dead now. For the *melu,* nonsmiths, this means a double exclusion, as the masters of death will bury one of their own in a period of high taboo for the majority. Immediately after her death, the village chief makes a tour through the village, shouting in all wards that tomorrow the smith woman will be buried and that no Kapsiki will "take his hoe and go to the field." This is not a common procedure in funerals, but it is the usual injunction at a major ritual occasion, such as the village sacrifice,[1] and thus defines this burial as special. A *rerhɛ* died, so all beware, and all show due respect.

> Later in a *rhena za,* a discussion about the state of the village during a drinking party, the same village chief would defend himself against criticism; there had been quite a few deaths lately, and as it is his duty to keep the village well, in Psikye *kahi meleme* [literally, oil the village], he used the occasion to vent his anger at his people: "The village is spoiled, and you know it. You heard me cry out that at the funeral of Kwanyè Made that nobody should cultivate, because the things of the *rerhɛ* are always heavy. You had been crying at the time: 'No rain, no rain; there is no rain' [there had been a dry spell at the start of the rainy season] and I had had to perform the ritual [on the sacred mountain] and the next day there was rain. Then, after one day, you did not want to obey me anymore. When people were dancing with the corpse, I saw others work on the land. You are like monkeys, like wild animals. How can I keep the village well if you do not respect me?"

The format of the ritual is about the same as for any other woman, with two important differences. During the dance with the corpse (see below), only smiths will dance. That is not because the woman has no links with *melu*; in fact she has, as she is part of the *ŋacɛ* clan. Any smith family is embedded in a *melu* clan, and the woman's daughters have married smiths who each have their relation with their own clans, so potentially there are plenty of nominal clansmen to dance. But no *melu*, whatever his relationship with the deceased, will venture out on the dance floor. This dance is completely dominated by the smiths, who of course have direct kinship lines with the woman, but also want to show off their *rhwɛ*, their medicines. Each of the smith men wears large necklaces with medicine vials, easily recognizable because of the red berries that adorn the wax stoppers of the vials. Also, all young smiths vie to dance with the body, proud to show off their strength. The smiths say: "Nonsmiths do not have the power even to beat their *livu* or to dance. Let them just chase the flies away, for now they can see a proper dance." Indeed, with all those medicine vials in cow or antelope horns, the *melu* keep their distance; even those *ŋacɛ* known as smith-friends stand at the side, watching the smiths parade their *baŋwa* and show off their dancing prowess. This is *rerhɛ* business, a smith show.

The many cross-cutting relations of the smiths make the dancing itself complicated. Any funeral dance features the various groups of kinsmen of the deceased, all in their proper role and outfit: friends, clan brothers, matrilateral relatives, and the two groups of in-laws—through one's wives, and through one's daughters—plus the general outsiders. The last category is practically absent here—and the *melu* do hardly dance this time—but the main issue is that the other categories overlap continuously. The smiths' marriage pattern, such as sister exchange, conflates the two kinds of in-laws and matrilateral kin, while any of them can be a friend. So the dance consists of separate small groups, each stressing one type of relationship with the deceased, also a way to avoid *zamale* (men who have been married to the same woman) dancing in the same group or being at the same spot together. This means a series of short dances in which each of them has the chance to show off, in the various bonds he had with the deceased. This particular funeral is extra-special as the deceased was a twin, and consequently all kinsmen also wear palm leaf strips, *peha*, a symbol of twins, around their heads.[2]

The second change is the duration of the funeral. Although a smith-show with many short dancing bouts, the funeral itself is now shorter and the burial rather quick. The reasons are clear for the smiths: "Who would give them the goats for the funeral?"—that is, the funeral is at the smiths'

own expense, so they cut it rather short. On the other hand, the women of the *ŋacɛ* honor their deceased "kinswoman" in their own way—that is, as a "man"—partly because her being a twin. Kwafa, the wife of chief smith Gwarda, takes his hourglass drum and leads eight women of the clan into the bush, all dressed in men's clothes, gowns, caps, and swords in hand. They are *melu* as well as *rerhɛ*, for the plants they are about to collect are the symbols of death, and "death is for everyone." Kwafa herself has a splendid headdress made of genet skins, as a sign of her status. A few hours later they come back, dancing and singing songs that usually only men sing, the songs of war (*geza za*) and the mourning dirges that men perform, *nhwene gela*, but definitely with the *safa* and *haze*, major symbols in Kapsiki (see below), which the smiths need to adorn the corpse. The two plants, *safa* and *haze*, have a wide symbolic significance, but in the case of Kwanyè Made signal an honor to a hard-working woman who raised chickens, owned sheep and goats, and was an example for all in the ward.

> This interlude is highly amusing for all, though a small discussion erupts: one woman should have joined them, but did not show up. She defends herself by saying that the baby on her back suddenly sneezed when she walked to the rendezvous place. Sneezing, for the Kapsiki, is a sign that one has to change plans—and certainly at the funeral of a smith woman (and a twin)—so she went back home.

The only other special feature of the smith funeral can be the grave itself, at the end of the rituals. For the smith woman it is a standard tomb, but for special smith dignitaries other rules apply. The chief smith is buried like the village chief, sitting on a stool in his grave. The smith who is head of the ironworkers, *maze gedla,* gets a narrow grave and is also buried seated, and also in his case all men from the village bring some charcoal to put in the burial chamber. He is buried on the fourth day, after his body has rested inside the forge. This funeral has special dirges, the mourning of the sorghum: "Here, my hoe is broken, can you repair it? There is the man who fills the granary!" In some villages an old hoe handle will adorn his tomb but usually just the *melɛ* and the *gɛŋa*, the upright stone that marks his progeny.

Figure 30. The deceased at the place of honor of her house

SMITH AND FUNERAL

Smiths are, if anything, the undertakers of the village. Once, I visited the village of Mabass with my assistant, and people told us that the last smith had left. My assistant's immediate reaction was: "How then do you bury your dead?" Funerals, as a truly liminal time, form the high time for the "other" people of the village, the smiths: they control the proceedings, from the first mourning and the first dance to the decoration of the corpse, and from the actual burial to the final performance of the concluding rites at the burial mound. Of all the many tasks and varied expertise, their responsibility for burial is crucial.

Kapsiki funeral rites follow a definite pattern: they start out small with just some small groups and over the three days of the funeral increase in size as more and larger groups join in. Then the ritual tapers off, ending with a ritual reversal of the main rites for the next of kin. The usual format is provided in the sidebar. The rites of the first two or three weeks form the first part of the funeral, while the rituals at the burial mound in January or February are in fact the "second funeral" and mark the end of the mourning period; in both, the smiths' role is crucial. The second funeral is a restricted affair, which—owing to the cyclical nature of Kapsiki rituals—is part of the annual cycle of ritual.[3]

The funeral schedule

Day 1	Death, announcement of the death, and limited mourning and dancing
Day 2	Decorating the corpse by the smiths for the first major dance, featuring the village of the deceased
Day 3	The corpse is fully decorated for the large dance, involving other villages. The smiths supervise grave digging.
Day 4	Sacrifice with meal; return of clothes; the widow's sacrifice; the first phase of constructing the burial mound
Day 5	Rest
Day 6	Closing sacrifice at the funeral mound by the chief smith. Additional work at the mound.
Day 7	Beer sacrifices on the mound (*tɛ ncimu* or *tɛ kwele*); the settling of inheritance; the finishing of the funeral mound
Next months	Rituals for the diverse groups of relatives
March	Final rites at the mound; return of the sacrificial jar

Death comes unannounced, but not always unexpected. An accident or severe illness that suddenly snatches away a strong member of society is a violent rupture of the normal course of life, in which an old man or woman dies after a long, fruitful, and productive life. The latter is what the Kapsiki call a "good death," and that is what we will follow here,[4] that is, the rituals as done for 'Yèngu, an old *melu* man. Not only do the funerals of *melu* form the majority, also a *melu* funeral highlights the crucial nature of the smiths' functions in funerals in general. The one of Kwanyè Made was rather particular, her being a smith woman as well as a twin. All burials are full of emotion, so funerals can be seen as expressions as well as canalizations of those emotions. And it is the smiths who perform the essential functions for this canalization. When an older man or woman dies, the family begins the mourning with cryptic, half-sung lines, punctuated with loud shrieks. One of the family members informs the chief smith, and, on hearing her mournful cries—usually it is a woman—neighbors gradually flock into the compound: "*Amaa, amaa*, where am I now? What shall become of us? Son of the sun, you have left us." Soon the chief smith Gwarda arrives with his son Kwada, who is also a drummer; Gwarda will take care of the corpse

while his son provides music for this first dance. The people present immediately start dancing at his beat, because to mourn is to dance, rhythmic moving to the drum but without specific steps, wailing softly. The women of the house (wives, daughters, and cowives) put on their *livu*, and together they accompany Kwada's drum with the rhythmic scraping of calabashes over their iron skirts. This first day, which may start in the evening, is filled with just that: dancing and singing dirges by immediate kin and neighbors. If there is time, a few younger smiths will come with their *shila* flutes, the one type of flute that is strictly reserved for *rerhɛ*. Their presence is greatly appreciated, and the kinsmen of the deceased honor them with money during the dance, gluing the coins to the sweaty foreheads.

Gwarda seats the deceased in his forecourt at his *pulu*, the place of honor. 'Yèngu's daughter chases away the first flies with a cow's tail whisker, wailing softly, and the women of the house place a vase at the corpse's feet, with sorghum grains, a calabash with arrow shafts, and a cow's tail to identify him as a cultivator, a warrior, a hunter, as well as a rich man. Owning cattle is the epitome of riches, either by raising, buying, or—formerly—stealing, which made no difference. People are very careful with these grains, as death is contagious in Kapsiki: should they fall on the ground and germinate, the deceased's male descendants might die soon; consequently, to avoid ill-wishers, they are later collected up by the chief smith.

Gwarda has sent a boy to his fellow smiths, as they have a crucial task tomorrow. The son of 'Yèngu has summoned his cousins to alert all direct kinsmen, and they will bring the news of the death to neighboring villages, calling upon all the in-laws and descendants of 'Yèngu. As the Kapsiki marriage system results in a large number of in-laws and dispersed kinsmen, this takes some time and is one main reason for the long, drawn-out funeral. At 'Yèngu's home, the mourning, with gently wailing, softly sung dirges, and a shuffling dance, continues until well into the night, and the women in particular remain singing and dancing, slowly moving to their own beat on the *livu* and the rhythm of the drum. They keep this up through the small hours, accompanied by an occasional *shila* flute. Kwada and his *shila*-playing cousins take turns during the night.

A funeral is a large event demanding the professional assistance of the smiths, and it also is a logistic challenge. During the night the family is busy finding women in the village who have brewed, in order to feed the smiths. The following days will see the women of the family prepare their own beer, white or red, but that takes time, so they rely on a chance brewing. 'Yèngu's kinsmen provide a goat for each day the corpse is above the ground, usually three days in total. One of the goats is used for the funeral

proceedings, the others are for the smiths. If the deceased was very rich, his son will slaughter a cow and the smiths will be very happy, but that is quite rare. However, keeping smiths content during the funeral is extremely important, as it really is their hour of power, and Gwarda and his kin feel exactly the same way.

The day of death is a preparation for the real mourning and dancing that is the gist of Day Two, and the proceedings start early with the other smiths coming at sunrise to 'Yèngu's house. Gwarda has slept in the compound under the *zulu*, the small, low lean-to that the family has constructed. Formerly it was used for the corpse to rest on during the night, but nowadays people prefer to let the body rest in his own hut; however, they need it later to place the chest for the bands of cloth the lineage members will bring to decorate of the deceased. In the funeral of Kwanyè Made, the smith woman, no *zulu* was built, as she had to be kept hidden, both as a smith and as a twin. Her corpse was kept in the brewery.

The message of death is one that spreads easily and quickly through any village, so in most wards of the village people are now aware of the death, if not by word of mouth then from the drumming. During the day the news will get to the neighboring villages as well, by kinsmen, formerly on foot, recently by motorbike, and nowadays by the all-present portable phones. In our case, the youngsters of 'Yèngu's clan get themselves ready to head for the bush. Armed with clubs, a dozen of them set out toward their eastern neighbors in Sirakuti to collect *safa* and *haze* plants.[5] These are central symbols in many Kapsiki rituals, but they are crucial in funerals. The plants must be collected from far afield, if possible from the bush near another village—hence, the carrying of clubs. In fact, the young men may try to provoke their neighbors into a fight: the greater the grief, the greater their inclination to fight. In the past, many a war started this way.[6] If the deceased is a woman, the plants will be collected from another ward, for a man from another village. In the case of Kwanyè Made they went to another village, to Sirakuti, this being a "heavy death," smith and twin. By collecting the plants, luck (*zalewa*) will disappear from that particular ward or village, so their people resent the intrusion; after all, *zalewa* is personal good fortune, situated invisibly in a person's body, a gift from one's personal god, *shala*. As such, it is in limited supply, a "limited good." The old custom of catching someone from the other village, shaving his head, smearing him with ocher (as a slave), and then letting him go was not exactly conducive of friendly

feelings either, but this was abandoned in the 1950s. Characteristically, no smith joins in this little raid, as smiths do not make war; they only make it possible. Only with Kwanyè's death, the female smiths had to go into the bush for one of their own.

In the meantime, Gwarda's son Kwada, assisted by some other older smiths, Cewuve and Degu, who just arrived, starts to clothe the body. In the dry season, this is in the forecourt; in the wet season, in the entrance hut.

This complicated job has to be done well, as 'Yèngu was important in Mogode, and the waiting crowd should see his worth. Characteristically, adorning the corpse is called *kapa wundu*, to buy the person. In any case, with a well-decorated corpse the smiths do gain stature. Gwarda directs the proceedings, and Kwada, with Cewuve, performs the actual job; later another smith will join them, from neighboring Kamale, where 'Yèngu's family stems from.[7] Kwada shuts the opening of the compound with a cloth; no nonsmith will dare to enter now, only the *ksugwe* (sister's sons) of the deceased who "are almost like smiths" at a funeral.

And, of course, I am present, as *ɲaœ*, smith friend and curious ethnographer. Actually, this was one funeral where I could at last really help the smiths, having seen quite a few now, trying my hand at decorating a corpse. Afterward,

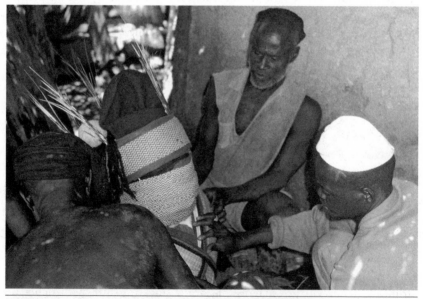

Figure 31. Clothing the corpse by smiths Gwarda, Cewuve, and Kwada

the daughter of 'Yèngu gave me a calabash beer, like the other smiths, thanking me for having really exerted myself. These are the small—but so important!—rewards of an anthropologist, the test of the apprentice.

The younger smith washes the body and himself, and splashes some perfume around to hide the smell. Setting 'Yèngu up on a stone under the lean-to, Gwarda fills his mouth and nose with cloth and ties a piece of the same white cloth around his face to keep his mouth shut. Kwada meanwhile picks up a piece of cardboard and fills out the neck of the corpse to stabilize the head. The three smiths cover the body, which is dressed in long pants and with a large gown, the clothing of the dead. Usually this is a black gown, but increasingly people prefer white burial shrouds, and so does 'Yèngu, as he indicated well before his death. Carefully, Gwarda cuts out the pockets and gives them to the *ksugwe* because a death gown has no pockets, either black or white. He also cuts off the sleeves, which he will keep himself: smiths make their own gowns out of the combined sleeves of the death gowns. This is one reason no one will ever steal a smith's gown, and why it is also used to swear an oath over. He tears off two strips from the underside of the gown and turns them into a sort of trousers, using the special knife that he keeps for this purpose. A small hole is cut to hook the gown around the big toe, and he makes a large hole between the legs to pass the decorating bands through. This first gown is called *rhamca* (literally, skin of the bull); although in the past some rich men are reported to have been buried dressed in a bull's skin, usually the *rhamca* was just a goat's skin, and today it is a gown. 'Yèngu is clothed in his "skin" and now has to be decorated in earnest, to express his true self and identity in life, and to add to the stature of his clan.

The corpse does not just need to be decorated, it has to be augmented as well, made more voluminous, larger than life. So first Kwada wraps two blankets around the body to fill it out. Then a second gown is put over the first one and the blankets, leaving large sleeves on the corpse. The basic clothing done, the smiths start with the decoration. In the early morning 'Yèngu's clan brothers have brought bands of cloth, sashes, towels, and blankets in all different colors to adorn their brother: the more, the better, and the more colorful, the prettier. Starting with broad bands, the smiths cross the corpse's chest and back, with each band being folded a little narrower so that all the bands are visible as one multicolored decoration, with crossing at the chest and the back, plus a similar band around the waist. Then the smiths add the sashes and woolen cords, with their woolen tassels in gaudy colors dangling in pairs over the corpse's shoulders. This is all strictly for decoration, for the joint glory of 'Yèngu and the *ŋace*.

The final decoration concentrates on 'Yèngu's head and is loaded with symbolism, as the decoration of the head signals who the deceased really is. A red felt cap, courtesy of his mother's brother, adorns his head. Carefully, Gwarda removes its little end-cord with his teeth, as it would be bad luck to have it sticking out on the corpse, and it has to be done with the teeth, not with a knife. This cap (*gwudu* or *vakwuru*), now a symbol of riches, was taken from the Fulbe, as these days the traditional *durugrese*, the blue and white cotton cap, is used only by old men. Personal caps are inherited by the youngest son on his father's death, to dance with at the funeral, and so with 'Yèngu. Gwarda puts two similar caps at the side of the head, keeping them in place with some wrappings. As a modern touch, Gwarda gives him a pair of glasses: 'Yèngu has to be able to see! Now for the deceased's specific identity: the head is decorated extensively, first with *jimu*, porcupine quills, a core symbol in burials. First a few *jimu* through the bonnet, as decoration; then two crossed *jimu* horizontally through the mouth, like cat's—or leopard's!—whiskers, an indication of fierce masculinity. And if the deceased had killed someone, two more would have to be added. When a woman is honored like a man, as Kwanyè Made was, sometimes the smiths apply this decoration to her as well. But there has to be a good reason; just before 'Yèngu's funeral, a woman in the village of Sena was decorated with double quills, and in the dance the other women were scared and did not dare to approach her.

Quills are stuck in various places: on the head, often in a row, and decoratively in a triangle on the chest with sashes wrapped around them, with the ones on his shoulders signaling his work, the women he married, the cattle he bought.[8] Gwarda attaches two bundles of *safa* and *haze* and two arrow shafts to the side of the head, with wrappings to hold them in place and increase the size of the head. 'Yèngu was rich, so cow horns are added to his head decoration. A cow's tail is attached to the back of his head, with its hair waving just in front of his face. On the corpse's chest, two crossed arrow shafts sport the black feathers of a rooster, while bird feathers, though not black, adorn the other arrow shafts. Gwarda himself has brought the porcupine quills, the arrow shafts, and the black rooster's tail feathers and will collect them after the funeral.

Everyone at the funeral ground will have to see 'Yèngu's importance. First, the cow's tail indicates a well-to-do person; more horns would have indicated that he owned more than one cow; the *jimu* indicate work and performance. Sometimes people who have worked with the deceased put *jimu* on his shoulder, whispering a message in his ear, their joint "secret." The two plants *safa* and *haze* are central in Kapsiki symbolism and are associated with fields and the bush: he was a cultivator and a warrior, diligent

at work and valiant in battle. The feathers in the shafts, *gɛdɛ gɛdɛ,* are very personal, especially the rooster's feathers, as they indicate ferocity, and the feathers stem from his *ŋulu rhɛ,* the rooster of the house, signaling his status as the master of the house, with a wife and children. One of them is longer than all others, and his oldest son will take this one after the dance to inherit his father's qualities and strength.

The absence of iron is striking, as all decorations are indeed tied on without using pins or other iron objects: iron holds people in place, and the dead person will have to move freely between the people of the village; in fact, he has to dance. The smiths work almost silently, not even looking at the people dropping in, and my usual presence is easily accepted, and appreciated when I hold the body for them to work on. In the meantime the smith from Kamale has come in, joining with his cousins; all smiths are narrowly related. Concentration is paramount as all decoration should stay in place during the dance, and they will be blamed if something comes loose. In fact, I never saw this happen. Distant relatives, in-laws, and others who have just arrived come into the house to see the deceased, then wail and dance a little, and join the mourning people outside the house. Dressing the corpse takes all morning, and a large crowd gradually gathers outside the compound, where the younger smiths have joined in with drums and flutes to direct the dancing. Funeral times highlight the smiths who lead the village during these liminal times, and the music is for the young smiths, while older smiths are in charge of the corpse.

Finally the smiths have produced the "real" 'Yèngu: large, strong, rich, powerful, and the master of his own house, a great warrior, a hard worker, and someone who forced luck to be on his side. He is put in a chair, and the smiths take a long sip of beer at the place of honor in the house. The musicians join in, and all the smiths, masters of the situation, at their leisure drink à deux: mouth-to-mouth, the two men empty a calabash with beer in one interminable draft. Some mourners are anxious to start the proceedings, for noon has passed and the dance should begin. As is usual, 'Yèngu's brothers and sons exhort the smiths to greater speed as the throng of mourners is getting impatient, but the "black people of death" do take their time anyway, relishing their moment in the sun. Meanwhile, 'Yèngu's daughter takes off the top cover of both his sleeping hut and his beer hut, a sign that he is truly dead, while a lineage brother at the side of the house pushes over a part of the wall and puts a mat in the gap, the exit of the corpse for this dance.

During the long hours that the smiths have decorated 'Yèngu, mourners have come to house, and the dance has already started long before the corpse is brought out. The young smiths lead the dance with drums and *shila* flutes,

and gradually a large crowd gathers, dancing and mourning. Some of them enter the house to greet 'Yèngu, but most are more interested in the dance, reticent anyway to enter the house of death. But it still is a dance of waiting, for the high point still has to come, the dance with the corpse. The people waiting and dancing outside are each adorned according to his or her own relationship with the deceased. Clansmen and women wear a cloth tied around their waists. 'Yèngu's personal belongings—his quiver, shield, and cow's tail whisker—are carried by his sons, while grandsons dance with a special dance quiver. This quiver, *kwagwecɛ*, is a typical heirloom, meant for his oldest son, and without son for his oldest daughter; his *durugrese*, blue cloth cap, is for his youngest son. Similarly, the personal legacy of a mother is her *rhuli*, her cache-sexe; in the absence of a daughter, the oldest son gets it. Luc tells the story of how he inherited his mother's *rhuli*, had to wear it, and ended up with blackened trousers. In the funeral of 'Yèngu, all his lineage children dance with a porcupine quill in their hair, the first-born among them (and for older children their first-born), and they all wear the same red felt cap that 'Yèngu wears, with a quill piercing it. Those in-laws that happen to be present this day are important guests at the funeral, and wear their best and finest: swords, grand gowns, dancing quivers, and sashes with tresses; of all the dancers, their outfits resemble most that of the corpse. But their main day has still to come, tomorrow at the grand dance.

Not only the men show their relationship with the deceased; there are also fine distinctions between the women. The wives of the clan, those who married one of his brothers, dance with a large hoe in their hands, a reminder of the work they did together in the fields. The daughters in 'Yèngu's lineage—that is, all the women born from the lineage—have tied on their *livu*, and so have all this year's new brides, the women of the ward, and close friends. All the women scrape a calabash over the iron rings of the *livu*, generating a characteristic harsh background sound amid the tumultuous noise of the dance. Any woman wearing her *livu* at a funeral dance expresses her close bond with the deceased. The women of 'Yèngu's *hwelefwe* (matrilateral kin) wave a large calabash to proclaim their kinship with him,[9] the finer points of kinship expressed by the strings of bean fibers they wear on their buttocks, the members of his matrilineage (*helefwe te ma*) wearing on the left, the others (*hwelefwe te za*) on the right. Finally, almost forgotten sometimes in the crowd, the deceased's widow and oldest daughter dance with the cow's tail whiskers, a sign of marriage in a wealthy house. All the kinswomen have tied a string of indigo cloth around their left wrists, the *shiŋli* or mourning band, which they will wear until the end of the mourning period, next January.

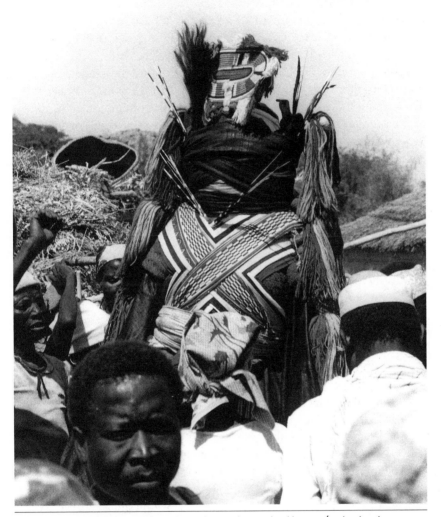

Figure 32. On the shoulders of the smith, a deceased meets her kinsmen (on her head she wears her coiled fan, a Higi custom)

At long last the smiths have drank enough and relished their importance to satisfaction. They carry 'Yèngu to the wall and put him in the gap in the wall. Gwarda's son Kwada then hoists the corpse onto his shoulders, holding him by the sleeves. A frenzy of drumming, wailing, crying, and shouting greets the deceased. Poised well above the shouting throng, 'Yèngu dominates his kinsmen for the last time, as everyone can see him in his full

splendor, and he, through his glasses, can see the multitude assembled for his sake. This is his finest hour. His daughter follows him through the gap in the wall after their mother's brother has sprinkled some ashes on her back, the girl carrying her iron skirt over her shoulder. The dance picks up immediately; everything is in full swing. All throng around the deceased, looking up to him, shouting, brandishing their lances, sticks, hoes, and calabashes. The women strike their iron skirts with their calabashes in accompaniment of the Kapsiki's real mourning song, the *nhwene za* (the dirge for the man), in a slow descending melody that allows for easy improvisation. The themes are perennial: "Why did your leave us, where do we go from here, we have become orphans, nobody here to protect us, with whom will I drink my beer henceforth, who will whistle the *njireke* now [a flute]," the same lines the women have been singing throughout the night.[10]

At a funeral a number of mourning dirges are sung. The most general one is the *nhwene male*, the female dirge, used in all funerals. For men, like this one, the *nhwene za*, the male dirge, is sung several times in the dance; the distinction between the two is a gentle difference in drum rhythms. In 'Yèngu's case, as at the funeral of any old man, the *geza*, a war chant, is performed; this one does not feature much text, but consists of loud exclamations on a rousing drum rhythm. After the funeral women sing the *nhwene gela*, the dirge of the rock, again with a slight alteration in drumming. Each village cluster has its own distinguishing songs: the *nhwene fte* for Sena, Kafa en Kama, the *dzagwa dzagwa* for Guria. Actually, during Kwanyè Made's funeral one very specific song was sung by the women who went into the bush to collect *safa* and *haze*, that is, the *kwarɛa kwarɛa*.[11] During her funeral dance the special smith's performance with all the medicine vials is called the *shila besheŋu*, the magical flute.

The smith takes the corpse to the largest open space, and the dance begins to move in earnest. The men make grouped charges toward smith-cum-corpse, women circle the male dancers and the young smiths are everywhere with their drums and flutes. Kwada, with the corpse on his shoulders, runs through the crowd, charging the men, dancing with the women while moving to the rhythm of the drums. The shouts of the men and the shrieks and ululations of the women mix with the powerful drums of the expert drummers. In the following hours, 'Yèngu has his last and finest dance, moving constantly, his bearer replaced from time to time by new smiths or occasionally a sister's son who wants to show off. It is a hot, sweaty, and smelly job but a wonderful way to stand out among the mourners.

This is 'Yèngu's moment of crowning glory, with his full and final identity completely visible. Dressed in his resplendent outfit with the symbols

of masculinity and achievement adorning his imposing presence and held high on the shoulders of the smith, he is the absolute center of the whirling dance. Each of the dancers expresses his or her special relationship with him; clansmen, in-laws, daughters or wives of the clan, family through his mother, all those crucial to him are there, their very adornment part of his existence, his identity. Never in his life was this so clear, so visible, and so rewarding. It is a pity these last two days only happen after his death and inevitably do lead toward his grave.

How long the dance lasts depends on age and grief: with a young corpse and when people grieve deeply, the dance may last for hours, but if the deceased is very old with a full life behind him, half an hour will suffice. With an older person like 'Yèngu, the smiths put in a fair performance; in the case of a young person,[12] the dance will be much longer, but many people will be too upset to dance at all and just sit and grieve instead. Dancing is a common expression of mourning, but a deep loss will prevent the cultural ways of showing one's emotions: people then "sit and look with the eyes."

During the long afternoon, from time to time the smiths rest and put 'Yèngu on a chair under a tree. After some hours of dancing, they put 'Yèngu at the place of honor in his forecourt (*pulu ŋeza*), while the dance goes on. One of his daughters stays with him, chasing away flies with her cow's tail and singing softly: "I am alone now in our house, without you. You have left, and now we are orphans. The people are here to greet you. If you are over there, tell my people that I suffer here." As the deceased is old and has had a good life, the dance loses its solemnity and amusement creeps in. The smith-drummers zoom in on the village notables, on the sons and in-laws of the deceased, on his daughters and sons, as these are the core persons in the dance and should honor the smith-musicians with money. Meanwhile at 'Yèngu's house, Cewuve and the smith from Kamale gently undress the corpse, putting all the cloths, sashes, tassels, and bands in the wooden boxes that used to belong to him. They do so very carefully, since people distrust each other with clothes and do not trust smiths at all. So some brothers oversee the proceedings and quickly put the full boxes on top of the *zulu* in full view of everybody.

At Teri Ngwene's funeral, a dispute breaks out about a missing piece of cloth. People then remember the same at a previous funeral, some years ago, and that was the same smith, Deli Kwanyerhu! It was this very Teri Ngwene who had voiced the accusations, so the smith must have now stolen the cloth in revenge. The smith vehemently denies the accusation: he had only taken the *dlave*, the small piece used

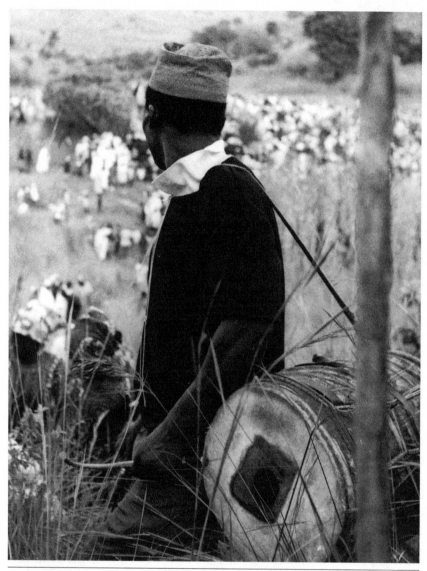

Figure 33. Smith Teri Buba with his *dimu* leaves the funeral dance

to fasten the ram's hair to the lance of the *gwela* initiate, as was his due. The dispute ends when the widow arrives and tells the smith that he should not be bothered as long as Teri's sons do not accuse him of anything. Deli Kwanyerhu, relieved and gathering up his courage, says that anyone who wants to accuse him of stealing something should do so in front of Rhwemetla (the ordeal mountain).

The smiths let the deceased sit in his forecourt until late in the evening, as visitors are still coming, and they have to see and greet him. For the night, Gwarda and his son put the body back in his personal hut, at the express wish of 'Yèngu's son, while the boxes remain on the *zulu* for the night, the small hangar built for burial purposes only, and Gwarda again stays the night, sleeping under it.

THE DEAD AND HIS IN-LAWS

The next morning one of 'Yèngu's daughters washes his body, to clean him but also—if possible—to wash off his skin. Though this has become rare, people used to be buried "white," without their epidermis; but often the corpse is too well preserved to wash off the black skin easily, even with the special *keyitu*[13] bark they use for it, so people leave it on.[14] Then the stage is set for the smiths for the second day of adornment. Day Three is even bigger than Day Two. The whole day people come from the surrounding villages to honor their in-law, old enemy, father, or grandfather. In 'Yèngu's case, women from his clan who left to go to other villages have also come. These women have brewed beer, prepared a meal with meat, slaughtered a goat, and hired at least one smith with a drum. They and their families eat and drink first at their home, have a short dance to warm up, and then go in a long line to the village of the deceased. The women carry their food, and the men have dressed up in their best gowns, with a quiver over their shoulders, and all take something to dance with—a sword, a spear, or a throwing knife—for an empty-handed dance is no dance. A troupe bringing this so-called *d'afa zhaŋe* can number between 30 and 100 persons.

Funeral is dancing time, but also cooking time, as so many mouths have to be fed. At the house of the deceased the women have been busy since sunrise, cooking and brewing white beer. During the morning 'Yèngu's sister's sons, or those of his close kinsmen, gather in the house and, led by the *maze kwele* (the old Zhinerhu, who is in charge of digging graves), head out to a burial field. The nephews have a busy time at funeral. They may not be closely related to one another, but together they are called *dagwama, ksugwe* to the same clan. They call the smiths, wash the body if there are no daughters, watch over the corpse, guard the possessions, and later brew red beer for the final rites. During the last day they have been busy presenting the smiths with food and beer, and some

of them stayed the night inside 'Yèngu's compound. Now they have to do their heaviest job, digging. Yesterday one of them cut a digging stick out of a tree belonging to the deceased, usually a *ndewuva vera* (*Ziziphus mauritiana*). Taking this stick, an iron point, adzes, and calabashes, they head to a spot indicated by 'Yèngu a long time ago, when he spoke his *mid'imte* ("the words for his death"). 'Yèngu has chosen to be buried at his clan's burial place, although some people nowadays prefer to be alone after death. The old smith Zhinerhu directs the digging of all graves; he has followed in the footsteps of his late father as master of the grave, so it is his responsibility to dig a proper grave, and he takes the task seriously. The old smith has brought along a large calabash, puts it on the ground, and draws a circle around it to outline the size of the tomb entrance. The "little *ksugwe*" begin digging, straight down at first and then gradually widening after half a meter, making a bell-shaped burial chamber about 1.3 meters deep and 1.5 meters in diameter, depending on how stony the soil is.[15] As *ksugwe*, the sons of the clansisters of 'Yèngu, it is their duty to dig his tomb, and they are being commanded by a smith, so they realize they are doing more or less a smith's job. When they make some deprecating remarks about smiths, as sometimes happens, Zhinerhu lets it pass.

Meanwhile they scout for a flat stone to close the tomb with, and then beer is brought by 'Yèngu's younger brother, whose wife brewed it this morning. When they drink, one of the deceased's younger in-laws comes along, as they are the star in the following dance and want the diggers to hurry. So he gently scolds the diggers for being slack: they should show the *nasara* (me) what real work is! The *ksugwe* pick up speed with the sweaty job, even showing off when other people come along to inspect the work.

A grave has to be a round underground chamber with a small entrance, but this opening must be large enough to accommodate the body, and 'Yèngu was a big man. So the *ksugwe* have exerted themselves and made it large enough to avoid a severe scolding and loss of face. The work is completed on time, at noon, as the sun should shine directly into the grave, and they all leave to find 'Yèngu's in-laws who have to pay them. The rationale for this is that in the past the sons-in-law were supposed to do the digging, but as they preferred to dance in their splendid costumes, they asked the deceased's nephews to do their job. Now they just have to pay. If they hesitate, the nephews take their sword or cap. Zhinerhu removes all iron from adzes and the digging stick, and he will sharpen them and return the next day. The adze handles, the calabash, and the newly cut digging stick remain on the grave; the stick can be collected by any smith who wants it. But he has to take it to the blacksmith first, to sharpen it; otherwise it will keep digging graves.

In the case of a woman who died without giving birth to children, the master of the grave touches both her shins with the digging hoe, and after digging, that hoe is thrown away in the bush, together with her cache-sexe. At the death of a childless man, a similar thing happens to his quiver: it is put inside a thorny Euphorbia, an act bearing the beautiful name *kwagwecɛ hwa hwulu* (the quiver in the thorns); no one will ever take it.

For a woman's funeral, also for Kwanyè Made, our smith woman, the *ksugwe* in question are not her own, but her husband's; the funeral services have to be performed by those who descend from the daughters of the clan into which she is married. Her own clan will, of course, be continued by her brother's sons, with whom she retains very close ties.

As at Day Two, Gwarda and the other smiths use the morning to decorate 'Yèngu again for the big dance, in even more splendor than the previous day, with ostrich feathers. During this morning, before the "coming out" of the corpse, the *ɗafa zhaŋe* groups arrive. They first gather in a neighboring compound where the women put their food and beer, first for the smiths, as they should be fed well, and then for themselves. When settled, the arriving men immediately mount a mock attack on 'Yèngu's house, shouting, brandishing their spears and swords, and yelling, while the women ululate. 'Yèngu's kinsmen are happy to challenge them with the same gusto, and the two groups mingle in a frenzy of sham fighting.

As the system of secondary marriages generates a wide circle of in-laws in most of the neighboring villages, and as all have heard the news now—the mobile phone!—all those *mekwe* (in-laws) arrive late in the morning. This will be the largest dance by far and also the most varied, as each village wants to show off its own mourning song. The central figures are the sons-in-law because they have to shine, showing that the deceased has given them his daughters for a very good reason. Tlimu Vandu, my good friend and informant, himself an experienced husband of four wives, explains:

> People dance as *mekwe* in full attire so the women can see you dance. If the *mekwe* does not dance well, who will know that his daughter is with you? So the *mekwe* puts on the quiver, puts a band around his waist close to his heart, and takes the bow and a large knife. He should dance on the granary, above all the others, with the daughter of the deceased, his wife or her sister. Then people say: "He has mourned well, he has danced well, and he is a real *mekwe*. I will give him my daughter as well."

Indeed, the sons-in-law and daughters dance on the granary, which is tricky as they dance on the rim of the opening and may fall through it; if so, they

would be the laughing stock of the whole village. From his high station, the *mekwe* throws coins into the dancing throng for the smiths. For the *mekwe*, this burial of his father- or mother-in-law is expensive. He has to furnish at least a large gown, several goats, a red bonnet, some other clothes, a sizable amount of sorghum, and, if possible, money.

Like in the day before, also this early afternoon the decorated corpse is brought out through the gap in the wall, this time for the final farewell, and the smiths have exerted themselves to make 'Yèngu look resplendent, even adding quite a few ostrich feathers to counter the outfit of his in-laws, who also may sport the waving feathers, accentuating their vigorous moves. Sometimes a sister's son wants to impress the audience and takes turns with the smiths in dancing with the corpse, but usually the smiths are not too keen on losing their monopoly position. So only when the smiths complain about a lack of beer or demand too much will the nephews ostentatiously take their place. As 'Yèngu was old and had a good long life, the dancing soon gets festive, and as also the season allows it, the *kwaberhewuzha* is held, the "ladies-excuse-me" dance. Just before the start of this dance, 'Yèngu's wife is honored by the smith drummers; as *kwadleke* (*dleke* is old sheepskin) she has stayed with her ailing husband until his end, and the drummers put on a special show for her. Then the corpse is put back in its place in the forecourt, and the drums begin with a new rhythm, calling especially the young people into the dance for the "ladies-excuse-me" dance.

The dancers form two large circles, with the men outside and the women inside, dancing in opposite directions and with everyone singing. This dance demands special steps to synchronize the dancers. After about half an hour, the women and girls stop moving, take a long sorghum stalk, and each girl and woman taps it on the head of one of the dancing men. He then leaves his fellow dancers and stands next to her until everyone has found a partner. The song continues, the women singing to the men, and vice versa. The texts of this *kade male* (to love a woman) change gradually: at first the two sexes playfully insult each other, but when they have found their partner, this evolves into a more inviting text.[16] In the seventies men and women sang just about physical attraction, nowadays the text is changing and reflects new values, especially new riches. The men now boast their wealth: "I have three cars," "I am going to Yaoundé," and the women zoom in on this: "I want you to give me a telephone," but the end is just as erotic as always. Dancing is always with something in hand, swords and sticks formerly, now with umbrellas and hockey sticks.

As is usual in liminal times, some license is allowed here. No husband or wife can interfere with or even object to what is happening during this

Figure 34. Funeral times

dance, and many a runaway marriage has resulted from this *kwaberhewuzha* dance. The name indicates this ("the dance to be with the girl"), and the more people from other villages there are present, the greater the gusto for the dance. Sometimes the hosting elders try to shorten the dance, afraid of losing women to those wonderful sons-in-law who are showing off, threatening to take the women to the neighboring villages.

It is only after the *la* festival, from December onward, that the *kwaberhewuzha* can be danced, and then only at the funeral of an old man or woman: for the death of a young person, mourning is too intense to allow for such frivolities. The first sowing ends the season for this dance. Since about 2003 this dance has become quite rare, as it often provokes discussions and fights, and it has been discouraged by the Lamido, the chief of the subdistrict (canton), at least in Mogode.

BURIAL

'Yèngu has been brought back to the house before the *kwaberhewuzha*, and gradually, about 5 P.M. the dance winds down as the dancers move away, with just a few left to watch the final proceedings, the burial itself. The smiths have clothed the body in only his *rhamca*. It used to be a fresh goatskin with, if possible, its leg strings fastened over the shoulder of the deceased; but if the deceased is as big as 'Yèngu, they would be attached around his waist. In the 1980s and 1990s, the *rhamca* was replaced by cloth trousers because, the people claimed, a corpse decomposes too quickly with a goatskin. With 'Yèngu, as we saw, the *rhamca* is a gown. But a goat is needed anyway, skin or no skin, and this goat is not slaughtered with a knife but strangled, or its neck is broken, as it should die without a sound and without spilling blood, lest other people die. If, very rarely, a bull is sacrificed, then it is stoned to death. The goat, in principle, should be from the deceased's flock: if it has to be bought, it will be very expensive, as nonkinsmen are reluctant to be linked so directly with death. Also his son-in-law might furnish it. While the other goats are just for the smiths, one leg of this goat is for the nephews who have helped the smiths, one for the smiths themselves; the head of the goat is for the chief smith, and the breast for the smith who measured the tomb. All of this will be eaten the next day

The smiths bind the corpse's mouth shut (using bean fibers for a woman and strips of cloth for a man) and then place a gown over the corpse, formerly a dark blue ("black" for the Kapsiki) one, a white one these days. They

close it at the sides and place a bonnet on the head, wrapping a broad strip of skin from the *kwe rembekɛma* around the head. This particular goat has to be given by a son-in-law especially for the occasion, in this case the husband of 'Yèngu's daughter. She had it slaughtered by 'Yèngu's sister's sons, who in turn will take home everything but two legs and the skin. The meat is for the sacrificial meal the next day, but now the skin is wrapped around the head of the deceased, covered with a piece of cloth, and then adorned with two arrow shafts with black tail feathers from a rooster that Gwarda brought along. This is done by the chief smith alone, with all the other smiths offering a running commentary.

'Yèngu is now back to "normal," without the grand stature of his decorations, ready for his burial; the smiths get some more beer, and the final farewell can start. One of the daughters gets some mush, and the chief smith places it on the head of the deceased and eats it, with the other smiths. Then 'Yèngu's children assemble before him, and the chief smith presents a calabash of white beer to the deceased, saying: "Drink this, we have mourned you well; do not bother us and keep us from harm." He takes a mouthful and sprays it over the children: "Here, be healthy, very healthy. Have many children, I am not jealous." Kwada hoists the body onto his shoulders, and, for the first time, he exits the forecourt through the normal entrance where some of the dancers are still waiting. They dance a few steps with him, and then he is quickly on his way, walking fast toward the grave: 'Yèngu is almost flying. There, Kwada puts the corpse upright with its feet in the hole and looks to see who has followed him. Silence reigns; no one may mourn out loud because the mourning will follow the deceased into the grave and will never stop.

Most of the times the burial follows immediately, but not always, depending on the purported cause of death. If an internal abscess is suspected to have caused death, the corpse will be operated on at the graveside by the chief smith, as a kind of autopsy. He cuts open the body and removes the suspected organ in case the whole clan dies from the same disease.

An old woman, Kwayèngu Kwada, was operated on in this fashion. Her corpse had burst after two days, which is a sign of adultery with a smith. The officiating smith—this time it was not Gwarda, who was ill, but a smith with less experience—had forgotten his knife and tore her body open with his bare hands, an action the next-of-kin did not appreciate at all, but against which they could do little. For protection, the smith touched his own forehead, Kwayèngu's

forehead, and again his own with an iron bar, *duburu*, put his foot on the bar,[17] and then proceeded to remove her organs, including her lungs and heart. After this grisly work, he found a small spot on one lung and surmised that he had found the culprit. The corpse was buried, but the organs remained above ground next to the opening and were later covered by the tomb itself. The iron bar was his, as protection against any possible infection, but also his reward, and might later serve as *shafa*, oath object.

These procedures are not always as brutal as this one in 1973, and have become more frequent lately, with some smiths accruing a reputation as skillful performers of the procedure. Kodji relates how in 2008 Ngawa, a nephew of Gwarda, made this "autopsy" into a spectacle, using the gestures he has seen on TV hospital series. Ngawa concluded that the liver had been destroyed. He showed it to the audience: "It became water. You all have seen it, you are my witnesses. I hope this illness will stop with him."[18] Both Ngawa in 2008 and the chief smith in 1973 managed to work serenely in a stench of putrefaction, while all spectators hold their noses closed, a striking and telling commentary on the enduring smiths' position. Often family turn their head and leave, even if they are expected to witness the procedure. This "surgery" is one custom the Christians have quickly abolished.

In the case of 'Yèngu no operation is needed, and we can proceed with the burial immediately. Gwarda, who has followed his son to the graveside, cuts strips of the white gown to hand to the next-of-kin, numbering a dozen people—some brothers perhaps but mostly children. No wives and no in-laws ever come to the grave; they stay behind in the compound. These strips will serve as *shiŋli* (mourning bands around the arm), and will later eventually be joined by a belt of baobab fibers. At that moment, just before the burial proper, the smith may comment on the death himself.

> At the funeral of a young man, just some twenty-six years of age, Gwarda stopped the proceedings, and made a speech. "This is not how we should die in Mogode. Not like this, not so young, not so sudden. If someone has killed this child, he should follow him into the grave immediately. Also, if it has just happened, he has to acknowledge him."
>
> This is cryptic, as a good Mogode-speech should be. Gwarda indicates that he thinks this does not call for revenge by *wuta* ritual, but might have been an accident. In this case there is no follow-up to this speech, as no one suggests that the chief smith prepare a *shafa*, a ritual object (such as a smith gown) to swear an oath of innocence on. Also the suggestion of *bedla*, a conditional curse, is

not taken too seriously, as the young deceased leaves no inheritance, and has no progeny or next of kin. In fact, Gwarda is just venting his emotions on an untimely death, with nobody to blame.

In the 'Yèngu funeral no such comments are needed, as this has been a "good death," one after a fulfilling life of sufficient length, so helped by Cewuve the smith chief lets the corpse down into the grave, crossing its arms above its head. When only the hands stick out above the ground, a son or daughter of the deceased picks up the arrow shafts with the feathers, then strokes the right thumb of the dead, and finally turns around and walks home without looking back, a rite called *kasede gweŋu* (stroke the thumb). Here it is 'Yèngu's oldest son who in this way takes his *ŋki*, his individual properties like wealth, luck, and success (*malema* in Kapsiki) that are represented by the rooster feathers. With a closed fist, he heads straight for his father's hut, "empties" his fist into the dark hut, and shuts the door.

A central symbol in the burial itself is the strip that holds the mouth shut, a strip of cloth with 'Yèngu, a string of bean fibers with a woman, *rhweme*.[19] The cutting of that strip or string highlights the fact that the deceased is no longer to be viewed, and cannot be communicated with any longer. So Gwarda cuts some of this *dlave*, strip of cloth, and hands it to 'Yèngu's daughter, who will use it as her mourning band. He lets the body slide farther into the grave and then joins 'Yèngu in the grave himself to arrange his body properly, for a dead man should lie on his right-hand side with his head toward the south and with his feet pointing north and facing east. A woman lies on her left-hand side, her head to the north and facing east toward the rising sun. Small babies are buried sitting upright, also facing east, and their hands are placed on their head, to "pray *shala* for another child." The chief smith climbs out of the grave with two handfuls of earth and throws them at both sides of the grave, while everybody checks to see whether Gwarda has done it well. (If not, bad luck will fall on the deceased's descendants.) He has, and with the strip of cloth and a bracelet he got from a maternal kinsman of the deceased, Gwarda touches the left shoulder or breast of all the descendants present, and in turn they throw sand into the grave, first with the left hand and then with the right. Tomorrow the daughter will retrieve the bracelet from the smith in exchange for a small gift of food. While the kin leave, Gwarda and Cewuve shut the opening to the grave with a large flat stone and shovel earth over it, leaving the handles of the adzes and digging stick in the sand.

The smiths are professionals, but they are also close village members,

and do share some of the emotions of the family. But compared to the emotional outbursts of the next of kin, the smiths exude a businesslike attitude, just doing their job, especially in the case of an old man, like 'Yèngu. Here they are at ease and make jokes: "Do not fill the grave yet," says the chief smith while in the grave. Others comment on the heavy stone. "I want a lighter one on me; this will crush my ribs." Young smiths try to impress the others by carrying the corpse without any hands and pretend that the smell of the corpse does not bother them. And if they feel they have been badly paid, they will let it show.

> At the burial of a poor man, the smiths did not get their goat—it should have been paid before the arrival of the in-laws, during the great dance, but nobody came up with their beast. So now they bury him very fast, tear the cloths off his head and throw them on the ground. For a split second, they give the son the chance to take the *ŋki*, but he refuses: "He was so poor; nobody wants that; better that his poverty enters the grave with him." The smiths quickly finish and do not show up the next day for the concluding rituals.

COMPLETING THE TOMB

On the morning of Day Four 'Yèngu's nephews repair the wall in his compound, while his daughters cook the food for today's sacrifice and put it in the calabash used to measure the grave. The special sauce is *rhedle* (the ritual sauce used at most rites of passage) with a large chunk of meat from the *kwe rembekɛma*, the goat 'Yèngu's daughter is also using for the upcoming ritual called *nerha dafa* (throw the mush). Gwarda leads them plus a few brothers to the grave. The women sing the *nhwene gela* (dirge of the rock) while walking: "I am like a dog now. Where can I go? The house is for whom now? I thought I was someone, but now that you have died, I have become a thing. Who will help us with our troubles?" Gwarda instructs them in building the tomb by piling the dug earth up on the grave, each with a few handfuls at first, and then they start building the low circular stone wall that makes up the structure of the tomb. When they are halfway done, the chief smith puts a broken pot in the sand, all the descendants hold their hands over the pot palms downward, and Gwarda puts some pieces of mush on the back of their hands, which they let roll onto the sand. All women participate except for those who are pregnant, as they are too vulnerable. The smith closes the pot with some leaves, and everyone sits down to eat the rest of the

mush and the sauce. They leave the adze shafts crossed on the grave as the *nerha d'afa* is finished.

The largest crowd is not at the tomb, however, but at 'Yèngu's compound, where clan members who provided the strips of cloth for 'Yèngu's adornment arrive to retrieve their possessions. First, though, his *hwelefwe* (bilateral kin) have to eat. Theirs is the ritual meal of *zhazha*, in this case the *zhazha hwelefwe*, a mix of cooked beans, *dewuze* (a *Rumex* species), and sorghum grains. *Zhazha* is not ground, and as such is an expression of poverty, as only celibates—the ultimate poor!—eat without grinding. They start eating with their left hand, then their right, making sure they eat all the grains in each bite. The *hwelefwe te ma*, the deceased's matriline, eat inside the compound, his *hwelefwe te za*, his cognatic stock, outside. They then have their heads shaved by the smith, who carefully burns all their hair. The second part of the meal is the *d'afa hwelefwe* (mush of the family), white mush with chicken that is eaten by clan members and their wives, while the *hwelefwe* members stay on the two spots in the compound where they are. The lineage members wait for their bands of cloth, and the tension of the funeral has clearly been released. They sit and chat, relieved that everything went well.

The next of kin in Kapsiki do not include the marriage partners, as they have other rights and obligations. 'Yèngu's widow ('Yèngu had only one wife) does not eat the *zhazha* but does have her head shaved. She will not go to the graveside but will cook some meat, part of the *kwe rembekɛma* that her daughter has brought. At nightfall, with a few of the wives of her brothers-in-law and her sons, she will walk to the road that leads toward the graveyard and eat the meal from her husband's personal eating calabash, breaking it when she has finished.

During the meal of both parts of the *hwelefwe*, a sister's son busies himself with the bands of cloth the clansmen have come for. He dips a sorghum stalk in sauce, rubs it over the chests with the cloth, and then hands the men their strip of cloth. Each then dips his fingers in the sauce, rubs the clothes with it to "cleanse the bad luck," and then packs them away. This is all the attention the strips of cloth get; they will not be washed, as "washing would reduce the brightness of the colors." The nephews, who hand back these cloths, have to be careful, for some clansmen try to get a better piece back, and any difference later has to be made up by the small *ksugwe*. This is the moment when anybody who happens to have special knowledge about the circumstances leading to the death should speak up—that is, if anyone suspects sorcery, now is the time to declare it. But, of course, with 'Yèngu this is not the case.

Two days later, the series of sacrifices of the *d'afa kwele*, which began with the *nerha d'afa*, continues: under the direction of the chief smith people build up the tomb and leave some *safa* and *haze*. About two weeks later the last and central ritual of this series will be held, called *tɛ kwele* (the beer of the grave) or *tɛ ncimu* (the beer of the tears). One of the daughters cooks mush and chicken sauce, and everyone eats at home. The son of one of 'Yèngu's sisters has brewed red beer and takes a jar to the tomb side. Wailing loudly their dirge, *nhwene gela*, the little cortege winds up to the grave: "I am like a dog now." "Why did you leave us alone?" "Please tell my father that his daughter is suffering here." At the tomb the sons take away the hoe handles, and finish the tomb. Gwarda pours beer into his bowl and pours it over the descendants' hands: "Let everyone be healthy." Another cap of beer is poured onto the tomb itself, and then they drink from the smith's *dzakwa*—a crucial detail, as in "normal" times a smith's cap is for him or other smiths only. Yet some people who descend from immigrants sometimes are wary to drink from the cap and leave that to the autochthonous ones.

If the deceased had any debts, this is the moment to settle them. Any debtor should claim his dues: they will get the first beer from the cap, and as it is a smith's cap at a graveside, if they lie they will surely die. The sons also discuss any outstanding loans 'Yèngu may have had, in order to claim those.

> At another funeral, the deceased's two brothers discuss the debts of their brothers-in-law, part of the bridewealth evidently. One has not given a goat for the funeral, while the other has just paid eight goats as bridewealth, which is not nearly enough. They are unsure how to approach the first case, but the second is clear. Their sister will not return to the man before he pays up! If he makes any comments, he will lose his wife plus his eight goats.

No debts are claimed at 'Yèngu's funeral, and the sons put the adze handle, the personal property of the deceased, back on the finished tomb with some *safa* and *haze* and return with the digging stick. The clan and ward members await them in the compound, drinking beer, as any red beer sacrifice has a public end. The sister's sons then repair the roofs of 'Yèngu's personal hut and his beer hut, because people danced on them during the funeral. Now all the descendants will have their heads shaved again except for a small tuft at the crown of the head, which will be removed during the closing rites— that is, at the "second funeral" in February, like the *gwela*.

There are three "beers" that together make up the second funeral: *tɛ kwele*, *tɛ kembu gɛŋa*, and the final one, *tɛ shiŋli*. The first one we just

saw. The second one is just before the yellow-sorghum harvest, called *tɛ kembu gɛŋa* (beer to pour on the stone). The ritual is done in principle for men only, as these have a proper *gɛŋa*, but a son may honor his mother by performing this ritual upon her grave as well. The son of the deceased brews beer and makes an appointment with the chief smith. From its place in the forecourt he takes the *gɛŋa*, the oblong stone that the deceased had kept there to adorn his grave. For a man this is the stone that will be on his tomb; a woman's grave may be finished with her millstone or several smaller stones. Gwarda leads the little group to the tomb, the son and some other members of the family with a pot of beer, while the sister's son carries the *gɛŋa*. It is a sober ritual, in fact. Gwarda just puts the stone on the tomb, and pours beer over it. Toward me, the chief smith insists that the grave-stone represents the sons of the deceased; for a childless man, these may be his brother's sons. Someone with a lot of children will have more *gɛŋa* on his grave, but 'Yèngu has only one, so gets one stone on his tomb, as is more or less standard. A woman with children like the deceased Kwanyè Made of my opening example will have three small stones on her grave. The smith then from his bowl pours beer over the descendants' hands, with the usual injunction: "Let everyone be healthy." The rest of the family are waiting at home to drink on their return.

In the case of a dry season funeral, one more ritual may be added. A son-in-law who could not attend the funeral hires a few smiths and gathers friends to come and dance at the deceased's home. This ritual is called *bukata*, a Hausa term that means doing something suddenly because it has been forgotten. At this time, usually three weeks after the funeral, the married daughters come to their parents' home to cook *d'afa kwele mɛ cɛ*, "mush for the entrance to the grave." Family and friends join them to eat this white mush and goat's meat. For 'Yèngu's funeral, this ritual was not held. In the north of the Kapsiki area, in Wula, as in Sukur, this is a standard ritual done months after the burial proper.

RETURN FROM THE TOMB

After the conclusion of these proceedings, people wait for the harvest to hold the concluding rites of *tɛ shiŋli* (the beer of the mourning bands). In what is for the Kapsiki the first month of the dry season, namely January/February, these rites are held to end the mourning period and symbolically bring the deceased back home. Although it is part of the ritual cycle, this is

an individual ritual done personally for each person who has died, but always during this moon. The next-of-kin consult the crab for a date and prepare beer. The evening before this *tɛ shiŋli*, the kinsmen and the chief smith take 'Yèngu's former *melɛ*, full of beer and representing his dead father of old, to the tomb. Gwarda pours a calabash of beer on the *gɛŋa* and another on the rest of the tomb: "May your children be healthy and have many children." A third calabash is drank by the sons, daughters, and the *hwelefwe* present at the tomb. The jar with the rest of the beer is left on the tomb.

It is still chilly the next morning, when the compound's forecourt fills up with old men, ward members, friends who have helped with the *d'afa zhaŋe*, in-laws, and the inevitable sister's sons of the deceased, along with some mother's brothers and quite a few neighbors. Gwarda has come early and is busy shaving everyone's heads, while a nephew cuts their mourning bands with an ax and burns the *shiŋli* with the hair. I did not witness these rites for the funeral of 'Yèngu, as I had left the field just before they began, so I give instead the *tɛ shiŋli* of Mbeleve, a member of the *zeremba* clan, who had died half a year before. The atmosphere is relaxed as the rains have been good, though some guests comment on the new *melɛ* (sacrificial jar) and whether it is too black for their taste. Most people chat about the following month when the *makwa* will start their preparations. The old men complain that too many boys now marry girls from another village, and indeed, quite a few marry girls from Guria, and the girls' parents are not happy about it, so they demand more bridewealth. While commenting, an old man crashes the empty jar he is sitting upon, eliciting a lot of jokes and a sour face from the son of the deceased, Deli Mbeleve, as the jar is someone else's, and he will have to pay for it. However, the culprit is an older clan brother, so not much can be said.

This part of the ritual falls to the exclusive domain of the chief smith, so it is Gwarda who leads the immediate kin to the grave. He takes along another jar of beer and some ground couch, which he got from Mbeleve's daughter. Two other lots of couch were distributed earlier between the smith himself and the mother's brother. At the graveside, Gwarda puts the new *melɛ* on the tomb, pours some beer from the jar on the tomb into a calabash, mixes it with some of the ground couch, and hands everyone present a piece of couch mush. He then shuts the opening of each *melɛ* with mush and decorates them with *safa* and *haze*, carefully avoiding spilling anything: if these grains germinate on the tomb, children will die.

Symbolic inversions mark these final rituals. The first is right at the start when the chief smith pours the mix of beer and couch over the backs of the hands of the children, who are stretching them out over the tomb, the

symbolism of eating together neatly and bodily inversed. Kwada asks his father to do the same on his hands, as both smiths are part of the *zeremba* clan and thus considered to be kinsmen. When pouring, Gwarda admonishes the deceased: "You have to be good now. You have been well mourned. Do not be jealous, and take care of your children. They have to have children themselves, and you should not prevent them." Mbeleve's children take mahogany oil and ocher from their bags and rub the *geŋa* until it is a fiery red, then they rub their own heads and legs. Together, the smiths and children drink the rest of the mix, and when it is finished, Kwada gives a long speech to the dead along the lines that "Mbeleve should not be naughty, and finally let his son marry, and also let Kwada marry and have children. Then his wife will not run away again."

Mbeleve's children are adults, and appreciate both the inversion and the amusement of the next item. One by one the children climb on the tomb.

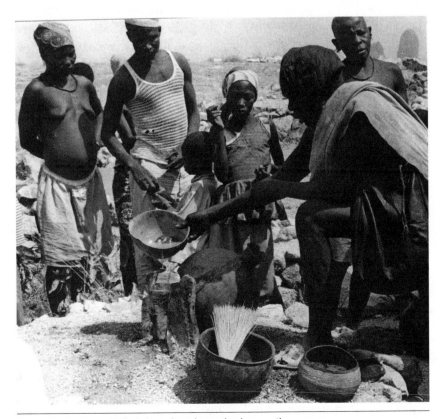

Figure 35. Meleε shiŋli of Mbeleve, Gwarda pouring beer on the *geŋa*

Gwarda takes a mouthful of beer with couch, sprays it over them, and, in the name of the deceased, blesses each of them. One daughter gets the following blessing: "Stay healthy and God will give you a child"; and her brother: "Your father will protect you and not be jealous any longer, and you can father a child, like he fathered you." Then, in a gesture that mirrors the arrival of the corpse, each of the children is taken on the shoulders of a mother's brother, carried a short distance and put down, just as the smith carried the corpse, so that "good luck can come back."

The smith hands the new sacrificial jar to Mbeleve's oldest son, who suggests taking his father's *melε*, as his own is too black and badly fired. Gwarda is adamant: Mbeleve was a mean person when he was alive, and it is better that he disappears completely. He shatters the old *melε*. (Gwarda is right: about two years later this son will die.) The cortege walks back home where Deli Mbeleve puts his new *melε* under the *tame*, the granary, and with a ritual meal starts his life as man of the house.[20] After eating, his siblings head for their own homes where their friends who helped during the funeral are waiting for them. Each of the children will have brewed beer, as this is an important occasion; after all, it is their own coming of age as independent persons, with their own sacrificial jar—in fact, their own father now residing in their home. Two days later Deli Mbeleve sacrifices on the new *melε* for the first time, called the *melε kapsa kwufurhu*, the hidden sacrifice, because one has to perform this ritual in strict privacy, very early in the morning, even without a smith present.[21]

A few days later, Mbeleve's widow visits the tomb for the first time, accompanied by a smith. She takes along another jar of *tε*, and at the tomb she tells her late husband that she was faithful to him but that this period has now ended. If she remarries, he should not begrudge her that. In principle she might remarry either a brother or a clan brother of her husband's— a levirate marriage. Or she might look for a new husband elsewhere, who will then have to pay a new bridewealth. Eventually, Mbeleve's wife will take a new husband.

SMELLING DEATH

Death is a matter of smell in Kapsiki. More than any other smith endeavor, the funeral is dominated by olfactory impressions, and the nose is the sense organ that structures the funeral proceedings. In fact, the funeral is one major reason why the anthropology of the senses is apt as a theme in this

book about crafts. The Kapsiki use smell as evidence that their social differentiation is based on a solid foundation—that is, smell is an argument for difference, carrying a particular weight inside their cultural discourse. And the relation to death adds considerable weight to that discourse. Their choice is not deodorization, but the use of odor to structure society. With its evocative powers, smell is well suited to creating barriers between humans. Our Western culture has turned nonsmelling into a lucrative business: smelling like a rose, overcoming the odor of the body, and not smelling one's environment have become conditional for having a good life. We are far removed from Napoleon Bonaparte, who, when writing to his beloved Josephine as he was returning from Moscow, requested that she not wash herself for the next two weeks as he liked the smell of her body so much.[22] However, reading Süskind's masterpiece one understands.[23]

My first ritual in Kapsiki was a funeral, so I received my anthropological baptism during the most spectacular of all the Kapsiki rites. Looking back, I can still remember the intense excitement I felt at that time. I walked behind the smith who was carrying the corpse on his shoulders through the throng of dancing people, with the drums going full throttle and the shrill sounds of the *shila* flutes just audible above the din of the mourning masses and their songs of war. I had a great time. Participating in a strange and unknown ritual is exhilarating, and the burial with the dancing dead is an intoxicating one, a shot of adrenalin for an anthropologist: "This is the 'real' thing; now I am truly doing fieldwork; now I will be a 'real' anthropologist," I told myself. An anthropologist defines himself through the strangeness of his environment, appreciating he has ventured into a parallel universe. I was entering a different world, a virtual world in fact, where nothing was what it seemed, and where meanings floated around to be understood at a later stage.

Reflections and analysis come later, as the first experience of a strange ritual is more guttural and existential than reflective, especially such a captivating one. My first memory, thinking back, is the smell, that unmistakable sweetish smell of death, and I remember thinking that I could almost follow the smith and corpse with my eyes closed. In our culture of sanitized death, we hardly ever smell death; but it does have a distinct smell of its own, one that evokes instant recognition. It smelled strangely familiar, and I knew I was following a corpse, and one of some days old. Actually, the smell was not too bad, more an odor than a stench, and it became for me the odor of the other, the smell of the field, the smell of ritual. It is not an odor we have learned to abhor in our culture, more one to avoid, and as aforementioned I expected the Kapsiki not to mind too much either, being used to it. But to

my intense astonishment the opposite proved to be the case: they detest the smell of death. In the Kapsiki terms for odors we saw the notion of *ndalɛke*, the smell of the corpse, stand out as the most abhorrent of all their fourteen named smells. But then, if they loathe the smell of a three-day-old corpse so much, abhorring the gentle reek of death, why do they take so long to bury it? Having a separate group of undertakers, the smiths, solves part of this riddle, as they are the ones who bear the brunt of the malodorous burial practice. But still, why do they do it so late that a separate caste is needed, which in many respects is a rather costly social solution?

This was actually one of the few questions about ritual to which informants had a ready answer. Everyone has to see for himself that the deceased is really dead, they told me, and the only way to be really sure is to see him, see him on the shoulders of the smith, dressed in his finery, his eyes visible through the slits in the headdress, dancing on the shoulders of someone else. Then one knows, and then one can mourn, lament, dance, and pay appropriate homage. This lack of trust in the acceptance of death appeared to tie in with the general gist of this society, with its notions of privacy, autarchy, and self-sufficiency, and a general distrust of the other, a society that has long been splintering under the relentless pressures of slave raiding and war. In its large communal rituals, Kapsiki society tries to define itself as being fully harmonious, but as a counterpoint, as a ritual communitas,[24] not a factual description. Indeed, the notion of "see for yourself" does fit, but it is still couched in terms of the ritual itself: one sees the dead on the shoulders of the smith, dancing by proxy. Given the tensions between Kapsiki villages with their long history of internal strife, war, and tension owing to runaway marriages,[25] it is almost inevitable that the final Kapsiki ritual should last three days. In any case, it is the funeral itself, the dancing dead, that is the real expression of death. And thus, notwithstanding the abhorrence of *ndalɛke*, the smell of ritual is created, generating the need for smiths, rendering inevitable the realization that a loved one is being transformed into a loathsome smelly object through the very ritual that defines its new status, through the same ritual that directs mourning and makes the loss bearable. The dancing dead is the real dead, but also the dancing dead is really dead. And the nose knows for sure.

For Kapsiki smiths, this is the core of their existence, burying the dead. Here they bridge the fundamental contradictions of Kapsiki culture, making it possible for their fellow Kapsiki to "see" the body while abhorring its state. In a long historical process, the Kapsiki have generated an in-between echelon of people who, with their inferior social position, "pay the price" for this contradiction. Thus, the "internal others" have become

ambivalence incorporated, between the living and the dead, between seeing the corpse and not smelling it, and between the love for a kinsman and the loathing for a corpse. In performing this task, the masters of the grave do not escape the close association with the enemy itself, with death, with decay, and with the smell of the corpse—an association that accords well with the structure of their food taboos, as throughout they are almost identified with the end of existence. Their divinatory acumen, their prowess in healing, and even their performances in music for a large part depend on this intermediary position between life and death. I started out with the notion of the transformer, from "earth" to "metal," and from metal to tool, a transformation that must have stood at the basis of their special position, somewhere, at some time in the past. As intermediaries between life and death, they are transforming again, not metal but human beings, and not into productive tools but by a farewell that transforms the deceased kinsman into a lasting memory of greatness.

Music and the Silence of the Smith

THE "SILENT" ENTRY

On a recent visit to the Mandara Mountains, my youngest daughter came with us. I had often told her that an anthropologist tries to remain almost invisible, as he has to fit into the society without too much disruption; after all, the essence of participant observation is that the anthropologist looks at the people, not that all the people look at the anthropologist. "A fly-on-the-wall perspective," I explained her, "means that life in the village goes on as it always does, without influence from the observer, and people simply have to forget your presence." As a medical doctor her relationship with people is usually quite different, but of course she understood the notion of "noninvasive techniques." But coming into the village, smith Kwada, the son of Gwarda, immediately spotted me in the car and started running alongside, shouting: "Zra, Zra Kangacè!" (my Kapsiki name). So I had to stop and greet him. Immediately he took his guitar from his back and started playing, singing out loudly: "Zra Kangacè has come back; he has come back, Zra Kangacè." More people came along, and I had to walk slowly to my house with a whole retinue of Kapsiki, Kwada singing at full voice. At our compound, after all the greetings with the family of Sunu Luc, my assistant of long standing, my daughter wryly commented upon my "silent" entry, my being a "fly on the wall": "If that is a low-profile entry, I would like to see an advertised one."

Smiths in Kapsiki are—also—praise singers, musicians at the many occasions that call for music, ranging from funerals to initiation, from the year rituals to weddings. So after all the other senses, we finally arrive at the ear, the very sense that is so important in societies with oral traditions.[1]

Though not all music is produced by smiths, most of it is. The drums, central in Kapsiki musical experience as in almost any African group, are smiths' business, featuring in all the great rituals, while the string instruments are central in praise singing. Tubiana calls the Toubou or Béri smiths "les hommes sans voix,"[2] men without voice, and that is the paradox that leads this chapter: the craft of smiths is music and occasionally singing, yet they should be silent. Except, of course, when singing praises. They are crucial in the loud and noisy festivals, and no ritual is complete without their drumming and fluting, but—as we saw—without smiths, things would never quiet down either. In fact, they are not expected to speak; they should never really say anything in public. Thus, the smiths dominate the "soundscape" of the village, silent among the speakers, noisy among the dancers, always the accompaniment, never masters of the discourse. Theirs is the music, but not the *rhena za*, the speech of men.

The notion of soundscape I take from Karin Bijsterveld's analysis of how mechanical sounds have changed European cities, and this notion covers the various sounds in a given setting, along with their mix and dynamics.[3] In an African village, the main sounds are nonmechanical: human voices and animal sounds form the background of an occasional passing car or motorbike for those close to the road, and nowadays some *poste radios* and cell phone ring tones can be heard as well. This is during the "low times" of village life, the "default soundscape." What always surprises me is how much of that village soundscape, especially during the night, is dominated by domesticated animals, with the (very) early morning rooster and especially the braying of a donkey as absolute acoustic highpoints. Domestication has rendered these animals noisy, as their wild colleagues have to be much more silent, just for survival. Human society has greatly increased its "soundscape," first with domesticated animals, with tools and instruments—including musical ones—and now mechanical and amplified sound.[4] Existential security comes with noise. Here I want to concentrate upon the "high times" of the village, the soundscape of the feasts and festivals, at least upon all occasions that call for music and where the *rerhɛ* come into full acoustic force. But without speech.

THE SOUNDSCAPE OF DEATH

The funeral is where most of the sounds come together. The soundscape of a death begins with wailing women, and this is usually also what it

ends with. At the start of the first day some smiths come in, first with a drum, later with more drums and some flutes, and the proper wailing begins—drums, flutes, and voices, punctuated by the scraping sound of calabashes on the *livu*, the iron skirt of the deceased's daughter. On this first day, the plaintive songs of the bereaved dominate, the *nhwene male* (female mourning). The soundscape of the first night is just a softly sung complaint of the women, mourning their irreparable loss, accompanying themselves on their *livu*. The next day sees (hears) a gradual build-up of sound, when the village visitors gather around the house singing, wailing, and shouting when the men make their charges. Young smiths have come in from neighboring villages to play the *shila* flutes, more drummers are present, and the plaintive *nhwene male* gives way to the louder *nhwene za* (male mourning) on the dancing ground. The sound gradually builds up, reaching its peak when the smiths arrive with the dressed-up corpse: then all drums shift into second gear, dancers shriek, and women ululate, the most distinctive African sound of all. The frenzy slowly abates at the end of the afternoon, when the dancers leave and the smiths prepare the body for the night. The soundscape of the next day has the same format, but with a larger crowd and new mourning songs added: the *nhwene gela* (rock mourning), and in case of an old warrior, the *geza*, the song of war, the loudest of all songs, all men shouting at the top of their voice, the roar of their voices almost drowning the drums, which go at full throttle now. Again, at sunset, the voices disappear, the *livu* are put away, the *shila* stop, and the drums—at long last—fall silent. The burial itself is performed without any sound other than the human voice, that of the smith, who, on behalf of the deceased, takes a farewell from the bereaved living. The rest is silence.

Now for the instruments, the music itself. The Kapsiki know five drum types, of which the *dimu* is the main one and is always beaten; a funeral without *dimu* drums is unthinkable. A nonsmith, *melu*, will not be keen to touch such a drum, as it is the instrument of death, and the smiths flaunt their instrument and their prowess during the dances.

The *dimu* is not the only drum used at a funeral; one other is the *ŋwe*, and sometimes the small hourglass drum. A fourth one is the *tlewembere* (see figure 36), the only one played by a *melu* and closely associated with chieftaincy. In the village of Mogode there are only three of these. The first one rests in the house of the village chief and is beaten just by him, but only when someone of the chief's clan dies: this is the drum of the grand funeral occasions, of the great losses. The chef de canton, the Fulbeized district head, uses a second one each October 1 to call all Kapsiki to Mogode for the

Figure 36. Wanga, playing the *dimu* at a funeral, and the *tlewembere*

festival of independence. Finally, one clan in Mogode, the *sunukuvekwanyɛ*, has a third one, using it for similar occasions for their respected dead. This clan stems from Kila on the Nigerian side, where the *tlewembere* is more commonly used.

If a very old man has died, one with many children and considerable riches, the *ŋwe* is beaten, a slender, almost man-high upright-standing drum. The chief smith has to beat this one, assisted by a close and old kinsman. There is only one in the village, in the house of the chief smith, and it is used sparingly. Only a *mazererhɛ*, the real functioning chief smith, may make such a drum, and people fear it, comparing it to *beshɛŋu*, black magic, one reason also the chief smith is reticent about using it. It was played most recently during the funeral of Mbekewe, since he was the blacksmith in charge of the *gedla* ritual, but I saw it played only once during all my stays in Kapsiki.

> Another reason why this *ŋwe* remains hidden might be that it has been stolen from Kamale, some two generations ago. At least that is how one story goes. A smith who had just moved from Rufta to Mogode and who knew how to play a *ŋwe* saw one during a funeral in Kamale. He reported that to his Mogode host, someone from the *makwiyɛ* clan, and together they set up a plan to steal it. At the next funeral down at Kamale, the smith and a host of *makwiyɛ* men went down to dance; the smith played the *ŋwe*, walked a bit away with it, came back, ambled away, and came back again. The third time the unsuspecting Kamale smiths saw him stroll again they let him go, and he ran away, uphill to Mogode, the *makwiyɛ* men shielding his flight. In Mogode they gave the drum to the *makwajɛ* clan to keep—entrusting spoils of war to another group is a common strategy, as they cannot be reclaimed from the ones who took them—and since then the smith chiefs have had access to it.

I could not confirm this story in Kamale, but it highlights the importance of drums in general and the *ŋwe* in particular.

The instruments of mourning are by no means limited to drums. Flutes are also important. First the *shila*, already mentioned, the one flute that is "pure smith and pure funeral." The *shila* is difficult to play, as it has neither block nor reed, and the whistling tone has to be made by curling the tongue and blowing through the teeth when playing, the four holes on the *shila* allowing for a real melody. *Shila* players, young smiths usually operating in twosomes or threesomes, gather in considerable tip money during a funeral, as mourners appreciate their contribution.

There is always some flute blown at the funeral, but not always the *shila*. At the start of the rainy season, when the rains have just started or should have started, the *zevu* is blown, adding a characteristic pique to the sounds of mourning with its breathy sounds not unlike a pan flute. This rather simple instrument—whose name means "buttocks" or "anus"—is just an open piece of bamboo without knots or bored holes and is always played in groups. This is the only time the *melu* add a significant element to the soundscape, and it is an important one.

THE MELODY OF FLUTES

Flute playing is season bound. In principle the *zevu* playing season starts with the coming out of the boy initiates, during their *gwela* rites; when the boys join the girls singing at Rhwemetla, the *zevu* accompanies them. The first time the *zevu* play during a funeral is itself ritualized: in this particular funeral, the village chief stays home until the group of *zevu* players invites him to the mourning, playing the special tune of the *zevu ha* (the melody of the sorghum). He then joins them, and together they head for the home of the deceased. The *zevu* can be played from the first appearance of the tender sorghum sprouts until the crop is about a meter high. From then onward, the *shila* has to be played again at funerals. The main reason, the Kapsiki indicate, is that the *zevu* invite the wind to blow, and if the sorghum is taller it might be damaged by the strong winds that characterize the start of the rainy season, so when the red sorghum starts ripening, the *zevu* becomes taboo.

Zevu players are nonsmiths, organized into a loose association of players. Each man makes his own instrument, a hollow piece of bamboo usually, or any other hollow pipe, in six more or less standardized lengths. The largest one is played by the *zevu* chief, with five smaller types following him. Playing is just blowing over the open top, setting up a resonance that allows for one tone only per flute, indeed like a pan flute. Each player has only one *zevu*, and the melody and harmony come from the *zevu* players playing together and the serial character, larger and shorter *zevu* alternating. The smallest type is called *gaŋgalɛ*; then follow the *wawake*, *mahkena* ("third"), *wufana* ("fourth"), and finally the largest one, *gema*, with occasionally an even larger one, *share gema* ("who follows the *gema*"), the chief's one. The flutes 1, 3, 4, and 5 play the melody, while the *wawake* and the *share gema* improvise their tones through the melody line. The larger types are considered more

important, and the leader of the group is the only one who may play the *share gema*—and, in any case, without *gema* and *wufana* no singing is at all possible; the sound is just too shrill.

The *zevu* is not restricted to use at funerals and can be played at any festive occasion or just for fun. The *zevu* group, one per village, can play whenever they like during the season they are allowed, and usually they perform on markets days or other festive occasions. Drawing quite a crowd, they have their audience participate in singing the *cimu zevu, zevu* songs, alternating between the men and the women, using texts that leave little to the imagination:

M: I have no wife.
W: I want to make love.
M: Show me your house.
W: I can shut the door [of my room].
M: Take the stick and guard the donkey.
W: To whom have you given your daughter?
M: Better that I go to Garoua [look for other women].
W: Give me the cloth to wrap around my head [and I will oblige you].
M: I am something to boast about, girls.[5]

The *zevu* is probably among the oldest of Kapsiki musical instruments, if we are to judge by its ritual and symbolic preeminence: it is crucial in the rain ritual at *Shala*, the burial place of Hwempetla, Mogode's culture hero. The *zevu ta shala*, a special terracotta *zevu*, is buried inside the tomb of Hwempetla and used during the yearly rain rituals. Throughout, the association between *zevu* and rain is strong. During the rain ritual the old men blow the *zevu* and sing the *kwaftɛa magweɗa*: "Oh, real people from Mogode, I am thirsty, I am thirsty."[6] When during the early wet season a *kwaberhewuzha* is sung, the *zevu* are the ones to accompany the dances and songs. When during any season one of the *kaheɗi*, the old men who perform the village sacrifice, dies, a *kwaberhewuzha* is always held with *zevu* playing, and then this alternating song is sung not between teenagers but between adult men and women and consists of a complicated series of—not so subtle—insults.

W: There are the Fulbe, where should we go, children?
M: Those are the words of the women who command the men.
W: Did your stuff survive the wet season [his penis]?
M: It passed the wet season well, let us try it on you.

W: My father told me not to take someone with a rope around his loins [a poor man].

M: Last year you tricked me, will you do that this year as well?

W: He is a leopard with an armor [are you afraid of my husband?].

M: I have no answer for the daughter of that man.

W: There is too little *kwantereza* [a plant] to wash the youngster, you will suffer badly.

M: The snake must bite you when you dig for termites and you will die.

W: There is the man, the real chief.

M: Your cunt is like a hollow tree.

W: Your balls are like the *yisa* [grains].

M: You have twenty vaginas, like a rabbit.

W: Your knees are spilt repairing the road.

M: You drink no water, as you are making problems [with other women].

But at the end they become more flattering:

W: Where did you leave your horse, warrior?

M: At the tree near Meweli, the fig tree near Lakwa [the spring].

W: White man, did you fashion your teeth [that you sing this well]?

M: Do not praise me in front of these people [do it later].

Other flute types are important beyond the confines of the funeral, mainly flutes for the *melu*, with one for the *rerhɛ* only. The *dawelɛa*, made from the horn of a Thomson antelope, is mainly an instrument of war. This hollow horn, with one hole bored in the long side—thus producing two tones only—is for the *katsala*, the real warrior. After a successful battle the *dawelɛa* was sounded when the warriors came home from the battlefield; also when people wanted to protect their fields against the raiders, they walked around the field blowing this flute. At a funeral the son of a very brave deceased may sound the *dawelɛa* to urge the youngsters into the bush to gather *safa* and *haze*, and he may accompany the smith when he carries the corpse to the grave, whistling this minitrumpet.

A second type, *njireke*, not unlike the *zevu* but smaller and made from acacia branches, is an instrument for young boys during the last wet season before their initiation. Like the *zevu*, it consists of an open shaft, but the *njireke* has two to four holes drilled in the side. At the start of the boys' initiation, when the initiates are clothed in their new skin, the *njireke* may be played; a son can whistle it while accompanying his deceased father on his final flight to his grave on the shoulders of a running smith, as can the

dawelɛa. At the closing of the market, after each funeral, and finally at the conclusion of the *gwela* initiation they play the elegant little flutes in small groups. Three types of *njireke* play together, the small *kwazhɛnekwarha* (1), the *mahkana* (2), and the largest one, the *zugwu* (3). Special songs for the *njireke* speak about stealing girls, a major preoccupation of the adolescent boys, and their song text is closely punctuated by the *njireke* flutes. An example:

(1) the old men is asleep now.
(2) I come into the house of your father.
(1) and the stick (2) of that man (3) I will take![7]

And so they go on, flutes 1 and 2 intoning the question, flute 3 accompanying the answer, and in the text the singers not only take the stick but also the knife, the spear, and the bow of the man, ending with a phrase indicating that the man has lost his daughter.[8] The market is an auspicious day to go for a girl, but so too is the last day of a funeral, of an old person at least. Other Mogode clans sing songs of war and peace, the issues of the past: "Let us go down under the roof, I will risk the war with the stick, I will risk the war with the quiver, peace is now in Dleru [a ward], Children of Kasunu Kuve Kwanyè, go down under the roof."[9]

The last type of flute is the *vuŋ*, a large antelope horn with one hole so more of a trumpet in fact, which is open for anyone to blow at any dance, but is becoming rare these days.[10]

OF SONGS AND SECRETARIES

One major yearly ritual complex combines marriage, initiation, and harvest rituals, the large initiation rituals of the Kapsiki. We saw smiths feature also in these rituals but not dominantly so; their material products are at least as important as their music. Still, all of the three major ritual complexes (marriage, initiation, and harvest ritual) are concluded by large feasts, and no feast is complete without the music of the smiths. In the first part of the marriage rituals, smiths are present only at the more public performances, accompanying the groom's party, which calls on the bride—playing their violin or guitar, lauding the groom, and extolling his riches and especially his generosity.

Only one instance of drum use is fully ritual, and that concerns a

fourth drum type, the *deŋwu*, a small hourglass drum. Only one person can play this drum "officially," the chief smith. The absolute high point of the initiation proceedings, the very moment that all previous rituals lead up to, and the moment that gives the initiation its proper name is characterized by this little hourglass drum. At the start of the *la* festivities, we saw the *gwela* initiates go through a little river, accompanied by an older brother and following the chief smith. Beating this *deŋwu* drum, the chief smith leads the way through the small brook. Then the boy is truly initiated, and with the smith he waits until all his peers have performed the same "test."

In all other parts of the rites of passage, the role of the smith is in fact just the music. To add luster to the occasion, they play their *dimu* drums, guitars, and violins. When the brides of the year sing together at the mountainside, a crucial part of the *la* festival of the village, the smiths roam the admiring crowd, singing praise wherever they spot a prospective client. During the same *la* rites, when the new grooms have their own night of dancing, the smiths turn out in full force; the next day they accompany the brides, who transfer their large and very visible trousseau to their husband's house.

The wedding itself, the *verhe makwa* that falls in April just before the boys' initiation, shows one other, quite curious, feature of smith work during festivals, that of master of ceremonies. A new custom was introduced in the Kapsiki villages in the early 1970s called *hirdε*, a ceremony of gift-giving at a wedding, aimed at helping the groom with the large costs of the wedding. At the *hirdε* (a Hausa term), friends and clients clothed in their festive best gather in the afternoon in the groom's compound and conspicuously present money to the groom. Here a smith acts as speaker. Each gift of money is widely acknowledged, with the speaker, the smith, greatly exaggerating the amount given: cfa 1,000, for example, becomes cfa 5,000. This custom, according to my informants, came from the Hausa in Nigeria.

In the late 1990s, a new version of this custom, called *amalεa*, arrived on the wedding scene. It is probably of the same origin (the word means "bride" in Hausa) but in any case came via the Nigerian Higi part of the Kapsiki area. In fact, the custom as such was already known in the 1960s among the Fulbe in the area, under a different name; conspicuous giving is very much a part of urban Muslim life. In the *amalεa*, the original *hirdε* has grown into a full-blown festival. The first evening is called the *kwana aŋgo* (in Hausa, spend the night), a dance to announce the *amalεa*. A group of young smiths is hired with tuners and large speakers, a table, chairs, and lights that they set up inside a fenced-off dancing area. The groom's sister's sons will have made the arrangements, and they also need a few "secretaries"

to note the gifts of money and food or drink, some organizers to keep out the uninvited, and a smith with a flute to direct the proceedings. The players are paid by the dancers with gifts of money and food.

This is just the warming up. The real *amalɛa* starts in the late afternoon of the next day, at the wedding proper. Two smiths with drums lead a procession of friends, the bride and groom, and some of the bride's friends, dancing slowly out of the house, their splendid gowns and dresses contrasting with their expressionless faces. On their arrival at the dancing area, chairs await them at the place of honor. The smiths return to the house to collect the groom's father and his friends, as well as the groom's mother and her retinue. When all have arrived, the smiths present the bride and groom in the first dance. The guests have arrived now and start giving money to the master of ceremonies with the microphone who is directing the session, while secretaries write down the amounts given. Unlike the *hirdɛ*, the exact amount is now written down, as this is an enterprise that should make money for the groom.

The role of the smiths is purely musical here. Usually a small group of young smiths performs the music, with a couple of drums and a guitar, but an electric one. Their main asset nowadays is the amplification, and they hire themselves out with their installation. Curiously, often one of them wears a *livu*, adding the very traditional sound of scraping on the iron skirt to the more high-tech music production. In any case, it is a lucrative business, and they earn between cfa 20,000 and cfa 40,000 ($40–$80) for the two nights, plus their nightly fill of beer and—recently—whiskey.

The audience is divided into the usual groups in Kapsiki ceremonies: the groom's father with his friends, the groom's mother with her friends, and the same for the bride. The groom's kin make a collection with a dish, but most people prefer to give their contribution to the master of ceremonies to have the amount broadcast over the sound system. The bride's mother and her friends mainly give clothes to the bride. Not only do the different kin groups give as one, they also dance together, the groom's clan and his mother's clan, the bride's clan and her mother's clan. As usual, the village chief takes the microphone to warn anyone with evil intent that no provocation will be tolerated. Most of the money given is in nairas, as the Nigerian currency looks more generous than the Cameroonian cfa. The point is that cfa 25 is a coin while the equivalent in naira is a bank note of 5 naira (but during the *amalɛa* the rate changes in favor of the naira, due to its Nigerian heritage), which looks better. After this huge festival of conspicuous giving, the secretaries count the money, pay the smiths, and give them a few gifts, such as beer, a bottle of whiskey, a case of Castell beer,

and tobacco. On average, an evening like this can make a profit of some cfa 50,000 (about $100).[11]

Both *hirdɛ* and *amalɛa* are classic examples of conspicuous giving, a trend that is becoming more common in Kapsiki society. In the days before the *hirdɛ*, the groom was helped discreetly over the back of the wall, but the notion of *fege* (showing off) is becoming increasingly popular in present-day Kapsiki. For the smiths, this means a curious trajectory: the *hirdɛ* made them master of ceremonies, using the reputation of the smiths as irresponsible social nonpersons for a role bordering on the clownish. The *amalɛa* changed that, in a large part owing to modern technology. In the 1990s, new technologies began to dominate: the smith musicians now came with sound equipment, carrying large speaker-boxes, and their music is now the popular music of the area. The smiths are always at the forefront of technological developments, so they professionalized as musicians. The event has mushroomed into a two-night all-out feast, to which the whole "fine fleur" of the village is invited. Its main function is still a giving party, very conspicuous but now more businesslike: no joking or insults, just showing off and an exact recording of the gifts. The smith-announcer has been replaced by a serious secretarial staff, completely *melu*, and the main role now is for the speaker, a nonsmith master of ceremonies who has to be educated, and—a crucial element—has to have a telephone. Actually two phones, for two reasons. First, people who cannot attend might phone in to promise their gift (as in an auction); the emcee then announces that gift to the waiting throng, and everybody applauds. The second reason is that any telephone is also a calculator. The emcee also uses his telephone as a calculator, registering precisely, together with the secretarial staff, the amounts donated or promised. This double use of the phone has changed the ceremony drastically: the smiths are just musicians, and the whole atmosphere is utterly serious, leading up to a final calculation of cost and benefit. So, riding the wave of technological change as always, the smiths were put in the front first, to be marginalized later, in a move that highlights the limitations of their marginal status.

SONGS OF PRAISE

Smiths are the bards of Kapsiki society, and the stringed instruments feature prominently in this lucrative business. Of the four chordophones, the smiths play three types, one type being open to the *melu*. A violin with one string bears a name that is typically onomatopoeic, *rhɛdɛrhɛdɛ*, reminiscent of the

many ideophones in which the Kapsiki language is so very rich, like the terms for smell. This small violin is for the smiths to play, individually, at any occasion, though usually not during rituals, serving as background music or as accompaniment to some praise singing. The two-string guitar, *gagera*, though, is the main instrument for an aspiring young smith to earn some money at any social gathering, as the guitar is the instrument of choice in praise singing.

Kapsiki smiths are not the kind of professional bards one finds among the Fulbe, who have a clearly political function, lauding chiefs and upstart politicians, and who are indispensable in politics. Nor do they have the deep cultural capital of the Mande griots, who are in charge of an epos that functions as the founding myth of political history. In the Mandara Mountains there is no epos, nor are the myths in Kapsiki religion sung; in fact, they are never officially recited, just told by anyone interested, smith or nonsmith. So praise singing is just honoring someone with incidental praise, either as a new arrival, or an official, or for special deed or performance.

A major, and quite self-congratulatory, example here of praise singing features, I am afraid, the old syndrome of the anthropologist-as-a-hero. Our arrival in 2008 was such an occasion; but a larger one, with a much larger effect, occurred during the first half of my main fieldwork. A film team had come to the area, as the Kapsiki plateau is famous for its scenery. It was a joint French-Cameroonian endeavor, as I was later to learn. They came with a large crew during the harvest festivals of some villages and settled down in Mogode: cameramen, sound men, directors, translators, everyone down to the inevitable script girl. The chef de canton issued an order that all villages in the vicinity were to send a delegation to Mogode to be filmed, thus interrupting various traditional rituals. This should have alerted me to the semiofficial nature of the enterprise, but it was not until much later that I grew savvy on filming dynamics. A large crowd turned up, the Kapsiki having no problems with attending spectaculars. As I had included the influence of tourism in my research—and still do—and as it was "my village" anyway, I was at the front of the crowd. Speaking with the director about what he wanted to film, I remarked that it might have been more interesting to film the very festivals that they had now interrupted, as that would be more true to what actually happened here and now, and was also very photogenic—a typical anthropological remark, but in a helpful mode I thought. His answer was that he was more interested in *la poésie* than in actuality, and that was just what he shot. First the "cavalry" had to make charges—that is, the Fulbeized Kapsiki who make up the retinue of the chef de canton and live in the central Mogode ward. This was duly performed and presented a nice spectacle indeed.

Then the traditional culture was to be filmed, but how? There was not much of a script—just the girl—and it was decided that they would film traditional warfare in the Mandara Mountains. At least they knew where to film it, as a special point some 7 kilometers out of Mogode offered a spectacular view into Nigeria. So the many vehicles of the crew transported a host of "traditionals" out of town, and at the border promontory they had "to do war." How? The only notion was that they had to make some charges, so that was arranged. The "translator" from the capital spoke no Kapsiki at all, or Fulfulde either, so they had to rely on my assistant Sunu Luc to explain the set-up. And indeed, a troupe of festively dressed Kapsiki ran in the direction of Nigeria, brandishing sticks. They were so impressed by the proceedings that they ran quietly, without a sound, portraying the first silent warfare ever! One old man, Zra Fama, a friend of mine and the father of my assistant Jean Zra, was selected to shoot an arrow, and this produced, at least for me, a picture that should not be missed.

To the far right in figure 37 is Sunu Luc, well dressed up for the festival; to the left the crew, one member holding up a reflecting screen, and in between them, Fama is trying to look convincing, with a friend in the background. The rest of the Kapsiki crowd are off-camera. The sun was setting, so soon after the shoot the whole caravan was preparing to take off. But then, instead of correctly transporting their subjects back to the village, the cars went back almost empty. I was furious: they were leaving all these people behind, not

Figure 37. Film shoot in Kapsiki, 1972

bothering to fill their vans with the people they had put out in the bush. Of course, I told them so in no uncertain terms: after disrupting the festivals, and after using the people without any pay, at least they could take them back home! The answer of the Cameroonian crew member—whose only duty consisted in handling the clapper—was just as clear: "You are meddling into government business! You are tolerated here thanks to the Cameroonian government, who can get you out of the country within forty-eight hours!" He promised me that he would personally see me evicted from Cameroon. And yes, they left, cars empty, and all the Kapsiki had to walk home. So I filled up my own car with "my" "film stars," drove home, and returned for more, shuttling some five times until everybody was home again. And the clue to this long introduction: that night the smiths came to my house with their guitars, and with quite a few others. Settling in the porch, they started singing at the sound of their *gagera* and one violin:

Zra, we are happy, we are proud
Our government came here to film
They left us out in the wilds [*gamba*]
But you defended us
You brought us home
Now we will call you "*gwamena*" [government]
Because our government left us out
And you took us home.
You are now our *gwamena*.

Well, it was not that wild a place, actually, but they were impressed by my taking action in defiance of their "government," and of course I did not mind being praised. But I did have second thoughts. I had not realized that the shoot was that official, and I was worried: maybe I would have to move over the border for the rest of my research? So, after the praise singing I went to the hotel in Rumsiki where the crew stayed, to see whether amends had to be made. But the crew had fallen out among themselves; according to the Kapsiki, the Cameroonian had embezzled project funds and in the ensuing row my criticism was wiped from their memory. But not so with the smiths, who for a long time afterward called me "*gwamena Zra*"—and I too never forgot their praise singing. And I never saw the film.

Thus far we have seen two stringed instruments in action, the guitar and the violin. Two others remain: the harp (*gwelɛŋu*) and the banjo (*getsepele*).

These two may be used in praise singing, but usually these instruments are played just for praise singing, the harp by smiths, the *gwelɛŋu* by anyone, but often also by smiths. Reputedly the chief smith has or should have a special harp, a red one, *gwelɛŋu ha*, to play at very special occasions, such as the funeral of a chief. I have never seen the instrument, and few people seem to know of it. In present-day tourism the harp has become the icon of Kapsiki instruments, and small harps are often offered to tourists as "Harpe Kapsiki." One enterprising smith has used it as a basis to introduce a completely foreign element into Kapsiki culture, sculpting. Noticing that Westerners associate Africa with sculpture, he makes sculptured harps, and sells them from his stall in Rumsiki, the tourist hotspot.

I do think there is some room here for further aesthetic development, but it is characteristic that it is a smith who pursues new ways of making money, in the meantime introducing new cultural elements into Kapsiki society.

Playing an instrument—any instrument—is among the most essentially embodied activities of mankind, where cognitions, actions, memory, and talent intermingle into one bundle of bodily knowledge. All human cultures make music, and the appreciation of music seems to be well embedded in our genes. Music, ethereal sound as it may seem, is an embodied phenomenon, affecting our moods, behavior, and physical movement. Moving with the music, singing with the songs, gazing at the musicians—all these responses shout embodiment. One major theme in African folktales is the compulsion to dance whenever there is music, either drums or songs, a compulsion that in the tales of the Kapsiki often saves a young heroine. In one story, a woman fleeing from an oppressive nonhuman spouse detracts her pursuers by singing from a tree, and as long as she sings they have to dance, forced to move by the tones of her voice. Usually in Kapsiki tales, she then defecates from fear, and her shit keeps on singing so the damsel in distress can escape. Of course, the poop only sings when warm, but that gives her enough of a head start to arrive home in one piece.[12] Here the embodiment of music is complete.

Music has to be learned, and all musical instruments are stubborn arenas for drawn-out periods of apprenticeship, in which practice, criticism, and perseverance finally produce an enjoyable performance. Birthright as *rerhɛ* implies a predisposition to practice, and music for the young smiths is a popular craft to practice, as they have a reasonable array of instruments to choose from. Music is also a heavily judged arena, where the clients know exactly what they want and will not settle for anything less. So music is a means to differentiate between performers, a craft with

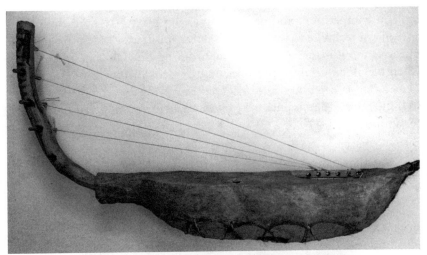

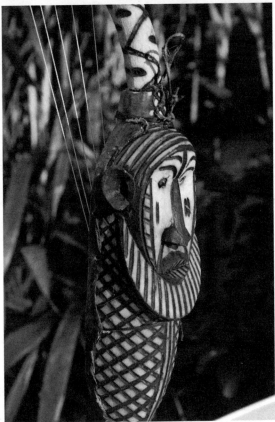

Figure 38. The classic and the new version of the harp

built-in competition, and people know who plays best, who sings best, and whom to invite to important functions. It is also a lucrative craft, as music is often made at liminal times, during funerals and other feasts, when people not only appreciate the indispensable music but also want to be seen as generous, and ostentatious giving to a smith who plays well enhances one's reputation. Investment in music practice pays off, for smiths.

THE SOUND OF SORGHUM

But music in Kapsiki is also a part of "dwelling," an aspect of the way they inhabit their landscape and carve out a living. Cultivation also has a sound-scape. In the period from February until May, the young boys aiming for initiation the next year blow their *njireke* flutes, especially when there is a funeral. They fete the fact that they are *dɛgwu*, *gwela*-to-be, singing, "If the rains do not come, at least I stay *dɛgwu*." They stop after the initiation itself, just before the new brides marry. After these initiation rituals, rain should fall, and the young brides are instructed not to walk over the fields once they have been sown in, lest the birds eat the grains.

Cultivation begins with the first rains, in early June, in absolute silence, at least from humans. This is a period of some tension, as the second rain may be too late, and the young sprouts may wither. If so, new sowing grains have to be planted; in any case, after June, rains become more dependable, but as the plants are still in the first tender phase of growing, not a sound is heard: no flutes, no singing, no guitar, and no violin. From the end of the *gwela* initiation, at the start of June, the *zevu* comes into force. At this time of the year the rains come with the wind, and that is exactly what the *zevu* provoke: wind. The young plants still easily bow with the rainstorms and are in need of water, so the *zevu* is welcome. From sowing time onward, no *kwaberhewuzha* may be held at a funeral, as that would also hinder the growing; the drums of the funeral may sound but should not wander from the house of the deceased, and a smith with a *dimu* should never cross a field with growing sorghum.

During this time a short dry spell may threaten the crops, some three weeks *rhele*, drought. Then the rites for the rain have to be performed, either "buying rain" or "hunting rain." The first option entails a sacrifice over the paraphernalia of a rainmaker and is done in silence, very discreetly, without any sound. The second way of procuring rain is a silent/boisterous affair,

not so much aimed at rain but at quelling the wind. It is a ritual hunt during which a host of men from the village visit a series of sacred spots of the village: some old houses of past rainmakers, a few special rocks with large clefts in them, and finally the burial place of Hwempetla, the culture hero of Mogode. Throughout, the *zevu* is present, accompanying the chanting "we are thirsty, we are thirsty" to convince the culture hero to plead with *shala* for more rain. The hunt itself is silent, of course, though not overly so, as bringing home animals is not the first priority.[13]

Mist during these months is a good sign, as then no *rhele* will set in. Mist is viewed as the rain that moves from west to east, as it should happen. Actually, Rain is a pair of gods, a husband with his wife, who as a couple are close to *shala*, and whom one should respect and fear, especially their "knife," lightning. It is the wind that forms the problem, as in the second half of the growing season winds no longer bring rain, but crush stalks. The ritual *berhe ba* aims at chasing away the epidemic or death (Death is another deity), and the pathway of chasing death follows, more or less, the direction of the wind. This ritual, in August, does feature drums and shouting, as the crops are large by now and are unlikely to be broken by storms.[14]

People watch very closely the development of the young ears in the sorghum, and when the first grains are discernible, or—as the Kapsiki define it—when the sorghum colors red, the *zevu* has to stop, usually in August. The women then take over, with a smaller version of the *zevu* called *fɛŋwa*, hollow reed stalks coming in two or three lengths. Each type of *fɛŋwa* has its proper name, with the largest one called *zugwu*, exactly like the *njireke* of the boys. The girls may flute during the next two or three weeks. At the end of August or beginning of September, the second weeding is done, and after that they also have to stop. Now the stalks have to ripen in silence again, and the main danger is no longer a lack of rain but an excess of wind. As the fields carry capital now, those men who have a *dawelɛa* will protect their fields against marauders and thieves by blowing this horn of a Thomson gazelle; in practice, only the real warriors-of-old have one, as it was used to signal a victory over the enemy. Sometimes a *vuŋ*, the large horn of a roan antelope, is sounded in the fields for the same reason, but this has become rare—both the horns and especially the antelope itself.

Harvest is a happy time—first the fast-growing sorghum varieties along with maize, then the staple of red and yellow sorghum. The season is fully dry now, in December, and the village resounds with the sounds of pounding, when in the many threshing places of the village, women thresh the ears with large wooden mallets. Threshing is women's work, their husbands standing at the side, proudly transporting the baskets home and filling the

granary. Now it is the husband who sings, loudly extolling his wives' work and diligence and taunting the lazy ones among his neighbors. In these months of the harvest, the yearly *la* rites are held, in a long series of festivals where neighboring villages hold their own *la* rituals in a fixed sequence. The large harvest feast focuses not so much on the crops; far more important is the harvest of people, as both the rituals for the crops and the rites of passage in Kapsiki are closely integrated. Thus ends the soundscape of sorghum in a huge feast, the noisiest of all, in a display of exuberance over another year well spent, well grown, well produced.

A final overview of the musical instruments indicates how the soundscape of the village is spread over *melu* and *rerhɛ*.

Drums are the instruments of passage, more than anything else, and smiths are important—even crucial—in these rites. After all is said and done, death is the prime passage in Kapsiki and is completely dominated by the

Overview of Kapsiki musical instruments							
Instruments	**Name**	**Burial**	**Dances**	**Initiation**	**Playing group**	**Played by**	**Remarks**
Drums	*dimu*	all	all		individual	*rerhɛ*	
	dɛŋwu			all	individual	*rerhɛ*	chief
	ŋwe	old men				*rerhɛ*	old
	tlewembere	old men				*melu*	chief
Flutes	*shila*	all			group	*rerhɛ*	young
	zevu	wet season	all		large group	*melu*	open access
	dawelɛa		some		2–3 persons	*melu*	hunt
	njirike		some		large group	*all*	rain
	vuŋ		some			*melu*	war
	feŋwa		some			*melu*	girls
Strings	*rhɛdɛrhɛdɛ*				individual	*rerhɛ*	praise
	gagera				individual	*rerhɛ*	praise
	gwelɛŋu				individual	*rerhɛ*	praise
	getsepele				individual	*rerhɛ*	praise

rerhε; the dead are drummed toward their next existence, just as the village mourns under the guidance of the smiths, in this way adapting to a new existence without the deceased. One flute, the *shila*, belongs to the drums—as already mentioned the most difficult and the most lucrative flute. For the other flutes, crop cultivation is a major arena, and here the *melu* take over, especially during the early growing season, with another category also, girls, as the musical caretakers of the tender sprouts. Dwelling is done by all, not particularly the smiths—and the male business of hunting is part of that dwelling, so predominantly for the *melu*. Stringing his guitar, violin, or harp, the smith finds a role as a bard, a role that suits him well; bards are the commentators of society, never society itself; bards never have power, but they laud, hail, and praise, thus underscoring the existing power configuration. As "children of the village," full of cunning but with little responsibility, they can sing what they want, simply because they cannot say what they want. They gain their livelihood by staying on the margin, and as long they can live with their powerlessness and with their muted silence,[15] they are the ones that enliven the Kapsiki soundscape with their performances, making a living for themselves while making life possible for all others.

The Smith and the Power of Things

THE PASSING OF THE SMITH

ZEME, AN OLD SMITH FROM SIR, WELL REMEMBERS THE COMING OF the first Roman Catholic missionaries to his native village, now (January 2012) about sixty years ago. He was a young boy at the time, and those *nasara* were looking for builders. With two *rerhɛ* friends he volunteered, finding that other smith boys had done the same. These missionaries started out building a small storehouse, and the project branched out into a dispensary, a house for the nuns and the mission station, and by then the *melu* came into the project as well. Zeme worked the whole project as a mason, learning the craft from six masons the fathers brought in from outside, and then stayed in the mission. Building was not finished by far, as the houses for the nuns, the chapel, and later the school followed. His family had a *gedla*, so with a smithy he was a blacksmith proper, and later learned brass casting from people from Guili, thanks to the missionary father who stimulated him to do so. As he was engaged with the mission since he was twelve years old, he never danced with the corpses; actually many of the smiths, who joined the mission in sizable numbers, did so. The school was important, he saw right away, and he sent all his children to school with the full support of his wife.

Their seven children all went to school, and did well. The oldest son finished the lycée, married a white woman, and now lives in Germany. His daughter Kwanyè as one of the first girls took full advantage of the education possibilities, and is now an ophthalmologist at the hospital in Mokolo. The next two are teachers, one in Sir, one in Mokolo. Number five has a tailor shop, and the others are good cultivators. Zeme is a content man, and

recognizes he has been lucky: the first ones to enter the mission all have done quite well. "When the *melu* saw that, they became jealous," he says, "and entered the schools as well." He never has seen his smith-hood as any barrier, though it still enters the situation of his children.

Early 2012: the first house I lived in in Mogode is being rebuilt by Izac, one of the sons of Timoti and Rebecca, my adopted Kapsiki parents. Izac is a successful businessman, and he has hired a group of *rerhɛ* from Rumsiki, smiths who have specialized in putting corrugated iron roofs on houses. They have learned their trade from the smiths of Sir first, and from the Lutheran mission at Mogode, later. Building has become a ready niche for the modern Kapsiki smiths: the government is rebuilding the road from Mogode to Sir (which has been cut off for the last fifteen years) with a solid drainage system. The chief mason of the project is a *rerhɛ*, from Kortchi.

So smiths have shown themselves eager to take on new crafts from early colonization, but not all of them still cherish their smith roots. During my first research period, 1972–73, I needed to develop my photos in the field. Sending the exposed negatives home was not an option, and anyway I wanted to see the pictures myself, but even more my informants wanted to see themselves: pictures are there to be given away, and for me handing out pictures was and still is a splendid bonding opportunity. So, during my first month in the field I scouted for a photographer in Mokolo and found one: Mousa Bale. He was recommended to me because he was Kapsiki (there is a Kapsiki ward in Mokolo), and Bale turned out to be a smith from Sir. He was a smith who no longer wanted to be *rerhɛ*, so when I reacted enthusiastically to his identity, he drew back and closed up. He explained to me that he did not like to be spoken about as a smith and that he had little contact with his family. He had Islamized, married an Islamized woman (yes, also a smith, a Mafa smith daughter), had shifted his food taboos, and now ate like a *melu* and drank like a Muslim. He had "left it behind," he told me. "Sanscritization" this process is called in India, trying to move up the caste ladder by adhering to the norms of the higher echelon. In North Cameroon it is called Fulbeization, as the city culture of the Fulbe is dominant.[1] His change in status, however, was clearer to himself than to his neighbors, who routinely referred to him as the smith from Sir. He was "passing" as Fulbe, but not very successfully yet.

Why did he choose photography and photo processing? His interest in cameras and later film processing had been kindled at the Catholic mission in Sir, and that was a new opportunity, a new niche using fascinating equipment. Usually, the road to riches in this part of Africa is through commerce, but being a *rerhɛ* is a serious obstacle to the kind of contacts and

networks a commercial entrepreneur has to rely on. But a technical job like a photo studio was an obvious niche for a "passing" smith. So Mousa used a new opportunity that fitted rather nicely into the array of smith specializations, and serviced the few photographers of Mokolo, and me. I could now see and hand out my pictures. He developed some of the pictures in this book. Yet in my repeated contacts with him I could not escape the impression of deep loneliness, for here was a man who had a respected job, a family, and nothing else: no people in his courtyard, no chitchat with neighbors, a classic case of someone betwixt and between. He was a *rerhε* no longer, but a *melu* by no means, and not yet a Fulbe by a long shot. At present almost all smiths of Kapsiki origin in Mokolo are Fulbeized.

The spectacular professional success of Zeme's daughter Kwanyè as a medical doctor does come with some inevitable social problems too: she is still unmarried, as no *melu* will take her as a bride, and there are no smith men with a comparable background. Yet modern Kapsiki women see her car as an important symbol of success that makes up for her lack of marriage and motherhood.

When Gwarda in his monologue to his son spoke about just this kind of smith, it was also with some sadness in his voice, considering them "lost"; and in a sense Gwarda was right: going against what is both a birthright and a "birthdoom" demands a heavy price, and starts with a severe sense of loss, loss of family and loss of social support. Kapsiki is a stratified society in which the ascribed status is very hard to shed. Fitting in, even in the lower ranking that smiths do have in Kapsiki, is easier than fighting the system. A young Kapsiki filmmaker is now producing a short feature film on the topic, but from a more romantic angle: boy *melu* falls in love with a smith girl—a ravishing beauty of course—and then the couple encounters huge problems on both sides of the family, plus the whole community. The theme is a well-trodden romantic path, which works well in European royalty marriages though much less, I think, in the setting of the Mandara Mountains; but it does illustrate the point. The echelon of the smith, as any castelike distinction, produces severe problems in the globalizing world of the cities. Also, in a village like Mogode with good connections to the outer world, more smiths are moving out, gradually renouncing their position as "internal others" in the wider society. Recently the chief smith of Mogode has asked some Nigerian *rerhε* to come to Mogode to fill the void, as the Higi smiths still are numerous, too numerous in fact to make a good living in their villages.[2] Mogode has a large core of Fulbeized Kapsiki, plus the Christian ones, and quite a few smiths have found a niche there: drumming for the chef de canton or in their church, they no longer engage in funerals.

Or, they just play the drums or *shila* flute, and do not carry the corpse. Some just cultivate and have desisted all smith crafts, and according to the *melu* these smith do cultivate a lot, more than anyone else.

The flipside of this combination of dependency and scarcity is that the smiths of today, in the eyes of the *melu*, become cocky, upstarts who do not know their place. "Formerly," said Sunu Luc, "one could give a smith anything you deemed sufficient for his services, and he could not complain. If he did not perform well, you could hit him. Now they set their own price, and have no *hawe* [shame]." His musing was elicited by the song of a smith boy in Rumsiki at the turn of the century. The young smith sang songs that were in principle just songs of the *la* festival, or so it seemed. But when transcribing the text, it became clear that he has taken quite some liberties, introducing a metacommentary on his own position:

> I will not drink water in this house
> Here are the people with the long necks [a sign of beauty]
> I am the real one, I am the leopard
> I am old enough to go to a woman without children
> I am in charge of myself

These lines are more or less standard, but only when sung by *melu*; the point is that this was a *rerhɛ* addressing a *melu* audience. This message settled, he went further:

> At night, the people here cannot get their penis straight
> When you bent over, what did you put in your vagina?
> I am from the family of the long ones
> People pay the vagina here, what did you find bald-headed one?
> I counted 700 clitoris inside the vagina

The sexual element, again, is customary, albeit quite blatant for Kapsiki norms, but the smith now turns all the tables. While the first part inverses the hierarchy of eating, the second one shatters the endogamy hierarchy. During his singing he played the clown as well, overacting his text and had people laugh, and that, typically, is the kind of cleverness that people expect of a smith. His was a performance with a lot of layers, which could still be fitted into the traditional relations, but in doing so one fact pops out, which is exactly that things have changed.

In this last chapter I will do two things. First, an overview of the Kapsiki *rerhɛ* as the internal other is due, to understand the combination of skills

the smiths engage in. Then we come back to the changes mentioned above, and sketch them as the outcome of long historic processes, so I close with a long-term view on the waxing and waning of the smith's crucial roles in the Mandara Mountain cultures throughout history, the "passing smith" in another sense of the term.

TRANSFORMATION, THINGS, AND EMBODIMENT

So, we turn again to the question that haunts most of the studies of smiths: why are people who are so important for society seemingly relegated to its margin?[3] And, related to this question: why are vital specializations concentrated in the hands of one group? In smiths' professions in general, genealogy joins with apprenticeship of skills and knowledge, and here the Kapsiki/Higi smiths exhibit their own particular variant on the common theme of African smithing: a separate group, surrounded by social prescriptions, proficient at a variety of special skills, that services the community from a marginalized situation. The Kapsiki/Higi variant is an exemplary case: with its sharp endogamy, revealing food taboos, evident notion of impurity, wide array of smith functions, and intricate interdependence of the smiths and the *melu* society, all showing the integrated distinctiveness of the smith.

In the descriptions, I focused on the embodied cognition that underlies any of the skills, irrespective of their combination and status. I used the cultural definition of the senses both as an expression of that embodied state and also as a means to highlight the existential challenges and appeals of the profession. But that does not explain the combination of skills or their cultural evaluation, so in the end the strange balance between the contribution smiths make to the society and their cultural definition as a group has to be dealt with from the point of view of the whole Kapsiki/Higi society, not just from the inherent qualities of the work itself.

Despite the many variants of the smith position in the Mandara Mountains—with or without endogamy, food taboos pollution, or underlying ideology—the overall relation to the society as a whole is remarkably stable. Smiths deliver essential services, furnish crucial tools, and provide essential relief in small-scale agricultural communities, from a position of inequality. The composition of that package of "deliverables" may differ

somewhat, but the essential contribution much less so. Patrick McNaughton mentions three processes that form a good starting point, and not only for his Mande: "Smiths facilitate, articulate and transform"[4]—three functions that Nicholas David and Judy Sterner subsume as "the full transformer type."[5] In fact, this is an example of what we as researchers try to formulate as the cultural logic of the pattern of smith skills inside their particular social niche. Let us see how this works out for the Kapsiki.

Higi/Kapsiki smiths are responsible for what I like to call the "thinginess" of human cultural existence. "Things" are not objects, Ingold insists[6]; a thing is crafted, used, and meaningful, an object lacks such a life. The blacksmith forges a hoe out of a tool blank, and that hoe will have a life of its own with its user, on the fields in cultivation, just lying in the compound, and occasionally coming back to the forge to be repaired or reshafted. When the anthropologist buys that old hoe and displays it on his living room wall, it becomes an object, with a nice patina from use, but no longer with a life. A craftsman makes things, our embodied existence relates to the world through things, and the smith is crucial for this "extended body," which is our thingy world. So things configure in the experience of our lived world.

The smith is a transformer, engineering an "embodied transformation" by things. Any analysis of the thinginess of the smith must begin with iron: the change from the gray earth to the spongy bloom and then to shining metal, if only cognitively, has to be the prime transformation that triggers the agglutination with other transformative functions. First: why are smelters and blacksmiths not simply the same people? The Kapsiki variant, with its smithing on the basis of smelting elsewhere, is not at all unique—in fact, almost typical. However, the fascination with smelting in the literature tends to obfuscate the distinction between smelter and smith. There are logistic and ecological reasons to specialize locally in iron production, such as available magnetite and adequate firewood. But that seems to hold for a limited time only, as vegetation runs out quickly with large-scale production,[7] and in any case, ecology may also lead to cultural logic. In the Kapsiki case, the notion of "tool" seems to be dominant. Smelting produces raw material, the spongy blooms that are then transformed into something useful: tools. So, while the production of basic materials, such as bloom (or food), is for everyone, the *rerhε* transform the raw material into survival tools, with the tool blanks of the *duburu* as an intermediate. Pottery also fits nicely into this cultural logic, as it also transforms basic material into very usable products. Brass is a newcomer in this area—though not in other parts of the continent—and, in an inversion of history, stresses social distinction over survival.

The centrality of iron in technology is mirrored by the central position of death in the passages of Kapsiki life. The transformer of things is the facilitator of social transformations; therefore, the larger the social transition, the larger the smiths' role. The *makwa* is transformed into a woman by his products and his gentle cicatrization; the *gwela* is first made into a man of the bush by brass, initiated into the hidden history of the village by a smith, and assisted on his final journey to manhood through the water by the *mazererhe*. But it is death that is the great passage in Kapsiki life, the real apogee of one's existence. Dancing on the shoulders of the smith, accompanied by the drums and flutes of the smith musicians, the deceased takes his final farewell in a feast of ultimate transformation: dressed in his full glory, he becomes the one he should have been. Then, when taken from that smith's shoulders he really dies, transforming into a "thing", and a smelly one at that, one that generates distance and distaste. This final transformation is facilitated by the smiths and almost by the smiths alone. Viewing the two transformations, one toward the iron tools for life, and the other toward the demise of personality, it becomes clear why iron is so absent in the funeral proceedings: the two transformations are antithetical, one sustaining life, the other ending it.

Most musical performances of the smith are part of the transformation

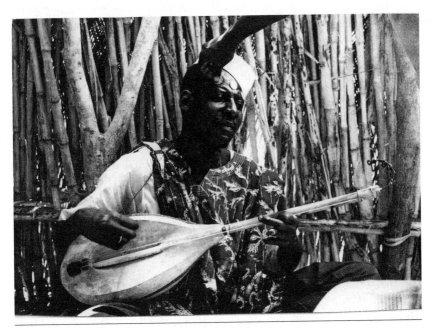

Figure 39. Teri Kwetèkwetè being rewarded for his singing

processes in the rites of passage. There is no major ritual without smith accompaniment, from the gentle tapping of the hourglass *deŋwu* when the *gwela* cross the rivulet, to the ferocious drumming of the *dimu* when the corpse appears in all its glory, the smiths dominate the soundscape of social transformation. Although they do operate in large numbers at funerals, smith musicians never form a real group. A few drums together try to regulate the dancing, and *shila* flutes may sustain each other in getting heard above the deafening roar of the dance, but this does not mean they form an ensemble. In contrast, the *zevu* players do form a kind of woodwind orchestra, and indeed they are not smiths but *melu*. They may perform at funerals, during a short part of the year cycle, and are part of the second part of the village sacrifice, but the *zevu* normally operate outside a ritual context, for fun, amusement, and some gain, enlivening the market or performing on official public holidays. Smiths, in principle, operate in small numbers, often alone. So it is predominantly the individual smith who fabricates things, produces knowledge, and renders services for the community of *melu*. The way the smiths are rooted in the social system reflects this: each of the smith families is attached to a different lineage or sublineage of *melu*, and the smiths as such remain more a category in the village than a proper group. Only when one of them dies they do come out in full numbers.

This seems to be one major axis of smith work: transforming raw material into life-supporting "things" and facilitating the transformation of living beings into things again, the focus on "thinginess" resonating well with the *rerhɛ*'s relative isolation in relational terms. A *melu* is identified through his relations first, a smith through the tools he makes for others. Kapsiki culture knows no sculpture, and unlike his Mande colleague, the Kapsiki smith lacks the articulation function McNaughton recognizes in the Mande case. Though aesthetics do enter in the form of a well-made thing, this type of evaluation is less dominant and does not deflect from its utility.

The other axis is skill and knowledge, combined with the notions of cleverness and insight, both in general and in one's relationship with "the other side" of the world. The Kapsiki have no *mana*-like concept (such as *nyama* in Mande), so no concept of impersonal supernatural power. Kapsiki know two kinds of power: *berete*, force, and *merhe*, masterhood. *Berete* is primarily the physical strength of a body—or machine—more or less its brute force. *Merhe* is entitlement to rule, the fact that a person enjoys the full rights of the position of social or political power he happens to occupy. The chief is a *ndemerhe*, the one entitled to chieftainship by the double virtue of being born in the *maze* clan and then elected as village chief by the appropriate clan elders. In fact, the chief is often addressed as *ndemerhe*,

the one rightfully ruling. A president of Cameroon has *merhe* as long as he is duly and rightfully elected; any usurper of a position does so by his *berete*, his personal—or military—force, but then he still has no *merhe*. Might makes not right, in Kapsiki, but *berete* does not have a pejorative ring: force is admired, as is *merhe*. *Berete* also has an economic association, as a rich man has economic *berete* through his wealth. Smiths have neither types of power and actually are outside this dichotomy, slightly reminiscent of Dumont's thesis of the separation of priest and king. Smiths are not considered rich— in fact, the wealth of Miyi the expert healer generated resentment: a smith on horseback, how incongruous!—and have no *merhe*, no "command," and no rightful rule over others. A blacksmith usually develops very strong arms and hands, but that is seldom mentioned by the *melu*.

As argued, the absence of a Psikye word for any form of mystic power is an indication that whatever power a smith has in Kapsiki culture should not be attributed to a presumed emic occult basis.[8] Instead, the power is in the things, in the configuration of *rerhε* crafts, and thus in the ambiguity of the smith position itself. That very ambiguity shows itself in another attribute: a smith has *ntsehwele*, cunning, intelligence, with the possibility of trickery. Anyone can have *ntsehwele*, but the smiths have the *merhe* of *ntsehwele*; they "command" it as their birthright and as their proper and appropriate arena. It is not an occult or supernatural knowledge; neither is there a discourse on secrecy around it; but it is the hidden dimension of everyday reality, hidden for *melu* but revealed to the smiths, who by descent have the ability to look behind things. This is the ideological component of the second axis of smithness: cleverness and deeper insight.

What about the relation of the smith to the other world? This also seems to be related to *ntsehwele*. In divination the smith converses with the crab, neither a supernatural being nor even a representative of *shala*, but simply an animal that "knows." And the smith knows how to talk to it, transforming its traces in the wet sand into something he "heard." Healing has similar dimensions: the healer has to "read" the client, translating visual signs into a deeper layer of messages, unraveling a hidden cause-and-effect sequence. This is not power, neither *berete* nor *merhe*, but this is *ntsehwele*, intelligence and cunning. Nature is stubborn and reclusive; illnesses hide themselves and have to be tricked out into the open; they are hidden "things" that can be found with the proper tools. For the smith this is a technique, a skill that he is not born with but to which he has an inborn access, a field to which he has right of entry. So, for the smith it is a question of technique, of skill, something to be learned by apprenticeship and natural ability. Others wanting to enter that field better have a special

ability, such as being clairvoyant, a faculty that is characteristically hidden to start with. I mentioned that in the traditional stories the ground squirrel, *meke*, is the hero, clever and cunning, but with a fierce little bite. That is the smith, and not by coincidence the main tool in the forge, the tongs, is called *meke* as well: the human *meke* wields a *meke* to fashion his tools.

One aspect of this axis is setting things right, reparation. Healing is for a large part setting things right by removing the problems of the past, with divination as a major tool for the construction of the relevant knowledge for this reparation. Knowledge for healing, as we saw, is a highly individual construct, the transmission not aimed at content but at the techniques for generating knowledge. This may not be smith "property," but it is smith "turf," into which others can venture, but the significant aspect here is that it is a technique of finding, a skill at construction, that is crucial. A healer needs *ntsehwele* to wring hidden information from a stubborn bush and then again to use it to set things right.

Part of the reparation is not somatic or "thingy," but social, and in this field too the smith finds his place. However, as this field is more sociopolitical and demands both *berete* and *merhe*, the position of the smith is different. No longer the owner of this field, but in a position of social marginality, he has fewer tools at his disposal in the settlement of *melu* disputes. In fact, he has some magic like *vutu*, but without his usual tools he just has himself to work with: he simply has to clap his hands, or sing his song, and be silent for the rest. Neither knowledge nor bodily skill, but just sound is required, the sound of his hands essentially. It is by defining himself as a nonperson that he can ease problems between "persons." He is always, inescapably, *rerhɛ*. Justice, for instance, is served by him in a nonpersonal way as well. When people go for *wuta*-revenge, he simply shows the way, but a nonsmith may perform the ritual; in curses, oaths, or collecting debt by *sekwa*, the smith may be a witness but again remains at the margin. The various special stones that enrich people or represent families are both purely relational and part of *merhe*, thus belonging to the chief of the village, or are direct, relations between a person and the "other" world mediated by untransformed objects: a stone for cows, a crystal for wealth. No need for a smith here, as there is neither a place for skill nor for knowledge. The stones and the crystal are not crafted, they are essentially objects, not proper "things". So in these endeavors, smiths are not in sight and in principle do not own these miracle objects, just as they can never be *mete* or *hweteru*, neither witch nor have the evil eye, since their *shinaŋkwe*, shadows, are always "normal," as they are marginal already in any case and not in a position to envy *melu* their things.

So, in contrast to Mande, the Kapsiki smith can be effective because he does not have power. But in his case it is not through a special relation with the occult that he has developed his tools or "means," but through a birthright to skills. That leaves open his role in ritual and magic. We saw that most of their input in Kapsiki religion is in rites of passage, gradually increasing their contribution toward the later phases in life: almost none in birth, significant in initiation of boys and girls, absolutely dominant in funeral. In the other types of rituals, the most important one being sacrifice, the smiths are either welcome or have just their share. In home sacrifices their presence is appreciated, as they are deemed to enhance the proceedings, but they can be left out, and in any case their presence is only possible at all by virtue of their being nonpersons. In ward and clan sacrifices, the same holds, but then if they are simply members of the clan or ward. The chief smith is crucial in the village sacrifice, but again as member of the village-family, and then as assistant to the main officiators. Here the smith has a minor facilitating role, as he is, as in the other collective sacrifices, mainly present and operating as a member of the group.

Magic is the normal flipside of the ritual coin, and indeed magic is smith turf, but not exclusively so. As we saw, medicine and magic are subsumed in Kapsiki under the one rubric of *rhwɛ*, means, but means in "thingy" terms, "stuff" to heal with. Others can gain access to this terrain as well, and often do, competing directly with the smiths with little or no handicap. In fact, those *melu* who do get proficient in magic gain extra renown by beating the *rerhɛ* at their forte. Black magic, *beshɛŋu*, is considered a thing apart, as it is always bad: unmitigated evil. In conversation, the line between *rhwɛ* and *beshɛŋu* is drawn with great precision, but we saw that all magic ritual—just as most healing—is tinged with ambivalence. For each kind of interference with the "normal" course of events, a price has to be paid, which calls for a chain of "means" needed to keep the negative stochastic sequence of events under control. So in practice, the line between *rhwɛ* and *beshɛŋu* is not so easy to draw. The point here is that *beshɛŋu* is also a thing to be learned, a skill one can acquire and a knowledge one can learn, whatever one's genealogical heritage. Smiths do have an initial advantage but not more than that, and only in making the "stuff" rather than actually using it. I never heard the name of a smith whispered in connection with *beshɛŋu* use; the hints always went in a *melu* direction. Again, however, the smiths furnish the tools, for whatever intention.

The efficacy of the magic is not so much a question of access to a "supernatural" source of power but to a more mundane field of knowledge and skills, mundane at least for the Kapsiki. Though much of the magic does

address "the other world," it is very much a mundane other world; a long time ago I dubbed Kapsiki magic "the religion of Monday," being practical ritual aimed at a concrete goal, yet ritual nevertheless. But with the dispersed reality of the Kapsiki "other world," people have about equal access to that world; it just depends on knowledge and personality. The evil magic, *beshɛŋu*, offers a good example of the human side of magic. The Kapsiki notion of the "other world" is shot through with ambivalence and ambiguity, exemplified by its central notion of god, *shala*.[9] *Rhwɛ* bears the same ambivalence, working in many directions, healing as well as dangerous and harmful. On the other hand, however, *beshɛŋu* is pure evil, too one-dimensional to fit into the fundamental ambivalence of the "other world." Black magic is too unambiguously evil to be, say, "supernatural"; it has to be human.

The humanness of the smiths' attributes and qualities does not render them less threatening at times. We saw during the funeral of the smith woman the collective of smiths exude quite a danger for the *melu*, producing a smith-only dance. In that funeral dance we saw the dancers vaunting their *rhwɛ* in the form of very visible "things," and thus express their smithness, their being perhaps marginal, but definitely an "internal other" with whom one has to reckon; after all, internal other does not mean irrelevant other. Nowhere in that funeral was any sign of inferiority or social submission, nowhere a despondent minority situation: this was a proud show of magical prowess through skill and knowledge, of the *merhe* of *ntsehwele*. But then this was a ritual with double liminality, a funeral first and a smith funeral second.

So here we have the two axes of smithness: one of transformation, and one of skills, knowledge, and cleverness. The linking of these two axes is through materiality, in two ways—both materiality of the body and materiality of things. I described the skills acquired by the smiths through the lens of the senses, as each of the special smith skills calls for special coordination between senses and the rest of the body. In embodied cognition, skill and knowledge, mentioned separately in the text, are effectively one and the same thing. This obviously holds for the technical skills such as forging or brass casting, and a fortiori for music, but the skills needed for divination, healing, and magic are for the Kapsiki not fundamentally different from what we consider the more technical skills. The point is one of personal integration: one does not have a skill, but one *is* the skill. The specialists are *rerhɛ*, to the very core of their essence: they are the internal others, "different people" (for the Marghi[10]) who, in everything they do and perform, continuously act out that difference. Wherever they are present, they are present as *rerhɛ*. By activating and instrumentalizing their birthright (or

birthdoom), they become what they cannot escape, embodied skills at the service of the community. When we speak about knowledge, it is always embodied knowledge that is meant; when we speak of skills, the head is also part of the hand. In all his transformative and reparative skills, the total persona of the smith is involved, not as a role player, not as an passing expert, but as embodied performer of skills crucial for the survival of the village and the future of society.

The second materiality is what I called the "thinginess" of the smith profession. The smith is the essential toolmaker, fabricating tools, even magical ones, he uses less than his *melu* clients do. The *melu* cultivate more, were more active in war, decorate themselves more, and need medication more often; their wives brew more beer—no *melu* will drink beer brewed by a *rerhɛ* woman—so need much more pottery. Service providers they are, the smiths, but thingy services. Divination operates through material objects; the crab shuffling around with tiny pieces of calabash furnishes the clearest example, but also both pebble and cowrie divination are quite material and technical, mainly manipulation of things. Even the *vutu* divination cannot be done without the relevant herbs. The *kwahɛ* technique is different, but also the soundscape of *kwahɛ* divination is with objects, tones in fact. There is no trance in Kapsiki divination, and diviners insist that anyone can learn it. Yet the specialization is dominated by the birthright of the smith first, and the ascribed birthright of the clairvoyant second. In any case, if there is more to it than technique and if its implementation has an intuitive side—I do think it has—its practitioners do not stress that side but in fact downplay it. Healing, magic, and certainly *beshɛŋu* are also done with things. The crucial term "*rhwɛ*" might best be translated as "stuff": objects, products, mixed plants, animal parts, and oils, whatever. Theirs is a thingy medication system. And the things the smiths use, they make themselves as they fabricate the tools they work with; when the "means to an end" are not man-made, such as the special stones, they are not smith business. Any work that does not lead to the end product of a tool, such as smelting, is open to anyone and not smith business. Being smith means producing embodied as well as materialized tools for others.

THE WAXING AND WANING OF THE KAPSIKI/HIGI SMITH

With this basic rationale of the smith in mind, that of "tools and transformation," we now take a long step backward and look at the deep history of

the smiths, such as the Kapsiki/Higi ones. With the cultural logic explored and the ecological niche clear, I want to glean some major historical trends in the smiths' contribution to human survival and reproduction of society. How old is this smith complex? After all, the idea that a "traditional" situation has been around for untold ages, has been long left by anthropology: smiths do have a history. Viewing the present state of our knowledge, some of this history is admittedly speculative, as indicated in the text by the wording, but some speculation might well be productive in furthering our understanding of the smith puzzle. At least, this is the picture as presents itself at this moment as the most probable.

Iron is old in Africa, and so it is in the area south of Lake Chad, but the population is even older. The prehistory of this part of Africa is gradually being unfolded and shows us a long occupation, one characterized by several trends and gradients. The longest occupation is in the plains, though evidence from palynology and food grains points to a quite old dwelling of the mountains.[11] Actual Neolithic remains are indeed found in the mountains but consist mainly just of flint axes that wind up among the ritual objects;[12] like other groups the Kapsiki do not acknowledge these as man-made objects (rain stones, they call them). And then, there are the stone grind mortars, those perennial objects that easily change function, stemming from late Neolithic times.[13] But all Neolithic artifacts are secondary, never in situ. MacEachern in his overviews stresses the relative absence of Neolithic sites (in contrast with artifacts) and the scarcity of early Iron Age sites in the Mandara Mountains, whereas Neolithic settlements are much more present in the plains. The archaeology of the area is still in development, but according to the most recent overviews,[14] this early occupation probably was very thin; any serious settlements in the Mandara itself date from much later. The foothills of the mountains became more populated between 750 BCE and 400 CE, settled by iron-using populations. For the production of iron the foothills are interesting, as the alluvial magnetite sands wash to the foot of the highlands and the inselbergs. The iron technology in the larger region dates from the last millennium BCE, and seems to have replaced the stone technology only gradually and piecemeal.[15]

Climatic variation in the area was considerable, but in general rains must have been more plentiful, game more abundant in a landscape with a substantial tree cover. War and especially slavery were threats of the distant future. After 400 CE, with diminishing moisture,[16] the hills became more attractive for settlement, both as a haven against external—and perhaps internal—enemies. The Mandara Mountains became the scene for dispersed iron production, but initially at very low population densities; the evidence

from the grind mortars points to a population a few percent of the present one.[17] Population density must have climbed slowly,[18] and the period between 400 and 1400 CE saw a gradual increase in settlement and agricultural intensification. It has been argued that for the Mountains to be really productive, intense agriculture is needed, because of the large-scale terracing that demands a huge labor input.[19] This holds for the northern Mandara more than for the southern part, but the archaeology of the latter part is still in its infancy. In the North people have lost the memory of making them and consider the major rock works as the work of giants, stemming from the beginning of time.[20] So these terraces seem to have been made in the deep history of the area, fanning out from isolated nuclear settlements.

Anyway, nucleated settlements are not overly old: "There is no firmly established evidence of occupation of the northern Mandara Mountains themselves until just less than one thousand years ago."[21] In fact, it is only after 1400 CE that the shift from the plains to the Mountains starts in earnest, and most of the remains date from that period, including the terracing. And with that date, 1400 CE, we are in historic times, in fact inside the realm of Kanem-Bornu, the rule of the Kanuri. Some pressure from that polity may have induced people to move into the Mountains, but the area was much more than just a refuge; the most spectacular remains, the DGB sites in the Mafa area, indicate significant populations around 800 years ago.

From an ecological point of view, there are good reasons to settle the Mandara Mountains with an early iron technology. This ancient volcanic area is quite fertile; the slopes and the plateau may not be overly easy to clear, but their soils are richer than the sandy plains, suitable for permanent cultivation based upon crop rotation. Rains are slightly more dependable in the Mountains, which also retain water better, and water can be found all over the plateau and slopes. The mountain slopes have to be terraced to be really profitable, but that work can be done in the slack season, and if properly kept up, is cumulative. The combination of cultivable slopes with a plateau open for both cultivation and cattle herding forms the typical situation of the Kapsiki plateau. So the Mountains are well suited for horticulture in nucleated settlements with a mixed husbandry.

This history is supplemented by linguistics. The greater Mandara area is an African Babel, counting some sixty-five languages, twenty-two in Nigeria, forty-three in Cameroon, belonging to four major families.[22] Linguistic research indicates a depth of separation between closely related languages of 500–700 years.[23] For the more distant language groups, mostly inside the Biu-Mandara group of the Chadic language family, this depth would have to be doubled. If the Mountains were thinly populated by Neolithic and

early Iron Age groups, and if gradually between 400 and 1400 CE Iron Age people moved first near the foothills, then into the Mountains themselves, then this linguistic diversification is plausible. Such a process could give some historical ground to the old religious relations between parts of the mountain area, such as the curious interdependency between Gudur, Sukur, and the adjoining groups. Throughout, Gudur has the stature elsewhere assumed by people claiming autochthony.[24]

Whether these immigrant groups were the direct ancestors of the present-day inhabitants of particular villages is difficult to say. In their oral traditions most groups trace their origin ultimately to outside the mountain confines.[25] But these points of migration departure are usually very close to the mountain perimeter, after which the groups have played "musical chairs" in the Mountains—to use an image evoked by Vincent. Some kernels of population have always lived in the Mountains, either forming their own ethnic group or lineage (some groups do claim autochthony in the Mountains), or blending in with newcomers in the area. In such a scenario, both linguistic diversity and political fragmentation fit well.

One indirect but compelling argument for old habitat exploitation in the larger area is the genetic diversity of domestic cattle. Nigeria and Cameroon count seventeen indigenous subspecies of cattle, usually subsumed by the FAO as "West African Shorthorn," a *Bos taurus*[26] variety. Although in total they comprise less than 1 percent of the bovine population (the large majority are the *Bos indicus* humped and long-horned variety), these varieties have considerable genetic importance. Many of them are highly resistant to sleeping sickness, and are also nutritionally well adapted to living in a poor environment. The Kapsiki have in their mountain area such a bovine variety, which is well integrated in their culture,[27] with a resistance to sleeping sickness that survives interbreeding with *Bos indicus*.[28] This genetic isolation indicates a long history of cattle breeding, though not necessarily confined to just the Mandara Mountains.[29] How long is difficult to guess, but among the Cameroonian Fali (south of the Kapsiki) and other areas, old traces of domestic cattle have been found, both Iron Age[30] and perhaps Neolithic.[31] The deep integration of cattle in some other mountain cultures, such as the Namchi and Dowayo, supports the argument.[32]

The history of the smith must have followed these general trends, and here we are on more speculative grounds. Iron products and, later, iron production must have reached the area halfway through the first millennium CE. At first, knives and hoes may have been imported; then gradually iron production arrived, possibly by smiths coming from elsewhere. If those smiths came from elsewhere, their separation from the *melu* was a given,

slowly giving way to a cultural integration. Traveling smith groups are still a feature of the African technological landscape, though much less so than in the past. This does not hold for smelting, just for smithing. Once these smiths settled, local people wanting to learn the trades must have associated with the newcomers, as iron production and smithing demand a long apprenticeship, being the most exacting of all preindustrial specializations. Agricultural implements form only a part of the total blacksmith output, and the initial social role of the "immigrants" probably was more purely technical than in later eras. Their ritual position could stem from two sources. First, they were strangers in a frontier situation,[33] and the notion of power coming from the outside is an easy one in Africa, especially when those powers are slightly hidden, such as we saw in divination, healing, and magic; therefore, they accrued symbolic power simply by being internal outsiders from the beginning. Second, the almost global association of iron with power forms a cultural logic that heightens the impact of the "powerful other."[34]

Cattle-keeping probably had little impact on metallurgy. First, cattle husbandry demands few metal implements. Second, in many societies smith and cattle are kept separate, smiths sometimes being prohibited from owning them—though not in Kapsiki, where smiths can own cattle but seldom do—as they are defined as the symbolic opposite of cattle.[35] Iron smelting we saw as a thing apart, more localized owing to iron ore and firewood availability, and more demanding in expertise and practice than smithing, and smelting is also more of a group enterprise. The Mandara metallurgical landscape probably only at a later stage came to be dominated by centralized production sites, such as Sukur. According to Nicholas David, when circumstances permitted, people first were self-sufficient in iron production, perhaps from the beginning of the second millennium CE, and local centers of iron production must have been scattered through the northern part of the mountain area. If so, Sukur's importance as a regional center of iron production is relatively recent, and may have been "facilitated by Sukur's advantages as a trading/marketing center in a situation where slaving made trade between mountains and planes generally difficult."[36] David reports the first settlement of Sukur from the late Neolithic, from grind mortars, and a steady increase in population ending in a massive iron production much later.

The second half of the second millennium CE, with its dryer climate,[37] probably brought more people into the area, given the lower ecological vulnerability of the Mountains. In any case, a dryer climate means a more diversified subsistence system, with more tools needed, and thus a larger

toolbox for agriculture. However, far more important for the position of the smiths has been the increased insecurity in the larger West African Sudanic belt. From the fourteenth century onward, first the Kanuri influence reached into the Mandara Mountains, followed by Baghuirmi and Wandala as local power nodes. Later centuries saw a series of Fulbe jihads sweep over the savanna, beginning in Futa Jallon and moving east until arriving in the early nineteenth century in Sokoto, Nigeria. For non-Islamic mountain populations such as the Kapsiki, the dominant strategy must have been to keep themselves, as Eric Wolf has called it, "out of history," avoiding the violent processes of state formation in the wider region. All Muslim emirates that have formed around the Chad basin have been based upon slave raiding and trading,[38] and both in the production of crops and as chattel, slaves have been of paramount economic importance. The European slave trading in the south was too far away to have exerted a direct influence, but indirectly it did exert an influence, as it deepened the view of human life as a commodity. So, during these centuries life became more precarious.

What was attractive for prehistoric populations became a necessity in times of war, when the hillsides became a refuge, and gradually the demographic density rose, up to the spectacular 100 square kilometers of the northern mountain area in the 1950s.[39] The habitat offers a good protection against mounted slave raiders, as the slopes and "massifs" form a fair defense against cavalry. The slopes the Higi, the Nigerian Kapsiki, live and cultivate on are long, steep, and studded with rocks and boulders, so they could mount an adequate defense over a long stretch of terrain, which enabled them to live close to their fields and crops—at least close to a considerable part of them. In addition, in the architecture of their houses they realized more possibilities for a spirited defense with high and thick walls; also in some narrow valleys they threw up earthen ramps against marauders. In many villages, people point out these defensive works with justifiable pride. Finally, drought-adapted vegetation, such as huge rows of Euphorbia or Agave, also offer a defense.[40]

The Mandara peoples defended against enemies from emirates both far and close to the Mountains.[41] The capitals of the Kanem/Bornu Empire were at a considerable distance but still within raiding radius. Somewhat closer was the Baghuirmi realm, at a few days' march,[42] but the smaller Wandala sultanate was a next-door neighbor, directly threatening the northern rim of the Mountains. In addition, this sultanate was either a fief of larger empires like Bornu and Sokoto or subjected by them, so often had to pay an additional tribute in slaves to the imperial centers. Sokoto, of course, was much farther away, in the distant northwest, in present-day Nigeria, but the

emirs of Adamawa, the easternmost Sokoto province, mounted their operations either from Yola or from Marua, close to the mountain fortresses.[43] Most of the captives were not sold in the region (although Mora and Madagali were important slave markets) but transported to the centers of the realm. From there they were redistributed, often to plantation settlements in order to produce food for the realm, or sold through trans-Saharan caravanning routes.[44] Thus, the raiders were not overly interested in having their captives bought back by the local population; in any case, if they wanted cattle (about the only currency for exchanging slaves), they captured them themselves. And they valued their own brand of cattle more than the indigenous one.

Denham, the first European to see the Mandara Mountains, mentioned that in the Wandala capital he saw a Kirdi[45] (pagan) tribe give 200 slaves to the sultan as a tribute in order to buy off a raid.[46] He estimated that a thousand slaves a year were captured in the hills and sold on the slave markets of Mora, the capital. The Wandala sultanate had built Mora as its third capital near the Mountains, under pressure from the Bornu emirate,[47] which has been the major political force in the area throughout this millennium. MacEachern rightly remarks that the large Arab-Kanuri expedition Denham was traveling with must have intensified reactions from both the Mandara and the mountain peoples concerned.[48] Buying off raids is not a phenomenon often recorded in other sources, and the Kapsiki/Higi vehemently deny ever having resorted to these despised tactics.

This threat of war, albeit not as intense as in the northern part of the Mountains,[49] plus the internal warfare that the Kapsiki knew at least from the early nineteenth century, must have increased the role of blacksmiths significantly. If caught by the Fulbe, they were usually more valuable as blacksmith than as commodity; however, their lower status meant that in some instances they may have been ransomed for other captives. For the villages, they were considered expendable to some extent—but then the *rerhe* group usually exceeded the number of blacksmiths needed. The most ferocious slave hunter, Hamman Yaji, nowhere in his diary mentions smiths, so this group might have managed to stay out of captivity for the main part. One reason is that they are not usually among the combatants in local skirmishes. The situation of Warre, in Thomas Hobbes's terms, on the whole must have made them much more important for the production of weaponry, such as lance points, arrow heads, throwing knives, and poison. Denham recounts how, during the Musfeia siege, the sound of hammering resounded through the night.[50] With a larger blacksmith output, more vital than ever, iron production centers such as Sukur have also increased their ritual esteem. Thus,

my—admittedly speculative—thesis is that the ritual elaboration of the *rerhɛ-melu* dichotomy came into full force during the eighteenth century. Also, brass technology came late to the Kapsiki area; this lost-wax technique was a late addition to the smith arsenal of specializations.[51] So, both the *gwela* initiation in its present form and the iron-brass opposition are not older than, say, two centuries, the whole war orientation of the initiation probably stemming from these slave-raiding times. The most spectacular iron implements probably also date from this period. Especially the defenders in the slave raids sported the most African of all weapons, the throwing knife. Although more a slashing weapon than a projectile, it was effective on foot.

So from the sixteenth century onward, the history of the Mandara area is a clash between, in Eric Wolf's terms, "history" and the "peoples without a history."[52] Like other mountain areas, the Mandara formed the violent frontier between quite sophisticated administrations and populations that did not want to become part of that administration. Early Europeans were more impressed by the slave raiders than they commiserated with the raided. When traveling through Baghuirmi (now Chad) in the years 1850–54, Barth recorded his deep astonishment in meeting an old blind Fulani who had read Plato and Aristotle, studied in Yemen and at the El Azhar university in Egypt, and was considered an expert in calculus. As Barth wrote:

> I could scarcely have expected to find in this out-of-the-way place a man not only versed in all branches of Arabic literature, but who had even read (nay possessed a manuscript of) those portions of Aristotle and Plato which had been translated into Arabic, and who possessed the most intimate knowledge of the lands he had visited.[53]

The German doctor, sounding out trade opportunities in West Africa, was impressed by the cosmopolitan character of the West African savanna states that hosted him. Traveling from emirate to emirate, from the Bornu court to the Fulani one in Sokoto, he was received as the emissary of a distant but equal, though infidel, suzerain. The general attitude of the African rulers to their European colleagues was one of mild condescension.

These sophisticated emirates resulted from the various "holy" wars, whose shock waves reached far into their periphery. Conditions in the Mandara Mountains, far from being a "pristine state of affairs" are the product of large-scale state formations, on the one hand, and reactive processes of local populations, on the other. So the pictures of a scholar like the one Barth

encountered and that of "naked anarchists of the hills"[54] present two sides of the same coin. All in all, the cultural position of the *rerhɛ* came into full force in turbulent times, when the demand for their technology as well as for their healing, divinatory, and magical prowess was at its peak. A powerful smith is the product of insecurity.

Colonial times changed the smith's position dramatically, for several

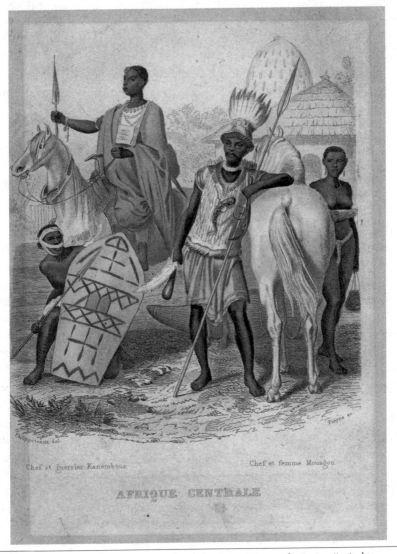

Figure 40. Ethnic differences in North Cameroon: Kanembu and Musgum (author's collection)

reasons. Curiously enough, it began with an increase in slave raiding, the "Hamman Yaji years" for these Mountains. Hamman Yaji was the most ferocious slave hunter of the period, whose diary has been preserved and published,[55] representing a short but explosive period of intense slave raiding.[56] The problem was that the European colonizers created first an administrative vacuum, as military conquest far preceded any administration proper. This was exacerbated by the constant change in colonial adherence of the region, between Germany, France, and Great Britain. Yaji was not the only one to benefit from this vacuum or from the way colonial rule was at first implemented:

> The colonial structures were hardly changed by the arrival of the German colonizer. The relations between the Habé (pagans) and the Fulbe remained that of vassals paying tribute to their feudal lords, with the addition that the European military might be put at the disposal of the institutional autochthonous authorities and so played into the hands of the Fulbe chiefs. In fact, these German officers relied on the lamibes; also, they tended to officially affirm Fulbe authority over the pagan groups which had rejected that authority and had kept themselves out of its rule throughout history.[57]

Crucial for the smith were changes in weaponry. Horses had been for centuries the main "means of destruction," in a mode of battle that was strongly associated with Islam in the region: the cavalry attack, against which a good defensive position, spears, and poisoned arrows could form a reasonable defense. The slightly skewed balance on the battlefield changed, however, with another military invention: the rifle. From the mid-nineteenth century, the trans-Saharan trade in horses had also meant a trade in front-loading muskets, both of course to be paid for in slaves. At first, the muskets did not upset the balance on the battlefield: Denham's story makes clear that these back-loading muskets were not yet a decisive force in the cavalry battles. Reyna, in his Baghuirmi history, mentions the scaring effect of the guns: "the dogs jumped from it."[58] But when the musket was replaced by the breech-loading rifle, this made a large difference. From that moment onward, the slaving battlefield was no longer even, and the supremacy of the slave raiders became absolute. The diary shows Hamman Yaji continuously busy with obtaining rifles and ammunition, and much of his raiding was aimed at getting exchange value for rifles. The blacksmiths in this region never learned to make their own muskets.[59] The reason is probably that their exposure to muskets was too brief; their first real "taste" of firearms were the rifles, with a complex firing construction that remained out of their reach.

With the second period, the pacification of the area, blacksmiths lost the crucial function of weapon-making, but the population increased and the market for agricultural and ritual objects bloomed. Thus, until the 1960s, iron production flourished, and so did the iron trade, as reports from Sukur testify.[60] After the 1960s, scrap iron from old cars rapidly replaced indigenous iron production, and the smelters lost their corner on the iron market. The blacksmiths in their smithies continued unabated, until from the 1980s externally produced iron tools, often coming from the cities, gradually pushed a lot of local products out of the market.[61] Enamel replaced pottery at the same time, while at the turn of the twenty-first century aluminum vessels and plastic containers started to dominate, all of them external products. So the blacksmiths held out longer than the smelters, and are still with us today.

In health and divination, the *rerhɛ* also lost part of their edge: health became a dual system, in which the dispensaries rose, hospitals appeared, and new healers developed their own corner of the healing market. Although the smiths held fast to this specialization, they lost their monopoly and were relegated to a more marginal role in the health field. The gradual Islamization of the Mandara Mountains meant a larger influence of general Fulbe culture.[62] In divination, this meant the fading out of the crab, in favor of cowrie divination. Those Kapsiki smiths that now live in Mokolo, Islamized as befits urban dwellers and trying to "pass," still practice divination, but only with cowries, considered the "more civilized way" (it is also difficult to get crabs in the city). Indigenous medication continues to be sought after, and some urban smiths continue to practice it, but this medication is mainly aimed at the "typical African" diseases. Healing has become a profession for the few, those who really go for it, and then their prices go up as well.

Kapsiki pottery has lost most of its place, to the point where most *rerhɛ* women in the city have stopped producing pots, and even in some Kapsiki villages, such as Mogode, Mafa smith women have come in to make pots. Kapsiki potters have difficulties competing with the Mafa smith women, whose production is considered more refined and varied. Although cooking is done with cast aluminum mainly, beer jars and eating bowls are still sought after from potters, but plastic is coming in rapidly.

Thus, the mainstay of smith work, more than ever from colonial times onward, are the funerals. However, Christian and Islamic funerals are much shorter and much simpler, and though the smiths retain their function as funeral directors, being the ones actually carrying the corpse and performing the burial, there is less to carry and less to dig. Nevertheless, the tainting

nature of the funeral still clings to them; food taboos still hold; endogamy is seldom infringed; and smiths are still the internal other, even if the Kapsiki need that other less and less.

So in the *longue durée* of Kapsiki and Higi history, the *rerhɛ* as a cultural topos, such as we saw it in the foregoing chapters, only relatively recently came into being, reminding us of the injunction that the Indian caste system is not nearly as old as people think, either. Iron technology with pottery came first, followed by the incremental nature of healing, divination, and the transformative powers of the smith in ritual, and capped by funeral directorship—all these slowly became more pronounced. The smiths must have kept accruing specializations as the centuries went by, the last one probably brass-casting, all based upon their "otherhood" and the cultural logic of being tool-making transformers. A background threat of slave raiding and war marked the heyday of the *rerhɛ* as pivotal members of the fragmented Kapsiki/Higi society, absolutely essential for survival in all aspects of life: getting food, protecting safety, and maintaining health as well as fair relations with the other world. Modern times ended much of the demand for their services, replacing many of their products and outdating their weapons, with new healing techniques shouldering them to the margin of the health market, rendering their divinatory techniques "uncivilized," and finally changing the format of the funeral.

The *rerhɛ* may be in the process of becoming part of history, but they are definitely still part of the present. Quick to learn new trades, some of them have seized the new opportunities of modern times; starting with the building of mission stations in the 1960s and 1970s, the smiths first dominated the missions' flocks and then once again were later dominated in numbers by the *melu*. My second opening example mentioned the smith-photographer who set up his studio in the city. Modernity, including change in religion, provides such smiths with the option to "Sanscritize," attempting to shed their castelike status and blend in with the majority of the population, at least in the cities;[63] but, as we saw, this is never an easy option, as they will retain vestiges of the *rerhɛ* status, the quintessential other, for generations to come. Stratified societies are very slow to forget their old social inequalities. But whatever their future, the smiths will remain active in searching for new opportunities, learning new skills even if they never regain the prominence they had in the bad old days, when the raids swept through the Mandara Mountains and smiths were the pivot of Kapsiki/Higi society.

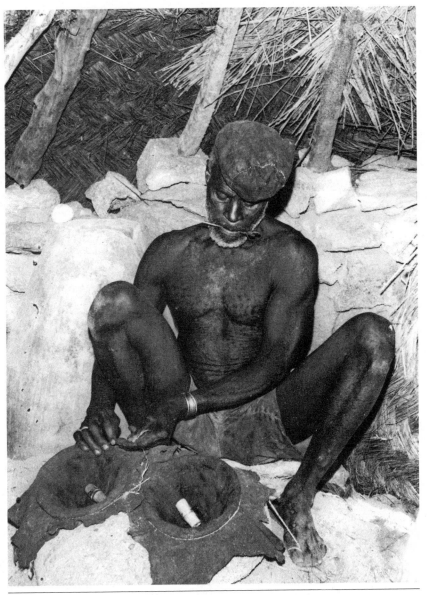

Figure 41. Cewuve fastening the bellows: the classic Kapsiki blacksmith

Notes

PREFACE

1. It is "inverted" because in science fiction time travel tales, the traveler does not age, while back home people do get older; fieldwork gives the reverse experience. Nigel Barley, *The Innocent Anthropologist: Notes from a Mud Hut* (London: British Museum, 1983).

2. Walter E. A. van Beek, *The Dancing Dead: Ritual and Religion among the Kapsiki/Higi of North Cameroon and Northeastern Nigeria* (New York: Oxford University Press, 2012).

3. Respectively, Walter E. A. van Beek, *Dancing Dead*; "Crab Divination among the Kapsiki of North Cameroon," in *Reviewing Reality Dynamics of African Divination*, eds. Phil Peek and Walter E. A. van Beek (Berlin: LIT Verlag, 2013), 185–210; "The Iron Bride: Blacksmith, Iron, and Femininity among the Kapsiki/Higi," in *Metals in Mandara Mountains Society and Culture*, ed. Nicholas David (Trenton, N.J.: Africa World Press, 2012), 285–301; "A Touch of Wildness: Brass and Brass Casting in Kapsiki," in David, *Metals in Mandara Mountains Society and Culture*, 303–23; "The Healer and His Phone: Medicinal Dynamics among the Kapsiki of North Cameroon," in *Mobile Phones: The New Talking Drums of Everyday Africa*, eds. Mirjam de Bruijn, Francis Nyamnyoh, and Inge Brinkman (Leiden: Langaa & African Studies Centre, 2009), 125–34; "Medicinal Knowledge and Healing Practices among the Kapsiki/Higi of Northern Cameroon and Northeastern Nigeria," in *Markets of Well-being: Navigating Health and Healing in Africa*, eds. Marleen Dekker and Rijk van Dijk (Leiden: Brill, 2011), 173–200.

LANGUAGE AND ORTHOGRAPHY

1. www.Ethnologue.com. I follow their spelling of Psikye and Kamwe.

CHAPTER 1. SMITH, SKILL, AND THE SENSES

1. Not all Kapsiki/Higi villages trace their descent from Gudur; those with a tradition of more Western origin, like some villages on the Nigerian side, do not participate in this ritual.
2. See Catherine Jouaux, "Gudur: Chefferie ou royaume?," *Cahiers d'Études Africaines* 114, no. 29-2 (1990): 193–224; Catherine Jouaux, "La chefferie de Gudur et sa politique expansioniste," in *Du politique à l'économique: Études historiques dans le bassin du lac Tchad*, ed. Jean Boutrais, vol 3. of *Actes du quatrième colloque Méga-Tchad* (Paris: ORSTOM, 1991), 193–224; Catherine Jouaux, "Premières et secondes obsèques en pays mofu-gudur: Symbolique et enjeux sociaux," in *Mort et rites funéraires dans le bassin du lac Tchad*, ed. Catherine Baroin, Daniel Barreteau, and Charlotte von Graffenried (Paris: ORSTOM, 1995), 115–36.
3. Eric Wolf, *Europe and the People without History* (Berkeley: University of California Press, 1982), 390–91.
4. Walter E. A. van Beek, *The Kapsiki of the Mandara Hills* (Prospect Heights, Ill.: Waveland Press, 1987), chapter 1.
5. The last "correction" of the international border between Nigeria and Cameroon occurred in 2006, shifting the border eastward, right through the village of Mogode, my research village.
6. See Language and Orthography in this volume; and Roger Morhlang, *Higi Phonology* (Zaria: Institute of Linguistics, 1981), 7.
7. Judy Sterner, *The Ways of the Mandara Mountains: A Comparative Regional Approach* (Köln: Rüdiger Köppe Verlag, 2003).
8. James H. Vaughan Jr., "The Religion and the World View of the Marghi," *Ethnology* 3, no. 4 (1964): 389–97.
9. Not to be confused with the Cameroonian Fali, near Garoua. See Jean-Gabriel Gauthier, *Les Fali de Ngoutchoumi, Hou et Tšalo: Montagnards du Nord-Cameroun. Vie matérielle, sociale et éléments culturels* (Oosterhout: Anthropological Publications, 1969). See for the neighboring groups: Renate Wente-Lukas, *Nicht-islamische Ethnien im Südlichen Tchadraum* (Wiesbaden: Franz Steiner Verlag, 1973).
10. Van Beek, *Kapsiki of the Mandara Hills*.

11. Walter E. A. van Beek, *The Dancing Dead: Ritual and Religion among the Kapsiki/Higi of North Cameroon and Northeastern Nigeria* (New York: Oxford University Press, 2012), 124–27.

12. Van Beek, *Kapsiki of the Mandara Hills.* Some villages, notably Rufta, have a slightly different kinship system, see Van Beek, *Dancing Dead,* 52.

13. Tim Ingold, *The Perception of the Environment: Essays on Livelihood, Dwelling and Skill* (London: Routledge, 2000), 296.

14. Tim Ingold, *Being Alive: Essays on Movement, Knowledge and Description* (London: Routledge, 2011), 9.

15. Raymond Gibbs Jr., *Embodiment and Cognitive Science* (Cambridge: Cambridge University Press, 2006), 120.

16. Lawrence Shapiro, *Embodied Cognition* (Abingdon: Routledge, 2011), 156.

17. Ingold, *Being Alive,* 86.

18. For instance, not only are we relatively accurate in judging the weight we see another person lift, but also our own corresponding brain areas are stimulated, as we watch, for the combination of that particular perception and action (Gibbs, *Embodiment and Cognitive Science,* 52).

19. Ibid., 59.

20. Andrew Lock and C. R. Peters, *Handbook of Human Symbolic Evolution* (Oxford: Clarendon, 1996), 133.

21. This is why anthropologists have increasingly taken the role of craft apprentice in order to bodily experience the buildup of skillful knowledge, often combining it with a general postmodern outlook of self-reflexivity, resulting in in-depth descriptions of the expertise systems into which they have been initiated. Some of these are highly cognitive, such as divination or healing systems (Jan Jansen, "Framing Divination: A Mande Divination Expert and the Occult Economy," *Africa* 79, no. 1 [2009]: 110–27); very few of them are as somatic as blacksmith's jobs (Patrick McNaughton, *The Mande Blacksmith: Knowledge, Power and Art in West Africa* [Bloomington: Indiana University Press, 1988]).

22. Which is not the same as an "object": a "thing" is used, lived with and has its own agency, while an object is isolated, beyond life: Tim Ingold, *Being Alive,* 23.

23. Kathryn Geurts, *Culture and the Senses: Bodily Ways of Knowing in an African Community* (Berkeley: University of Los Angeles Press, 2002).

24. For a general approach to cultural aspects of the senses, see David Howes, *Sensual Relations: Engaging the Senses in Culture and Social Theory* (Ann Arbor: University of Michigan Press, 2003); David Howes, "Hyperesthesia, or the Sensual Logic of Late Capitalism," in *Empire of the Senses: The Sensual Culture*

Reader, ed. David Howes (London: Sage, 2005), 134–55. The philosophical basis comes from Marcel Merleau-Ponty, *Phenomenology of Perception* (London: Routledge, 1962).

25. This wording supersedes, I hope, the debate between David Howes and Tim Ingold in the debate section of Social Anthropology (2011) 19, 3; the difference they discuss between "the world of sense" and "sensing the world" I see as two sides of our sensual embodiment.

26. Tim Ingold, "Introduction." In *Redrawing Anthropology: Material, Movement, Lines*, ed. Tim Ingold (Farnham: Ashgate, 2011), 8.

27. Walter E. A. van Beek, "The Dirty Smith: Smell as a Social Frontier among the Kapsiki/Higi of North Cameroon and Northeastern Nigeria." *Africa* 2, no. 1 (1992): 38–58; Walter E. A. van Beek, "Eyes on Top: Culture and the Weight of the Senses," in *Perception of the Invisible: Religion, Historical Semantics and the Role of Perceptive Verbs*, ed. Anne Storch, Special Volume of Sprache und Geschichte in Afrika, band 21 (Köln: Rüdiger Köppe Verlag, 2010), 245–70.

28. Robert Jütte, *A History of the Senses, from Antiquity to Cyberspace* (Cambridge: Polity Press, 2005); Van Beek, "Eyes on Top."

29. Ingold, *Perception of the Environment*, 314. However, he has moderated his standpoint recently, Ingold, *Being Alive*, 61.

30. Ibid., 153.

31. Ibid., 157.

32. See Paul Crowther, *Art and Embodiment: From Aesthetics to Self-Consciousness* (Oxford: Clarendon Press, 1993), 107.

33. Merleau-Ponty, *Phenomenology of Perception*, 24.

34. Ibid., 204; also, M. Patterson, *Senses of Touch: Haptics, Affects and Technologies* (Oxford: Berg, 2007), 51.

35. Cited in Patterson, *Senses of Touch*, 47.

36. Ingold, *Being Alive*, 57.

37. Steven Feld and Keith H. Basso, ed. *Senses of Place* (Sante Fe, N.Mex.: School of American Research Press, 1997).

38. Tim Ingold, *Lines, a Brief History* (London: Routledge 2007), 103.

39. Ingold, *Being Alive*, 11.

40. Ingold, *Lines*, 76.

CHAPTER 2. AN AFRICAN ENIGMA

1. For the Mandara Mountains, see the publications of Wade, Vincent, Podlevski, David, Sterner, and Genest. For Mande West Africa, see Patrick R. McNaughton,

The Mande Blacksmith: Knowledge, Power and Art in West Africa (Bloomington: Indiana University Press, 1988); for East Africa, see Georges Celis and Emmanuel Nzikobanyanka, *La métallurgie traditionelle au Burundi: Techniques et croyances* (Tervuren: Musée National de l'Afrique Central, 1976). For the Tuareg, a recent publication by Susan Rasmussen, *Neighbors, Strangers, Witches, and Culture-Heroes: Ritual Powers of Smith/Artisans in Tuareg Society and Beyond* (Lanham, Md.: University Press of America, 2013), highlights for their smiths similar processes, comparing the Tuareg with some other groups, including the Kapsiki.

2. Judy Sterner and Nicholas David, "Pots, Stones and Potsherds: Shrines in the Mandara Mountains (North Cameroon and Northeastern Nigeria)," in *Shrines in Africa: History, Politics and Society*, ed. Allan C. Dawson (Calgary: University of Calgary Press, 2009), 1–40; Renate Wente-Lukas, "Eisen und Schmied in Südlichen Tschadraum," *Paideuma* 18 (1972): 112–43; Nicholas David, "Introduction," in *Metals in Mandara Mountains Society and Culture*, ed. Nicholas David (Trenton, N.J.: Africa World Press, 2012), 3–26.

3. Jan Jansen, *The Griot's Craft: An Essay on Oral Tradition and Diplomacy* (Munich: LIT Verlag, 2000); Jan Jansen, *Les secrets du Manding: Les récits du sanctuaire Kamabolon de Kangaba (Mali)* (Leiden: CNWS University of Leiden, 2002).

4. In this my approach differs from that in Rasmussen, *Neighbors, Strangers, Witches, and Culture-Heroes*, where the notion of mystic "power" is central.

5. For the inherent complexities of West African alloys, see Eugenia W. Herbert, *Red Gold of Africa: Copper in Precolonial History and Culture* (Madison: University of Wisconsin Press, 1984), 92–100.

6. Eugenia W. Herbert, *Iron, Gender and Power: Rituals of Transformation in African Societies* (Bloomington: Indiana University Press, 1993), 93.

7. Nicholas David and Judy Sterner, "Smith and Society: Patterns of Articulation in the Northern Mandara Mountains," in David, *Metals in Mandara Mountains Society and Culture*, 87–113.

8. André-Michel Podlewski, *La dynamique des principales populations du Nord-Cameroun (entre Benoué et lac Chad)* (Paris: ORSTOM, 1966), 3–194; Serge Genest, *La transmission des connaissances chez les forgerons Mafa (Nord-Cameroun)* (Quebec: Université Laval, 1976).

9. Herbert, *Red Gold of Africa*.

10. Viz, Nicholas David, R. Heimann, D. Killick, and M. Wayman, "Between Bloomery and Blast Furnace: Mafa Iron Smelting in North-Cameroon," *African Archaeology Review* 7 (1989): 183–207.

11. In Africa, iron melting is done in so-called reduction furnaces, which cannot fully reach melting temperatures for iron (±1500° C), but reduce the ore to

a spongy mixture of iron, charcoal, and earth, called a bloom. Each different type of furnace produces its characteristic bloom. Bloom iron then is transformed into iron bars, the tool blanks, by continuous, long heating and hammering in the forges, work of the blacksmiths.

12. One problem with these early African dates is that in the period between 2350 and 2550 BP—that is, the middle of the first millennium BCE—the C14 dates have a calibration range of 300–400 calendar years, the C14 "black hole." David Killick, "What Do We Know about African Iron Working?" *Journal of African Archaeology* 2 (2004): 190. I thank David Killick for his comments on an earlier draft of this section.

13. Some posit both earlier and independent dates for Africa (Étienne Zangato and A. F. C. Holl, "On the Iron Front: New Evidence from North-Central Africa," *Journal of African Archaeology* 8, no. 1 [2010]: 7–23), but these claims are the topic of heated debates. On the whole, the Francophone tradition seems to be more inclined toward taking independent African invention seriously. Some are definitely in favor of the notion (Joseph-Marie Essomba, "Le fer dans le développement des sociétés traditionelles du Sud Cameroun," *West African Journal of Archaeology* 16 [1986]: 1–24; Joseph-Marie Essomba, "Les fondements archéologiques de l'histoire du Cameroun," *Rio dos Camaroes* 1 [2010]: 13–24; Danilo Grébénart, *Les origines de la métallurgie en Afrique Occidentale* [Paris: Éditions Errance, 1988]; Celis and Nzikobanyanka, *La métallurgie traditionelle au Burundi*). Others are very critical of it (Bernard Clist, "Vers une réduction des préjugés et la fonte des antagonismes: Un bilan de la métallurgie du fer en Afrique Sud-Saharienne," *Journal of African Archaeology* 10, no. 1 [2012]: 71–84). The Anglophone response is less outspoken but more skeptical, wait-and-see, pointing at the huge technological challenges of iron production (Killick, "What Do We Know about African Iron Working?"; David Killick and Thomas Fenn, "Archaeometallurgy: The Study of Preindustrial Mining and Metallurgy," *Annual Review of Anthropology* 41 [2012]: 559–75; Peter R. Schmidt, ed., *The Culture and Technology of African Iron Production* [Gainesville: University Press of Florida, 1996]). Anyway, the debate seems to have its low and high tides, as early dates tend to be followed by intense scrutiny and criticism, as Alpern notes (Stanley B. Alpern, "Did They or Didn't They Invent It?: Iron in Sub-Saharan Africa," *History in Africa* 32 [2005]: 81). At the moment we seem to be at an ebb, as the skeptics of independent invention seem to have the upper hand. Without a preceding tradition of cupreous metal production that is also linked in time to iron, the scientific community is unlikely to be convinced. Anyway, the debate has to be freed from its obvious political overtones to be academically mature.

14. Alpern, "Did They or Didn't They Invent It?," 86–87.

15. J. Woodhouse, "Iron in Africa: Metal from Nowhere," in *Transformations in Africa: Essays on Africa's Later Past,* ed. G. Connah (London: Leicester University Press, 1998), 160–85.

16. O_2, CO, and CO_2, in order to get a workable bloom: "iron working can only succeed only within a very narrow window of temperature and gas composition." Killick, "What Do We Know about African Iron Working?," 182, cited in Alpern, "Did They or Didn't They Invent It?," 82. See also Killick and Fenn, "Archaeometallurgy."

17. Alpern, "Did They or Didn't They Invent It?," 67.

18. Haaland estimates for the Darfur region, with a similar climate, that two volumes of ore need four volumes of charcoal to produce two volumes of bloom iron and two volumes of slag. Randi Haaland and Peter Shinnie, *African Iron Working—Ancient and Traditional* (Oslo: Norwegian University Press, 1985), 62. However, de Barros stresses that the efficiency of the various techniques differed greatly, even by as much as a factor of 40 (Philip de Barros, "Iron Metallurgy: Sociocultural Context," in *Ancient African Metallurgy: The Sociocultural Context*, ed. Michael S. Bissos et al. [New York: Altamira Press, 2000], 153). The exact magnitude of these differences is unclear.

19. Cornelis Notebaart, *Metallurgical Metaphors in the Hebrew Bible* (Bergambacht [Netherlands]: 2VM Publishers, 2010), 170–86.

20. Alpern, "Did They or Didn't They Invent It?," 78.

21. Ibid., 85. The variety in iron furnace types stands in curious contrast to the technique of lost-wax brass casting, in which almost no variety seems to be possible, but then early copper stages had no lost-wax casting yet.

22. Schmidt, *Culture and Technology of African Iron Production*, 45.

23. See A. Tuden and L. Plotnicov, "Introduction," in *Social Stratification in Africa*, ed. A. Tuden and L. Plotnicov (New York: Free Press, 1970), 1–29. For North Cameroon, see Oliver Langlois, "The Development of Endogamy among Smiths of the Mandara Mountains Eastern Piedmont: Myths, History and Material Evidence," in David, *Metals in Mandara: Mountains Society and Culture*, 226–55.

24. Walter E. A. van Beek, "Iron, Brass and Burial: The Kapsiki Smith and His Many Crafts." In *Forge et forgerons*, ed. Yves Monino (Paris: CNRS/ORSTOM, 1991) 281–310.

25. For example, among the Dogon of Mali, where the blacksmith is endogamous, but nonsmith women pot.

26. See Philip Peek and Walter E. A. van Beek, "Reality Reviewed: Dynamics of African Divination," in *Reviewing Reality: Dynamics of African Divination*, ed. Philip M. Peek and Walter E. A. van Beek (Berlin: LIT Verlag, 2013), 1–24.

27. Wente-Lukas, "Eisen und Schmied"; Guido Schmitz-Cliever, *Schmiede in Westafrika: Ihre soziale Stellung in traditionellen Gesellschaften* (Munich: Klaus Berner, 1979).

28. David and Sterner, "Smith and Society".

29. Gideon Sjoberg, *The Preindustrial City: Past and Present* (New York: Free Press, 1960), 187–88.

30. Anthony Black, *Guilds and State: European Political Thought from the Twelfth Century to the Present* (London: Methuen, 2005), 7.

31. Ibid.

32. The view on the purported technological stagnation in the guild system has changed considerably in the last decades; on closer inspection guilds have shown to be very adaptive to change, did stimulate new techniques, and were at the basis of artistic and technological developments. See S. R. Epstein and Maarten Prak, *Guilds, Innovation, and the European Economy, 1400–1800* (New York: Cambridge University Press, 2008); Richard Mackenney, *Tradesmen and Traders: The World of the Guilds in Venice and Europe, c. 1250–c. 1650* (London: Croon Helm, 1987).

33. Like after the French Revolution. Michael P. Fitzsimmons, *From Artesan to Worker: Guilds, the French State, and the Organization of Labor, 1776–1821* (New York: Cambridge University Press, 2010).

34. Consulting the list of Schmitz-Cliever, *Schmiede in Westafrika*.

35. Pierre De Maret, "Ceux qui jouent avec le feu: la place du forgeron en Afrique Centrale," *Africa* 50 (1980): 263–79.

36. McNaughton, *Mande Blacksmith*.

37. De Barros, "Iron Metallurgy." For North Cameroon Christian Seignobos proposes a protohistoric phase of smith-kings, basing this speculative theory on mythic material. Christian Seignobos, "Les Murgur ou l'identification par la forge (Nord-Cameroun)," in *Forge et forgerons*, ed. Yves Monino, vol. 1 of *Actes du quatrième colloque Méga-Tchad* (Paris: ORSTOM, 1988), 43–225; Christian Seignobos, "La forge et le pouvoir dans le bassin du lac Tchad ou du roi-forgeron au forgeron-fossoyeur," in Monino, *Forge et forgerons*, 383–84.

38. Roderick J. McIntosh, "The Pulse Model: Genesis and Accommodation of Specialization in the Middle Niger," *Journal of African History* 34 (1993): 181–220; Schmitz-Cliever, *Schmiede in Westafrika*.

39. This runs parallel with a distinction between unstratified and stratified societies. The Tuareg case is important here as well; see Rasmussen, *Neighbors, Strangers, Witches, and Culture-Heroes*, 130.

40. According to scholars on India, the term should be reserved for the Indian subcontinent; the word stems from the Portuguese *casta*: something not mixed. See also Judy Sterner and Nicholas David, "Gender and Caste in the

Mandara Highlands: Northeastern Nigeria and Northern Cameroon," *Ethnology* 30, no. 4 (1991): 355–69; Marie-José Tubiana, *Hommes sans Voix. Forgerons du nord-est du Tchad et de l'est du Niger* (Paris: Harmattan, 2008); Jean-Pierre Warnier, "Afterword: On Technologies of the Subject, Material Culture, Castes and Value," in David, *Metals in Mandara Mountains Society and Culture*, 328–45; James H. Wade, "Caste, Gender and Chieftaincy: A View from the Southern Mandaras," in *Man and the Lake: Proceedings of the 12th Mega Chad Conference*, ed. Catherine Baroin, Gisela Scheidensticker-Brikay, and K. Tijani (Maiduguri: Centre for Transsaharan Studies, 2005), 279–303. Rasmussen uses "smith/artisan"; Rasmussen, *Neighbors, Strangers, Witches, and Culture-Heroes*.

41. McNaughton, *Mande Blacksmith*, 165.

42. Schmitz-Cliever, *Schmiede in Westafrika*.

43. Dipandar Gupta, "Cattle and Politics: Identity over System," *Annual Review of Anthropology* 21 (2005): 409–27; Gerald D. Berreman, *Caste and Other Inequities: Essays on Inequality* (New Delhi: Folklore Institute, 1979); J. C. Heesterman, *The Inner Conflict of Tradition: Essays in Indian Ritual, Kingship and Society* (Chicago: University of Chicago Press, 1985). This paragraph has greatly benefited from a lengthy conversation with J. C. Heesterman.

44. Louis Dumont, *Homo Hierarchicus: The Caste System and Its Implications* (Chicago: University of Chicago Press, 1980).

45. See Declan Quigley, *The Interpretation of Caste* (Oxford: Oxford University Press, 1993). This, despite the fact that the conglomerate of religions from which Hinduism could be constructed, generates opposition to the caste system more often than providing a grounding for it. In the Rg Veda the "Laws of Manu" provide the first ideological charter for the *varna* system, yet almost all new religious movements in India rebel against it, despite the shared notion of transmigration of the soul, the presumed basic notion underlying it.

46. Louis Dumont, "History of Ideas," in *Social Stratification: Critical Concepts in Sociology*, Vol. 3, *Dimensions of Social Stratification I: Caste, Ethnicity and Gender*, ed. David Ingliss and John Bone (London: Routledge, 2006), 71–85.

47. Susan Baily, *The New Cambridge History of India, IV, 3. Caste, Society and Politics in India from the Eighteenth Century to the Modern Age* (Cambridge: Cambridge University Press, 1999), 25.

48. Mary Searle-Chatterjee and Ursula Sharma, eds., *Contextualising Caste: Post-Dumontian Approaches* (Oxford: Blackwell, 1994); Quigley, *Interpretation of Caste*. The anthropologists' fascination with the *jajmani* system—the patron-client relation between *jati*— reflects this integration.

49. Dumont, *Homo Hierarchicus*, 124.

50. Ibid.

51. De Barros, "Iron Metallurgy."

52. Ibid., 184–86.

53. The Tuareg case is apt here, as there the smith/artisan is mobile within a mobile society. Rasmussen uses the notion of the stranger as one of her analyzing tools; see *Neighbors, Strangers, Witches, and Culture-Heroes*. I choose the term "internal other" for the Kapsiki/Higi smiths, as their integration into village society seems to be much higher than in the Tuareg case.

54. Quigley, *Interpretation of Caste*.

55. Scott MacEachern, "Selling Iron for Their Shackles: Wandala-'Montagnard' Interactions in Northern Cameroon," *Journal of African History* 34 (1993): 260.

56. Dixon Denham, *Narrative of Travels and Discoveries in Northern and Central Africa in the Years 1822–1823* (London: Hackluyt, 1826), 195.

57. In principle, the Muslim emirate of Wandala or Mandara bears the same name as the mountain range where the Kapsiki/Higi live. For clarity, I use "Wandala" for the Muslim emirate and "Mandara" for the mountains.

58. Scott MacEachern, *Du Kunde Ethnogenesis in North Cameroon* (Calgary: University of Calgary, 1990), 91.

59. Paul Lovejoy, *Slavery, Commerce and Production in the Sokoto Caliphate of West Africa* (Trenton, N.J.: Africa World Press, 2005).

60. Ibid., 153ff.

61. Ibid., 117, 81ff.

62. Walter E. A. van Beek, "Slave Raiders and Their Peoples without History," in *History and Culture: Essays on the Work of Eric R. Wolf*, ed. Jon Abbink and Henk Vermeulen (Amsterdam: Het Spinhuis, 1992), 53–71.

63. James H. Vaughan Jr. and Anthony H. M. Kirk-Greene, eds., *The Diary of Hamman Yaji: Chronicle of a West African Muslim Ruler* (Bloomington: Indiana University Press, 1995); Walter E. A. van Beek, "Intensive Slave Raiding in the Colonial Interstice: Hamman Yaji and the Mandara Mountains (North Cameroon and North-Eastern Nigeria)." *Journal of African History* 53, no. 3 (2012): 301–23; Anthony H. M. Kirk-Greene, *Adamawa Past and Present: An Historical Approach to the Development of a Northern Cameroons Province* (London: IAI, 1969). If anything, the present Boko Haram scourge is remarkably recognizable; history seems to repeat itself in the Mandara Mountains.

64. Nicholas David, "Patterns of Slaving and Prey-Predator Interfaces in and around the Mandara Mountains (Nigeria and Cameroon)," *Africa* 84, no. 3 (2014): 371–97.

65. Orlando Patterson, "Slavery," in Ingliss and Bone, *Social Stratification* 3:136.

66. Lovejoy, *Slavery, Commerce and Production*, 355ff.

67. Walter E. A. van Beek and Sonja Avontuur, "Dynamics of Agriculture in the Mandara Mountains: The Case of the Kapsiki/Higi of Northern Cameroon and North-eastern Nigeria," in *Man and the Lake*, ed. Catharine Baroin, Gisela Seidensticker-Brikay, and K. Tijani, (Maiduguri: Maiduguri University Press, 2006), 335–82. For the Mofu-Diamaré, see Jeanne-Françoise Vincent, *Princes montagnards du Nord-Cameroun: Les Mofou-Diamaré et le pouvoir politique* (Paris: Harmattan, 1991).

68. David, "Patterns of Slaving."

69. On the slow death of collective inequality, see Lotte Pelckmans, *Travelling Hierarchies: Roads in and out of Slave Status in a Central Malian Fulbe Network* (Leiden: African Studies Centre, 2011).

70. Wente-Lukas, "Eisen und Schmied"; David and Sterner, "Smith and Society."

71. Genest, *Transmission des connaissances*; Paul Hinderling, *Die Mafa: Ethnographie eines Kirdi-Stammes in Nordkamerun*, Vol. 1, *Soziale und religiöse Strukturen*; Vol. 3, *Materialen* (Hanover: Verlag für Ethnologie, 1984); Podlewski, *Dynamique des principales populations*.

72. Though it never was a "kingdom" as described by Anthony H. M. Kirk-Greene, "The Kingdom of Sukur: A Northern Nigeria Ichabod," *Nigerian Field* 25 (1960): 67–96; the various publications of Nicholas David and Judy Sterner have made that absolutely clear.

73. Bernard Juillerat, *Les bases de l'organisation sociale chez les Mouktélé (Nord Cameroun)* (Paris: University of Paris, Mémoires de l'Institut de l'Ethnologie VIII, 1971).

74. Vincent, *Princes montagnards du Nord-Cameroun*.

75. Ibid.

76. Sterner and David, "Pots, Stones and Potsherds," 18.

77. James H. Vaughan Jr., "Eŋkyagu as Artists in Marghi Society," in *The Traditional Artist in African Societies*, ed. Warren L. d'Azevedo (Bloomington: Indiana University Press, 1973), 162–93.

78. Black, *Guilds and State*.

79. Such as the Dyerma; Schmitz-Cliever, *Schmiede in Westafrika*, 197.

80. James H. Wade, "The Wife of the Village: Understanding Caste in the Mandara Mountains," in David, *Metals in Mandara Mountains Society and Culture*, 257–84.

81. James H. Wade, "The Context of Adoption of Brass Technology in Northeastern Nigeria and Its Effects on the Elaboration of Culture," in *What's New? A Closer Look at the Process of Innovation*, ed. Sander E. van der Leeuw and Robin Torrence (London: Unwin, 1989), 225–244.

82. Scott MacEachern, "'Symbolic Reservoirs' and Inter-Group Relations: West African Examples," *African Archeological Review* 12 (1994): 205–24.

83. Vaughan and Kirk-Greene, *Diary of Hamman Yaji*.
84. Wente-Lukas, "Eisen und Schmied," 138ff., posits here several layers of historical combinations. I do not think this cultural historical theorizing is apt here, as all combinations do also exist at the same time and thus are easier interpreted as different responses to diverging historical contingencies.
85. Sterner and David, "Pots, Stones and Potsherds," 17.
86. Wente-Lukas, "Eisen und Schmied," 137.

CHAPTER 3. THE INTERNAL OTHER

1. M. G. Smith, "Secondary Marriages in Northern Nigeria," *Africa* 23 (1953): 298–323.
2. A large lizard of the family *Varanidæ*, found in Africa, Asia, and Australia; so called from supposedly giving warning of crocodile presence.
3. See Walter E. A. van Beek, *The Kapsiki of the Mandara Hills* (Prospect Heights, Ill.: Waveland Press, 1987).
4. See Walter E. A. van Beek, *The Dancing Dead: Ritual and Religion among the Kapsiki/Higi of North Cameroon and Northeastern Nigeria* (New York: Oxford University Press, 2012), chapter 10.
5. Walter E. A. van Beek, "Dynamic of Kapsiki/Higi Marriage Exchanges," in *Les échanges et la communication dans le bassin du lac Tchad*, ed. Sergio Baldi and Géraud Magrin, (Naples: Università degli studi di Napoli "L'Orientale," Studi Africanistici, Serie Ciado-Sudanese 6, 2014), 105–31.
6. James H. Vaughan Jr., "Eŋkyagu as Artists in Marghi Society," in *The Traditional Artist in African Societies*, ed. Warren L. d'Azevedo (Bloomington: Indiana University Press, 1973), 162–93; Judy Sterner, *The Ways of the Mandara Mountains: A Comparative Regional Approach* (Köln: Rüdiger Köppe Verlag, 2003).
7. Walter E. A. van Beek, *Bierbrouwers in de bergen: De Kapsiki en Higi van Noord-Kameroen en Noord-Oost Nigeria* (Utrecht: ICAU, 1978), 194–95.
8. For an extended treatment, see Walter E. A. van Beek, "Les Kapsiki," in *Contribution de la Recherche Ethnologique à l'histoire des Civilisations du Cameroun*, vol. 1, ed. Claude Tardits (Paris: ORSTOM, 1981), 113–19; Walter E. A. van Beek and Sonja Avontuur. "The Making of an Environment: Ecological History of the Kapsiki/Higi of North Cameroon and North-Eastern Nigeria," in *Beyond Territory and Scarcity in Africa: Exploring Conflicts over Natural Resource Management*, eds. Quentin Gausset, Michael Whyte, and Torben Birch-Thomsen (Copenhagen: Nordiska Afrika Institutet, 2005) 70–89.

9. Van Beek, "Les Kapsiki," 116–17.

10. Judy Sterner and Nicholas David, "Pots, Stones and Potsherds: Shrines in the Mandara Mountains (North Cameroon and Northeastern Nigeria)," in *Shrines in Africa: History, Politics and Society*, ed. Allan C. Dawson (Calgary: University of Calgary Press, 2009), 1–40.

11. Sterner, *Ways of the Mandara Mountains*.

12. Van Beek, *Dancing Dead*, 128 ff.

13. Gamache Kodji, *Le forgeron Kapsiki* (Yaoundé: Mémoires Université Yaoundé, 2009), 30.

14. Ibid., 50.

15. Serge Genest, *La transmission des connaissances chez les forgerons Mafa (Nord-Cameroun)* (Quebec: Université Laval, 1976).

16. Christian Seignobos, "La forge et le pouvoir dans le bassin du lac Tchad ou du roi-forgeron au forgeron-fossoyeur," in *Forge et forgerons*, ed. Yves Monino, vol. 1 of *Actes du quatrième colloque Méga-Tchad* (Paris: ORSTOM, 1988), 383–84.

17. Oliver Langlois, "The Development of Endogamy among Smiths of the Mandara Mountains Eastern Piedmont: Myths, History and Material Evidence," in *Metals in Mandara: Mountains Society and Culture*, ed. Nicholas David (Trenton, N.J.: Africa World Press, 2012), 226–55. He also focuses on "ancestralization," the role of the funeral, and thus of smiths, to procure the wherewithal of an ancestral cult. However, for the Kapsiki, this argument does not hold at all, as they have no ancestral cult. Smiths operating inside Muslim communities, like the Tuareg *inaden,* trace their mythical origin inside Muslim sacred history, through their patron prophet Dauda (David). Yet, in this completely different kind of mythical genealogy the noncombatant character of the smith/artisan remains intact (Susan Rasmussen, *Neighbors, Strangers, Witches, and Culture-Heroes: Ritual Powers of Smith/Artisans in Tuareg Society and Beyond* [Lanham: University Press of America, 2013], 33.)

18. James H. Wade, "The Wife of the Village: Understanding Caste in the Mandara Mountains," in David, *Metals in Mandara Mountains Society and Culture*, 265.

19. Kodji, *Le forgeron Kapsiki*, 43, 44.

20. André-Michel Podlewski, *Les forgerons Mafa: Description et évolution d'une groupe endogame* (Paris: ORSTOM, 1966).

21. Mary Douglas, *Purity and Danger* (London: Routledge, 1966).

22. Yasumaka Sekine, *Pollution, Untouchability and Harijans: A South Indian Ethnography* (Jaipur: Rawat Publications, 2011), 21.

23. Walter E. A. van Beek, "Les savoirs Kapsiki," in *La quête du savoir: Essais pour une anthropologie de l'éducation au Cameroun*, ed. Renaud Santerre and Céline Mercier-Tremblay (Montreal: Press Universitaire Laval, 1982), 195.

24. Like anywhere, this activity generates a series of euphemisms: in the 1980s it was *vatlekwendekwe*; today people use *dɛku*, to thread upon.

25. Walter E. A. van Beek and Henry Tourneux, eds., *Contes Kapsiki du Cameroun* (Paris: Karthala, 2014).

26. Walter E. A. van Beek, "Forever Liminal: Twins among the Kapsiki/Higi of North Cameroon and Northeastern Nigeria," in *Twins in African and Diaspora Cultures: Double Trouble or Twice Blessed*, ed. Philip M. Peek (Bloomington: Indiana University Press, 2011), 163–82.

27. Christian Duriez, *À la rencontre des Kapsiki du Nord-Cameroun: Regards d'un missionaire d'après Vatican II* (Paris: Karthala, 2002); Christian Duriez, *Zamane: Tradition et modernité dans la montagne du Nord-Cameroun* (Paris: Harmattan, 2009).

28. Louis Dumont, *Homo Hierarchicus: The Caste System and Its Implications* (Chicago: University of Chicago Press, 1980).

29. Walter E. A. van Beek, "Eating Like a Blacksmith: Symbols in Kapsiki Ethno-Zoology." In *Symbolic Anthropology in the Netherlands*, ed. P. E. de Josselin de Jong and Eric Schwimmer (The Hague: Nijhoff, 1982), 114–25.

30. Douglas, *Purity and Danger*.

31. Podlewski, *Les forgerons Mafa*.

32. Mafa smiths have the same prerogative, and even in times of internal warfare, the prerogative held that the Mafa smiths received the meat of the Fulbe horses that died in battle. Jeanne-Françoise Vincent, "Sur les traces du major Denham: le Nord-Cameroun il y a cent cinquante ans. Mandara, 'Kirdi' et Peul," *Cahiers d'Études Africaines* 72, no. 18-4 (1978): 575–606.

33. Cited in Constance Classen, David Howes, and Anthony Synnott, *Aroma: The Cultural History of Smell* (London: Routledge, 1994).

34. Paolo Camporesi, *The Anatomy of the Senses: Natural Symbols in Medieval and Early Modern Italy* (Cambridge: Polity Press, 1994), 107, 125.

35. Patrick Süskind, *Das Parfum, die Geschichte eines Mörders* (Zurich: Diogenes Verlag, 1985).

36. Classen, Howes, and Synnott, *Aroma*, 4.

37. Alain Corbin, *The Foul and the Fragrant: Odours and the French Social Imagination* (Leamington Spa: Berg, 1986).

38. Alain Corbin, *Time, Desire and Horror: Towards a History of the Senses* (Cambridge: Polity Press, 1995), 78.

39. Ibid., 150.

40. Uri Almagor, "The Cycle and Stagnation of Smells: Pastoralist-Fishermen Relationships in an East African Society," *Res* 13 (1987): 106–21; Uri Almagor, "Odours, and Private Language: Observations on the Phenomenology of Scent," *Human Studies* 13 (1990): 253–74.

41. Marguérite Dupire, "Des gouts et des odeurs: classifications et universaux," *l'Homme* 27, no. 4 (1981): 13.

42. Classen, Howes, and Synnott, *Aroma*, 103; see also David Howes, *The Varieties of Sensory Experience: A Sourcebook in the Anthropology of the Senses* (Toronto: University of Toronto Press, 1991), 139–40.

43. Roger Blench, "The Sensory World: Ideophones in Africa and Elsewhere," in *Perception of the Invisible: Religion, Historical Semantics and the Role of Perceptive Verbs*, ed. Anne Storch, Special Volume of Sprache und Geschichte in Afrika, band 21 (Köln: Rüdiger Köppe Verlag, 2010), 271–92.

44. A sorting test and a cognitive triad test.

45. For a detailed account see Van Beek, " 'Eating Like a Blacksmith': Symbols in Kapsiki Ethno-Zoology," 45–46.

CHAPTER 4. HOT IRON AND COOL POTS

1. My second fieldwork.

2. The word "*tsu*" has two meanings, dependent on tone. The grind mortar is *tsú* (high), while *tsù* (low) means bean.

3. Also the European hammers, with their square heads, are called *ndevele*.

4. Peter R. Schmidt, ed., *The Culture and Technology of African Iron Production* (Gainesville: University Press of Florida, 1996).

5. Robert L. Baker and Y. Zubeiro, "The Higis of Bazza Clan," *Nigeria* 47 (1955): 213–22; Charles K. Meek, *Tribal Studies in Northern Nigeria*, 2 vols. (London: Kegan Paul, Trench, Trubner, 1931).

6. Nicholas David and Judy Sterner, "Constructing a Historical Ethnography of Sukur (Adamawa State). Part I: Demystification," *Nigerian Heritage* 4 (1995): 11–33.

7. For a comparison with the other ethnic groups, see Ian G. Robertson "Hoes and Metal Templates in Northern Cameroon," in *An African Commitment: Papers in Honor of Peter Lewis Shinnie*, ed. Judy Sterner and Nicholas David (Calgary: University of Calgary Press, 1992), 231–40; Nicholas David, K. Gavua, A.S. MacEachern, and J. Sterner, "Ethnicity and Material Culture in North Cameroon," *Canadian Journal of Archaeology* 15 (1991): 171–77; Nicholas David and Ian G. Robertson, "Competition and Change in Two Traditional African Iron Industries," in *Metals in Mandara Mountains Society and Culture*, ed. Nicholas David (Trenton, N.J.: Africa World Press, 2012), 171–84.

8. Peter Westerdijk, *The African Throwing Knife: A Style Analysis* (Utrecht: OMI Press, 1988).

9. Walter E. A. van Beek, "Les Kapsiki et leurs bovins," in *Des taurins et des hommes, Cameroun, Nigéria*, ed. Christian Seignobos and Eric Thys (Paris: ORSTOM, 1998), 15–39.

10. Eugenia W. Herbert, *Iron, Gender and Power: Rituals of Transformation in African Societies* (Bloomington: Indiana University Press, 1993).

11. Adam Smith and Nicholas David, "The Production of Space and the House of Xidi Sukur," *Current Anthropology* 36, no. 3 (1995): 441–71; Nicholas David, "Mortuary Practices, Ideology and Society in the Central Mandara Highlands, North Cameroon," in *Mort et rites funéraires dans le bassin du lac Tchad*, ed. Catherine Baroin, Daniel Barreteau, and Charlotte von Graffenried (Paris: ORSTOM, 1995), 75–101; Nicholas David, "The Ethnoarchaeology and Field Archaeology of Grinding at Sukur, Adamawa State, Nigeria," *African Archaeological Review* 15, no. 1 (1998): 13–63; Nicholas David, "Lost in Third Hermeneutic? Theory and Methodology, Objects and Representations in the Ethnoarchaeology of African Metallurgy," *Mediterranean Archaeology* 14 (2001): 49–72.

12. Walter E. A. van Beek, *Bierbrouwers in de bergen: De Kapsiki en Higi van Noord-Kameroen en Noord-Oost Nigeria* (Utrecht: ICAU, 1978), 145.

13. Walter E. A. van Beek, *The Kapsiki of the Mandara Hills* (Prospect Heights, Ill.: Waveland Press, 1987).

14. Walter E. A. van Beek, "Les Savoirs Kapsiki," in *La quête du savoir: Essais pour une anthropologie de l'éducation au Cameroun*, ed. Renaud Santerre and Céline Mercier-Tremblay (Montreal: Press Universitaire Laval, 1982), 180–207.

15. Walter E. A. van Beek, "The Innocent Sorcerer: Coping with Evil in Two African Societies, Kapsiki and Dogon," in *Religion in Africa: Experience and Expression*, ed. Thomas D. Blakely, Walter E. A. van Beek, and Dennis L. Thomson (London: James Currey, 1994), 196–228.

16. David and Robertson, "Competition and Change"; Nicholas David, "Ricardo in the Mountains: Iron, Comparative Advantage, and Specialization," in *Metals in Mandara Mountains Society and Culture*, ed. N. David (Trenton, N.J.: Africa World Press, 2012), 115–70.

17. Walter E. A. van Beek, "Forever Liminal: Twins among the Kapsiki/Higi of North Cameroon and Northeastern Nigeria," in *Twins in African and Diaspora Cultures: Double Trouble or Twice Blessed*, ed. Philip M. Peek (Bloomington: Indiana University Press, 2011), 163–82.

18. For an analysis of the importance of the bull in wedding symbolism, see Van Beek, "Les Kapsiki et leurs bovins," 15–39. With their neighbors, the Mafa, the bull is central in the major ritual. Charlotte von Graffenried, *Das Jahr des Stieres: Ein Opferritual der Zulgo und Gemjek in Nordkamerun* (Freiburg: Studia Ethnographica Friburgensia 2, Freiburg Universitäts Verlag, 1984).

19. Walter E. A. van Beek, "Agency in Kapsiki Religion: A Comparative Approach," in *Strength beyond Structure: Social and Historical Trajectories of Agency in Africa*, ed. Mirjam de Bruijn, Rijk van Dijk, and Jan-Bart Gewald (Leiden: Brill, 2007), 114–43.

20. For the role of pots and their personalization in the larger area, see Nicholas David, Judy Sterner, and Kodzo Gavua, "Why Pots Are Decorated," *Current Anthropology* 29 (1988): 365–89; David et al., "Ethnicity and Material Culture in North Cameroon"; Judy Sterner and Nicholas David, "Pots, Stones and Potsherds: Shrines in the Mandara Mountains (North Cameroon and Northeastern Nigeria)," in *Shrines in Africa: History, Politics and Society*, ed. Allan C. Dawson (Calgary: University of Calgary Press, 2009), 1–40; Judy Sterner, "Sacred Pots and 'Symbolic Reservoirs' in the Mandara Highlands of Northern Cameroon," in Sterner and David, *African Commitment*, 171–79; and Gerhard Müller-Kosack, "Sakrale Töpfe der Mafa (Nordkamerun) und ihre kulträumliche Dimensionen," *Paideuma* 34 (1988): 91–118.

21. Walter E. A. van Beek, "Kapsiki Beer Dynamics," in *Ressources vivrières et choix alimentaires dans le bassin du lac Tchad*, ed. Christine Langlois, Éric Garine, and Olivier Langlois (Paris: IRD, 2005), 477–500.

22. Compare Gerhard Müller-Kosack, *The Way of the Beer: Ritual Re-enactment of History among the Mafa* (London: Mandaras Publishing, 2003).

CHAPTER 5. YELLOW WILDNESS

1. In an earlier publication (Walter E. A. van Beek, "A Touch of Wildness: Brass and Brass Casting in Kapsiki," in *Metals in Mandara Mountains Society and Culture*, ed. Nicholas David, [Trenton, N.J.: Africa World Press, 2012], 303–23) I used the name Teri, which is in principle correct—people have various names and this is a birth-order name—but his widows insisted I use Puku, a given name. For birth-order names in the area see Chantal Collard, "Les noms numéro chez les Guidar," *L'Homme* 11, no. 4 (1973): 91–95; Chantal Collard, *Organisation sociale des Guidar ou Baynawa* (Paris: EHESS 1977). For Kapsiki names, see Walter E. A. van Beek, *The Dancing Dead: Ritual and Religion among the Kapsiki/Higi of North Cameroon and Northeastern Nigeria* (New York: Oxford University Press, 2012), 302–3.

2. Brass is an alloy of copper and zinc. One of their bracelets I had tested contained about 75 percent copper and 20 percent zinc, with 5 percent other metals and impurities. Tourist brochures indeed mention *les bronzes Kapsiki*, but the alloy is always brass. Bronze, copper with tin, is not used in this part of Africa.

3. Cornelis Notebaart, *Metallurgical Metaphors in the Hebrew Bible* (Bergambacht [NL]: 2VM Publishers, 2010), 269, 344–45.

4. Van Beek, "Touch of Wildness."

5. Walter E. A. van Beek, "The Innocent Sorcerer: Coping with Evil in Two African Societies, Kapsiki and Dogon," in *Religion in Africa: Experience and Expression*, ed. Thomas D. Blakely, Walter E. A. van Beek, and Dennis L. Thomson (London: James Currey, 1994), 196–228.

6. Probably *Phoenix reclinata Jacq.*

7. For the founding myth featuring Hwempetla see Van Beek, *Dancing Dead*, 297-301.

8. Renate Wente-Lukas, *Die Materielle Kultur der Nicht-Islamischen Ethnien von Nordkamerun und Nordost Nigeria* (Wiesbaden: Franz Steiner Verlag, 1977), 286.

9. See also Renate Wente-Lukas, *Handbook of Ethnic Units in Nigeria*, Studien Zur Kulturkunde 74 (Wiesbaden: Franz Steiner Verlag, 1985).

10. See Walter E. A. van Beek, "African Tourist Encounters: Effects of Tourism in Two West-African Societies," *Africa* 73, no. 3 (2003): 251–89; Walter E. A. van Beek, "Approaching African Tourism: Paradigms and Paradoxes," in *African Alternatives*, ed. P. Chabal, U. Engel, and L. de Haan (Leiden: Brill, 2007), 145–72; Walter E. A. van Beek and Annette Schmidt, "African Dynamics of Cultural Tourism," in *African Hosts and Their Guests: Dynamics of Cultural Tourism in Africa*, ed. Walter E. A. van Beek and Annette Schmidt (Oxford: James Currey, 2012), 1–33.

11. Walter E. A. van Beek, *The Kapsiki of the Mandara Hills* (Prospect Heights, Ill.: Waveland Press, 1987); Van Beek, "Touch of Wildness." The situation among the Nigerian Fali seems to be more dynamic; see James H. Wade, "The Context of Adoption of Brass Technology in North-eastern Nigeria and Its Effects on the Elaboration of Culture," in *What's New? A Closer Look at the Process of Innovation*, ed. Sander E. van der Leeuw and Robin Torrence (London: Unwin, 1989), 225–44.

12. B. Jules-Rosette, *The Messages of Tourist Art: An African Semiotic System in Comparative Perspective* (New York: Plenum, 1984).

13. Akan and Senufo accounts testify to this preserving function (Till Förster, *Glänzend wie Gold: Gelbguss bei den Senufo, Elfenbeinküste* [Berlin: Reimer, 1986]; Till Förster, *Paroles de devin: La fonte à la cire perdue chez les Senufo de Cote d'Ivoire* [Paris: ADEIAO, 1988]; Christine Fox, "Asante Brass Casting," *African Arts* 19, no. 4 [1986]: 66–71; Christine Fox, *Asante Brass Casting: Lost Wax Casting of Goldweights, Ritual Vessels and Sculptures, with Handmade Equipment* [Los Angeles: African Studies Centre, UCLA, 1988]) mention the same tendency.

14. His stylistic array is quite different from the Kapsiki one, but in the Mandara Mountains stylistic variation on a small geographical scale is quite common; see Scott MacEachern, "Ethnicity and Stylistic Variation around Mayo Plata, Northern Cameroon," in *An African Commitment: Papers in Honor of Peter Lewis Shinnie*, ed. Judy A. Sterner and Nicholas David (Calgary: University of Calgary Press, 1992), 211–30.

15. The man used the term "Marghi," the way the Kapsiki often refer to themselves. The term means "black," here used in contrast with the "brown" Fulbe; the "red" *nasara* is the European we tend to call "white," but whose face is usually quite red in Africa. . . . I choose not to use the word "Marghi," as the Western neighbors of the Higi in Nigeria are habitually referred to as "Marghi" (James H. Vaughan Jr., "The Religion and the World View of the Marghi," *Ethnology* 3, no. 4 [1964]: 389–97); so let us reserve this term for them. The Kapsiki call them "*kaŋwaya.*"

16. A different myth on the provenance of the white man, the Fulbe, and the black man is given in Van Beek, *The Dancing Dead*.

17. "*Hwulu*" is the most exasperating word in Kapsiki. Depending on the tones, it can mean euphorbia, sweat, stream, or tortoise. It was one major reason I did not translate my Dutch name, beek = stream, into Kapsiki.

18. Already in 1978, Spande's bibliography had thirty-three pages on iron as against six on "nonferrous metals." Dennis Spande, *A Historical Perspective on Metallurgy in Africa: A Bibliography* (Waltham, Mass.: African Studies Association, 1978).

19. James H. Vaughan Jr., "Caste Systems in the Western Sudan," in *Social Stratification in Africa*, ed. A. Tuden and L. Plotnicov (New York: Free Press, 1970), 59–92; James H. Vaughan Jr., "Eŋkyagu as Artists in Marghi society," in *The Traditional Artist in African Societies*, ed. Warren L. d'Azevedo (Bloomington: Indiana University Press, 1973), 162–93; André Marliac and Olivier Langlois, "Archéologie de la Région Mandara-Diamaré," in *Atlas de la province de l'Extrême-Nord du Cameroun*, ed. Christian Seignobos and Olivier Iyébi-Mandjek (Paris: Minrest, Cameroun, and Éditions de l'IRD, 2000), 71–76.

20. Judy Sterner, *The Ways of the Mandara Mountains: A Comparative Regional Approach* (Köln: Rüdiger Köppe Verlag, 2003); Judy Sterner and Nicholas David, "Gender and Caste in the Mandara Highlands: Northeastern Nigeria and Northern Cameroon," *Ethnology* 30, no. 4 (1991): 355–69; Nicholas David, "A New Slag-Draining Type of Bloomery Furnace from the Mandara Mountains," *Historical Metallurgy* 44 (2010): 36–47.

21. Eugenia W. Herbert, *Red Gold of Africa: Copper in Precolonial History and Culture* (Madison: University of Wisconsin Press, 1984); Eugenia W. Herbert,

Iron, Gender and Power: Rituals of Transformation in African Societies (Bloomington: Indiana University Press, 1993).

22. Herbert, *Red Gold of Africa*, 289ff; Herbert, *Iron, Gender and Power*, 19ff.

23. Herbert, *Red Gold of Africa*, 266ff.

24. Cited in ibid., 267.

25. Herbert, *Red Gold of Africa*, 267–71.

26. Ibid., 293.

27. Walter E. A. van Beek, "Color Terms in Kapsiki," in *Papers in Chadic Linguistics*, ed. Paul Newman and Roxana Ma (Leiden: CNWS, 1977), 13–20.

28. Scott MacEachern, "'Symbolic Reservoirs' and Inter-Group Relations: West African Examples," *African Archeological Review* 12 (1994): 205–24.

29. Marliac and Langlois, "Archéologie de la Région Mandara-Diamaré," 72.

30. Nicholas David, *Performance and Agency: The DGB Sites of Northern Cameroon*, BAR International Series 1830 (Oxford: Archaeopress, 2008).

31. Nicholas David and Judy Sterner "Smith and Society: Patterns of Articulation in the Northern Mandara Mountains." In *Metals in Mandara Mountains Society and Culture*, ed. Nicholas David (Trenton, N.J.: Africa World Press, 2012), 87–113.

32. Wade, "Context of Adoption of Brass Technology," shows an even more recent, similar process among the Nigerian Fali. Note that the brass casters' statements regarding the diffusion of brass casting are not related to their claim to Gudur origins.

33. David, *Performance and Agency*; Scott MacEachern, "The Prehistory and Early History of the Northern Mandara Mountains and Surrounding Plains," in David, *Metals in Mandara Mountains Society and Culture*, 27–67.

34. This recent introduction in the Mandara Mountains does not preclude an older presence of copper in the region (Herbert, *Red Gold of Africa*, 7–8). But in the Kapsiki area, copper came in as brass, which has to be younger—owing to the metallurgical problems of handling zinc—with Roman times as the earliest African occurrence.

35. H. M. Cole, *Icons of Power: Ideals and Power in the Art of Africa* (Washington, D.C.: Smithsonian Institution Press, 1989).

36. Walter E. A. van Beek, "Slave Raiders and Their Peoples without History," in *History and Culture: Essays on the Work of Eric R. Wolf*, ed. Jon Abbink and Henk Vermeulen (Amsterdam: Het Spinhuis, 1992), 53–71.

CHAPTER 6. OF WHISTLING BIRDS AND TALKING CRABS

1. Walter E. A. van Beek, "Eyes on Top: Culture and the Weight of the Senses," in *Perception of the Invisible: Religion, Historical Semantics and the Role of Perceptive Verbs*, ed. Anne Storch, Special Volume of Sprache und Geschichte in Afrika, band 21 (Cologne: Rüdiger Köppe Verlag, 2010), 245–70.

2. This session was on December 22, 1999, in Mogode.

3. Session of March 1973.

4. Van Beek, "Eyes on Top."

5. Tim Ingold, *The Perception of the Environment: Essays on Livelihood, Dwelling and Skill* (London: Routledge, 2000), 268–69.

6. Some names of the clients involved have been changed for reasons of privacy, but I do use the real names of the diviners with their permission.

7. For an overview of divination techniques using animals, see Lorenz Homberger, "Tier-Orakel," in *Orakel: Der Blick in die Zukunft*, ed. Axel Langer and Albert Lutz (Zurich: Museum Rietberg, 1999), 254–60.

8. A. Regourd, "Le jet de coquillage divinatoire en Islam arabe et en Afrique subsaharienne: Première contribution à une étude comparative," *Journal of Oriental and African Studies* 11 (2002): 133–49.

9. For more general overviews of techniques, see J. Pemberton, "Weissagung in Schwarzafrika," in *Orakel: Der Blick in die Zukunft*, ed. A. Langer and A. Lutz (Zurich: Rietburg Museum Publishing, 1999), 228–45; J. Pemberton, ed., *Insight and Artistry in African Divination* (Washington, D.C.: Smithsonian Institution Press, 2000); and Umar Danfulani, "Taxonomy and Classification of Divination with Emphasis on African Divination Systems," *Africana Marburgensia* 30, no. 1 (1997): 3–23.

10. Jeanne-Françoise Vincent, *Princes montagnards du Nord-Cameroun: Les Mofou-Diamaré et le pouvoir politique*. Paris: Harmattan, 1991; James H. Vaughan Jr., "Mafakur: A Limbic Institution of the Marghi (Nigeria)," in *Slavery in Africa: Historical and Anthropological Perspectives*, ed. Suzanne Miers and Igor Kopytoff (Madison: University of Wisconsin Press, 1977), 82–104.

11. The verb "*kaŋa*" has a wider meaning and is also used for building a house, making pottery, and performing a sacrifice. The last connotation is the closest in this case.

12. *Boerhavia diffusa L.*, a medicine to avoid problems between two men who have sexual relations with the same woman. Without this *rhwɛ*, if one of them fell ill, the other one would die, especially when they met.

13. Kapsiki language is rich in ideophones, and this is one of the few with an English equivalent.

14. For the dynamics of compound building among the Kapsiki, see Walter E. A. van Beek, "The Ideology of Building: The Interpretation of Compound Patterns among the Kapsiki of North Cameroon," in *Op zoek naar mens en materiële cultuur*, ed. Harry Fokkens, Pieteke Banga, and Mette Bierma (Groningen: Groningen University Press, 1986), 147–62.

15. Walter E. A. van Beek, "Kapsiki Beer Dynamics," in *Ressources vivrières et choix alimentaires dans le bassin du lac Tchad*, ed. Christine Langlois, Éric Garine, and Olivier Langlois (Paris: IRD, 2005), 477–500.

16. Walter E. A. van Beek and Philip M. Peek, "Divination: Du bon sens dans le chaos," in *Art d'Afrique*, ed. Paul Matharan (Bordeaux: Musée de l'Occitanie, 2011), 149–54.

17. One quite African problem that is not addressed through the crab is witchcraft, as this is not considered a major problem in Kapsiki. And there is no technique for identifying witches; see Walter E. A. van Beek, "The Innocent Sorcerer: Coping with Evil in Two African Societies, Kapsiki and Dogon," in *Religion in Africa: Experience and Expression*, ed. Thomas D. Blakely, Walter E. A. van Beek, and Dennis L. Thomson (London: James Currey, 1994), 196–228; Walter E. A. van Beek, "The Escalation of Witchcraft Accusations," in *Imagining Evil: Witchcraft Beliefs and Accusations in Contemporary Africa*, ed. Gerrie ter Haar (Trenton, N.J.: Africa World Press, 2007), 293–316.

18. André-Michel Podlewski, *La dynamique des principales populations du Nord-Cameroun (entre Benoué et lac Tchad)* (Paris: ORSTOM, 1966).

19. A special category of persons in Kapsiki, different from witch and evil eye; they are "night wanderers" who can see into the future. See Walter E. A. van Beek, *The Dancing Dead: Ritual and Religion among the Kapsiki/Higi of North Cameroon and Northeastern Nigeria* (New York: Oxford University Press, 2012).

20. *Rhwete* in Kapsiki. This is an important concept in their value system. It has no negative value but indicates intelligence and a redressing of social inequalities, which in fact are smith characteristics.

21. *Yitiyaberhe*: before entering her husband's house, the bride is first "given to" one of her father's kinsmen, who then presents her to her husband. Later he will keep a watchful eye on her and ensure her well-being.

22. See Wim van Binsbergen, "African Divination across Time and Space: Typology and Intercultural Epistemology," in *Reviewing Reality: Dynamics of African Divination*, ed. Walter E. A. van Beek and Philip M. Peek (Berlin: LIT Verlag, 2013), 339–75; Philip M. Peek, "Introduction," in *African Divination Systems: Ways of Knowing*, ed. Philip Peek (Bloomington: Indiana University Press, 1991), 1–22; Philip M. Peek, "Recasting Divination Research," in Pemberton, *Insight and Artistry in African Divination*, 25–33; Philip Peek and Walter E. A. van Beek. "Reality Reviewed: Dynamics of African Divination,"

in *Reviewing Reality: Dynamics of African Divination*, ed. Philip M. Peek and Walter E. A. van Beek (Berlin: LIT Verlag, 2013), 1–24.

23. See Van Beek, *Dancing Dead*.

24. For an appraisal of intuition and divination, see Barbara Tedlock, "Toward a Theory of Divinatory Practice," *Anthropology of Consciousness* 17, no. 2 (2006): 62–77; and Nomfundo Lily Rose Mlisa, "Intuition as Divination among the Xhosa of South Africa," in *Reviewing Reality: Dynamics of African Divination*, ed. Philip M. Peek and Walter E. A. van Beek, (Berlin: LIT Verlag, 2013), 59–82.

25. Knut Graw, "Locating Nganyiyo: Divination as Intentional Space," *Journal of Religion in Africa* 36, no. 1 (2006): 78–119; Knut Graw, "Beyond Expertise: Reflections on Specialist Agency and the Autonomy of the Divinatory Ritual Process," *Africa* 79, no. 1 (2009): 92–109.

26. Danfulani, "Taxonomy and Classification of Divination."

27. Jeanne-Françoise Vincent, "Divination et possession chez les Mofu montagnards du Nord-Cameroun," *Journal de la Société des Africanistes* 51, no. 1 (1971): 71–132.

28. Z. S. Strother, "Smells and Bells: The Role of Scepticism in Pende Divination," in Pemberton, *Insight and Artistry in African Divination* (Washington, D.C.: Smithsonian Institution Press, 2000), 99–115.

29. In an inverse way, this special position of the smith diviner reflects that of the occult economy of Islamic geomancy (Jan Jansen, "Framing Divination: A Mande Divination Expert and the Occult Economy," *Africa* 79, no. 1 (2009): 110–27). So Peek justly insists on more focus on the diviner himself in Pemberton, "Recasting Divination Research," 25–33, and in Peek and Van Beek, "Reality Reviewed," 1–24.

30. Richard P. Werbner, *Ritual Passage, Sacred Journey: The Process and Organization of Religious Movement* (Manchester: Manchester University Press, 1989), 4.

31. Alfred Adler, *Le bâton de l'aveugle: divination, maladie et pouvoir chez les Moundang du Tchad* (Paris: Hermann, 1971); Kees Schilder, *The Quest for Self-esteem: State, Islam, and Mundang Ethnicity in Northern Cameroon* (Leiden: ASC, 1994).

CHAPTER 7. SMITH AND RITUAL

1. See Walter E. A. van Beek, "Rain as a Discourse of Power: Rainmaking in Kapsiki," in *L'homme et l'eau dans le bassin du lac Tchad*, ed. H. Jungraithmayer, D. Barreteau, and U. Seibert (Paris: ORSTOM, 1997), 285–97.

2. Eugenia W. Herbert, *Red Gold of Africa: Copper in Precolonial History and Culture* (Madison: University of Wisconsin Press, 1984).

3. James H. Wade, "The Wife of the Village: Understanding Caste in the Mandara Mountains," in *Metals in Mandara Mountains Society and Culture*, ed. Nicholas David (Trenton, N.J.: Africa World Press, 2012), 257–84.

4. This "genderization" of the smith is common in Africa, also for the Tuareg smiths (Susan Rasmussen, *Neighbors, Strangers, Witches, and Culture-Heroes. Ritual Powers of Smith/Artisans in Tuareg Society and Beyond* [Lanham, Md.: University Press of America 2013], 128).

5. James H. Vaughan Jr., "Caste Systems in the Western Sudan," in *Social Stratification in Africa*, ed. A. Tuden and L. Plotnicov (New York: Free Press, 1970), 85–88.

6. Nicholas David, "Mortuary Practices, Ideology and Society in the Central Mandara Highlands, North Cameroon," in *Mort et rites funéraires dans le bassin du lac Tchad*, ed. Catherine Baroin, Daniel Barreteau, and Charlotte von Graffenried (Paris: ORSTOM, 1995), 75–101.

7. See Walter E. A. van Beek, *The Dancing Dead: Ritual and Religion among the Kapsiki/Higi of North Cameroon and Northeastern Nigeria* (New York: Oxford University Press, 2012).

8. See W. Arens and Ivan Karp, eds., *The Creativity of Power: Cosmology and Action in African Societies* (Washington, D.C.: Smithsonian Institution Press, 1989).

9. Christian Seignobos, "Les Murgur ou l'identification par la forge (Nord-Cameroun)," in *Forge et forgerons,* ed. Yves Monino, vol. 1 of *Actes du quatrième colloque Méga-Tchad* (Paris: ORSTOM, 1988), 43–225; Christian Seignobos, "La forge et le pouvoir dans le bassin du lac Tchad ou du roi-forgeron au forgeron-fossoyeur," in *Forge et forgerons*, ed. Yves Monino, vol. 1 of *Actes du quatrième colloque Méga-Tchad* (Paris: ORSTOM, 1988), 383–84; Christian Seignobos, "Le rayonnement de la chefferie théocratique de Gudur (Nord-Cameroun)," in *Du politique à l'économique: Études historiques dans le bassin du lac Tchad*, ed. Jean Boutrais, vol. 3 of *Actes du quatrième colloque Méga-Tchad* (Paris: ORSTOM, 1991), 225–315.

10. See Cornelis Notebaart, *Metallurgical Metaphors in the Hebrew Bible* (Bergambacht, Netherlands: 2VM Publishers, 2010).

11. Scott MacEachern, "The Prehistory and Early History of the Northern Mandara Mountains and Surrounding Plains," in David, *Metals in Mandara Mountains Society and Culture*, 27–67.

12. Wade, "Wife of the Village."

13. James H. Vaughan Jr., "The Religion and the World View of the Marghi," *Ethnology* 3, no. 4 (1964): 389–97; David, "Mortuary Practices."

14. In the Diamaré plains the chief's garbage dump is a symbol of power; though that is not what the chief hinted at here, this may have informed his choice of symbol. See Emilie Guitard, *"Le grand chef doit être comme le grand tas d'ordures"*: *La gestion des déchets comme arène politique et "objet de pouvoir" dans deux villes moyennes du Cameroun (Garoua et Maroua)* (Paris: EHESS, 2014).

15. For a full description, see Van Beek, *Dancing Dead*, chapter 4.

16. Ibid., 80–81.

17. He also used to be the war leader.

18. More or less a standard text, so here is the Kapsiki original: *pa hale ta da paya meleme ganye kama kempa mbeli kaya mbeli dzakwa nyε, mba mbeli kadzemte.*

19. Walter E. A. van Beek, *The Kapsiki of the Mandara Hills* (Prospect Heights, Ill.: Waveland Press, 1987).

20. These *wudu makwa*, small iron bars, have become rare. Nowadays the *kweper-huli* gets money, at least cfa 5000, so the ritual has become more expensive.

21. *"Rhwa"* in Kapsiki means any size of river or stream, with or without water in it.

22. Rasmussen, *Neighbors, Strangers, Witches, and Culture-Heroes*, 2.

23. Patrick R. McNaughton, *The Mande Blacksmiths: Knowledge, Power, and Art in West Africa* (Bloomington: Indiana University Press, 1988), 41.

24. For an anthropologist such a situation creates an acute danger of overinterpretation, a trap I have tried to avoid. This higher level of conceptualization in Tuareg culture might well result from a longer interaction with Islam; Rasmussen, *Neighbors, Strangers, Witches, and Culture-Heroes*, 114.

CHAPTER 8. MASTERS OF HEALING

1. Called *kwantedewhushi* and *mezeveze*, resp. *Indigofera dendroides Jacq.* and *Cassyta filiformis L.*

2. Susan Reynolds-Whyte, *Questioning Misfortune: The Pragmatics of Uncertainty in Eastern Uganda* (Cambridge: Cambridge University Press, 1997).

3. Matthieu Schoffeleers, "Twins and Unilateral Figures in Central and Southern Africa: Symmetry and Asymmetry in the Symbolization of the Sacred," *Journal of Religion in Africa* 21, no. 4 (1991): 345–72.

4. Judy Sterner, *The Ways of the Mandara Mountains: A Comparative Regional Approach* (Köln: Rüdiger Köppe Verlag, 2003).

5. Jeanne-Françoise Vincent, "Sur les traces du major Denham: Le Nord-Cameroun il y a cent cinquante ans. Mandara, 'Kirdi' et Peul," *Cahiers d'Études Africaines* 72, no. 18-4 (1978): 575–606.

6. For a comparative analysis of Kapsiki witchcraft, see Walter E. A. van Beek, "The Escalation of Witchcraft Accusations," in *Imagining Evil: Witchcraft Beliefs and Accusations in Contemporary Africa*, ed. Gerrie ter Haar (Trenton, N.J.: Africa World Press, 2007), 293–316.

7. With the help of A. Leeuwenberg of Wageningen Agricultural University, where the identification was also performed.

8. This estimate derives from comparing two samples: the actual plants collected and an independent collection of plant names.

9. The *Crinum* species we collected were all sterile.

10. This plant has a wide distribution as a ritual, symbolic, and medicinal plant in the whole Mandara area.

11. John Janzen, *The Quest for Therapy in Lower Zaire* (Berkeley: University of California Press, 1994).

12. Ibid.

13. Janzen, *Quest for Therapy in Lower Zaire*.

14. Marc Hobart, ed., *An Anthropological Critique of Development: The Growth of Ignorance* (London: Routledge, 1993).

15. A similar observation is made by Robert Thornton about South African sangomas; see Robert Thornton, "The Transmission of Knowledge in South African Traditional Healing," *Africa* 79, no. 1 (2009): 29.

16. Walter E. A. van Beek, "Medicinal Knowledge and Healing Practices among the Kapsiki/Higi of Northern Cameroon and Northeastern Nigeria." In *Markets of Well-being: Navigating Health and Healing in Africa*, ed. Marleen Dekker and Rijk van Dijk (Leiden: Brill, 2011), 173–200.

17. This list was collected, as were the ones of the smiths, by having Kweji Hake list the somatic and nonsomatic purposes for which he had *rhwɛ*; this was then checked with a list of medicinal plants collected independently.

18. For his detailed life story, see Walter E. A. van Beek, "The Healer and His Phone: Medicinal Dynamics among the Kapsiki of North Cameroon," in *Mobile Phones: The New Talking Drums of Everyday Africa*, ed. Mirjam de Bruijn, Francis Nyamnyoh, and Inge Brinkman (Leiden: Langaa & African Studies Centre, 2009), 125–34.

19. That money never existed, in fact, as the Cameroonian government is not in the habit of handing out cash to healers.

CHAPTER 9. A SENSE OF JUSTICE

1. René Girard, *Violence and the Sacred* (Baltimore: Johns Hopkins University Press, 1977).
2. *Hwelefwe* is the bilateral kin group centering around the matrilateral kinsmen; see Walter E. A. van Beek, *Bierbrouwers in de bergen: De Kapsiki en Higi van Noord-Kameroen en Noordoost Nigeria* (Utrecht: ICAU, 1978).
3. *Philostygma thonningii.*
4. *Combretum glutinosum.*
5. Walter E. A. van Beek and Henry Tourneux, *Contes Kapsiki du Cameroun* (Paris: Karthala, 2014).
6. See Walter E. A. van Beek, *The Kapsiki of the Mandara Hills* (Prospect Heights, Ill.: Waveland Press, 1987).
7. Like the *kwahɛ* divination.
8. Gamache Kodji reports to have assisted at one such ritual in Mogode in 2008. Gamache Kodji, *Le forgeron Kapsiki* (Yaoundé: Mémoires Université Yaoundé, 2009), 49.
9. Walter E. A. van Beek, *The Dancing Dead: Ritual and Religion among the Kapsiki/Higi of North Cameroon and Northeastern Nigeria* (New York: Oxford University Press, 2012).
10. Viewing the stone, the five hollows probably have been to grind tobacco, the long traces for sharpening arrow points.
11. André Marliac and Olivier Langlois, "Archéologie de la région Mandara-Diamaré," in *Atlas de la province de l'Extrême-Nord du Cameroun*, ed. Christian Seignobos and Olivier Iyébi-Mandjek (Paris: Minrest, Cameroun, and Éditions de l'IRD, 2000), 71–76.
12. Not to be confounded with *nhwene gela*, the dirge sung at funerals.
13. Walter E. A. van Beek, "Les Kapsiki et leurs bovins," in *Des taurins et des hommes, Cameroun, Nigéria*, ed. Christian Seignobos and Eric Thys (Paris: ORSTOM, 1998), 15–39.
14. For an extensive treatment of the notion of privacy in Kapsiki, see Walter E. A. van Beek, "Les savoirs Kapsiki," in *La quête du savoir: Essais pour une anthropologie de l'éducation au Cameroun*, ed. Renaud Santerre and Céline Mercier-Tremblay (Montreal: Press Universitaire Laval, 1982), 180–207.
15. David Parkin, ed., *The Anthropology of Evil* (Oxford: Blackwell, 1985); William C. Olsen and Walter E. A. van Beek, eds., *Evil in Africa: Encounters with the Everyday.* Bloomington: Indiana University Press, 2015.
16. Ibid.; Walter E. A. van Beek, "The Innocent Sorcerer; Coping with Evil in Two African Societies, Kapsiki and Dogon," in *Religion in Africa: Experience*

and Expression, ed. Thomas D. Blakely, Walter E. A. van Beek, and Dennis L. Thomson (London: James Currey, 1994), 196–228.

17. Walter E. A. van Beek, "A Granary in the Earth: Dynamics of Mortuary Rituals among the Kapsiki/Higi," in *Mort et rites funéraires dans le bassin du lac Tchad*, ed. C. Baroin, D. Barreteau, and C. von Graffenried (Bondy: ORSTOM, 1996), 137–52.

18. For a more extensive treatment of this, see Van Beek, "Innocent Sorcerer."

19. Roy Willis, "Do the Fipa Have a Word for It?" in Parkin, *Anthropology of Evil*, 165–82.

20. Mustafa Emirbayr and Ann Mische, "What Is Agency?" *American Journal of Sociology* 103, no. 4 (1996): 962–1023.

21. Lee Cronk, *That Complex Whole: Culture and the Evolution of Human Behavior* (Boulder, Colo.: Westview Press, 1999), 49.

22. Alfred Gell, *Art and Agency: An Anthropological Theory* (Oxford: Clarendon, 1998), 16.

23. Emirbayr and Mische, "What Is Agency?"

24. Susan Reynolds-Whyte, *Questioning Misfortune: The Pragmatics of Uncertainty in Eastern Uganda* (Cambridge: Cambridge University Press, 1997), 20.

25. This ordeal is surprisingly like the friction oracle, well known from DR Congo. See Patricia Lamarche-de Largentaye, "The Friction Oracle for the Congo Basin," in *Reviewing Reality: Dynamics of African Divination*, ed. Walter E. A. van Beek and Philip M. Peek (Berlin: LIT Verlag, 2013), 313–38.

CHAPTER 10. THE SMELL OF DEATH

1. For an analysis of the place of the funeral in the whole cycle of rites of passage and the ritual calendar, see Walter E. A. van Beek, *The Dancing Dead: Ritual and Religion among the Kapsiki/Higi of North Cameroon and Northeastern Nigeria* (New York: Oxford University Press, 2012), 247–48.

2. Walter E. A. van Beek, "Forever Liminal: Twins among the Kapsiki/Higi of North Cameroon and Northeastern Nigeria," in *Twins in African and Diaspora Cultures: Double Trouble or Twice Blessed*, ed. Philip Peek (Bloomington: Indiana University Press, 2011), 163–82.

3. See Van Beek, *Dancing Dead*, chapter 13, informed by the models of Peter Metcalfe and Richard Huntington, *Celebrations of Death: The Anthropology of Mortuary Ritual*, 2nd ed. (Cambridge: Cambridge University Press, 1991).

4. For a description of a "bad death" of a young adult, see Van Beek, *Dancing Dead*, chapter 1.

5. *Combretum glutinosum* and *Cymbopogon giganteus*.

6. See the opening chapter in Walter E. A. van Beek, *The Kapsiki of the Mandara Hills* (Prospect Heights, Ill.: Waveland Press, 1987).

7. 'Yèngu is a so-called *ndenza*, a descendant of immigrants in Mogode, as in fact are most of those in the village. However, his village of origin, Kamale, is only an hour's walk away, downhill, in Nigeria.

8. The quills of a rare variety of red porcupine are used for the burial of men known as great warriors—or thieves. Red porcupines have a reputation for ferocity, and catching one is tricky, as they are clever and evade capture easily when one reaches out for the animal, so their quills are used for special occasions.

9. In the case of a female death, her sister's daughter, the husband's brother's wife, the direct descendants of the mother of the deceased woman, as well as the wives of her husband's clan.

10. For a sample text, see Van Beek, *Dancing Dead*, 5–6.

11. The song refers to catching slaves, the most male of all activities. When a slave was caught, he held *safa* in his hand, while singing the praise of his captor.

12. See Van Beek, *Dancing Dead*.

13. *Grewia stanoides*.

14. Nicholas David suggests that washing off the epidermis symbolically relates to the layers of "skin" on a seed. The moist soil has to reach the under layer for the seed to germinate. Likewise the body, put in a granary-like tomb, will ultimately produce life. This interpretation fits with the Kapsiki symbolism of the tomb, but none of my informants have ever mentioned it. But, then, I had to find out the tomb symbolism myself as well.

15. For a comparative overview of burial chambers in the region, see Nicholas David, "The Archaeology of Ideology: Mortuary Practices in the Central Mandara Highlands, North Cameroon," in *An African Commitment: Papers in Honor of Peter Lewis Shinnie*, ed. Judy Sterner and Nicholas David (Calgary: University of Calgary Press, 1992), 181–210.

16. For a sample text see Van Beek, *Dancing Dead*, 261.

17. This is the iron bar used as a *shafa*, to swear an oath upon. See chapter 9.

18. Gamache Kodji, *Le forgeron Kapsiki* (Yaoundé: Mémoires Université Yaoundé, 2009).

19. "*Rhweme*" means beans, mountain, or sky depending on the tones used. The first *rhweme* also refers to the arteries on the placenta, thus serving as an important symbol of femininity.

20. Called *tɛ kwarha dzeve durhwu* (beer to put the hand into the pot), see Van Beek, *Dancing Dead*, 270.

21. See Van Beek, *Dancing Dead*, 272 for a description.
22. Alain Corbin, *The Foul and the Fragrant: Odours and the French Social Imagination* (Leamington Spa: Berg, 1986), 223.
23. Patrick Süskind, *Das Parfum, die Geschichte eines Mörders* (Zurich: Diogenes Verlag, 1985).
24. Victor Turner, *The Ritual Process: Structure and Anti-structure* (London: Routledge, 1969).
25. This is the main theme of Van Beek, *Kapsiki of the Mandara Hills*.

CHAPTER 11. MUSIC AND THE SILENCE OF THE SMITH

1. David Howes, *Sensual Relations: Engaging the Senses in Culture and Social Theory* (Ann Arbor: University of Michigan Press, 2003).
2. Marie-José Tubiana, *Hommes sans voix: Forgerons du nord-est du Tchad et de l'est du Niger* (Paris: Harmattan, 2008).
3. Tim Ingold criticizes this notion, not so much as an oxymoron ("scape" implies seeing) but as it seems to cut up our experience into discrete aspects in *Being Alive: Essays on Movement, Knowledge and Description* (London: Routledge, 2011), 138. Yet, as a device to highlight Kapsiki village life and the distinctness of the smith, it is productive.
4. Karin Bijsterveld, *Mechanical Sound: Technology, Culture, and Public Problems of Noise in the Twentieth Century* (Cambridge: MIT Press, 2008).
5. *male va d'a we / yɛ vatlekendekwe / ncɛ d'a kwa rhɛŋa / d'ɛd'ɛ dle mejiga d'a / kele geta ya kwara / kewa ndeke nda wuzha taŋa narima? / jara kadzerhwa d'a 'ya kadza Garua / wusu ke mped'e / rhu rhwemperapawa / 'ya wusu kemene fege, ŋwale ke mi.*
6. *A kwaftɛa magwed'a, a 'ya ndere 'ya, a 'ya ndere 'ya.*
7. *tsah tsarahwe jiwembi dza rhɛ 'yita 'yaŋa mpa geta—ke za—'ya kelete.*
8. *belɛ kasha badla*, ("*belɛ*" means the sheepskin of the man—a skin he wears at his side).
9. *Dza reɓumu to gelinka, mpa gate keze 'ya kelete, mpa gwecɛ keze 'ya kelete, nza kwa Gleru, ŋwale Kasunu Kuve Kwanyɛ, dza reɓumu ta gelinka.*
10. See Renate Wente-Lukas, *Die Materielle Kultur der Nicht-Islamischen Ethnien von Nordkamerun und Nordost Nigeria* (Wiesbaden: Franz Steiner Verlag, 1977), 270.
11. See Walter E. A. van Beek, "Dynamics of Kapsiki/Higi Marriage Exchanges," in *Les échanges et la communication dans le bassin du lac Tchad*, ed. Sergio Baldi and Géraud Magrin, Naples: Università degli studi di Napoli "L'Orientale," Studi Africanistici, Serie Ciado-Sudanese 6 (2014): 122.

12. Walter E. A. van Beek and Henry Tourneux, eds., *Contes Kapsiki du Cameroun* (Paris: Karthala, 2014).

13. Van Beek, *Dancing Dead*, 132 ff.

14. Ibid., 140 ff.

15. The comparison with blacksmiths from northeast Chad is apt here; Tubiana, *Hommes sans voix*.

CHAPTER 12. THE SMITH AND THE POWER OF THINGS

1. José van Santen, *They Leave Their Jars Behind: The Conversion of Mafa Women to Islam* (Leiden: VENA, 1993). Emily A. Schultz, "From Pagan to Pullo: Ethnic Identity Change in Northern Cameroon," *Africa* 54, no. 1 (1984): 46–64.

2. Gamache Kodji, *Le forgeron Kapsiki* (Yaoundé: Mémoires Université Yaoundé, 2009), 72.

3. Patrick R. McNaughton, *The Mande Blacksmith: Knowledge, Power and Art in West Africa* (Bloomington: Indiana University Press, 1988), 156.

4. Ibid., 151.

5. Nicholas David and Judy Sterner, "Smith and Society: Patterns of Articulation in the Northern Mandara Mountains," in *Metals in Mandara Mountains Society and Culture*, ed. Nicholas David (Trenton, N.J.: Africa World Press, 2012), 87–113.

6. Tim Ingold "Introduction," in *Redrawing Anthropology: Material, Movement, Lines*, Tim Ingold ed. (Farnham: Ashgate, 2011), 11.

7. Philip De Barros, "Iron Metallurgy: Sociocultural Context," in *Ancient African Metallurgy: The Sociocultural Context*, ed. Michael S. Bisson et al. (New York: Altamira Press, 2000), 147–98.

8. The notion of mystic smith power is central in the Tuareg case: (Susan Rasmussen, *Neighbors, Strangers, Witches, and Culture-Heroes. Ritual Powers of Smith/Artisans in Tuareg Society and Beyond* [Lanham, Md.: University Press of America, 2013]). This forms one major difference between Tuareg *inaden* and Kapsiki *rerhɛ*.

9. See Walter E. A. van Beek, *The Dancing Dead: Ritual and Religion among the Kapsiki/Higi of North Cameroon and Northeastern Nigeria* (New York: Oxford University Press, 2012), chapter 6.

10. James H. Vaughan Jr., "Caste Systems in the Western Sudan," in *Social Stratification in Africa*, ed. A. Tuden and L. Plotnicov (New York: Free Press, 1970), 59–92.

11. Scott MacEachern, "The Prehistory and Early History of the Northern Mandara Mountains and Surrounding Plains," in David, *Metals in Mandara Mountains Society and Culture*, 27–67. See also Nicholas David and Judy Sterner, "Wonderful Society: The Burgess Shale Creatures, Mandara Chiefdoms and the Nature of Prehistory," in *Beyond Chiefdoms: Pathways to Complexity in Africa*, ed. Susan K. McIntosh, (Cambridge: Cambridge University Press, 1999), 365–89.

12. Bernard Juillerat, *Les bases de l'organisation sociale chez les Mouktélé (Nord Cameroun)* (Paris: University of Paris, Mémoires de l'Institut de l'Ethnologie VIII, 1971), 11; Jean-Yves Martin, *Les Matakam du Cameroun: Essai sur la dynamique d'une société pré-industrielle*, Mémoires Orstom 41 (Paris: ORSTOM, 1970).

13. Nicholas David, "The Ethnoarchaeology and Field Archaeology of Grinding at Sukur, Adamawa State, Nigeria," *African Archaeological Review* 15, no. 1 (1998): 13–63.

14. MacEachern, "Prehistory and Early History of the Northern Mandara Mountains."

15. Scott MacEachern, *Du Kunde Ethnogenesis in North Cameroon* (Calgary: University of Calgary, 1990), 44–46.

16. Daniel Barreteau and Charlotte von Graffenried, eds., *Datation et chronologie dans le bassin du lac Tchad* (Paris: ORSTOM, 1993).

17. David, "Ethnoarchaeology and Field Archaeology of Grinding."

18. The only known prehistoric culture of the wider area are the Sao with their great legacy of splendid pottery. From the ninth century people known today as Sao have lived dispersed over a wider area south of Lake Chad; they may also have penetrated into the Mandara Mountains. However, their descendants seem to have been still in place in the sixteenth century, at least in the river areas, at a time when the Kapsiki and Higi had already begun to settle the area. They are usually considered as proto-Kotoko, and probably with good reason.

19. Antoinette Hallaire, *Paysans montagnards du Nord-Cameroun: les Monts Mandara* (Paris: ORSTOM, 1991).

20. Martin, *Les Matakam du Cameroun*; José Van Santen, *They Leave Their Jars Behind*.

21. MacEachern, "Prehistory and Early History of the Northern Mandara Mountains," 49.

22. Daniel Barreteau, ed., *Langues et cultures dans le bassin du lac Tchad* (Paris: ORSTOM, 1987).

23. Daniel Barreteau and Henri Tourneux, eds., *Le milieu et les hommes: Recherches comparatives et historiques dans le bassin du lac Tchad* (Paris: ORSTOM, 1988).

24. Jeanne-Françoise Vincent, *Princes montagnards du Nord-Cameroun: Les Mofou-Diamaré et le pouvoir politique* (Paris: Harmattan, 1991).

25. Walter E. A. van Beek, "Les Kapsiki," in *Contribution de la recherche ethnologique à l'histoire des civilisations du Cameroun*, Vol. 1, ed. Claude Tardits (Paris: ORSTOM, 1981), 113–19.

26. The distinction *Bos taurus* and *Bos indicus* would imply a difference in species, but given the ease of interbreeding, both are subspecies at most. See Éric Thys, Yves Bouquet, Alex van der Weghe, and Alex van Zeveren, "Caractérisation de l'individualité génétique des Taurins Kapsiki," in *Des taurins et des hommes, Cameroun, Nigéria*, ed. Christian Seignobos and Éric Thys (Paris: ORSTOM, 1998), 45–53.

27. Walter E. A. van Beek, "Les Kapsiki et leurs Bovins," in *Des taurins et des hommes, Cameroun, Nigéria*, ed. Christian Seignobos and Eric Thys (Paris: ORSTOM, 1998), 15–39.

28. Bruno Dineur and Éric Thys, "Caractéristiques phanéroptiques and barymétriques de la race Kapsiki," in Seignobos and Thys, *Des taurins et des hommes*, 39–44.

29. Éric Thys, Yves Bouquet, Alex van der Weghe, and Alex van Zeveren, "Caractérisation de l'individualité génétique des taurins kapsiki," in Seignobos and Thys, *Des taurins et des hommes*, 50.

30. Alain Marliac and Philippe Columeau, "Taurins de l'age de fer au Cameroun Septentrional," in Seignobos and Thys, *Des taurins et des homme, Cameroun, Nigéria*, 345.

31. Jean-Gabriel Gauthier, "À Propos du taurin en pays Fali actuel et en pays Sao ancien," in Seignobos and Thys, *Des taurins et des hommes, Cameroun, Nigéria*, 336, but the dates are debatable.

32. Christian Seignobos, "Les Dowayo et leurs taurins," in Seignobos and Thys, *Des taurins et des hommes*, 61; Éric de Garine, "Contribution à l'ethnologie du taurin chez les Duupa," in Seignobos and Thys, *Des taurins et des hommes*, 123. A similar argument can be construed from the diversification of varieties and strains of sorghum, the main staple of the Mountains. Also in this field, long occupancy seems to be a necessary precondition for the diversification of sorghum varieties.

33. Igor Kopytoff and Suzanne Miers, "Introduction," in *Slavery in Africa: Historical and Anthropological Perspectives*, ed. Igor Kopytoff and Suzanne Miers (Madison: University of Wisconsin Press, 1987), 1–35. The association between types of hoes with ethnicity must have come much later. Ian G. Robertson, "Form, Style, and Ethnicity: Iron Hoes and Knives in the Mandara Region, Northern Cameroon," in David, *Metals in Mandara Mountains Society and Culture*, 185–222.

34. I see little reason to follow Seignobos in his thesis of earlier "smith-kings" in the area. Whatever the position of smith in the first millennium CE, these early settlements must have been too small for any clear differentiation, let alone "kingship."

35. Among the Dowayo, cattle represent wealth and "freshness," blacksmiths are associated with "heat" and "power" (Seignobos, "Les Dowayo et leurs taurins," 91). This opposition may be related to the generally lower status of smiths among cattle-keeping cultures.

36. Nicholas David, personal communication, February 2014. See also http://www.sukur.info/home.

37. Barreteau and Tourneux, *Le milieu et les hommes.*

38. Walter E. A. van Beek, "Slave Raiders and Their Peoples without History," in *History and Culture: Essays on the Work of Eric R. Wolf,* ed. Jon Abbink and Henk Vermeulen (Amsterdam: Het Spinhuis, 1992), 53–71.

39. André-Michel Podlewski, *La dynamique des principales populations du Nord-Cameroun (entre Benoué et lac Tchad)* (Paris: ORSTOM, 1966), 3–194.

40. Christian Seignobos and Olivier Iyébi Mandjek, eds., *Atlas de la province de l'Extrême Nord du Cameroun* (Paris: Minrest Cameroun Paris IRD, 2000).

41. For a close comparison on the Jos plateau, see D. C. Tambo, "The 'Hill Refuges' of the Jos Plateau: A Historical Reexamination," *History in Africa* 5 (1978): 201–23. For Adamawa, see Sa'ad Abubakar, *The Lamibe of Fombina: A Political History of Adamawa, 1809–1901* (Zaria: Ahmado Bello University Press, 1977).

42. Stephen R. Reyna, *Wars without End: The Political Economy of a Precolonial African State* (Hanover, N.H.: University Press of New England, 1990).

43. All in all, these are typical "shatter zones" leading to unstable, fragmented polities and low ethnic self-esteem. Eric Wolf, *Europe and the People without History* (Berkeley: University of California Press, 1982), 390–91. See Alain Beauvilain, *Nord-Cameroun, crises et peuplement* (Paris: Alain Beauvilain, 1989); Jean Boutrais et al., *Le nord du Cameroun, des hommes, une région,* Collection Mémoires 102 (Paris: ORSTOM, 1984); D. Brunetière, *Les Djimi: Montagnards du Cameroun Septentrional* (Thèse de 3ème cycle) (Paris: Université de Paris VII, 1982).

44. Paul Lovejoy, *Slavery, Commerce and Production in the Sokoto Caliphate of West Africa* (Trenton, N.J.: Africa World Press, 2005), 25–26.

45. The term "Kirdi" means "pagan" in Wandala, and as such is widely used throughout the region for all non-Muslim groups. Of course, "Kirdi" never specifies which group. I have avoided using the term.

46. Dixon Denham, *Narrative of Travels and Discoveries in Northern and Central Africa in the Years 1822–1823* (London: Hackluyt, 1826), 313.

47. Bwaro M. Barkindo, *The Sultanate of Mandara to 1902: History of the Evolution, Development and Collapse of a Central Sudanese Kingdom* (Stuttgart: Franz Steiner Verlag, 1989), 150.

48. MacEachern, *Du Kunde Ethnogenesis*, 93.

49. Nicholas David, "Patterns of Slaving and Prey-Predator Interfaces in and around the Mandara Mountains (Nigeria and Cameroon) from the 16th to the 20th Century," *Africa* 84, no. 3 (2014): 371–97.

50. Denham, *Narrative of Travels and Discoveries*, 217.

51. Walter E. A. van Beek, "A Touch of Wildness: Brass and Brass Casting in Kapsiki," in David, *Metals in Mandara Mountains Society and Culture*, 303–23.

52. Wolf, *Europe and the People without History*.

53. Heinrich M. Barth, *Reisen und Entdeckungen in Nord- und Central-Afrika in den Jahren 1849 bis 1855: Tagebuch seiner im Auftrag der Brittischen Regierung unternommenen Reise* (Berlin: Perthes, 1857), 3: 373.

54. Denham, *Narrative of Travels and Discoveries*, 197.

55. James H. Vaughan Jr. and Anthony H. M. Kirk-Greene, eds., *The Diary of Hamman Yaji: Chronicle of an African Ruler* (Bloomington: Indiana University Press, 1995); Walter E. A. van Beek, "Intensive Slave Raiding in the Colonial Interstice: Hamman Yaji and the Mandara Mountains (North Cameroon and North-Eastern Nigeria)." *Journal of African History* 53, no. 3 (2012): 301–23; David, "Patterns of Slaving and Prey-Predator Interfaces."

56. Mainly for the western side of the Mandara Mountains, though; the eastern side had its own problems. See Guy Pontié, *Les Guiziga du Cameroun septentrional: L'organisation traditionelle et sa mise en contestation*, Mémoires ORSTOM 63 (Paris: ORSTOM, 1973).

57. Jacques Lestringant, *Le pays des Guider au Cameroun: Essai d'une histoire régionale* (Paris: private printing, 1964), 162 (translation mine).

58. Reyna, *Wars without End*, 142.

59. As their Mande colleagues would do, though earlier (McNaughton, *Mande Blacksmith*). Mande blacksmiths, however, still make front-loading muskets, not rifles. Also, the total array of Mandara ironwork is less elaborate and diversified that their western Sudanic counterparts.

60. David and Sterner, "Wonderful Society."

61. Marcel Roupsard, *Nord-Cameroun: Ouverture et développement d'une région enclavée* (Paris: EHESS, 1987); David and Robertson, "Competition and Change."

62. Van Santen, *They Leave Their Jars Behind*.

63. For an example, see P. MacGaffey, "The Blacksmiths of Tamale: the Dynamics of Space and Time in a Ghanaian Industry," *Africa* 79, no. 2 (2009): 169–85.

Glossary of Kapsiki Terms

amalɛa	gift-giving feast during wedding
ba	epidemic
baŋwa	protective medicine
bedla	curse
berete	strength
berhemte / berhe ba	ritual to chase death
beshɛŋu	black magic
ɓama	flour explosion
Damara	smallpox (personalized)
dambatsaraka	hamerkop (bird)
dawelɛa	horn flute
deŋwu	hourglass drum
derha	forecourt
dɛgwu	uninitiated boy
dimu	drum
dlave	strip of cloth
dleke	sheepskin as side cover
dlera	crab, divination
dlerekwe	roof cover
duburu	tool blank
durhwu	pot
durugrese	cloth cap
dzakwa	smith cap
dzakwa ta maze	cap of chief smith
dzale	carnivorous locust
dzirhwa	rite in *la* feast
ɗafa	mush, porridge
ɗafa hwelefwe	mush of the family, during burial
ɗafa kwele	ritual on the tomb
ɗafa zhaŋe	mourning gift
fege	show off, pride

fela	oath
fete	fault, guilt
feŋwa	small open flute
gagera	guitar
gamba	bush
gedla	smithy
gela	rock
geta	stick
geta lɛ	iron stick
geta meleme	stick of the village
geza	war song
gɛŋa	upright stone
gutuli	bush "spirit"
gwamena	government
gwela	boy initiate
gwelɛŋu	harp
gwenji	clan in Mogode
hegi	locust
helape	vase
helape wulekɛ	divided vase
helape za	man's vase
hirdɛ	party at wedding
hwa	knife
hwa ta Va	lightening
hwelefwe	bilateral family
hwelefwe te ma	matrilateral family
hwelefwe te za	patrilateral family
hweteru	evil eye
hwulu	euphorbia, sweat, brook, tortoise (tonal)
jaŋate	fire iron
jimu	porcupine quills
jinerhu	magical challenge
kadza ŋkwa	"go to the place," ritual for appeasement
kahɛd'i	officiants in village sacrifice
kahi meleme	"oil the village," keep it well
katsala	warrior
kelɛŋu	"clairvoyant" "nightwalker"
ksugwe	mother's brother, sister's son
kwaberhewuzha	"ladies-excuse-me" dance
kwagwecɛ	quiver

kwahɛ	divining bird
kwajuni	beloved wife
kwantedewushi	extracting objects by magic
kwatewume	previously married wife
kwe	goat
kwe rembekɛma	goat to wrap the face
kwele	tomb
kweperhuli	initiation mother of *gwela* or *makwa*
kwetlekwe	calabash
kwetlekwe damara	calabash against smallpox
la	year ritual
lɛ	iron
livu	iron bridal skirt
makwa	bride, previously unmarried
makwajɛ	clan in Mogode
makwamte	clan in Mogode
makwiyɛ	clan in Mogode
male	woman
matini	child born without intervening menstruation
matlaba	brass *gwela* adornment
maze	chief
maze gedla	blacksmith in charge of *gedla* ritual
mazererhɛ	chief smith
mblama	ward chief
mblaza	medicine holder
mehteshi	young helper of *gwela* or *makwa*
meke	squirrel, blacksmith tongs
mekwe	father-in-law, son-in-law
meleme	village
melɛ	sacrificial jar, sacrifice
melu	nonsmith
meŋele	miracle
merhe	agency, chief
mete	witch
mezeke	itch
midʼimte	last words
mnze	brass, honey, bee
mnzefɛ	village officiator, war leader
mpedli	white beer
mpisu	to spit, exsufflate

Mte	Death
ndalɛke	smell of the corpse
ndegwevi	autochthone
ndemara	guardian
ndemara gedla	guardian of the smithy
ndemerhe	chief
ndenza	immigrant
ndevele	hammer
nerha d'afa	graveside ritual
newe le ntsu	"look with the eyes," resignation
nhwene	dirge, to mourn
nhwene gela	Mogode mourning song
nhwene male	female mourning song
nhwene ta gela	rock crystal
nhwene za	male mourning song
njireke	flute
ntsehwele	cleverness
ŋa	to build
ŋacɛ	clan in Mogode (the author's clan)
ŋki	personal characteristics
ŋkwa	place, spot
ŋulu rhɛ	rooster of the house
ŋwe	long drum
paya	brass triangle
pelɛ	stone
pelɛ meleme	stones of the village
psekɛ	to germinate
Psikye	Kapsiki language
pulu ŋeza	place of honor in forecourt
rerhɛ	smith
rhamca	burial shroud
rhele	dry season
rhena	word
rhena heca	folk story
rhena za	"men talk," symbolic speech
rhɛdɛrhɛdɛ	violin
rhuli	cache-sexe
rhwelepe	jar
rhweme	bean fibers
Rhwemetla	judging and initiation mountain

rhwɛ	medicine
Rhungeɗu	place of old Mogode
sasurgwa	star
sekwa	means to enforce debt payment
shafa	oath object
shaga	meat bowl
shala	god
shala pelɛ rhweme	god in heaven
Shasha	measles
shila	flute
shila beshɛŋu	magical flute
shinaŋkwe	shadow, spirit
shiŋli	mourning band
takase	bracelet
tame	plaited granary
tɛ	red beer
tɛ ba	beer of the epidemic
tɛ kembu gɛŋa	beer to set up the stone, second funeral
tɛ kwele	beer of the tomb, second funeral
tɛ shiŋli	beer of the mourning band, second funeral
tɛndɛ	divinatory crab
tla psekɛ	Kapsiki Bos taurus
tlewembere	type of drum
tsu	grind mortar, hollow stone
Va	Rain
vatlekwendekwe	sex
veci	sun, sacrificial jar
verhe	food party
verhe makwa	wedding feast
visu	to cast, bellows
vuŋ	horn trumpet
vutu	oracle technique
wudu	iron point
wudu makwa	iron points used in wedding
wumbete	large jar
wume	bridewealth, maturing
wume gwela	initiation of boy
wushi meŋele	miracle objects
wushi ŋererhɛ	smith food
wuta	beer vat, ritual revenge

wuvɛ	excrement
yitiyaberhe	ritual father
za	man
zalewa	luck
zamale	other husband of wife
zeme fela	swear ("eat") an oath
zeremba	clan in Mogode
zevu	reed flute
zhazha	bean dish
zugwu	type of flute, both *njireke* and *feŋwa*
zulu	lean-to

Note: Only Kapsiki lexemes occurring more than once in the text feature in this glossary. Verbs in Psikye are without their *ka* prefix.

Bibliography

Abubakar, Sa'ad. *The Lamibe of Fombina: A Political History of Adamawa, 1809–1901.* Zaria: Ahmado Bello University Press, 1977.

Adler, Alfred. *Le bâton de l'aveugle: divination, maladie et pouvoir chez les Moundang du Tchad.* Paris: Hermann, 1971.

Almagor, Uri. "The Cycle and Stagnation of Smells: Pastoralist-Fishermen Relationships in an East African Society." *Res* 13 (1987): 106–21.

———. "Odours, and Private Language: Observations on the Phenomenology of Scent." *Human Studies* 13 (1990): 253–74.

Alpern, Stanley B. "Did They or Didn't They Invent It?: Iron in Sub-Saharan Africa." *History in Africa* 32 (2005): 41–94.

Arens, W., and Ivan Karp, eds. *The Creativity of Power: Cosmology and Action in African Societies.* Washington, D.C.: Smithsonian Institution Press, 1989.

Baily, Susan. *The New Cambridge History of India, IV, 3: Caste, Society and Politics in India from the Eighteenth Century to the Modern Age.* Cambridge: Cambridge University Press, 1999.

Baker, Robert L., and Y. Zubeiro. "The Higis of Bazza Clan." *Nigeria* 47 (1955): 213–22.

Barkindo, Bwaro M. *The Sultanate of Mandara to 1902: History of the Evolution, Development and Collapse of a Central Sudanese Kingdom.* Stuttgart: Franz Steiner Verlag, 1989.

Barley, Nigel. *The Innocent Anthropologist: Notes from a Mud Hut.* London: British Museum, 1983.

Barreteau, Daniel, ed. *Langues et cultures dans le bassin du lac Tchad.* Paris: ORSTOM, 1987.

Barreteau, Daniel, and Charlotte von Graffenried, eds. *Datation et Chronologie dans le bassin du lac Tchad.* Paris: ORSTOM, 1993.

Barreteau, Daniel, and Henri Tourneux, eds. *Le milieu et les hommes: recherches comparatives et historiques dans le bassin du lac Tchad.* Paris: ORSTOM, 1988.

Barth, Heinrich M. *Reisen und Entdeckungen in Nord- und Central-Afrika in den Jahren 1849 bis 1855: Tagebuch seiner im Auftrag der Brittischen Regierung unternommenen Reise.* Berlin: Perthes, 1857.

Beauvilain, Alain. *Nord-Cameroun, crises et peuplement*. Paris: Alain Beauvilain, 1989.

Berreman, Gerald D. *Caste and Other Inequities: Essays on Inequality*. New Delhi: Folklore Institute, 1979.

Bijsterveld, Karin. *Mechanical Sound: Technology, Culture, and Public Problems of Noise in the Twentieth Century*. Cambridge: MIT Press, 2008.

Black, Anthony. *Guilds and State: European Political Thought from the Twelfth Century to the Present*. London: Methuen, 2005.

Blench, Roger. "The Sensory World: Ideophones in Africa and Elsewhere." In *Perception of the Invisible: Religion, Historical Semantics and the Role of Perceptive Verbs*, ed. Anne Storch, 271–92. Special Volume of Sprache und Geschichte in Afrika, band 21. Cologne: Rüdiger Köppe Verlag, 2010.

Boutrais, Jean et al. *Le nord du Cameroun, des hommes, une région*. Collection Mémoires 102. Paris: ORSTOM, 1984.

Brunetière, D. *Les Djimi: Montagnards du Cameroun septentrional*. Thèse de 3ᵉᵐᵉ cycle, Université de Paris VII, 1982.

Camporesi, Paolo. *The Anatomy of the Senses: Natural Symbols in Medieval and Early Modern Italy*. Cambridge: Polity Press, 1994.

Celis, Georges, and Emmanuel Nzikobanyanka. *La métallurgie traditionelle au Burundi: techniques et croyances*. Tervuren: Musée National de l'Afrique Central, 1976.

Classen, Constance, David Howes, and Anthony Synnott. *Aroma: The Cultural History of Smell*. London: Routledge, 1994.

Clist, Bernard. "Vers une réduction des préjugés et la fonte des antagonismes: Un bilan de la métallurgie du fer en Afrique sud-saharienne." *Journal of African Archaeology* 10, no. 1 (2012): 71–84.

Cole, H. M. *Icons of Power: Ideals and Power in the Art of Africa*. Washington, D.C.: Smithsonian Institution Press, 1989.

Collard, Chantal. "Les noms numéro chez les Guidar." *L'Homme* 11, no. 4 (1973): 91–95.

———. *Organisation sociale des Guidar ou Baynawa*. Paris: EHESS, 1977.

Corbin, Alain. *The Foul and the Fragrant: Odours and the French Social Imagination*. Leamington Spa: Berg, 1986.

———. *Time, Desire and Horror: Towards a History of the Senses*. Cambridge: Polity Press, 1995.

Cronk, Lee. *That Complex Whole: Culture and the Evolution of Human Behavior*. Boulder, Colo.: Westview Press, 1999.

Crowther, Paul. *Art and Embodiment: From Aesthetics to Self-Consciousness*. Oxford: Clarendon Press, 1993.

Danfulani, Umar. "Taxonomy and Classification of Divination with Emphasis on African Divination Systems." *Africana Marburgensia* 30, no. 1 (1997): 3–23.

David, Nicholas. "The Archaeology of Ideology: Mortuary Practices in the Central Mandara Highlands, North Cameroon." In *An African Commitment: Papers in Honor of Peter Lewis Shinnie*, ed. Judy Sterner and Nicholas David, 181–210. Calgary: University of Calgary Press, 1992.

———. "Mortuary Practices, Ideology and Society in the Central Mandara Highlands, North Cameroon." In *Mort et rites funéraires dans le bassin du lac Tchad*, ed. Catherine Baroin, Daniel Barreteau, and Charlotte von Graffenried, 75–101. Paris: ORSTOM, 1995.

———. "The Ethnoarchaeology and Field Archaeology of Grinding at Sukur, Adamawa State, Nigeria." *African Archaeological Review* 15, no. 1 (1998): 13–63.

———. "Lost in Third Hermeneutic? Theory and Methodology, Objects and Representations in the Ethnoarchaeology of African Metallurgy." *Mediterranean Archaeology* 14 (2001): 49–72.

———. *Performance and Agency: The DGB Sites of Northern Cameroon*. BAR International Series 1830. Oxford: Archaeopress, 2008.

———. "A New Slag-Draining Type of Bloomery Furnace from the Mandara Mountains." *Historical Metallurgy* 44 (2010): 36–47.

———. "Introduction." In *Metals in Mandara Mountains Society and Culture*, ed. Nicholas David, 3–26. Trenton, N.J.: Africa World Press, 2012.

———. "Ricardo in the Mountains: Iron, Comparative Advantage, and Specialization." In *Metals in Mandara Mountains Society and Culture*, ed. Nicholas David, 115–70. Trenton, N.J.: Africa World Press, 2012.

———. "Patterns of Slaving and Prey-Predator Interfaces in and around the Mandara Mountains (Nigeria and Cameroon)" *Africa* 84, no. 3 (2013): 371–97.

David, Nicholas, and Ian G. Robertson. "Competition and Change in Two Traditional African Iron Industries." In *Metals in Mandara Mountains Society and Culture*, ed. Nicholas David, 171–84. Trenton, N.J.: Africa World Press, 2012.

David, Nicholas, K. Gavua, A. S. MacEachern, and J. Sterner. "Ethnicity and Material Culture in North Cameroon." *Canadian Journal of Archaeology* 15 (1991): 171–77.

David, Nicholas, R. Heimann, D. Killick, and M. Wayman. "Between Bloomery and Blast Furnace: Mafa Iron Smelting in North-Cameroon." *African Archaeology Review* 7 (1989): 183–207.

David, Nicholas, and Judy Sterner. "Constructing a Historical Ethnography of Sukur (Adamawa State). Part I: Demystification." *Nigerian Heritage* 4 (1995): 11–33.

———. "Wonderful Society: The Burgess Shale Creatures, Mandara Chiefdoms and the Nature of Prehistory." In *Beyond Chiefdoms: Pathways to Complexity in*

Africa, ed. Susan K. McIntosh (Cambridge: Cambridge University Press, 1999): 365–89.

———. "Smith and Society: Patterns of Articulation in the Northern Mandara Mountains." In *Metals in Mandara Mountains Society and Culture,* ed. Nicholas David (Trenton, N.J.: Africa World Press, 2012), 87–113.

David, Nicholas, Judy Sterner, and Kodzo Gavua. "Why Pots Are Decorated." *Current Anthropology* 29 (1988): 365–89.

De Barros, Philip. "Iron Metallurgy: Sociocultural Context." In *Ancient African Metallurgy: The Sociocultural Context,* ed. Michael S. Bisson, S. Terry Childs, Philip de Barros, Augustin F. C. Holl. 147–198. New York: Altamira Press, 2000.

De Garine, Éric. "Contribution à l'etnologie du taurin chez les Duupa." In *Des taurins et des hommes, Cameroun, Nigéria,* ed. Christian Seignobos and Éric Thys, 123–82. Paris: ORSTOM, 1998.

De Maret, Pierre. "Ceux qui jouent avec le feu: la place du forgeron en Afrique Centrale." *Africa* 50 (1980): 263–79.

Denham, Dixon. *Narrative of Travels and Discoveries in Northern and Central Africa in the Years 1822–1823.* London: Hackluyt, 1826.

Dineur, Bruno, and Éric Thys. "Caractéristiques phanéroptiques and barymétriques de la race Kapsiki." In *Des taurins et des hommes, Cameroun, Nigéria,* ed. Christian Seignobos and Éric Thys, 39–44. Paris: ORSTOM, 1998.

Douglas, Mary. *Purity and Danger.* London: Routledge, 1966.

Dumont, Louis. *Homo Hierarchicus: The Caste System and Its Implications.* Chicago: University of Chicago Press, 1980.

———. "History of Ideas." In *Social Stratification: Critical Concepts in Sociology.* Vol. 3, *Dimensions of Social Stratification I: Caste, Ethnicity and Gender,* ed. David Ingliss and John Bone, 71–85. London: Routledge, 2006.

Dupire, Marguérite. 1981. "Des gouts et des odeurs: Classifications et universaux." *l'Homme* 27, no. 4 (1981): 11–14.

Duriez, Christian. *À la rencontre des Kapsiki du Nord-Cameroun: Regards d'un missionaire d'après Vatican II.* Paris: Karthala, 2002.

———. *Zamane: Tradition et modernité dans la montagne du Nord-Cameroun.* Paris: Harmattan, 2009.

Emirbayr, Mustafa, and Ann Mische. "What Is Agency?" *American Journal of Sociology* 103, no. 4 (1996): 962–1023.

Epstein, S. R., and Maarten Prak. *Guilds, Innovation, and the European Economy, 1400–1800.* New York: Cambridge University Press, 2008.

Essomba, Joseph-Marie. "Le fer dans le développement des sociétés traditionelles du Sud Cameroun." *West African Journal of Archaeology* 16 (1986): 1–24.

———. "Les fondements archéologiques de l'histoire du Cameroun." *Rio dos Camaroes* 1 (2010): 13–24.

Feld, Steven, and Keith H. Basso, eds. *Senses of Place*. Sante Fe, N.Mex.: School of American Research Press, 1997.

Fitzsimmons, Michael P. *From Artesan to Worker: Guilds, the French State, and the Organization of Labor, 1776–1821*. New York: Cambridge University Press, 2010.

Förster, Till. *Glänzend wie Gold: Gelbguss bei den Senufo, Elfenbeinküste*. Berlin: Reimer, 1986.

———. *Paroles de devin: La fonte à la cire perdue chez les Senufo de Cote d'Ivoire*. Paris: ADEIAO, 1988.

Fox, Christine. "Asante Brass Casting." *African Arts* 19, no. 4 (1986): 66–71.

———. *Asante Brass Casting: Lost Wax Casting of Goldweights, Ritual Vessels and Sculptures, with Handmade Equipment*. Los Angeles: UCLA African Studies Center, 1988.

Gauthier, Jean-Gabriel. *Les Fali de Ngoutchoumi, Hou et Tšalo: Montagnards du Nord-Cameroun: Vie matérielle, sociale et éléments culturels*. Oosterhout: Antropological Publications, 1969.

———. "À propos du taurin en pays fali actuel et en pays sao ancien." In *Des taurins et des hommes, Cameroun, Nigéria*, ed. Christian Seignobos and Éric Thys, 335–42. Paris: ORSTOM, 1998.

Gell, Alfred. *Art and Agency: An Anthropological Theory*. Oxford: Clarendon, 1998.

Genest, Serge. *La transmission des connaissances chez les forgerons Mafa (Nord-Cameroun)*. Quebec: Université Laval, 1976.

Geurts, Kathryn L. *Culture and the Senses: Bodily Ways of Knowing in an African Community*. Berkeley: University of Los Angeles Press, 2002.

Gibbs, Raymond W., Jr. *Embodiment and Cognitive Science*. Cambridge: Cambridge University Press, 2006.

Girard, René. *Violence and the Sacred*. Baltimore: Johns Hopkins University Press, 1977.

Grébénart, Danilo. *Les origines de la métallurgie en Afrique Occidentale*. Paris: Éditions Errrance, 1988.

Graw, Knut. "Locating *Nganyiyo*: Divination as Intentional Space." *Journal of Religion in Africa* 36, no. 1 (2006): 78–119.

———. "Beyond Expertise: Reflections on Specialist Agency and the Autonomy of the Divinatory Ritual Process." *Africa* 79, no. 1 (2009): 92–109.

Guitard, Emilie. *"Le grand chef doit être comme le grand tas d'ordures": La gestion des déchets comme arène politique et "objet de pouvoir" dans deux villes moyennes du Cameroun (Garoua et Maroua)*. Paris: EHESS, 2014.

Gupta, Dipandar. "Cattle and Politics: Identity over System." *Annual Review of Anthropology* 21 (2005): 409–27.

Haaland, Randi, and Peter Shinnie. *African Iron Working—Ancient and Traditional*. Oslo: Norwegian University Press, 1985.

Hallaire, Antoinette. *Paysans montagnards du Nord-Cameroun: Les Monts Mandara.* Paris: ORSTOM, 1991.

Heesterman, J. C. *The Inner Conflict of Tradition: Essays in Indian Ritual, Kingship and Society.* Chicago: University of Chicago Press, 1985.

Herbert, Eugenia W. *Red Gold of Africa: Copper in Precolonial History and Culture.* Madison: University of Wisconsin Press, 1984.

———. *Iron, Gender and Power: Rituals of Transformation in African Societies.* Bloomington: Indiana University Press, 1993.

Hinderling, Paul. *Die Mafa: Ethnographie eines Kirdi-Stammes in Nordkamerun.* Vol 1, *Soziale und religiöse Strukturen.* Vol 3, *Materialen.* Hanover: Verlag für Ethnologie, 1984.

Hobart, Marc, ed. *An Anthropological Critique of Development: The Growth of Ignorance.* London: Routledge, 1993.

Homberger, Lorenz. "Tier-Orakel." In *Orakel: Der Blick in die Zukunft,* ed. Axel Langer and Albert Lutz. Zurich: Museum Rietberg, 254–60.

Howes, David. *The Varieties of Sensory Experience: A Sourcebook in the Anthropology of the Senses.* Toronto: University of Toronto Press, 1991.

———. *Sensual Relations: Engaging the Senses in Culture and Social Theory.* Ann Arbor: University of Michigan Press, 2003.

———. "Hyperesthesia, or The Sensual Logic of Late Capitalism." In *Empire of the Senses: The Sensual Culture Reader,* ed. David Howes, 134–55. London: Sage, 2005.

———. "Reply to Tim Ingold" *Social Anthropology* 19 no. 3 (2011): 318–22, 328–31.

Ingold, Tim. *The Perception of the Environment: Essays on Livelihood, Dwelling and Skill.* London: Routledge, 2000.

———. *Lines: A Brief History.* London, Routledge, 2007.

———. "Worlds of Sense and Sensing the World: A Response to Sarah Pink and David Howes" *Social Anthropology* 19 (2011) 3: 313–17.

———. "Introduction." In *Redrawing Anthropology: Material, Movement, Lines,* ed. Tim Ingold, 1–20. Farnham: Ashgate, 2011.

———. *Being Alive: Essays on Movement, Knowledge and Description.* London: Routledge, 2011.

Jansen, Jan. *The Griot's Craft: An Essay on Oral Tradition and Diplomacy.* Munich: LIT Verlag, 2000.

———. *Les secrets du Manding: Les récits du sanctuaire Kamabolon de Kangaba (Mali).* Leiden: CNWS University of Leiden, 2002.

———. "Framing Divination: A Mande Divination Expert and the Occult Economy." *Africa* 79, no. 1 (2009): 110–27.

Janzen, John. *The Quest for Therapy in Lower Zaire.* Berkeley: University of California Press, 1994.

Jouaux, Catherine. 1990. "Gudur: chefferie ou royaume?" *Cahiers d'Études Africaines* 114, no. 29-2 (1990): 259–88.

———. "La chefferie de Gudur et sa politique expansioniste." In *Du politique à l'économique: Études historiques dans le bassin du lac Tchad*, ed. Jean Boutrais, 193–224. Vol. 3 of *Actes du quatrième colloque Méga-Tchad*. Paris: ORSTOM, 1991.

———. "Premières et secondes obsèques en pays mofu-gudur: symbolique et enjeux sociaux." In *Mort et rites funéraires dans le bassin du lac Tchad*, ed. Catherine Baroin, Daniel Barreteau, and Charlotte von Graffenried, 115–36. Paris: ORSTOM, 1995.

Juillerat, Bernard. *Les bases de l'organisation sociale chez les Mouktélé (Nord Cameroun)*. Paris: University of Paris, Mémoires de l'Institut de l'Ethnologie VIII, 1971.

Jules-Rosette, B. *The Messages of Tourist Art: An African Semiotic System in Comparative Perspective*. New York: Plenum, 1984.

Jütte, Robert. *A History of the Senses, from Antiquity to Cyberspace*. Cambridge: Polity Press, 2005.

Killick, David. "What Do We Know about African Iron Working?" *Journal of African Archaeology* 2 (2004), 187–203.

Killick, David, and Thomas Fenn. "Archaeometallurgy: The Study of Preindustrial Mining and Metallurgy." *Annual Review of Anthropology* 41(2012): 559–75.

Kirk-Greene, Anthony H. M. *Adamawa Past and Present: An Historical Approach to the Development of a Northern Cameroons Province*. London: IAI, 1969.

———. "The Kingdom of Sukur: A Northern Nigeria Ichabod." *Nigerian Field* 25 (1960): 67–96.

Kodji, Gamache. *Le forgeron Kapsiki*. Yaoundé: Mémoires Université Yaoundé, 2009.

Kopytoff, Igor, and Suzanne Miers. "Introduction." In *Slavery in Africa: Historical and Anthropological Perspectives*, ed. Igor Kopytoff and Suzanne Miers, 1–35. Madison: University of Wisconsin Press, 1987.

Langlois, Olivier. "The Development of Endogamy among Smiths of the Mandara Mountains Eastern Piedmont: Myths, History and Material Evidence." In *Metals in Mandara Mountains Society and Culture*, ed. Nicholas David, 226–55. Trenton, N.J.: Africa World Press, 2012.

Lamarche-de Largentaye, Patricia. "The Friction Oracle for the Congo Basin." In *Reviewing Reality: Dynamics of African Divination*, ed. Walter E. A. van Beek and Philip M. Peek, 313–38. Berlin: LIT Verlag, 2013.

Lestringant, Jacques. *Le pays des Guider au Cameroun: Essai d'une histoire régionale*. Paris: private printing, 1964.

Lock, Andrew, and C. R. Peters. *Handbook of Human Symbolic Evolution*. Oxford: Clarendon, 1996.

Lovejoy, Paul. *Slavery, Commerce and Production in the Sokoto Caliphate of West Africa.* Trenton, N.J.: Africa World Press, 2005.

MacEachern, Scott. *Du Kunde Ethnogenesis in North Cameroon.* Calgary: University of Calgary, 1990.

———. "Ethnicity and Stylistic Variation around Mayo Plata, Northern Cameroon." In *An African Commitment: Papers in Honor of Peter Lewis Shinnie,* ed. Judy Sterner and Nicholas David, 211–30. Calgary: University of Calgary Press, 1992.

———. "Selling Iron for Their Shackles: Wandala-'Montagnard' Interactions in Northern Cameroon." *Journal of African History* 34 (1993): 247–70.

———. "'Symbolic Reservoirs' and Inter-Group Relations: West African Examples." *African Archeological Review* 12 (1994): 205–24.

———. "The Prehistory and Early History of the Northern Mandara Mountains and Surrounding Plains." In *Metals in Mandara Mountains Society and Culture* ed. Nicholas David, 27–67. Trenton, N.J.: Africa World Press, 2012.

MacGaffey, P. "The Blacksmiths of Tamale: The Dynamics of Space and Time in a Ghanaian Industry." *Africa* 79, no. 2 (2009): 169–85.

Mackenney, Richard. *Tradesmen and Traders: The World of the Guilds in Venice and Europe, c. 1250–c. 1650.* London: Croon Helm, 1987.

Marliac, Alain, and Philippe Columeau. "Taurins de l'age de fer au Cameroun septentrional." In *Des taurins et des hommes, Cameroun, Nigéria,* ed. Christian Seignobos and Éric Thys, 343–346. Paris: ORSTOM, 1998.

Marliac, André, and Olivier Langlois. "Archéologie de la région Mandara-Diamaré." In *Atlas de la province de l'Extrême-Nord du Cameroun,* ed. Christian Seignobos and Olivier Iyébi-Mandjek, 71–76. Paris: Minrest, Cameroun, and Éditions de l'IRD, 2000.

Martin, Jean-Yves. *Les Matakam du Cameroun: Essai sur la dynamique d'une société pré-industrielle.* Mémoires Orstom 41. Paris: ORSTOM, 1970.

McIntosh, R. J. "The Pulse Model: Genesis and Accommodation of Specialization in the Middle Niger." *Journal of African History* 34 (1993): 181–220.

McNaughton, Patrick R. *The Mande Blacksmiths: Knowledge, Power, and Art in West Africa.* Bloomington: Indiana University Press, 1988.

Meek, Charles K. *Tribal Studies in Northern Nigeria.* 2 vols. London: Kegan Paul, Trench, Trubner, 1931.

Merleau-Ponty, M. *Phenomenology of Perception.* London: Routledge, 1962.

Metcalfe, Peter, and Richard Huntington. *Celebrations of Death: The Anthropology of Mortuary Ritual.* 2nd ed. Cambridge: Cambridge University Press, 1991.

Mlisa, Nomfundo Lily Rose. "Intuition as Divination among the Xhosa of South Africa." In *Reviewing Reality: Dynamics of African Divination,* ed. Philip M. Peek and Walter E. A. van Beek. Berlin: LIT Verlag, 2013, 59–82.

Morhlang, Roger. *Higi Phonology*. Zaria: Institute of Linguistics, 1981.

Müller-Kosack, Gerhard. "Sakrale Töpfe der Mafa (Nordkamerun) und ihre kultraümliche Dimensionen." *Paideuma* 34 (1988): 91–118.

———. *The Way of the Beer: Ritual Re-enactment of History among the Mafa*. London: Mandaras Publishing, 2003.

Notebaart, Cornelis. *Metallurgical Metaphors in the Hebrew Bible*. Bergambacht, Netherlands: 2VM Publishers, 2010.

Olsen, William C., and Walter E. A. van Beek, eds. *Evil in Africa. Encounters with the Everyday*. Bloomington: Indiana University Press, 2015.

Parkin, David, ed. *The Anthropology of Evil*. Oxford: Blackwell, 1985.

Patterson, M. *Senses of Touch: Haptics, Affects and Technologies*. Oxford: Berg, 2007.

Patterson, Orlando. "Slavery." In *Social Stratification: Critical Concepts in Sociology*. Vol. 3, *Dimensions of Social Stratification I: Caste, Ethnicity and Gender*, ed. David Ingliss and John Bone, 108–59. London: Routledge, 2006.

Peek, Philip M. 1990. "Introduction." In *African Divination Systems: Ways of Knowing*, ed. Philip M. Peek, 1–22. Bloomington: Indiana University Press, 1991.

———. "Recasting Divination Research." In *Insight and Artistry in African Divination*, ed. John Pemberton III, 25–33. Washington, D.C.: Smithsonian Institution Press, 2000.

Peek, Philip M., and Walter E. A. van Beek. "Reality Reviewed: Dynamics of African Divination." In *Reviewing Reality: Dynamics of African Divination*, ed. Philip M. Peek and Walter E. A. van Beek, 1–24. Berlin: LIT Verlag, 2013.

Pelckmans, Lotte. *Travelling Hierarchies: Roads in and out of Slave Status in a Central Malian Fulbe Network*. Leiden: African Studies Centre, 2011.

Pemberton, John, III. "Weissagung in Schwarzafrika." In *Orakel: Der Blick in die Zukunft*, ed. A. Langer and A. Lutz, 228–45. Zurich: Rietburg Museum Publishing, 1999.

———, ed. *Insight and Artistry in African Divination*. Washington, D.C.: Smithsonian Institution Press, 2000.

Podlewski, André-Michel. *La dynamique des principales populations du Nord-Cameroun (entre Benoué et lac Tchad)*. Paris: ORSTOM, 1966.

———. *Les forgerons Mafa: Description et évolution d'une groupe endogame*. Paris: ORSTOM, 1966.

Pontié, Guy. *Les Guiziga du Cameroun septentrional: L'organisation traditionelle et sa mise en contestation*. Mémoires ORSTOM, 65. Paris: ORSTOM, 1973.

Quigley, Declan. *The Interpretation of Caste*. Oxford: Oxford University Press, 1993.

Rasmussen, Susan. *Neighbors, Strangers, Witches, and Culture-Heroes: Ritual Powers of Smith/Artisans in Tuareg Society and Beyond*. Lanham, Md.: University Press of America, 2013.

Regourd, A. "Le jet de coquillage divinatoire en Islam arabe et en Afrique

subsaharienne: première contribution à une étude comparative." *Journal of Oriental and African Studies* 11 (2002): 133–49.

Reyna, Stephen R. *Wars without End: The Political Economy of a Precolonial African State*. Hanover, N.H.: University Press of New England, 1990.

Reynolds-Whyte, Susan. *Questioning Misfortune: The Pragmatics of Uncertainty in Eastern Uganda*. Cambridge: Cambridge University Press, 1997.

Robertson, Ian G. "Hoes and Metal Templates in Northern Cameroon." In *An African Commitment: Papers in Honor of Peter Lewis Shinnie*, ed. Judy Sterner and Nicholas David, 231–40. Calgary: University of Calgary Press, 1992.

———. "Form, Style, and Ethnicity: Iron Hoes and Knives in the Mandara Region, Northern Cameroon." In *Metals in Mandara Mountains Society and Culture*, ed. Nicholas David, 185–222. Trenton, N.J.: Africa World Press, 2012.

Roupsard, Marcel. *Nord-Cameroun: Overture et developpement d'une région enclavée*. Paris: EHESS, 1987.

Schilder, Kees. *The Quest for Self-esteem: State, Islam, and Mundang Ethnicity in Northern Cameroon*. Leiden: ASC, 1994.

Schmidt, Peter R., ed. *The Culture and Technology of African Iron Production*. Gainesville: University Press of Florida, 1996.

Schmitz-Cliever, Guido. *Schmiede in Westafrika: Ihre soziale Stellung in traditionellen Gesellschaften*. Munich: Klaus Berner, 1979.

Schoffeleers, Matthieu. "Twins and Unilateral Figures in Central and Southern Africa: Symmetry and Asymmetry in the Symbolization of the Sacred." *Journal of Religion in Africa* 21, no. 4 (1991): 345–72.

Schultz, Emily A. "From Pagan to Pullo: Ethnic Identity Change in Northern Cameroon." *Africa* 54, no. 1 (1984): 46–64.

Shapiro, Lawrence. *Embodied Cognition*. Abingdon: Routledge, 2011.

Searle-Chatterjee, Mary, and Ursula Sharma, eds. *Contextualising Caste: Post-Dumontian Approaches*. Oxford: Blackwell, 1994.

Seignobos, Christian. "Les Murgur ou l'identification par la forge (Nord-Cameroun)." In *Forge et forgerons*, ed. Yves Monino, 43–225. Vol. 1 of *Actes du quatrième colloque Méga-Tchad*. Paris: ORSTOM, 1988.

———. "La forge et le pouvoir dans le bassin du lac Tchad ou du roi-forgeron au forgeron-fossoyeur." In *Forge et forgerons*, ed. Yves Monino, 383–84. Vol. 1 of *Actes du quatrième colloque Méga-Tchad*. Paris: ORSTOM, 1988.

———. "Le rayonnement de la chefferie théocratique de Gudur (Nord-Cameroun)." In *Du politique à l'économique: Études historiques dans le bassin du lac Tchad*, ed. Jean Boutrais, 225–315. Vol. 3 of *Actes du quatrième colloque Méga-Tchad*. Paris: ORSTOM, 1991.

———. "Les Dowayo et leurs taurins." In *Des taurins et des hommes, Cameroun, Nigéria*, ed. Christian Seignobos and Éric Thys, 61–122. Paris: ORSTOM, 1998.

Seignobos, Christian, and Olivier Iyébi Mandjek, eds. *Atlas de la province de l'Extrême Nord du Cameroun.* Paris: Minrest Cameroun Paris IRD, 2000.

Sekine, Yasumaka. *Pollution, Untouchability and Harijans: A South Indian Ethnography.* Jaipur: Rawat Publications, 2011.

Sjoberg, Gideon. *The Preindustrial City, Past and Present.* New York: Free Press, 1960.

Smith, Adam, and Nicholas David. 1995. "The Production of Space and the House of Xidi Sukur." *Current Anthropology* 36, no. 3 (1995): 441–71.

Smith, M. G. "Secondary Marriages in Northern Nigeria." *Africa* 23 (1953): 298–323.

Spande, Dennis. *A Historical Perspective on Metallurgy in Africa: A Bibliography.* Waltham, Mass.: ASA, 1978.

Sterner, Judy. "Sacred Pots and 'Symbolic Reservoirs' in the Mandara Highlands of Northern Cameroon." In *An African Commitment: Papers in Honor of Peter Lewis Shinnie,* ed. Judy Sterner and Nicholas David, 171–79. Calgary: University of Calgary Press, 1992.

———. *The Ways of the Mandara Mountains: A Comparative Regional Approach.* Cologne: Rüdiger Köppe Verlag, 2003.

Sterner, Judy, and Nicholas David. "Gender and Caste in the Mandara Highlands: Northeastern Nigeria and Northern Cameroon." *Ethnology* 30, no. 4 (1991): 355–69.

———. "Pots, Stones and Potsherds: Shrines in the Mandara Mountains (North Cameroon and Northeastern Nigeria)." In *Shrines in Africa: History, Politics and Society,* ed. Allan C. Dawson, 1–40. Calgary: University of Calgary Press, 2009.

Strother, Z. S. "Smells and Bells: The Role of Scepticism in Pende Divination." In *Insight and Artistry in African Divination,* ed. J. Pemberton, 99–115. Washington, D.C.: Smithsonian Institution Press, 2000.

Süskind, Patrick. *Das Parfum, die Geschichte eines Mörders.* Zurich: Diogenes Verlag, 1985.

Tambo, D. C. 1978. "The 'Hill Refuges' of the Jos Plateau: A Historical Reexamination." *History in Africa* 5 (1978): 201–23.

Tedlock, Barbara. "Toward a Theory of Divinatory Practice." *Anthropology of Consciousness* 17, no. 2 (2006): 62–77.

Thornton, Robert. "The Transmission of Knowledge in South African Traditional Healing." *Africa* 79, no. 1 (2009): 17–34.

Thys, Éric, Yves Bouquet, Alex van der Weghe, and Alex van Zeveren. "Caractérisation de l'individualité génétique des taurins kapsiki." In *Des taurins et des hommes, Cameroun, Nigéria,* ed. Christian Seignobos and Éric Thys, 45–53. Paris: ORSTOM, 1998.

Tubiana, Marie-José. *Hommes sans voix: Forgerons du nord-est du Tchad et de l'est du Niger.* Paris: Harmattan, 2008.

Tuden, A., and L. Plotnicov. "Introduction." In *Social Stratification in Africa*, ed. A. Tuden and L. Plotnicov, 1–29. New York: Free Press, 1970.

Turner, Victor. *The Ritual Process: Structure and Anti-structure*. London: Routledge, 1969.

Van Beek, Walter E. A. "Color Terms in Kapsiki." In *Papers in Chadic Linguistics*, ed. Paul Newman and Roxana Ma, 13–20. Leiden: CNWS, 1977.

———. *Bierbrouwers in de bergen: De Kapsiki en Higi van Noord-Kameroen en Noordoost Nigeria*. Utrecht: ICAU, 1978.

———. "Les Kapsiki." In *Contribution de la recherche ethnologique à l'histoire des civilisations du Cameroun*, Vol. 1, ed. Claude Tardits, 113–19. Paris: ORSTOM, 1981.

———. " 'Eating Like a Blacksmith': Symbols in Kapsiki Ethno-Zoology." In *Symbolic Anthropology in the Netherlands*, ed. P. E. de Josselin de Jong and Eric Schwimmer, 114–25. The Hague: Nijhoff, 1982.

———. "Les savoirs Kapsiki." In *La quête du savoir: Essais pour une anthropologie de l'éducation au Cameroun*, ed. Renaud Santerre and Céline Mercier-Tremblay, 180–207. Montreal: Presse Universitaire Laval, 1982.

———. "The Ideology of Building: The Interpretation of Compound Patterns among the Kapsiki of North Cameroon." In *Op zoek naar mens en materiële cultuur*, ed. Harry Fokkens, Pieteke Banga and Mette Bierma, 147–62. Groningen: Groningen University Press, 1986.

———. *The Kapsiki of the Mandara Hills*. Prospect Heights, Ill.: Waveland Press, 1987.

———. "Iron, Brass and Burial: The Kapsiki Smith and His Many Crafts." In *Forge et forgerons*, ed. Yves Monino, 281–310. Paris: CNRS/ORSTOM, 1991.

———. "The Dirty Smith: Smell as a Social Frontier among the Kapsiki/Higi of North Cameroon and Northeastern Nigeria." *Africa* 2, no. 1 (1992): 38–58.

———. "Slave Raiders and Their Peoples without History." In *History and Culture: Essays on the Work of Eric R. Wolf*, ed. Jon Abbink and Henk Vermeulen, 53–71. Amsterdam: Het Spinhuis, 1992.

———. "The Innocent Sorcerer: Coping with Evil in Two African Societies, Kapsiki and Dogon." In *Religion in Africa: Experience and Expression*, ed. Thomas D. Blakely, Walter E. A. van Beek, and Dennis L. Thomson, 196–228. London: James Currey, 1994.

———. "A Granary in the Earth: Dynamics of Mortuary Rituals among the Kapsiki/Higi." In *Mort et rites funéraires dans le bassin du lac Tchad*, ed. C. Baroin, D. Barreteau, and C. von Graffenried, 137–52. Bondy: ORSTOM, 1996.

———. "Rain as a Discourse of Power: Rainmaking in Kapsiki." In *L'homme et l'eau dans le bassin du lac Tchad*, ed. H. Jungraithmayer, D. Barreteau, and U. Seibert, 285–97. Paris: ORSTOM, 1997.

————. "Les Kapsiki et leurs bovins." In *Des taurins et des hommes, Cameroun, Nigéria*, ed. Christian Seignobos and Eric Thys, 15–39. Paris: ORSTOM, 1998.

————. "African Tourist Encounters: Effects of Tourism in Two West-African Societies." *Africa* 73, no. 3 (2003): 251–89.

————. "Kapsiki Beer Dynamics." In *Ressources vivrières et choix alimentaires dans le bassin du lac Tchad*, ed. Christine Langlois, Éric Garine, and Olivier Langlois, 477–500. Paris: IRD, 2005.

————. "Agency in Kapsiki Religion: A Comparative Approach." In *Strength beyond Structure: Social and Historical Trajectories of Agency in Africa*, ed. Mirjam de Bruijn, Rijk van Dijk, and Jan-Bart Gewald, 114–43. Leiden: Brill, 2007.

————. "The Escalation of Witchcraft Accusations." In *Imagining Evil: Witchcraft Beliefs and Accusations in Contemporary Africa*, ed. Gerrie ter Haar, 293–316 Trenton, N.J.: Africa World Press, 2007.

————. "Approaching African Tourism: Paradigms and Paradoxes." In *African Alternatives*, ed. P. Chabal, U. Engel, and L. de Haan, 145–72. Leiden, Brill, 2007.

————. "The Healer and His Phone: Medicinal Dynamics among the Kapsiki of North Cameroon." In *Mobile Phones: The New Talking Drums of Everyday Africa*, ed. Mirjam de Bruijn, Francis Nyamnyoh, and Inge Brinkman, 125–34. Leiden: Langaa & African Studies Centre, 2009.

————. "Eyes on Top: Culture and the Weight of the Senses." In *Perception of the Invisible: Religion, Historical Semantics and the Role of Perceptive Verbs*, ed. Anne Storch, 245–70. Special Volume of Sprache und Geschichte in Afrika, band 21. Cologne: Rüdiger Köppe Verlag, 2010.

————. "Medicinal Knowledge and Healing Practices among the Kapsiki/Higi of Northern Cameroon and Northeastern Nigeria." In *Markets of Well-being: Navigating Health and Healing in Africa*, ed. Marleen Dekker and Rijk van Dijk, 173–200. Leiden: Brill, 2011.

————. "Forever Liminal: Twins among the Kapsiki/Higi of North Cameroon and Northeastern Nigeria." In *Twins in African and Diaspora Cultures: Double Trouble or Twice Blessed*, ed. Philip M. Peek, 163–82. Bloomington: Indiana University Press, 2011.

————. *The Dancing Dead: Ritual and Religion among the Kapsiki/Higi of North Cameroon and Northeastern Nigeria*. New York: Oxford University Press, 2012.

————. "The Iron Bride: Blacksmith, Iron, and Femininity among the Kapsiki/ Higi." In *Metals in Mandara Mountains Society and Culture*, ed. Nicholas David, 285–301. Trenton, N.J.: Africa World Press, 2012.

————. "A Touch of Wildness: Brass and Brass Casting in Kapsiki." In *Metals in Mandara Mountains Society and Culture*, ed. Nicholas David, 303–23. Trenton, N.J.: Africa World Press, 2012.

————. "Intensive Slave Raiding in the Colonial Interstice: Hamman Yaji and the

Mandara Mountains (North Cameroon and North-Eastern Nigeria)." *Journal of African History* 53, no. 3 (2012): 301–23.

———. "Crab Divination among the Kapsiki of North Cameroon." In *Reviewing Reality Dynamics of African Divination*, ed. Philip M. Peek and Walter E. A. van Beek, 185–210. Berlin: LIT Verlag, 2013.

———. "Dynamic of Kapsiki/Higi Marriage Exchanges." In *Les échanges et la communication dans le bassin du lac Tchad*, ed. Sergio Baldi and Géraud Magrin, 105–31. Naples: Università degli studi di Napoli "L'Orientale," Studi Africanistici, Serie Ciado-Sudanese 6, 2014.

Van Beek, Walter E. A., and Sonja Avontuur. "The Making of an Environment: Ecological History of the Kapsiki/Higi of North Cameroon and North-Eastern Nigeria." In *Beyond Territory and Scarcity in Africa: Exploring Conflicts over Natural Resource Management*, ed. Quentin Gausset, Michael Whyte, and Torben Birch-Thomsen, 70–89. Uppsala: Nordiska Afrikainstitutet, 2005.

———. "Dynamics of Agriculture in the Mandara Mountains: The Case of the Kapsiki/Higi of Northern Cameroon and North-eastern Nigeria." In *Man and the Lake: Proceedings of the 12th Mega Chad Conference*, ed. Catharine Baroin, Gisela Seidensticker-Brikay, and K. Tijani, 335–82. Maiduguri: Maiduguri University Press, 2006.

Van Beek, Walter E. A., and Philip M. Peek. "Divination: Du bon sens dans le chaos." In *Art d'Afrique*, ed. Paul Matharan, 149–54. Bordeaux: Musée de l'Occitanie, 2011.

Van Beek, Walter E. A., and Annette Schmidt. 2012. "African Dynamics of Cultural Tourism." In *African Hosts and Their Guests: Dynamics of Cultural Tourism in Africa*, ed. Walter E. A. van Beek and Annette Schmidt, 1–33. Oxford: James Currey, 2012.

Van Beek, Walter E. A., and Henry Tourneux, eds. *Contes Kapsiki du Cameroun*. Paris: Karthala, 2014.

Van Binsbergen, Wim. "African Divination across Time and Space: Typology and Intercultural Epistemology." In *Reviewing Reality: Dynamics of African Divination*, ed. Walter E. A. van Beek and Philip M. Peek, 339–75. Berlin: LIT Verlag, 2013.

Van Santen, José. *They Leave Their Jars Behind: The Conversion of Mafa Women to Islam*. Leiden: VENA, 1993.

Vaughan, James H., Jr. "The Religion and the World View of the Marghi." *Ethnology* 3, no. 4 (1964): 389–97.

———. "Caste Systems in the Western Sudan." In *Social Stratification in Africa*, ed. A. Tuden and L. Plotnicov, 59–92. New York: Free Press, 1970.

———. "Eŋkyagu as Artists in Marghi Society." In *The Traditional Artist in African Societies*, ed. Warren L. d'Azevedo, 162–93. Bloomington: Indiana University Press, 1973.

———. "Mafakur: A Limbic Institution of the Marghi (Nigeria)." In *Slavery in Africa: Historical and Anthropological Perspectives*, ed. Suzanne Miers and Igor Kopytoff, 82–104. Madison: University of Wisconsin Press, 1977.

Vaughan, James H., Jr., and Anthony H. M. Kirk-Greene, eds. *The Diary of Hamman Yaji: Chronicle of a West African Muslim Ruler*. Bloomington: Indiana University Press, 1995.

Vincent, Jeanne-Françoise. "Divination et possession chez les Mofu montagnards du Nord-Cameroun." *Journal de la Société des Africanistes* 51, no. 1 (1971): 71–132.

———. "Sur les traces du major Denham: Le Nord-Cameroun il y a cent cinquante ans. Mandara, 'Kirdi' et Peul." *Cahiers d'Études Africaines* 72, no. 18–4 (1978): 575–606.

———. *Princes montagnards du Nord-Cameroun: Les Mofou-Diamaré et le pouvoir politique*. Paris: Harmattan, 1991.

Von Graffenried, Charlotte. *Das Jahr des Stieres: Ein Opferritual der Zulgo und Gemjek in Nordkamerun*. Freiburg: Studia Ethnographica Friburgensia 2, Freiburg Universitäts Verlag, 1984.

Wade, James H. "The Context of Adoption of Brass Technology in North-eastern Nigeria and Its Effects on the Elaboration of Culture." In *What's New? A Closer Look at the Process of Innovation*, ed. Sander E. van der Leeuw and Robin Torrence, 225–244. London: Unwin, 1989.

———. "Caste, Gender and Chieftaincy: A View from the Southern Mandaras." In *Man and the Lake: Proceedings of the 12th Mega Chad Conference*, ed. Catherine Baroin, Gisela Scheidensticker-Brikay, and K. Tijani, 279–303. Maiduguri: Centre for Transsaharan Studies, 2005.

———. "The Wife of the Village: Understanding Caste in the Mandara Mountains." In *Metals in Mandara Mountains Society and Culture*, ed. Nicholas David, 257–84. Trenton, N.J.: Africa World Press, 2012.

Warnier, Jean-Pierre. "Afterword: On Technologies of the Subject, Material Culture, Castes and Value." In *Metals in Mandara Mountains Society and Culture*, ed. Nicholas David, 328–45. Trenton, N.J.: Africa World Press, 2012.

Wente-Lukas, Renate. "Eisen und Schmied in Südlichen Tschadraum." *Paideuma* 18 (1972): 112–43.

———. *Nicht-islamische Ethnien im Südlichen Tchadraum*. Wiesbaden: Franz Steiner Verlag, 1973.

———. *Die Materielle Kultur der Nicht-Islamischen Ethnien von Nordkamerun und Nordost Nigeria*. Wiesbaden: Franz Steiner Verlag, 1977.

———. *Handbook of Ethnic Units in Nigeria*. Studien Zur Kulturkunde 74. Wiesbaden: Franz Steiner Verlag, 1985.

Werbner, Richard P. *Ritual Passage, Sacred Journey: The Process and Organization of Religious Movement*. Manchester: Manchester University Press, 1989.

Westerdijk, Peter. *The African Throwing Knife: A Style Analysis.* Utrecht: OMI Press, 1988.

Willis, Roy. "Do the Fipa Have a Word for It?" In *The Anthropology of Evil*, ed. David Parkin, 165–82. Oxford: Blackwell, 1985.

Wolf, Eric. *Europe and the People without History.* Berkeley: University of California Press, 1982.

Woodhouse, J. "Iron in Africa: Metal from Nowhere." In *Transformations in Africa: Essays on Africa's Later Past,* ed. G. Connah, 160–85. London: Leicester University Press, 1998.

Zangato, Étienne, and A. F. C. Holl. 2010. "On the Iron Front: New Evidence from North-Central Africa." *Journal of African Archaeology* 8, no. 1 (2010): 7–23.

Index